Harker Pottery

From Rockingham and Yellowware to Modern

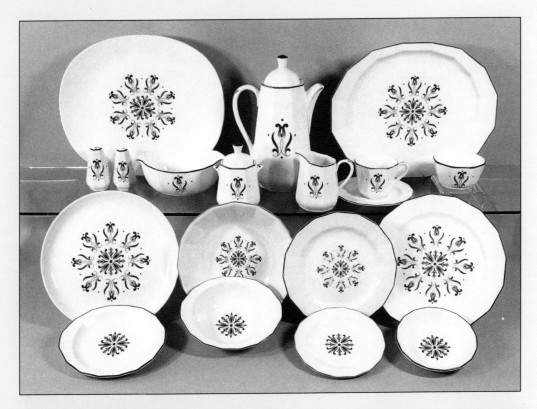

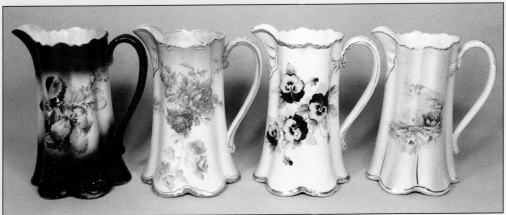

William and Donna Gray

4880 Lower Valley Road, Atglen, PA 19310 USA

Dedication

This book is dedicated to the memory of my Grandmother, Anna Jane Holtzman, who worked at Harker for over nineteen years. It is also dedicated to the large family of potters, managers, and owners who worked at and guided the various Harker Potteries from 1840 until 1972, and to those who love and collect Harker Pottery. The fruits of their labor are a significant part of the rich and wonderful history of the East Liverpool Ohio Historical Pottery District.

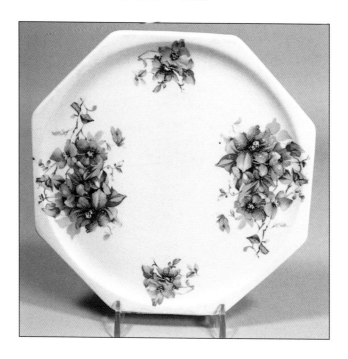

Designed by Mark David Bowyer
Type set in Bernhard Modern BT/Aldine 721 BT

ISBN: 0-7643-2408-X
Printed in China
1 2 3 4

Published by Schiffer Publishing Ltd.
4880 Lower Valley Road
Atglen, PA 19310
Phone: (610) 593-1777; Fax: (610) 593-2002
E-mail: Info@schifferbooks.com

For the largest selection of fine reference books on this and related subjects, please visit our web site at
www.schifferbooks.com
We are always looking for people to write books on new and related subjects. If you have an idea for a book please contact us at the above address.

This book may be purchased from the publisher.
Include $3.95 for shipping.
Please try your bookstore first.
You may write for a free catalog.

In Europe, Schiffer books are distributed by
Bushwood Books
6 Marksbury Ave.
Kew Gardens
Surrey TW9 4JF England
Phone: 44 (0) 20 8392-8585; Fax: 44 (0) 20 8392-9876
E-mail: info@bushwoodbooks.co.uk
Website: www.bushwoodbooks.co.uk
Free postage in the U.K., Europe; air mail at cost.

Contents

Acknowledgments .. 4

Introduction – How To Use This Book 5

Chapter 1. A Short History of Harker Pottery 6

Chapter 2. First There Was Yellow Ware &
Rockingham 1840-1878 ... 12

Chapter 3. Benjamin Harker, Jr. ... 16

Chapter 4. The First Harker Whiteware 1879-1889 18

Chapter 5. The Harker Pottery Company 1890-1925 29

Chapter 6. Moving Across the River & Surviving the
Great Depression 1926-1940 ... 95

Chapter 7. Modern Age, Cameo Ware, and More! 1939-1959 147

Chapter 8. Demise of a Great American Pottery 1960-1972 186

Chapter 9. Backstamps and Marks Found on Harker Pottery 206

Bibliography ... 219

Glossary ... 220

Index .. 223

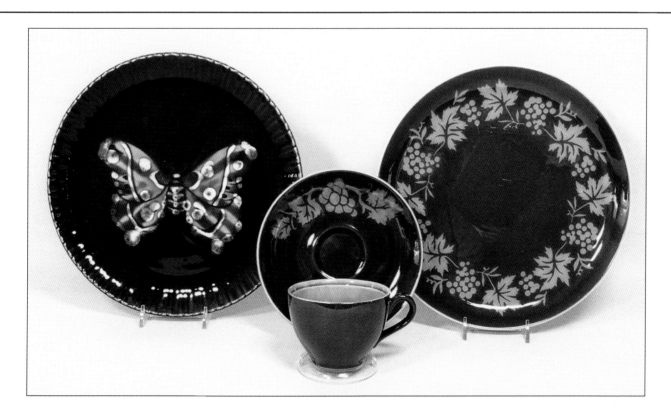

Acknowledgments

This magnificent obsession began during our Hilton Head honeymoon in 1991. We already knew we were blessed, having found each other this late in life. We went antiquing and found ourselves in Morehead City, North Carolina, where we found a Harker gray Chesterton teapot. Donna had to have it because it matched her new last name. Bill wondered if either his Grandmother, Anna Holtzman, or his mother, Dorothy Gilmore had handled it since both had worked for Harker Pottery. From then on, we turned over almost every piece of pottery we saw and took the Harker home with us. Neva Colbert was working on her Harker book at this time and we tried, without success, to make contact. During our antiquing trip to the Pacific Northwest Coast, we were told Neva had been there only hours before. Our collection continued to grow and we soon ran out of room in our Maryland home. Almost by accident, or divine providence, we found the house of our dreams in, of course, East Liverpool, Ohio. It took us a year to pack and move our Harker collection to our new home. From the first to the present, in our quest to learn more about Harker pottery, we have learned something new, almost every day.

Our dear friend, Jo Cunningham, started telling us we had to write a book on Harker and enlisted Peter Schiffer of Schiffer Publishing, Ltd. in encouraging us to write this book, in spite of our, "Maybe someday, after we retire...". Shortly after we committed to a contract, Bill retired and began photographing our collection. Donna began doing microfilm research, after school. Microfilm was a major source of information as there are no archives or old company files in existence.

So, we thank our families and friends for their forbearance during our even more obsessive period with Harker Pottery.

Special Acknowledgments

Lisa Rohrbaugh, Librarian and Tamra Hess, Assistant Librarian at East Palestine Memorial Library, who rendered valuable assistance in many ways, including obtaining & returning the microfilm for us.

Phil L. Rickerd, Caretaker, Ohio Historical Society, Museum of Ceramics, East Liverpool, Ohio. Phil is knowledgeable, amiable, and works tirelessly to provide access to East Liverpool's finest historical collection. Phil has rendered invaluable assistance for over two decades to numerous historical and pottery researchers with a variety of agendas. We also wish to thank Sarah Webster Vodrey, Historic Site Manager for her assistance. We photographed many pieces belonging to the East Liverpool Historical Society, most of which are on permanent loan to the Ohio Historical Society, Museum of Ceramics.

Cynthia Boyce Sheehan, who has unselfishly shared Harker information, catalog pages, sales brochures, rare Harker Pottery heirlooms, and loving encouragement.

Trustees of the East Liverpool Historical Society, who allowed us to photograph their collection in the Thompson House and in the Museum of Ceramics.

Jo Cunningham, consummate pottery author and dear friend, who *made* us write this book.

Paul Pinney, who was Grandma Holtzman's friend, served as a fount of knowledge, and has been a very special friend to us.

Schiffer Publishing, Ltd., Special thanks to Peter Schiffer for believing in us and to Jeff Snyder, our editor, for his assistance and patience in guiding us through our first book.

Camera Mart, East Liverpool. A sincere thank you to Larry & Carol Walton who fussed over our photographs, provided rush services, and were invaluable time and again.

Joan Witt, local historian, who knows where everything and everyone was located in East Liverpool.

Helen Stenger, Superintendent, Riverview Cemetery, who knows where all the potters are buried.

John & Emmy Lewis, Bill Mackall, & Steve Safakis, who, among many others, fed our Harker habit.

Marsha Seeley Nurmi. Daughter of Eugene Seeley, long time Harker employee. Marsha allowed us to photograph several pieces of ware, including medallions, a perfume ewer, and the yellow ware bedbug deterent.

Betty Pratt Dornik & Judy Miller, who allowed us to photograph their Rockingham inkwell.

Brett Hartenbach & Arden Duffy, who allowed us to photograph their yellow cameo chamber pot.

Patricia Peterson, Pearl China Co., who allowed us to refer to the company name & backstamp on Quaker Maid ware.

Lois Myers was one of our earliest mentors. She spent many evenings explaining the history and everchanging relationships of East Liverpool's potteries and the primary importance of pottery marks.

Introduction –
How To Use This Book

Captions

We have arranged our captions left to right and back to front with rare exceptions. Decals, patterns, and shapes are listed and what follows in the caption is the same until a different designation is listed. Sometimes the same designation is repeated on two or more pieces because they are unusual, especially important, or perhaps not as easily seen in the photograph. We encountered so much size variation that we were forced, due to the volume of detail in our captions, to round sizes up or down by a .25" (1/4") in order to save space for more important details.

Decals

We have used the decal name most Harker collectors are familiar with, inserting the Harker name for a decal when we have found it. We have also tried to keep ware with the same decal together, regardless of shape. We had to depart from this approach in several places in the book. The most popular decals are included in our Index, but we could not include them all, as this would have been impractical. Clearly, this book includes many more examples of Harker decaled ware than any book has attempted heretofore. We hope our book will provide collectors with valuable information to aid them in expanding their Harker collections.

Backstamps

Color photographs of over 200 Harker backstamps are shown in this book. A few backstamps in Chapter 9 are on Harker pieces in our collection that may have been decorated for another pottery or wholesaler, or are on pieces Harker may have sold as blanks. We refer to these backstamps as "of uncertain origin", so they are included. One mark, showing an impressed bow & arrow and "USA" is a prime example of this unknown origin. Since Harker is the only pottery we know of that used this type of mark, we have included it as well. Hopefully, this mark will be identified with certainty in the near future.

Catalog Pages

We have included numerous catalog pages to serve as a guide to collectors. We couldn't include every catalog page we own, but made sure to include the really significant ones.

Non-Harker

There are a few pieces of non-Harker in this book. Bennett Pottery Cameo is often mistaken for Harker. The Wallace & Chetwynd backstamp is included because Chetwynd was a mold maker for Harker. If you see what appears to be a Harker shape with a Wallace & Chetwynd backstamp, you will understand our reasoning.

Glossary

The Glossary in this book is generally Harker specific, although many terms are generic.

Index

The Index is arranged alphabetically within categories.

Pricing

Prices can vary widely due to location, scarcity, condition, and a variety of other factors. Listed prices are generally based on above average to pristine condition. Prices shown are, for the most part, based largely on prices we encountered while building our extensive collection, so you may well find prices that differ from our experience. Price ranges reflect market conditions current at the time we wrote this book and are intended as an informational guide only. The authors and publisher accept no responsibility for the future accuracy of these values.

Chapter One
A Brief History

Benjamin Harker, Sr., a roof slater by trade, lived in Dudley, in the Staffordshire area of England, in the 1830s. At that time, numerous fliers were posted in the region, offering cheap land in Ohio, the beginning of the Northwest Territory in North America. Harker sold everything he owned, and booked himself, his second wife, Elizabeth Ann, and their six children (the youngest only a year old) on a steamer bound for America.

By the summer of 1839, the family had made its way to Allegheny Town (later Pittsburgh, Pennsylvania), where Benjamin rented a house for his family. He bought two horses and started out with his eldest son, fifteen-year-old George, for Ohio. Their first stop in Ohio was the Boyce farm, in Calcutta. Boyce was willing to sell his farm, but not his stock and household goods.

Benjamin and George continued their journey, just a few miles, to East Liverpool, where again they inquired about land for sale. They were directed to Abel Coffin, who agreed to sell Benjamin Harker fifty acres bordering the Ohio River, plus Custard's (Babb's) Island in the river, for $3,700, complete with stock, house, and household goods. On September 4, 1839, Benjamin Harker, his wife, and children took possession of the farm just before dinner. Local legends say the Harkers ate the Coffin's warm supper, but had to learn to milk the cow, which none of them had ever done before.

Abel Coffin told Benjamin Harker there were rich clay deposits on his land bordering the Ohio River, but few local people recognized them as significant. Benjamin Harker and his two eldest sons began to mine the clay, selling it to glass factories in Pittsburgh, and to James Bennett, who had just begun the first pottery in East Liverpool.

Benjamin sent young George with one load of clay down river toward Cincinnati in search of new buyers. Prospects looked very poor by the time George docked in Cincinnati. George went ashore for dinner. During dinner, a large steamer hit the docked clay barge and sank it in the river. Wanting to avoid litigation, the steamer captain promptly paid the asking price of the load of clay. George returned home with the full price of the clay he had not been able to sell. Benjamin never sent another load of clay down river.

Observing James Bennett's success with pottery, Benjamin Harker soon decided to try his own pottery. He and his sons, George and Benjamin, Jr., utilized a log cabin distillery built by Coffin on the land. They built a six-foot beehive kiln like Benjamin, Sr., had seen in Staffordshire, England, and a small slip house. Late in 1840, the Harker men began potting.

Because they had no potting knowledge, their efforts were not successful. Benjamin Harker Sr. leased his little pottery to Edward Tunnicliff and John Whelton, who were also unsuccessful.

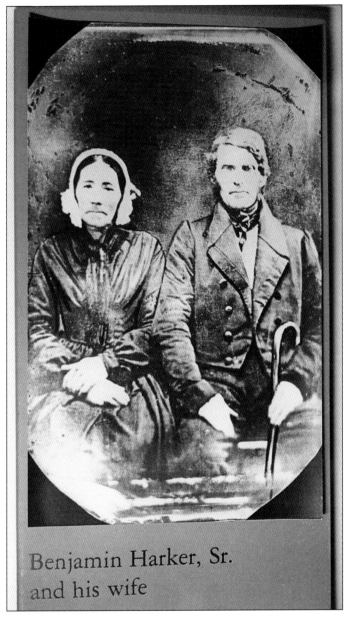

Benjamin Harker, Sr. and his second wife, Elizabeth Ann, *Courtesy East Liverpool Historical Society.*

In 1842, Harker leased the pottery to Tunnicliff, John Goodwin, and Thomas Croxall, newly arrived Staffordshire potters, with the proviso that they train his two elder sons, George and Benjamin, Jr., in the pottery. This union lasted until 1846. Then Benjamin, Sr., George, Benjamin Jr., and James Taylor, under the name Harker, Taylor and Company, built a three story brick pottery called the Etruria Works, after the Wedgwood Pottery in England. This pottery was quite successful, making many Rockingham items still highly sought after today, including the beautifully molded hound handled jugs, and spittoons in several shapes.

In February 1850, Benjamin Harker, Sr. and his wife sold their share of the pottery to the oldest son, George S., for $122. In 1851, James Taylor left East Liverpool to establish his own pottery in New Jersey. The Harker firm added Ezekiel Creighton and Matthew Thompson, and became Harker, Thompson and Company. The youthful partners faced the same problems all the other domestic potteries shared. Foreign, especially English, potteries disseminated advertising declaring their products to be far superior to American made products. American housewives believed what they read. In the autumn of 1853, the young potters dared to enter an international exhibition in Boston, because they believed their Rockingham products to be as good as any imports.

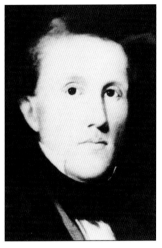

They packed a selection of their choice Rockingham and yellow ware, and sent it off to Boston. Several weeks later, they received a letter, and a silver medal from the judging committee, praising their ware in glowing terms. Upon the death of Ezekiel Creighton in April 1854, the firm became known as George S. Harker and Company.

George S. Harker, *Courtesy East Liverpool Historical Society.*

Cover of George S. Harker's Journal, East Liverpool, Ohio, c. 1845, *Courtesy East Liverpool Historical Society.*

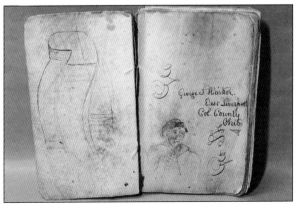

Drawings from Journal of George S. Harker, c. 1845, *Courtesy East Liverpool Historical Society.*

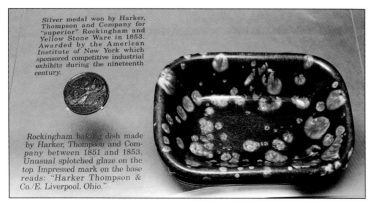

Silver medal won by Harker, Thompson and Company for "superior" Rockingham and Yellow Stone Ware in 1853. Awarded by the American Institute of New York which sponsored competitive industrial exhibits during the nineteenth century.

Rockingham baking dish made by Harker, Thompson and Company between 1851 and 1853. Unusual splotched glaze on the top. Impressed mark on the base reads: "Harker Thompson & Co./E. Liverpool, Ohio."

Rockingham 8" x 6" bowl and 2" Silver Medal awarded in 1853 to Harker, Thompson and Co., East Liverpool Ohio, by the American Institute of New York, *Courtesy East Liverpool Historical Society*.

Many potters who later opened their own potteries in East Liverpool were employed at the Etruria Works by George S. Harker at various times, including:

Wm. Brunt, James Vodrey, Isaac Knowles, J. Goodwin, Wm. Flentke, John Croxall, S. Cartwright, Holland Manley, Geo. Hallam of Agner & Fouts & Co., S. Moore, Wm. Burton, Sr. & Jr., Josiah Thompson, and Wm. Bloor.

Benjamin Harker, Jr. left Harker, Thompson and Company in 1853. With William G. Smith, James Foster, and Daniel J. Smith, Benjamin Harker, Jr. bought the old Mansion House Pottery abandoned by Salt and Mear. It was not a good time to start a new pottery, due to a bad flood in 1852. The financial outlook became even worse in 1854, with money scarce, and food and necessity prices prohibitive in East Liverpool. Harker, Smith and Company was among the first East Liverpool potteries to pay workers in script, good for pottery. In 1855, Benjamin Harker, Jr. returned to the George S. Harker Pottery Company to work with his brother, until he went to fight for the Union in the Civil War in 1863. He rejoined the firm after his 100 days of service was over.

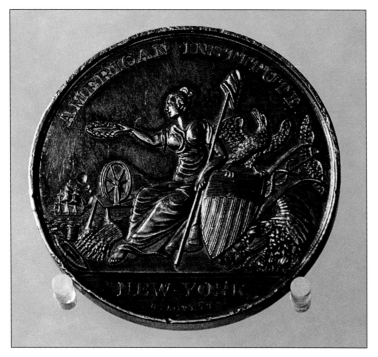

Silver Medal, detail of front, "American Institute, New York", awarded in 1853, *Courtesy East Liverpool Historical Society*.

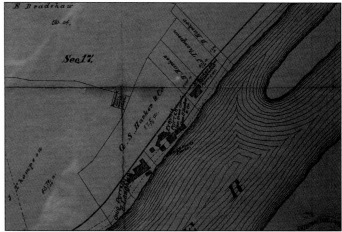

Map showing location of land owned by George S. Harker, and Benjamin Harker along the Ohio River in 1879, *Courtesy East Liverpool Historical Society*.

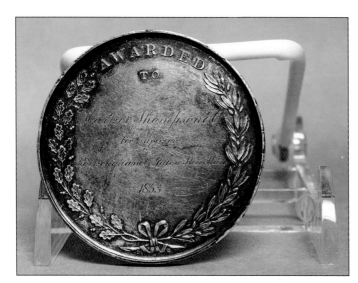

Silver Medal, detail of back, "Awarded To Harker Thompson & Co for Superior Rockingham, & Yellow Stone Ware 1853", *Courtesy East Liverpool Historical Society*.

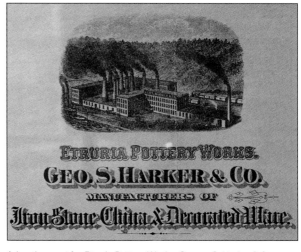

Advertisement for Etruria Pottery Works, George S. Harker & Co. on 1879 Map, *Courtesy East Liverpool Historical Society*.

In 1864, George S. Harker died suddenly of typhoid fever at the age of forty. He left his second wife, Rachel, a widow of twenty, and two young sons, Harry (Hal), five, and William (W.W.), seven. George had been preceded in death by his first wife, Zilliah, two sons, and a daughter. George's sister, Jane, had married David Boyce. David Boyce stepped in to manage the George S. Harker Pottery Company until George's sons were old enough. Thus began a Harker-Boyce relationship that would steer the company until its demise over one hundred years later.

W.W. Harker began assisting his uncle, David Boyce, in the management of the George S. Harker Pottery Company in 1877, when he was but twenty. That same year, his uncle, Benjamin Harker, Jr., and his sons sold their interest in the company to his brother's widow, Rachel Harker, and established their own pottery, called the Wedgewood Pottery. Benjamin Harker, Jr.used both spellings (Wedgwood/Wedgewood) in his catalogs and advertisements.

Benjamin and his sons outfitted their pottery with the latest equipment and began making white ironstone and other white ware, preceded in East Liverpool only by Knowles, Taylor, Knowles, in 1872, and Laughlin Brothers, in 1874. In 1881, Benjamin Harker, Jr. died suddenly and the Wedgewood Pottery was sold to Wallace and Chetwynd, who renamed it the Colonial Pottery. Joseph Chetwynd of Wallace and Chetwynd was the brother of Jesse Chetwynd, who had been the chief mold designer/maker for George S. Harker for many years. Wallace and Chetwynd took advantage of the well-outfitted pottery to produce a line of not only well made, but beautifully decorated pottery.

In 1879, George S. Harker and Company ceased making Rockingham ware and began making white ware. The company treated its employees to a picnic at Rock Springs Park, across the Ohio River, in Chester, West Virginia, to celebrate. The new "Republic" and "Cable" shapes were the first white ware shapes made, but their delicate grape leaf compote

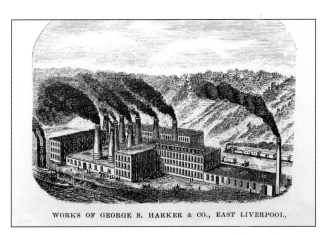

Artist's Conception of George S. Harker & Co. Pottery, *Courtesy East Liverpool Historical Society.*

was also made that very first year. There was a major flood along the Ohio River in 1884. The changeover to white ware in 1879, and the flood in 1884, put the George S. Harker Pottery Company in severe financial straits. Isaac Knowles, founder of Knowles, Taylor, Knowles Pottery, loaned the Harker brothers, Hal and W.W., money to repair the flood damage. He told the young men that their father, George S., had loaned him money when he had needed it. Since George S. had never needed Isaac's help, he was extending the favor to George's sons to enable them to repair their pottery.

In 1890, the George S. Harker Pottery Company became incorporated as the Harker Pottery Company, giving birth to the stone china bow and arrow mark, the semi-porcelain bow and arrow mark, and the inverted bow and arrow mark. Diligent research has not revealed the motivation for the bow and arrow marks. Most of the early Harker marks on white ware, except the "faux English mark", were uniquely American, sporting eagles, United States flags, and later the Statue of Liberty in the Columbia mark. In 1911, the Harker Pottery Company purchased the adjacent National China pottery building (formerly the Homer Laughlin pottery), and doubled their capacity.

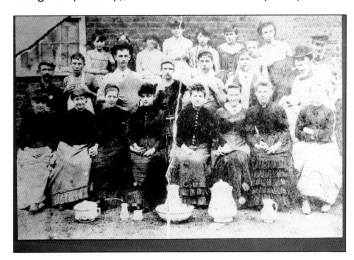

"Harker's First Decorating Crew 1885", *Courtesy East Liverpool Historical Society.*

In 1894, at the age of nineteen, Charles R. Boyce joined the Harker Pottery Company as a college educated "general office boy". When he died in 1934, forty years later, he was the secretary, a substantial stockholder, and close associate of President H.N. Harker. Charles R. Boyce is given credit by many for the growth and success of the Harker Pottery Company in the early 1900s. His eldest son, Robert E. Boyce, became the company's ceramic engineer in 1927, and President in 1949, after H.N. Harker's death. Ten years later, in 1959, his brother, David Boyce, became President when Robert became the treasurer of Harker Pottery, and also President of the First National Bank of East Liverpool.

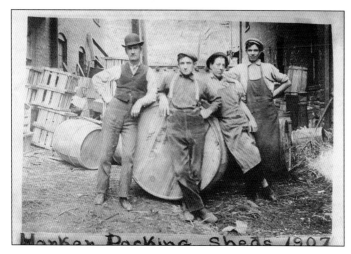

"Harker Packing Sheds 1907", *Courtesy East Liverpool Historical Society.*

Photo of Harker Pottery Co. abandoned round & square kilns, East Liverpool, Ohio, c. 1931, *Courtesy East Liverpool Historical Society.*

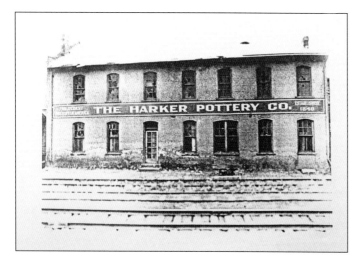

Photo of "The Harker Pottery Co., Established 1840", East Liverpool, Ohio, *Courtesy East Liverpool Historical Society.*

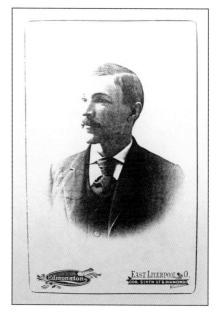

Photo of Hal Harker, East Liverpool, Ohio, *Courtesy East Liverpool Historical Society.*

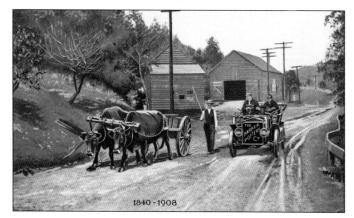

1908 Postcard showing oxen pulling wagon, & Harker automobile.

The "best gamble Harker never took" occurred in 1929. Several East Liverpool potteries merged to become the American Chinaware Corporation. Harker Pottery Company was pressured to join, but declined. The American Chinaware Corporation failed in 1931, taking all of the merged companies, including the Knowles, Taylor, Knowles Pottery, with it. K.T.K. had been the largest pottery in America in 1929.

Before the Army Corps of Engineers built the locks and dams spanning the Ohio River, annual flooding continued to be a major problem. In 1931, the Edwin M. Knowles Pottery building, located on a high plateau across the river in Chester, West Virginia, became available. Harker Pottery Company purchased the pottery and moved its operations across the Ohio River. With the move came more modern bow and arrow marks and many new products. Hotoven items, the first decal decorated bake ware in America, were first produced in East Liverpool in 1926, but the majority of those items were produced in Chester, West Virginia. The lovely Melrose shape was a new offering from the new location. As with most of the potteries who moved across the river to higher ground and much needed room for expansion, the Harker Pottery Company retained its East Liverpool, Ohio, mailing address.

Although Harker Pottery Company appeared to spend much less on advertising than other East Liverpool potteries, until Robert and David Boyce were at the helm, Harker tried to market ware through wholly owned subsidiaries, such as Columbia Chinaware. Columbia Chinaware targeted smaller towns from 1935 to 1955, with brightly decaled pottery, and other kitchen items, including glass, enamel, and aluminum ware. Columbia also made several Jewel Tea Autumn Leaf items until Hall China Company secured an exclusive right to the decal in the late 1930s. Sun-Glow and Bakerite were other marketing lines by Harker, as was Bungalow Ware.

By the 1950s, United States potteries found themselves competing with not only less expensive imported wares, but also plastics, glass, and aluminum. Harker Pottery Company turned to some of the best ceramic designers of the times. German immigrant, George Bauer, had patented the cameo process used by the Bennett Pottery in Baltimore, but his most prolific work was for Harker, designing the myriad Cameoware patterns and shapes in the 1940s. The famed modern designer, Russel Wright, created his first two-color design, White Clover, in production for the Harker Pottery Company from 1953 to 1958. East Liverpool artist, Hans Hacker, also a German immigrant, designed the award-winning and brightly colored Country Style stoneware in 1962. Vincent Broomhall, later a ceramic designer for Homer Laughlin, produced an exclusive decal for Harker in 1964. Harker's own designers, Norman Clewlow and Doug Manning, were the valiant workhorses of the 1960s. Norman Clewlow designed all the Harker Rockingham reproduction pieces, even though he was not allowed to touch an original Harker-Taylor hound handled jug. He designed the delicate Oriental bone china cups and saucers marketed only in the art departments of Horne's Department Store in Pittsburgh, Pennsylvania, and Woodward & Lothrop in Washington, D.C. Many of his other lovely experimental designs were never marketed due to prohibitive production costs. Doug Manning's designs include the beautiful Tahiti line.

In spite of some of the best innovative and creative ceramic talents in the country, the Harker owner/ managers realized the Harker Pottery Company's days were limited. As had been their history through the Civil War, World War I, the Great Depression, and World War II, the many moods and seasons of the mighty Ohio River, and in the face of foreign and domestic competition, Harker Pottery Company executives worried most about their employees. To preserve their employees' jobs, the Harker Pottery Company was sold to Jeannette Glass in late 1969. Jeannette retained not only most of the employees, but also the company name. On March 24, 1972, after two years of major losses, Jeannette Glass closed the Harker Pottery Company forever, ending one hundred thirty-one years of continuous pottery production. At that time, the Harker Pottery Company held the record for the longest continuously operating U.S. pottery.

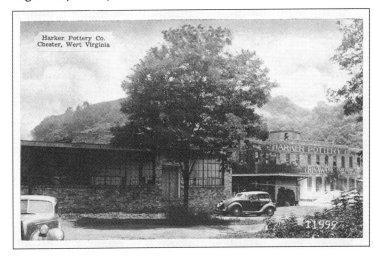

Postcard showing Harker Pottery in Chester, WV, c. 1931, "Silvercraft, Made by Dexter Press, Pearl River, NY, Pub. By Ralph N. Sassara, Pittsburgh, PENNA".

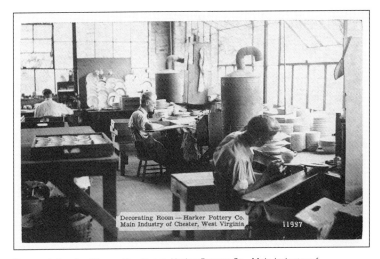

Postcard showing "Decorating Room, Harker Pottery Co., Main Industry of Chester, West Virginia", 1945, "Silvercraft, Made by Dexter Press, Pearl River, NY, Pub. By Ralph N. Sassara, Pittsburgh, PENNA".

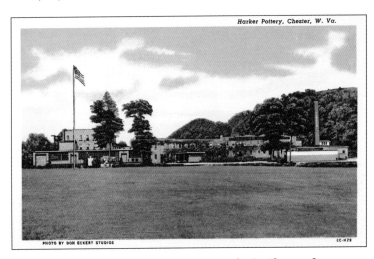

Postcard showing Harker Pottery Co., 1945, Don Ekert Studios (*Courtesy Camera Mart, Larry H. Walton*), Rogers News Agency, East Liverpool, Ohio, Genuine Curtech-Chicago "C.T. Art-Colortone" ™.

Chapter Two

Yellow Ware and Rockingham

In the mid-to-late 1700s, potters on the Marquis of Rockingham's estate in Yorkshire, England, decorated their household pottery with a mottled brown glaze. Other English potters began to use the lovely brown glazes. The glaze recipes immigrated to the American East Coast in the 1820s with English potters.

East Liverpool, Ohio, in the 1840s, was on the edge of the Northwest Territory. Sketchy records indicate Benjamin Harker, Sr. began making very utilitarian pottery for American households along the Ohio River. This included terra cotta pots and jardinières, and a variety of yellow ware. The clay mined from the banks of the Ohio River was a natural pale yellow. Early on, most yellow ware received an almost colorless lead glaze.

One of the most unusual early Harker yellow ware items pictured is a bedbug deterrent. These containers sat on the floor, surrounding each of the legs of the bed. Near the bottom of the piece was a depression, which was filled with water. Bedbugs could crawl up to the water reservoir, but supposedly would not cross the water, thereby preventing them from getting at the occupant(s) of the bed.

Harker began applying Rockingham glazes to many yellow ware items, with the intention of making these utilitarian items more desirable to American housewives. Serving bowls, milk pans, plates, platters, pots, jugs, mugs, bedpans, doorknobs, toys, ceramic tiles, humidors, and spittoons were among the items potted. Harker Rockingham glazes were made in a variety of colors. Some were dark brown, heavily applied over the native yellow clay, while some were a glorious lighter shade of brown. Some glazes were nearly golden in color, and many had unique green and blue shadings within the brown. All the Harker Rockingham pieces we own are glazed on the bottom of the piece. The glaze on the bottom of the pieces is quite often the same color as the outside glaze. Sometimes stray strands of the darker glaze were mixed into the clear glaze, and sometimes a clear glaze was used over an impressed mark.

Yellow Ware slip applicator tool; Rockingham custard cup; Rockingham milk pail, *Courtesy East Liverpool Historical Society.*

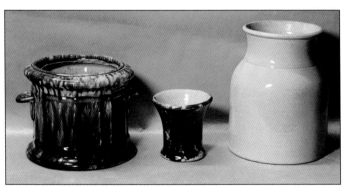

Rockingham humidor (missing the lid); Rockingham tumbler; and Yellow Clay jar, c. 1840-1865, *Courtesy East Liverpool Historical Society.*

Pieces we photographed in the Ohio Historical Society Museum of Ceramics in East Liverpool, Ohio, belong to the East Liverpool Historical Society and are on permanent loan to this museum. Several of the Rockingham pieces are unmarked and were attributed to the Etruria Pottery Works by Harold Barth, an avid collector of East Liverpool Ware. William C. Gates, Jr. and Dana E. Ormerod co-authored a book on East Liverpool pottery marks. We have assigned a number to the marks found on these items and referenced several marks from their book, with permission, in our Chapter 9 on Marks & Backstamps.

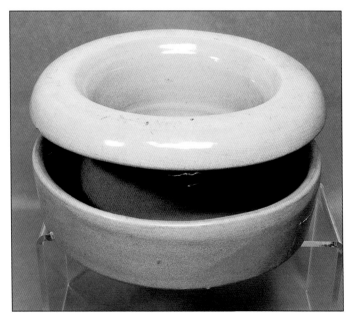

Yellow Ware bed bug ring, 7" W x 4" H, attributed to Harker, Unmarked, *Courtesy M. Nurmi – Daughter of Eugene Seeley.*

William Gates also wrote *The City of Hills & Kilns* and was the first curator of the Museum of Ceramics. The collection in the Ohio Historical Society Museum of Ceramics was curated between 1970 and 1980.

The two most beautiful and well preserved Harker Rockingham items in the Museum of Ceramics are the Harker-Taylor marbleized water cooler and the Harker-Thompson ceramic calling card. The Rockingham inkwell depicting Wm. Penn and Iroquois braves is in sad shape, but still illustrates the Harker expertise in applying early Rockingham glazes.

We believe the much sought-after hound handled jugs came in six sizes, 7.5 inches to 12.5 inches high, with glazes ranging from a very dark brown to a golden honey color.

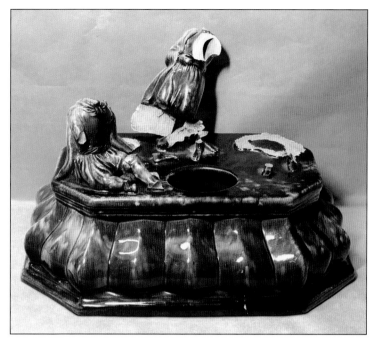

Rockingham Inkwell, "William Penn & the Iroquois Braves", 10" Wide, *Courtesy East Liverpool Historical Society*.

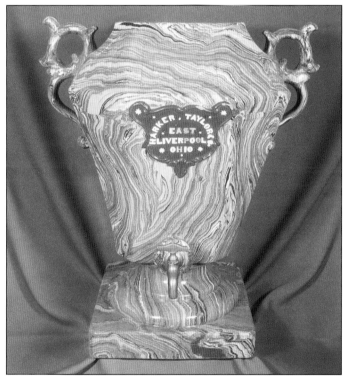

"HARKER TAYLOR & CO., EAST LIVERPOOL, OHIO" Marbleized water cooler, 21" H x 11" D x 19" W, c. 1846-1851, *Courtesy East Liverpool Historical Society, Photo Courtesy Camera Mart, Larry H. Walton*.

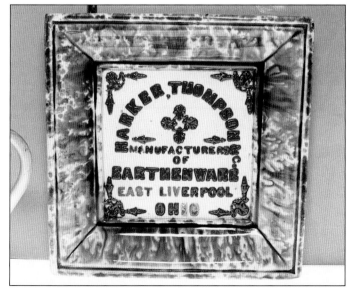

The Harker Toby jugs are outstanding examples of Rockingham ware. They are full figured, standing jugs, while most Tobys are either half-figures, or sitting examples. These jugs are exquisitely detailed, from the bow-tied cravat to vest buttons to shoe buckles. The handles are particularly pleasing. They are also finished in George S. Harker's finest shiny glazes, ranging from dark brown to a lighter, more golden color. A Harker Rockingham inkwell, with local provenance, surfaced when we were in the final stages of this book and we have included a photograph of the piece.

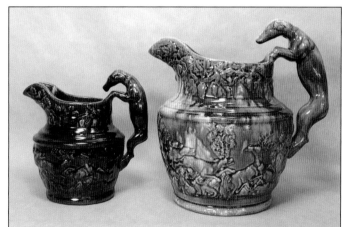

Rockingham hound handle jugs, surface details, 7" H, MK 1, $500-$800; 10" high honey glaze, MK 2, $200-600.

HARKER THOMPSON "Calling Card", 8.5" square, c. 1851-1854, *Courtesy East Liverpool Historical Society*.

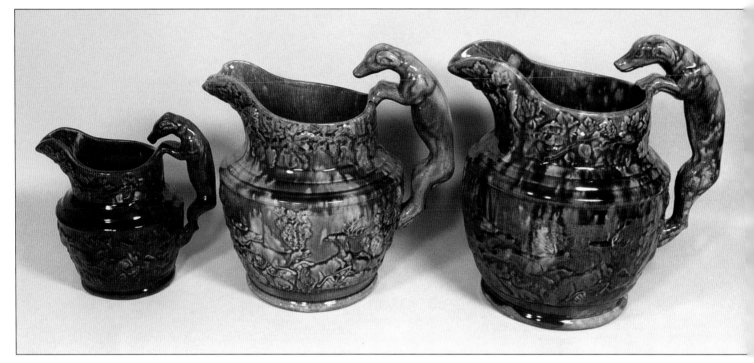

Rockingham Glaze variations, 7" H Jug, MK 1, $500-800; 10" H Jug, MK 2, $200-600; 11" H Jug, no mark, $200-400.

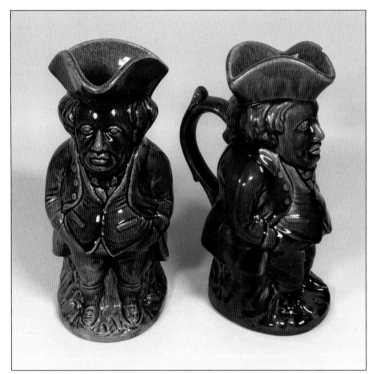

Toby Jugs, 9.5" H, attributed to Harker, $250-350 each.

Rockingham Jug, 7" H, attributed to Harker, *Courtesy East Liverpool Historical Society*.

Rockingham Spittoons & Ink Wells, attributed to Harker, *Courtesy East Liverpool Historical Society*.

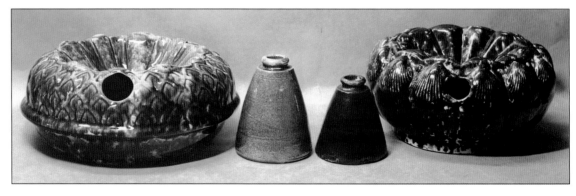

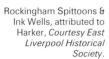

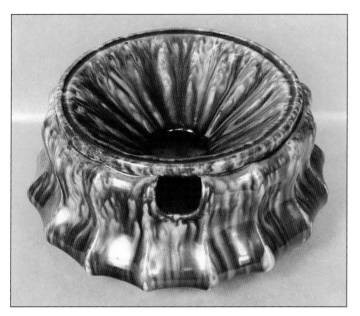

9" W Rockingham Spittoon, MK 4, *Courtesy East Liverpool Historical Society.*

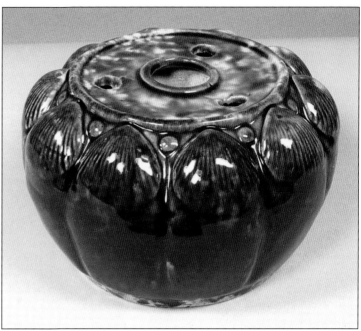

Rockingham Inkwell, 4.25" W x 2.5" H, c. 1850, $150, *Courtesy Betty Pratt Dornick.*

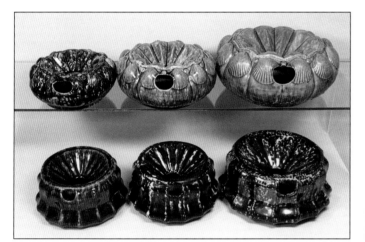

Rockingham Spittoons, **Top** – Unmarked Shell & Button Shape, 6" W medium brown glaze, $50-75; 8" W honey glaze, $60-80; 10" W honey glaze, $60-100; **Bottom** – Paneled Shape, 7" W medium brown glaze, MK 3, $60-75; 7" W dark brown glaze with green highlights, MK 215, $60-75; & 9" W, speckled dark brown glaze MK 211, $120-125.

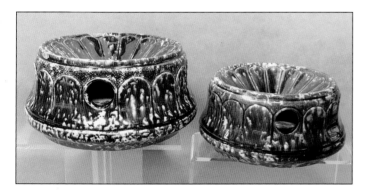

Rockingham Spittoons, 8" W, MK 3, $100-125; 7" W, MK 5, $75-100, *Courtesy Nancy L. Wetzel.*

George S. Harker, Etruria Pottery Works Ads, top ad from Volume 2, Number 27 of *Crockery & Glass Journal* dated July 8, 1875; bottom ad from Volume 7, Number 1 of *Crockery & Glass Journal* dated January 3, 1878.

Benjamin Harker, Jr.

Benjamin Harker, Jr. was Benjamin Harker, Sr.'s second son. Benjamin, Jr. earned shares of the pottery, but it was his elder brother, George Simeon Harker, who was allowed to purchase the pottery when Benjamin, Sr. wished to retire. It was the descendants of George S. who perpetuated the Harker Pottery name. Still, Benjamin, Jr. should not be overlooked.

Three years after George S. purchased the family business, Benjamin, Jr. left the company for the first time, forming Harker, Smith and Company in 1853. This company lasted for only two years. The economy was so poor in 1854, "the Black Year", that the workers were often paid in pottery, in lieu of money. We know of no existing pieces of this ware. Benjamin, Jr. returned to work for his brother in 1855, to support his wife and many children.

In the spring of 1864, it was decided to Federalize the National Guards of several states in order to give the regular Union Army troops some respite, and to regroup. Many units were nearing the end of their three-year terms. Several East Liverpool businessmen signed up for 100 days of service. Benjamin Harker, Jr. was thirty-six when he signed on, the father of six children, with one on the way. Pvt. Harker was assigned to the 143rd Ohio Volunteer Infantry, Company 1. His first commanding officer was John Cartwright, an East Liverpool potter. Company 1 served its 100 days under another East Liverpool potter, William H. Vodrey, as garrison troops guarding Forts Slocum, Stevens, Totten, and Slemmer, north of Washington, D.C. These troops were called the "Sunshine Soldiers" for the brevity of their enlistment and the ease of their duty. Pvt. Benjamin Harker mustered out with his company on September 13, 1864, and returned to work at his brother's pottery.

In 1877, Benjamin, Jr. and his sons sold their interest in the George S. Harker and Company Pottery to his brother's widow, Rachel Harker. The men established the Wedgewood Pottery, and purchased the very latest equipment. While the George S. Harker Pottery was still turning out Rockingham ware, Benjamin, Jr.'s Wedgewood Pottery began making white ironstone and other white ware. Only Knowles, Taylor, Knowles (1872) and the Laughlin Brothers (1874) had converted from producing Rockingham to white ware before this time in East Liverpool. Benjamin Harker and Sons proudly advertised that they manufactured "C.C. Ware, Exclusively". C.C. Ware was commonly referred to as cream-colored, also common clay. Their catalog included bird baths, bed pans, bakers, bowls, chambers, creams, cuspidors, dishes,

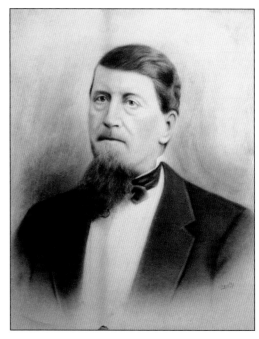

Benjamin Harker, Jr., *Courtesy East Liverpool Historical Society.*

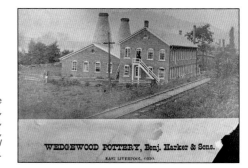

Photo of the "Wedgewood Pottery, Benj. Harker & Sons, East Liverpool, Ohio.", *Courtesy East Liverpool Historical Society.*

WEDGEWOOD POTTERY, Benj. Harker & Sons.
EAST LIVERPOOL, OHIO.

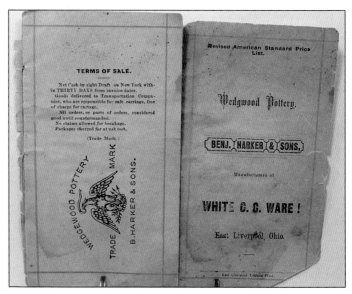

Price List for Wedgwood Pottery, c. 1877-1881. (Note cover & Eagle backstamp spelling disparity), $20-25.

ewers, basins, jugs, mugs, mustards, nappies, plates, fruit saucers, soap drainers, soap slabs, sugars, spittoons, slop jars, teas, tea pots, tea sets, toilet sets, and double thickness Hotel ware in sugars, bakers, dishes, butters, and molasses cans. This ware is very rare, but can be found marked. Refer to Marks 8, (shown in price list photo), 9, and 213 in Chapter 9 (Backstamps/Marks).

In December 1881, the Wedgewood Pottery announced a new toilet set, the "Celtic" shape, but Benjamin Harker, Jr. died unexpectedly that month. The Wedgewood Pottery was sold to Wallace and Chetwynd, who marketed the attractive new toilet set shape as the "Sultan".

Benjamin Harker, Jr.'s second son, Benjamin R. Harker, worked beside his father in the potteries. In 1877, he had moved to Altoona, Pennsylvania, to market pottery from the Wedgewood Pottery. He became the proprietor of a crockery store there, selling only East Liverpool ware. He later returned to the East Liverpool area, and was working for Knowles, Taylor & Knowles in 1890. In the meantime, the Homer Laughlin China Company had also moved across the Ohio River to higher ground, and much needed room to expand. Benjamin R. Harker later worked for Homer Laughlin, becoming Superintendent, a position he held for several years until his retirement in 1907. Benjamin died on June 10, 1923, at the age of sixty-four, having lived longer that either his father or grandfather.

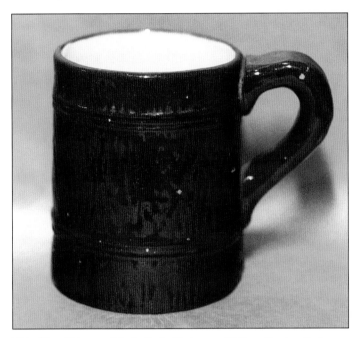

Benj. Harker & Sons, Wedgewood Pottery Ad, Volume 13, Number 11 of *Crockery & Glass Journal* dated March 10, 1881.

White Ware 4" H mug, attributed to the Wedgewood Pottery, *Courtesy East Liverpool Historical Society.*

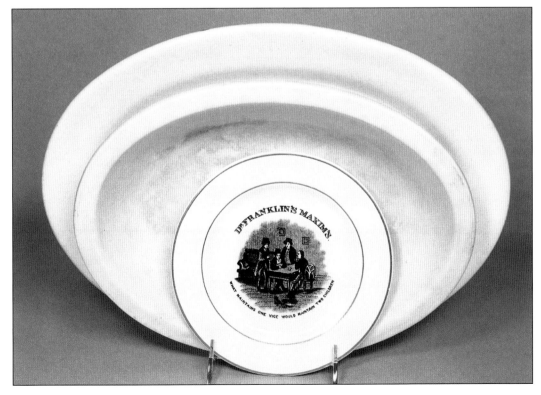

White Ware examples, each with a different mark: 6" "Dr. Franklin's Maxims", "What Maintains One Vice Would Maintain Two Children", MK 213, $30-45; 11" oval bowl MK 9, $20-30; 14" platter, MK 8, $15-20.

1879 – 1889 White Ware

George S. Harker and Company was the fourth East Liverpool pottery to manufacture white ware (also called cream-colored, common clay, or C.C. ware). Their first white ware offerings were the Republic and Cable shapes. All the East Liverpool potteries making white ware at that time, made the cable shape, as did most of the East Coast and English potteries. The Republic shape featured the raised Cross of St. George on the dinner plates, and on the handles of the hollowware, and served to distinguish this Harker shape. The Republic shape is often seen with a cable lid, but Republic shape lids were also made. The Republic shape mixing bowls came in many sizes, and had a pleasing almost flat scalloped edge, and smooth round sides. Toilet sets were also made in this shape. Occasionally, a Republic chamber pot may be found with another manufacturer's mark such as Homer Laughlin, K.T.K., Globe, or the Potter's Co-operative. These pieces may have been made by Harker to fill the other potteries' orders.

The marks on the first Harker white ware were undeniably American, sporting Eagles, flags, and crossed flags. Most of this ware was heavy, but the delicate grape leaf compote was also first made in 1879. In 1880, Harker introduced the Argonaut toilet set. Although we have an advertisement, we have never found a single piece of this shape, and do not know how it was marked. The Etruria toilet set came out this same year, and beautiful pieces of this set can be found. It bears the George S. Harker Etruria horseshoe mark. The lovely Iolanthe toilet set, designed by Jesse Chetwynd, newly immigrated Staffordshire mold maker, was introduced in 1883. The new Mineola Underglaze was introduced in 1884, but all of the pieces we own with the Mineola Underglaze mark are on Atlanta shape, which was not made until 1891.

The Bedford dinnerware shape came out in 1884. While the industry journals of the time said the Bedford shape sold well, it is extremely rare. Compared to the Republic shape, the Bedford shape is short, squat, and square. The three pieces we own are marked with the faux English mark. The Bedford shape was remodeled with a flat bottom in 1885, the same year Harker introduced their square nappie in seven sizes. The Harker square nappie can be distinguished from the myriad other domestic and foreign nappies in that it has an embossed basket weave design half way up the exterior sides.

The year 1885 also found Harker making the new Hall Boy Jug and a molasses can, which were identical in shape to all the other East Liverpool Hall Boy Jugs and molasses cans. The Harker Bailed Jugs (with heavy wire handles), also introduced in 1885, were unique. They sported the Cross of St. George handle, and many were beautifully decorated. We have only found one with an ice retainer across the mouth of the jug.

Harker offered a new white granite version of the Wm. Penn and Iroquois braves inkwell in 1886. Since these were so intricate, and lighter weight, very few examples of these exist, and most are damaged. In 1887, Harker offered an "improved combinet", and the masculine, and highly decorated rectangular Cambria toilet set.

The George S. Harker Pottery Company did not advertise as prolifically in trade journals, such as the *Crockery and Glass Journal*, during these years, when compared to other potteries in the area. Because of this fact, when the *Journal* reporter sent frequent reports on the East Liverpool area potteries, activities at the Harker Pottery often were not even mentioned. The Harker brothers, Hal and W.W., wanted prime coverage for their new dinnerware shape introduced in April of 1888, so they named the new set Elodie "in honor of the charming daughter of Mr. George M. Jaques, of the *Crockery Journal*", (Vol. 28, # 9, Aug. 30, 1888). The Harker brothers received great coverage and glowing comments in a couple of issues of the *Journal*, but since they only ran a few

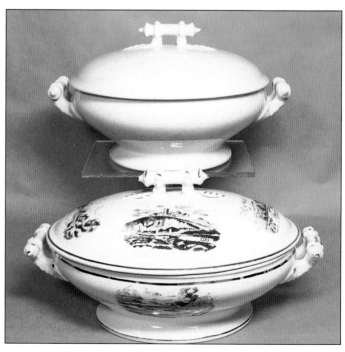

Cable Shape Ironstone, 11" W round tureen, MK 12, $40-60; 11" W oval tureen with brown transfer, MK 13, $70-85.

ads for their new line, no additional comments appeared in the *Journal* after the initial flurry. Still, the Elodie shape proved to be one of their best designs. The original Elodie pieces were often beautifully decorated, and marked with the faux English mark. The Elodie shape teapot, jug, and creamer became the "gargoyle handled" teapots, jugs, and creamers of the 1930s. Any of the shapes mentioned, and shown in this chapter, are not only rare, but are among the best examples of early East Liverpool, Ohio, pottery.

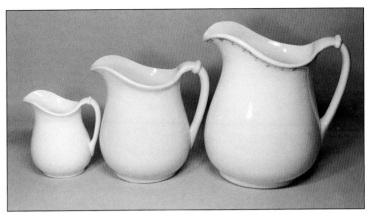

Cable Shape Jugs, 5" H, MK 23, $12-18; 8" H, MK 23, $30-35; 10" H, MK 25, $40-45.

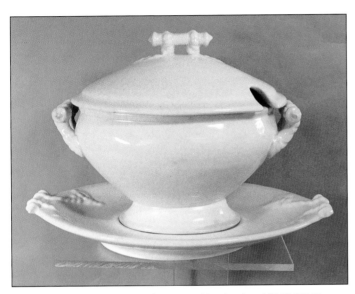

Cable Shape, 8" W gravy, MK 10, $25-50; 10" W under plate, MK 13, $10-20.

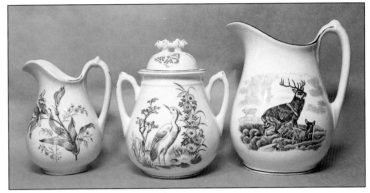

Cable Shape, 5.75" H Brown Transfer creamer, MK 13, $20-30; 7" H Republic shape Blue Transfer sugar, MK 13, $35-50; 7" H Black Transfer jug, MK 12, $75-100.

Republic Shape, Back of Harker Catalog, c. 1879-1889, $25.

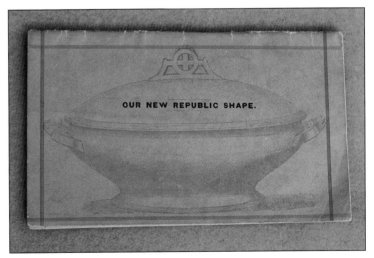

Cable Shape, MK 15, 13" H ewer, $34-40; 14" bowl, $25-30.

Republic Shape Ironstone, 12" W round tureen, MK 12, $75-85; 11" monogrammed plate, MK 12, $50-60; 7" H sugar, MK 13, $40-50.

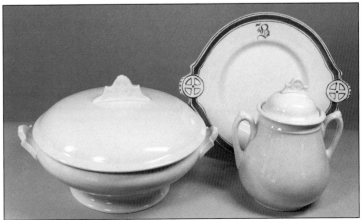

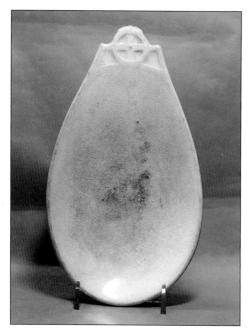

Republic Shape spoon rest, MK 13, *Courtesy East Liverpool Historical Society*.

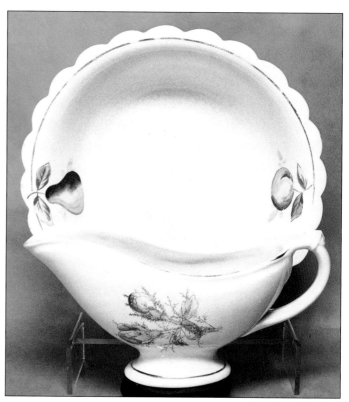

Republic Shape, 8" H molasses cans, MK 13, $35-60; decorated, MK 25, $75-100.

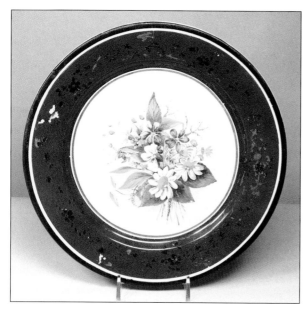

Republic Shape, 9" hand painted daisies & violets plate, MK 12, $25-30.

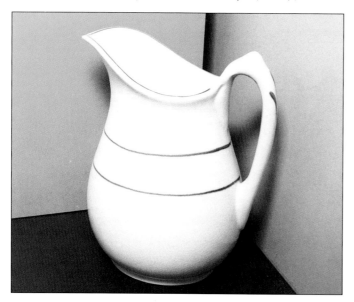

Republic Shape, 10" L Moss Rose gravy, MK 14, $30-45; 10" bowl with apple & pear hand-colored transfer, MK 13, $40-60.

Republic Shape, 8" H jug, MK 13, *Courtesy East Liverpool Historical Society*.

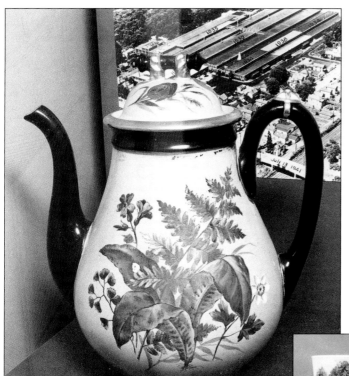

Republic Shape, 9" H hand-painted teapot, MK 13, *Courtesy East Liverpool Historical Society*.

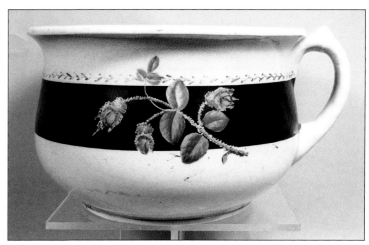

Republic Shape, 10" W hand-painted Moss Rose transfer on black band chamber pot, MK 12, $50-75.

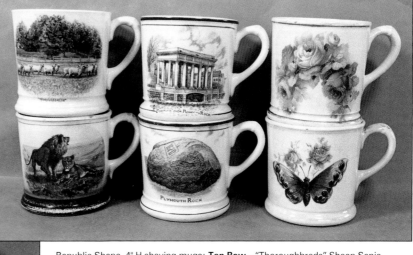

Republic Shape, 4" H shaving mugs: **Top Row** – "Thoroughbreds" Sheep Sepia Transfer, MK 23, $25-40; "Portico Over Plymouth Rock" Blue Transfer, MK 23, $60-75; Pink Roses Decal, MK 25, $30-50; **Bottom Row** – "Protected" Lions Sepia Transfer, MK 23, $35-50; "Plymouth Rock" Blue Transfer, MK 25, $30-50; Butterfly decal, No Mark, $25-40.

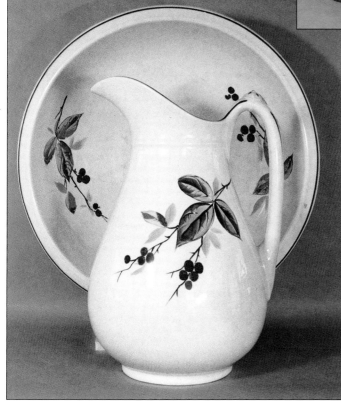

Republic Shape, 12" H ewer, & 14" bowl, decorated with currants, MK 13, $100-150.

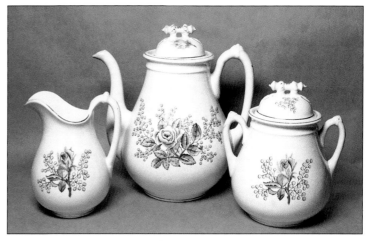

Pink Rose & Lily of the Valley decals, MK 13, 6" H Cable Shape creamer, $25-35; 9" H Republic Shape teapot with Cable lid, $45-75; 7" H Republic Shape sugar with Cable lid, $25-40.

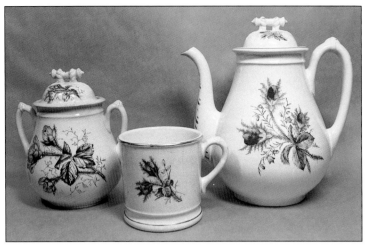

Republic Shape, Moss Rose hand-colored transfers, 7" H sugar with Cable lid, MK 14, $20-35; 4" H shaving mug, MK 13, $12-24; 9" H teapot with Cable lid, MK 13, $45-75.

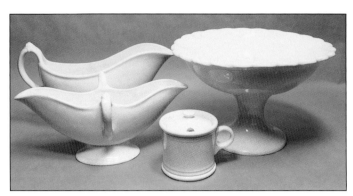

Republic Shape, **Left Front** – 9" L double handle gravy, MK 13, $30-40; **Left Rear** – 10" L single handle gravy, MK 13, $25-35; **Center** – 3" H covered mustard, MK 25, $30-40; **Right** – 9" W compote, MK 13, $50-75.

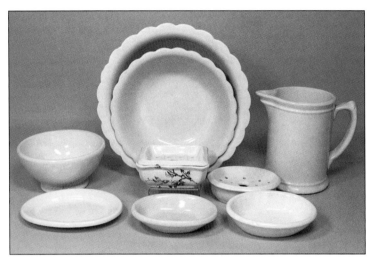

Ironstone, **Front Row** – 6" oval dish, MK 13, $18-24; 5" oval soap, MK 13, $10-15; 5" oval soap, MK 26, $12-18; **Back Row** – 6" W Footed Bowl, MK 26, $25-30; 11" & 9" Republic mixing bowls, MK 12 & 13, $40 each; 5" L brown transfer hollow rectangular soap, MK 13, $20-30; 5" L hollow oval soap, MK 13, $20-30; 6" H Hall Boy Jug, MK 25, $20-30.

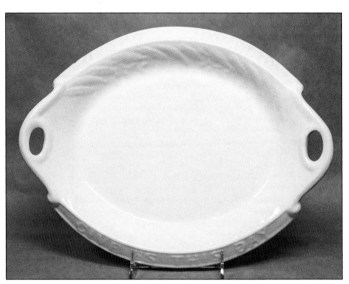

13" Ironstone "Give Us This Day Our Daily Bread" plate, MK 13, $40-60.

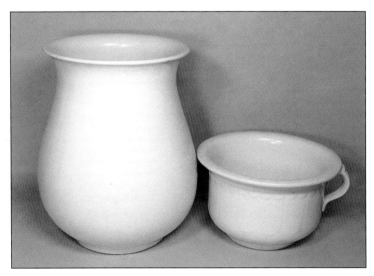

Ironstone, 11" H open cospador [Harker Catalog spelling], MK 25, $60-70; 9" W paneled chamber pot, MK 23, $25-35.

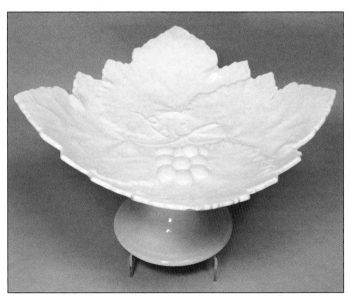

Grape Leaf compote, 5" H x 11" W, c. 1879, MK 13, $80-125.

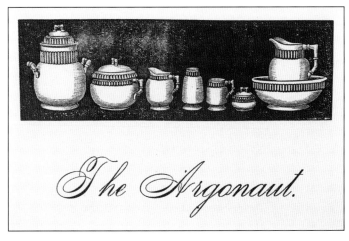

Argonaut Shape Toilet Set, *Crockery & Glass Journal* ad, c. 1880, no known examples.

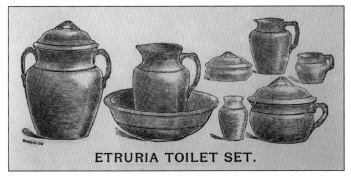

Etruria Shape Toilet Set catalog page, c. 1880.

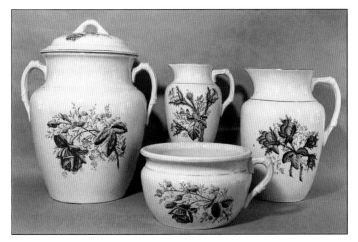

Etruria Shape, MKs 16 & 17, hand-colored Moss Rose transfer, 15" H slop jar, $40-60; 5.25" H chamber pot, $35-50; 8" H ewer, $50-60; 11.75" H ewer, $60-95.

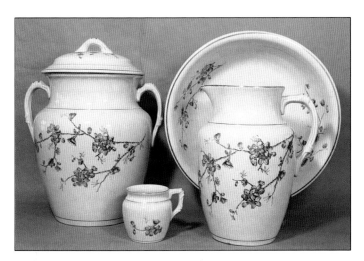

Etruria Shape ewer, MK 16, hand-colored transfer, 11.75" H, $40-50.

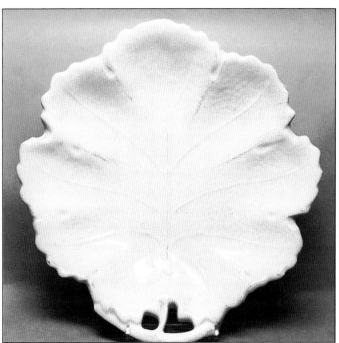

Grape Leaf candy dish, MK 13, *Courtesy East Liverpool Historical Society*.

Etruria Shape, MK 16, 15" H slop jar; 4" H shaving mug; 11.75" H hot water ewer; 14" bowl, $125-200 set.

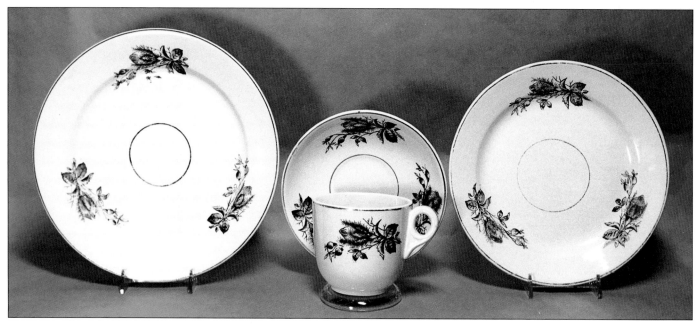

Moss Rose, 9" plate, MK 13, $10-15; 6" saucer, & 3" H cup, MK 10, $12-20; 8" plate, MK 11, $10-15.

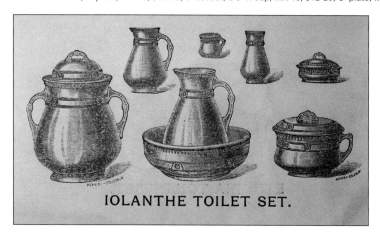

Iolanthe Shape Toilet Set catalog page, c. 1883.

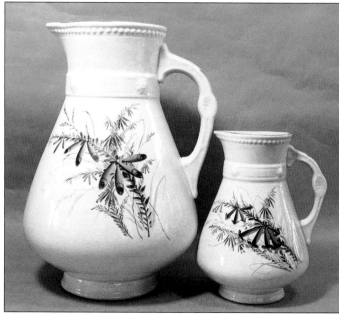

Iolanthe Shape, MK 13, 12.5" H hand-colored flowers ewer, $60-90; 7.5" H ewer, $25-50.

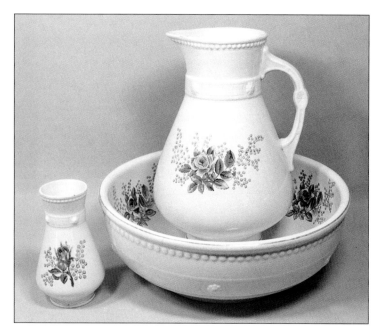

Iolanthe Shape, MK 13, hand-colored transfer of Pink Rose, & Lily of the Valley, 6" H toothbrush, $25-35; 14" bowl, $30-40; 12" ewer, $75-100.

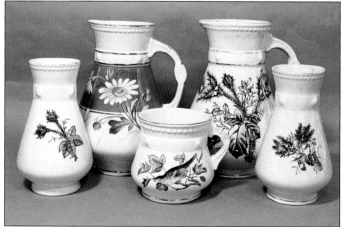

Iolanthe Shape, hand-colored transfers, Moss Rose toothbrush, MK 13, $25-40; Painted Daisies cold water ewer, MK 13, $30-50; Painted Bird shaving mug, MK 18, $50-75; Moss Rose ewer, MK 18, $30-60; Moss Rose toothbrush, MK 18, $25-60.

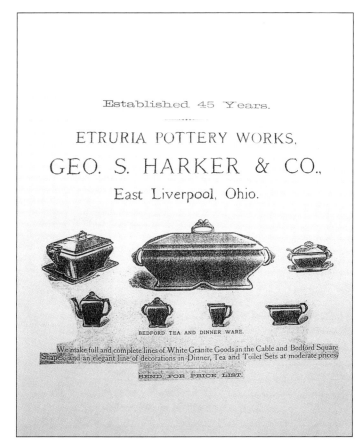

Bedford Shape catalog photo, c. 1884.

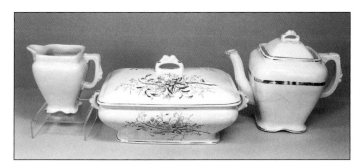

Bedford Shape, MK 157, 4" H creamer, $20-25; 10" L tureen, hand-colored transfer, note 1885 remodeled flat bottom, $30-40; 6" H teapot, badly broken in shipment, glued together for photo, $45-60.

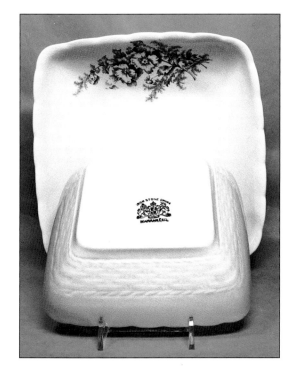

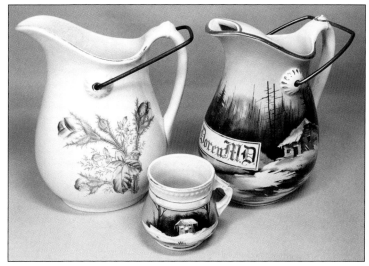

Republic & Iolanthe Shapes, MK 13, 10" H Moss Rose Bailed jug, $80-100; 4" H Iolanthe Sepia winter scene shaving mug, $100-115; 10" H Sepia winter scene Bailed jug with ice retainer across spout, personalized "Dr. Loren, MD", $240-260.

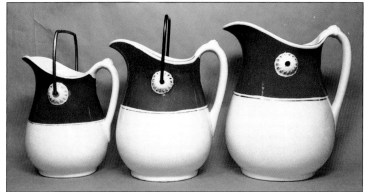

Republic Shape, Bailed Jugs, MK 13, 8" H burgundy stripe, $40-60; 9" H blue stripe, $50-75; 10" H burgundy stripe, $50-85.

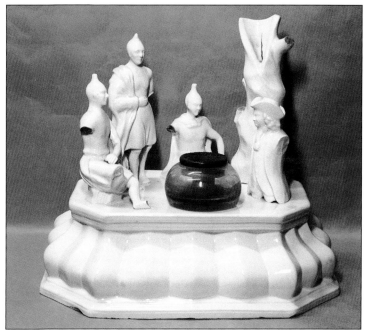

William Penn and Iroquois Braves, 13" L inkwell, c. 1886, *Courtesy East Liverpool Historical Society*.

Bedford Shape Nappies, Basket Weave base, (2 of 7 sizes), 6" W, MK 15, $5-10; 8" W Brown Transfer, MK 14, $10-15.

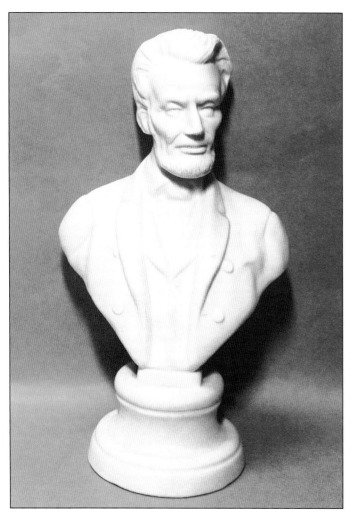

Abraham Lincoln 9" H Bust, attributed to George S. Harker Pottery, *Courtesy East Liverpool Historical Society*.

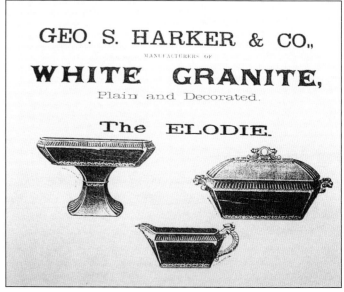

Elodie Shape catalog photo, c. 1888.

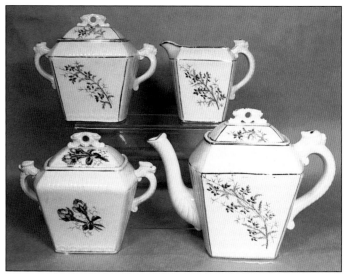

Elodie, MK 14, **Top** – 6" H sugar, pink & yellow hand-colored flowers, $20-30; 4" H creamer, $15-20; **Bottom** – 6" H Moss Rose sugar, $25-40; 7" H teapot, $30-45.

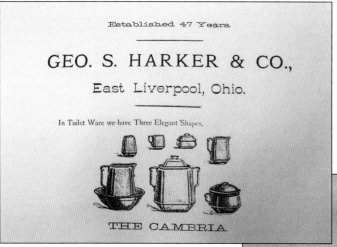

Cambria Shape Toilet Set catalog page, c. 1887.

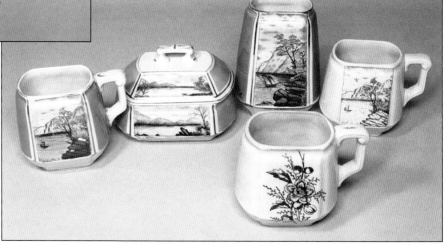

Cambria, 4" H hand-colored seashore shaving mug, MK 22A, $45-60; 6" L covered soap, MK 22A, $50-60; 4" H brown transfer flowers shaving mug, MK 22B, $30-40; 5.75" H toothbrush, MK 22A, $45-50; 4" H brown transfer seashore shaving mug, MK 22A, $30-40.

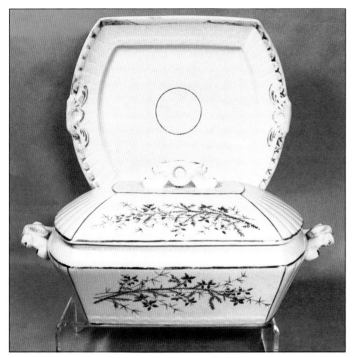

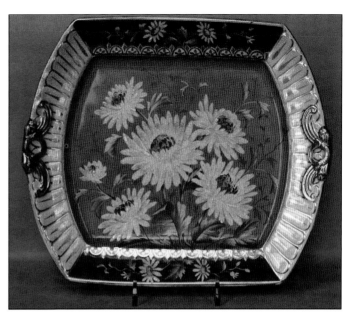

Elodie, 9" hand-painted under plate, MK 14, *Courtesy East Liverpool Historical Society*.

Elodie, MK 14, 11" L tureen, pink & yellow hand-colored flowers, $30-45; 9" under plate, $12-18.

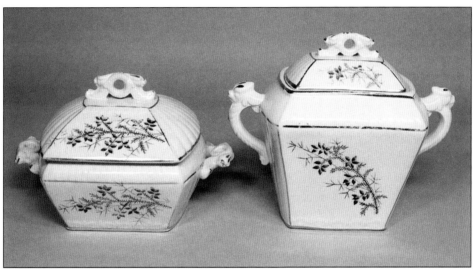

Elodie, pink & yellow hand-colored flowers, 4" H covered sauce, MK 157, $30-45; 6" H sugar, MK 14, $30-45.

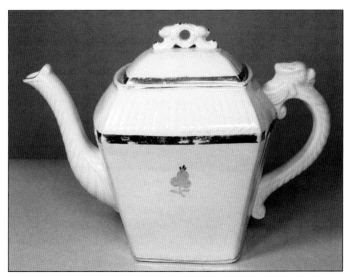

Elodie, 7" H Tea Leaf teapot, MK 14, $90-110.

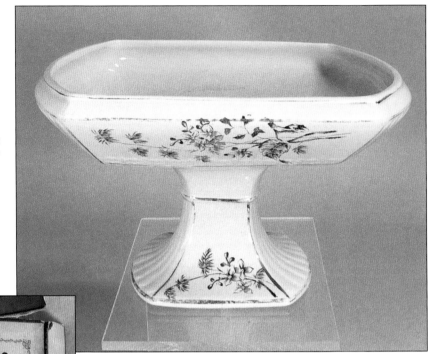

Elodie, 5" H x 9" W compote, Brown Transfer, MK 157, $40-60.

Toy box lid, 8" x 10", $40-60.

Covers of 3 Harker Catalogs spanning 1879-1891.

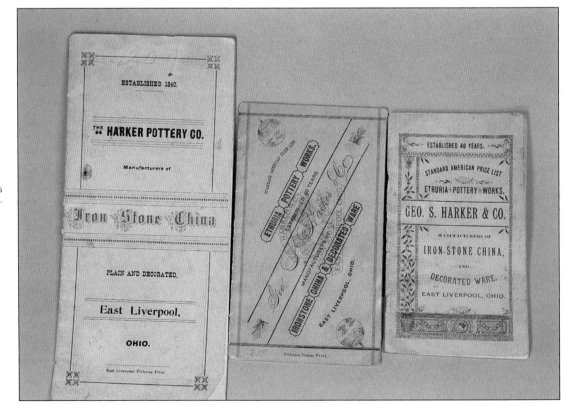

1890-1925

The year 1890 is an important date in Harker Pottery history. It is the year the George S. Harker Pottery Company incorporated as the Harker Pottery Company. The newly incorporated company began using totally new marks: the stone china bow and arrow, the semi-porcelain bow and arrow, and the inverted bow and arrow. We believe the stone china bow and arrow and the inverted bow and arrow marks ceased to be used around 1900, but the upright bow and arrow mark was used right up until 1931, when the Harker Pottery Company moved across the Ohio River to Chester, West Virginia. The remodeled Bedford dinnerware shape was discontinued in 1890. The Columbia toilet set was introduced in 1890, with its own mark.

The lovely Atlanta dinnerware shape, with its distinctive bird's tail fluting, was introduced in January of 1891. Our pieces bear the stone china bow and arrow, the faux English, and the Mineola Underglaze marks. While this set is still relatively heavy, the gorgeous, often hand colored, decals, and the hand applied gold trim would have made it difficult to distinguish from English ware. Harker also offered a gold tea leaf set on Atlanta shape, as it had on Elodie. The Atlanta dinner plate was especially nice, featuring a raised, curved strand design, matching the s-shaped strand handles on the casseroles and teapots. In August 1891, Harker Pottery introduced the Tremont toilet set. It had its own mark, but can also be found bearing the faux English mark. April of 1892 found Harker producing the pleasing, ruffle-embossed Rainbow toilet set. While Tremont is heavy and masculine looking, Rainbow is usually lighter weight, and decorated to appeal to ladies. It does have its own mark, and is more rare than Tremont. In December of 1893, Harker introduced the lovely Waverly dinnerware shape. All the pieces we own are marked with the stone china bow and arrow. Many serving pieces could be purchased with this set, including several sizes of narrow oval platters, several pitcher sizes, tea sets, etc. Three years later, in December 1896, the Fairfax shape was introduced. This shape seems to be marked exclusively with the upright bow and arrow.

The prolific Dixie shape dinnerware was introduced in 1897. Harker used this shape for everything from complete dinner and game sets to inexpensive souvenir items and store give-aways. The Dixie cake plate was decorated in the latest decals, and often embellished with gold hand-painted details. Harker flow blue pieces can be found in this shape. Blue decals of turkeys or Dutch windmill scenes were applied first, with a matching flow blue border hand applied after. On one of our favorite plates, one can still see what appear to be the faint fingerprints of the flow blue decorator. Harker made the Dixie platter in nine sizes.

Harker also introduced the swirled Loraine dinnerware shape in 1897. It bears the upright bow and arrow mark. In 1897, Harker also introduced the beautiful chop plates in two sizes, "fancy" spittoons, the delicate sugar baskets, and hanging soaps. The late 1890s also brought the Western ewer and basin, Dixie chamber, and the Acme combinent. Another dinnerware shape was produced at this time, which was particularly beautiful. It was lighter weight, had a flat edge on serving pieces, and fine scallop-footed cup and saucers. This shape was highly decorated, and marked with the vertical bow and arrow. We have not yet discovered a reference to this shape name.

In December 1897, the Miami, Manila, and Menlo toilet sets were introduced. Menlo is often marked with the stone china bow and arrow. Miami and Manila usually bear the upright bow and arrow, but we own examples of both shapes with the inverted bow and arrow mark.

The popular Paris shape, with its distinctive handle, was introduced in 1900. Paris shape had many serving pieces, including water sets with tumblers, berry sets, and cake sets. The earliest Paris shape pieces can still be found with hand-colored decals. Paris jugs were produced in five sizes. The largest ewer may have been sold with a basin.

This was an era when Harker Pottery Company produced particularly beautiful pottery shapes on an almost daily basis. The Savoy tea sets, punch bowls in several sizes, vases, water and lemonade sets, portrait plates, fish and game sets, flue covers, children's dishes, ABC plates, patriotic novelties, match strikers, sepia-tone novelties, blue, black, and turquoise line souvenir plates, flow blue, tea leaf, and dinner sets with every conceivable accompaniment, including candy dishes, celeries, butter pats, roll plates, and covered butters were made at this time. Harker Pottery Company made thousands upon thousands of calendar, advertising, and souvenir items in the years between 1900 and 1920. Dinnerware, lemonade, and water sets were offered by Harker as store premiums for businesses, along with glass, enamelware, tinware, and glass lamps. Harker made the pottery items, but marketed the other items with their pottery.

In 1910, Harker introduced a gently shaped dinnerware set, nearly identical to the Empress shape introduced by Homer Laughlin in 1914. Instead of strategically placed decals, border decals were becoming popular, and were utilized on this new shape.

River Road was finally paved past the Harker Pottery Company in 1922. It ran quite close to the potteries still operating on River Road, as the Ohio River constantly eroded the shoreline. However, flooding was still a problem, as the Army Corps of Engineers had not yet built the series of locks and dams spanning the Ohio River, which would lessen the yearly flood damage of the mighty river.

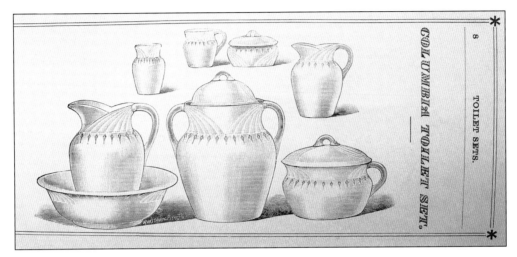

Columbia Shape Toilet Set catalog page, c. 1890.

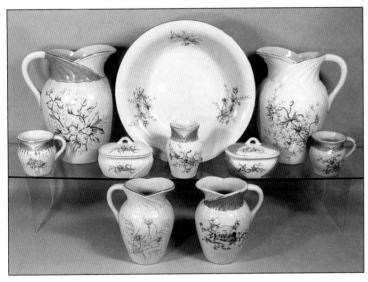

Columbia, MK 24 unless noted otherwise, Black & Brown Transfers (some hand-colored), **Top Row** – 4" H blue trim shaving mug, $20-25; 12" H pink trim ewer, $50-60; 5" L covered soap, MK 157, $35-40; 15" bowl, $30-40; 5" H blue trim toothbrush, $20-30; 5" L blue trim covered soap, $35-40; 12" H ewer, $50-60; 4" H blue trim shaving mug, $20-25; **Bottom Row** – 8" H ewer, MK 157, $40-50; 8" H pink trim ewer, $40-50.

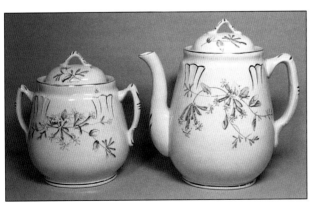

Atlanta Shape catalog pages, c. 1891.

Atlanta, MK 14, hand-colored pink trumpet flowers on Brown Transfer, 7" H sugar, $25-40; 9" H Teapot, $35-60.

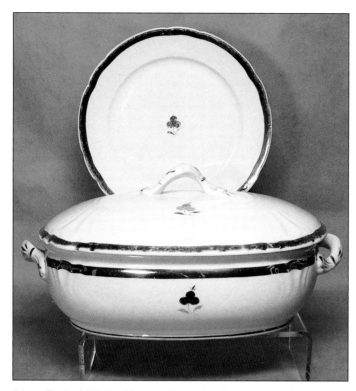

Atlanta, Tea Leaf, MK 15, 11" L covered vegetable, $50-75; 8" plate, $12-20.

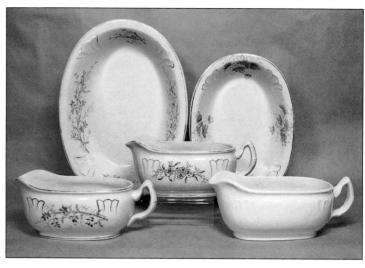

Atlanta, hand-colored black & brown transfers, MKs 14 & 15, 7" L gravy, $12-18; 11" oval bowl, pink & yellow flowers, $8-15; 7" L gravy, blue flowers, $12-18; 9" oval bowl, pink & yellow flowers, $8-12; Ironstone gravy, $12-18.

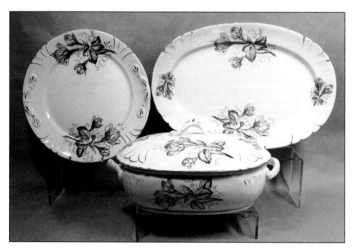

Atlanta, hand-colored Moss Rose on Brown Transfer, MK 15, 10" dinner plate, $20-30; 11" covered vegetable, $30-60; 14" platter, $18-30.

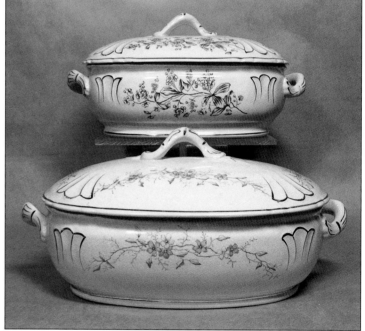

Atlanta, MK 14, **Front** – 12" L covered vegetable, pink, yellow, & blue flowers black transfer, $35-50; **Back** –11" L covered vegetable, brown transfer, $25-40.

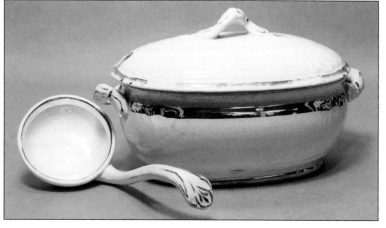

Atlanta, 7" ladle, $8-15; covered sauce MK 14, $25-40.

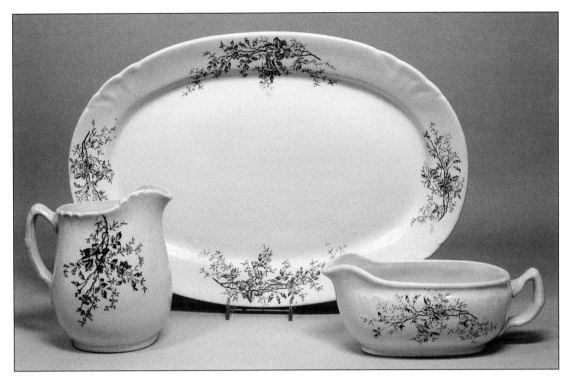

Atlanta, Mineola Underglaze, MK 20, 5" H jug, blue transfer, $15-30; 15" platter, blue transfer, $25-45; 7" L gravy, brown transfer, $15-25.

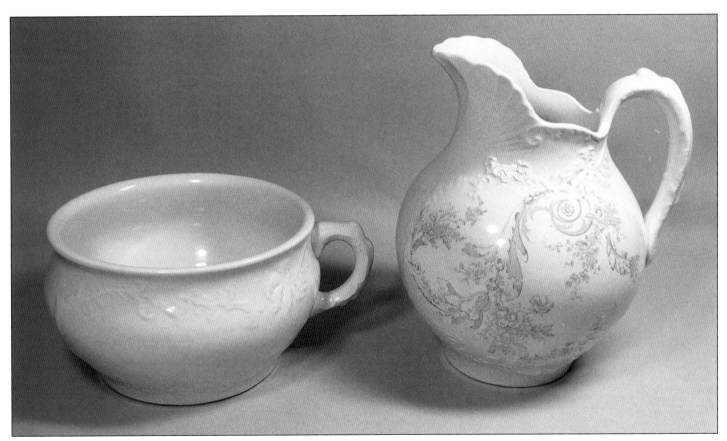

Unknown Shape Toilet Set, MK 15, Ironstone chamber pot, $30-40; 10" H jug, Blue Transfer, $40-50.

Inverted Bow & Arrow

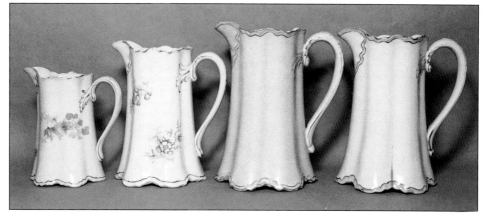

Inverted Bow & Arrow MK 21, Harker Jugs, 5" H pink flowers, $15-40; 7" H yellow & pink, $15-45; 8" H blue & pink, $50-85; 8" H cream & green, $40-60.

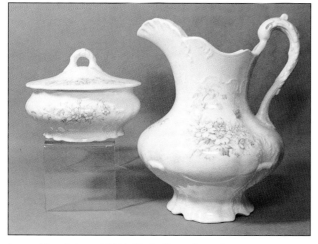

Inverted Bow & Arrow MK 21, Manila Shape, Toilet Set, pink transfer, MK 21, 5" W covered soap, $35-50; 8" H ewer, $50-65.

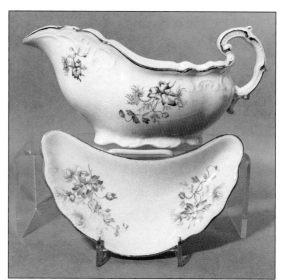

Inverted Bow & Arrow MK 21, purple transfer Fairfax gravy, $30-40; bone dish, $10-15.

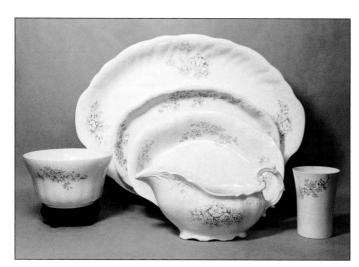

Inverted Bow & Arrow MK 21, Fairfax shape green transfer, 5" bowl, $15-18; 15" platter, $20-35; 11" platter, $15-20; 10" oval bowl, $15-25; gravy, $20-35; 4" H tumbler, $10-15.

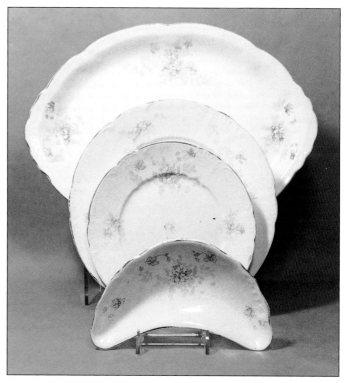

Inverted Bow & Arrow MK 21, unless noted, unknown shapes, pink flowers, 13" platter, MK 25, $18-25; 9" plate, $10-12; 7" plate, $7-10; bone dish, $10-15.

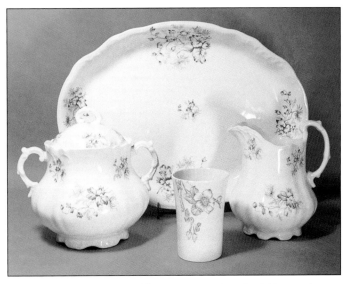

Inverted Bow & Arrow MK 21, Fairfax shape, Brown Transfer, 6" H covered sugar, $20-30; 13" platter, $18-30; 3" H tumbler, $25-35; 5" H creamer, $15-25.

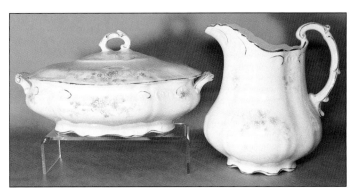

Inverted Bow & Arrow MK 21, Fairfax shape, pink, white, blue & purple flowers hand-colored transfer, 11" L covered vegetable, $20-40; 7" H jug, $35-45.

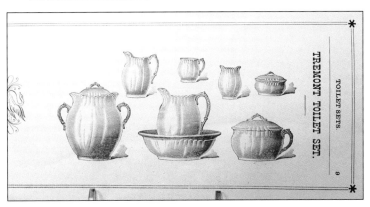

Tremont Shape Toilet Set catalog page, c. 1891.

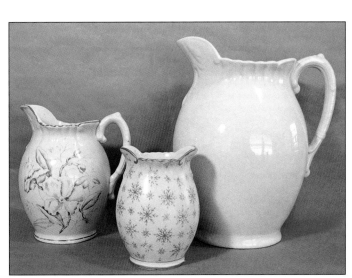

Tremont Shape, MK 27, 7" H ewer, black transfer, $35-40; 6" H bisque toothbrush, $20-35; 11" H Ironstone ewer, $30-60.

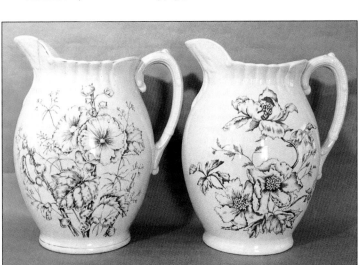

Tremont Shape, MKs 14 & 27, 11" H ewers, Brown Transfers, $40-60 each.

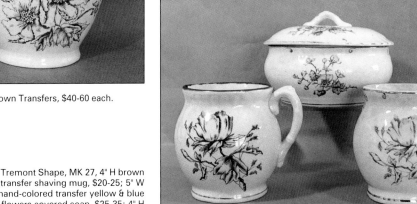

Tremont Shape, MK 27, 4" H brown transfer shaving mug, $20-25; 5" W hand-colored transfer yellow & blue flowers covered soap, $25-35; 4" H hand-colored transfer yellow flowers shaving mug, $20-35.

Rainbow Shape Toilet Set, catalog page, c. 1892.

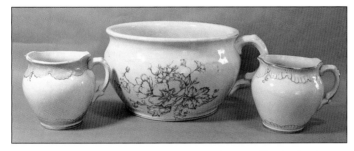

Rainbow Shape, MK 28, 4" H pink & gold trim shaving mug, $25-40; chamber pot, pink flowers transfer, $30-40; 4" H shaving mug, $15-30.

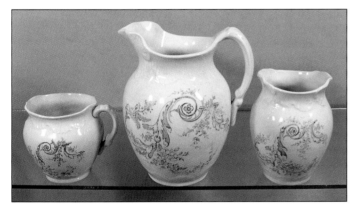

Rainbow Shape, MK 28, green transfer, 4" H shaving mug, $10-15; 8" H ewer, $20-30; 5" H toothbrush, $10-15.

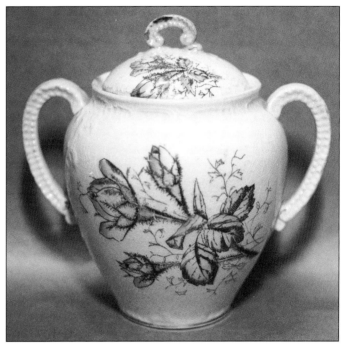

Waverly Shape, hand-colored transfer Moss Rose sugar, MK 15, *Courtesy East Liverpool Historical Society.*

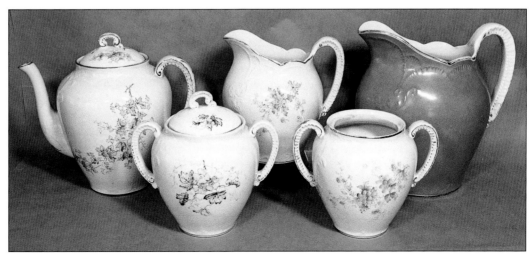

Waverly Shape, hand-colored transfers, MK 15, 8" H teapot, $40-60; 6" H covered sugar, $30-40; 6" H jug, $25-40; 5" H sugar (no lid), $15-20; 8" H blue jug, $80-100.

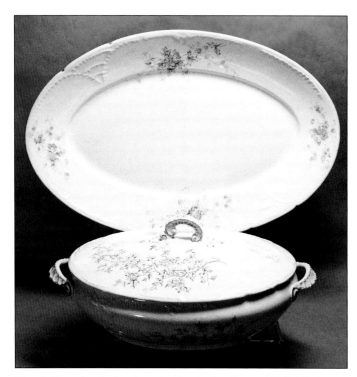

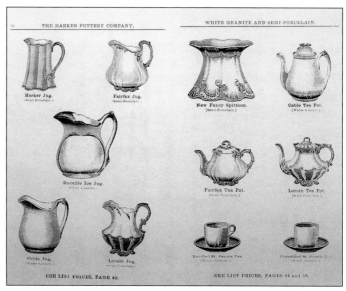

Catalog page – Fairfax, Lorain, Cable, & Rocaille Shapes.

Waverly Shape, hand-colored transfer blue & yellow flowers, MK 15, 15" platter, $25-35; 12" W Brown Transfer covered vegetable, $40-60.

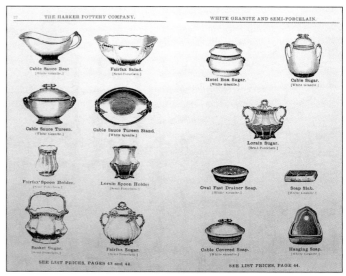

Catalog page – Fairfax, Lorain, Cable, & Hotel Shapes.

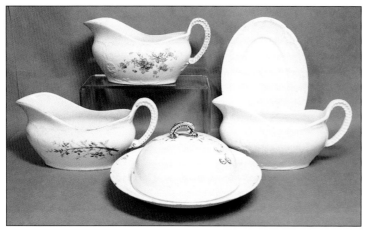

Waverly Shape, hand-colored transfers & white, MK 15, purple & yellow flowers gravy, $12-20; pink roses gravy, $18-25; 7" W covered butter, $25-40; white gravy, $12-20; 8" under plate, $12-15.

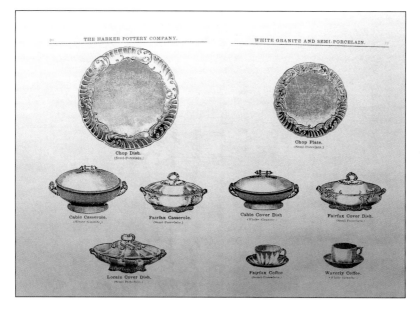

Catalog pages, c. 1897-98 – Waverly, Fairfax, Lorain & Cable Shapes, plus Chop Plates.

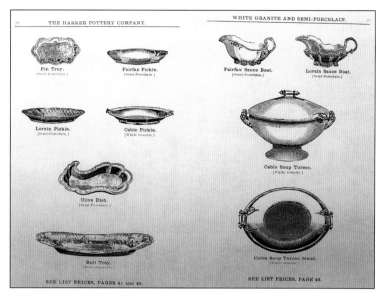

Catalog page – Fairfax, Lorain, & Cable Shapes.

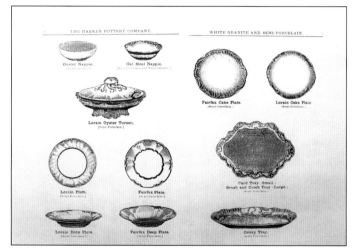

Catalog page – Fairfax & Lorain Shapes.

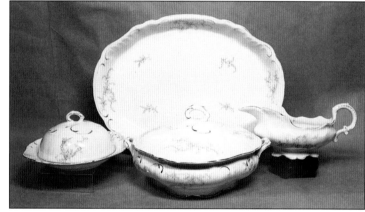

Fairfax Shape, hand-colored transfers, pink, yellow, & blue flowers, MK 25, 8" W covered butter, $25-35; 15" platter, $20-30; 10" L covered vegetable, $30-45; gravy, $12-18.

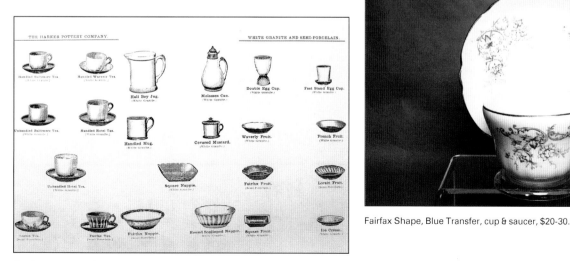

Catalog page – Fairfax, Lorain, Hotel, Baltimore, & Waverly Shapes.

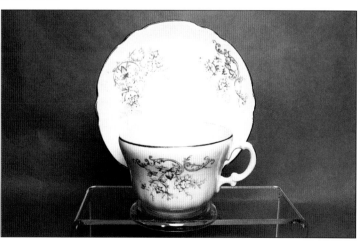

Fairfax Shape, Blue Transfer, cup & saucer, $20-30.

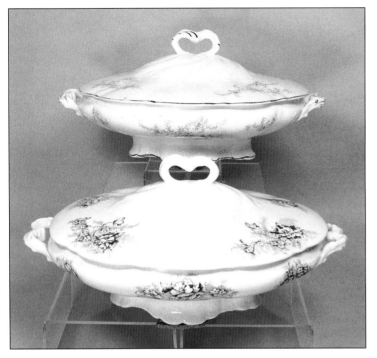

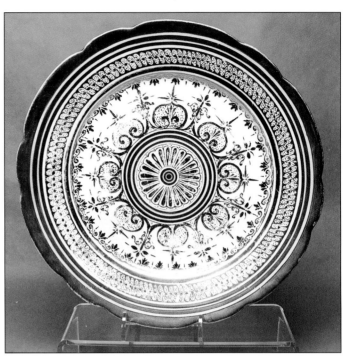

Lorain Shape, MK 25, **Top** – pink & blue flowers Brown Transfer, 12" covered vegetable, $35-50; **Bottom** – Brown Transfer, 12" covered vegetable, $35-50.

10" Highly decorated gold plate, MK 23, $20-25.

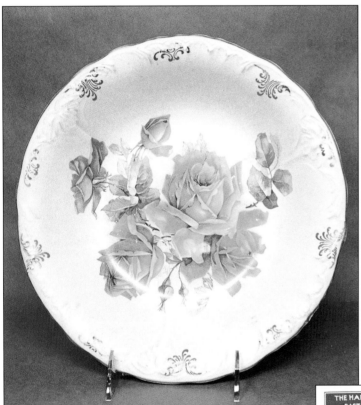

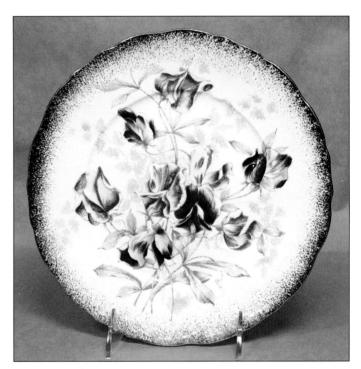

9" Sweet Peas plate, MK 25, $12-20.

10" Yellow roses bowl, MK 25, $18-25.

Harker Premiums Catalog Page, showing Dixie Shape, c. 1897.

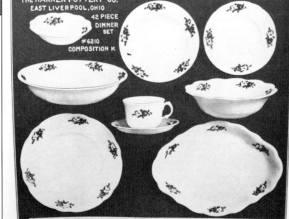

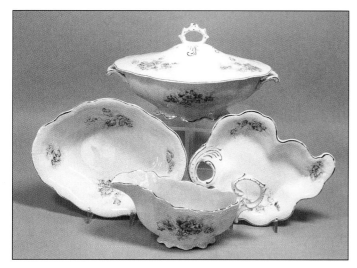

Dixie Shape, hand-colored transfers, yellow & blue flowers, MK 25, 9" oval bowl, $10-15; gravy, $12-20; 10" covered vegetable, $30-40; 8" L candy dish, $20-30.

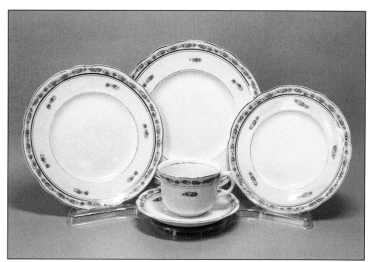

Dixie Shape, pink roses, MK 25, 8" plate, $7-10; 9" plate, $8-12; 7" plate, $5-8; cup & saucer, $15-20.

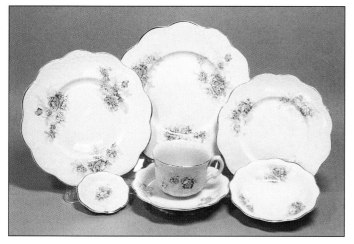

Dixie Shape, hand-colored transfers, yellow & blue flowers, MK 25, **Front** – butter pat, no mark, $1-3; cup & saucer, $8-12; 5" bowl, $4-8; **Back** – 8" plate, $4-8; 9" plate, $5-8; 7" plate, $4-8.

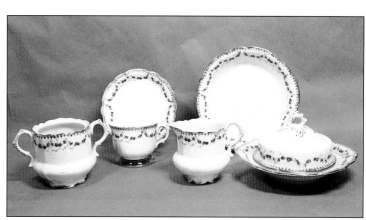

Dixie Shape, draped pink roses, MK 25, 3" H sugar (no lid), $8-12; cup & saucer, $9-15; 3" H creamer, $8-12; 7" bowl, $5-10; 8" W covered butter, $20-30.

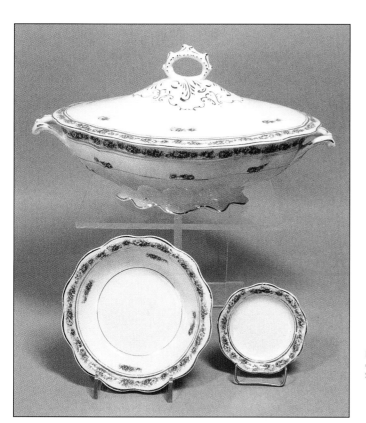

Dixie Shape, pink roses, MK 25, 11" L covered vegetable, $40-60; 5" bowl, $5-8; butter pat, no mark, $3-6.

Dixie Shape, red & yellow roses, 3 PC child's set, MK 25, 6" plate; cup & saucer, $75-85 set.

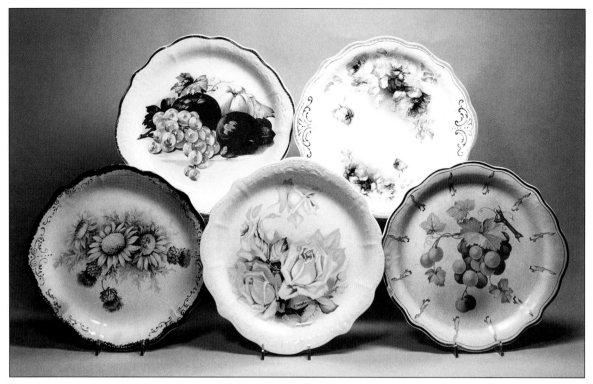

Dixie Shape cake plates, 11", MK 25, sunflowers & thistles, $25-35; mixed fruit, $25-40; yellow roses, $25-40; pink roses, $20-30; purple grapes with pink blush, $20-30.

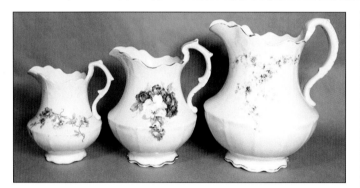

Dixie Shape jugs, MK 25, 6" H pink flowers, $15-25; 7" H red & white roses, $25-40; 9" H blue flowers, $40-65.

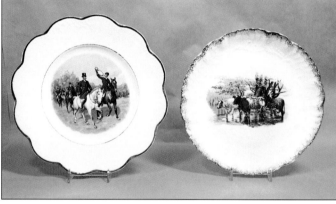

Dixie Shape, 10" plate, Fox Hunt, MK 25, $40-50; 9" Small Chop Plate, Cows in a Stream, MK 25, $20-25.

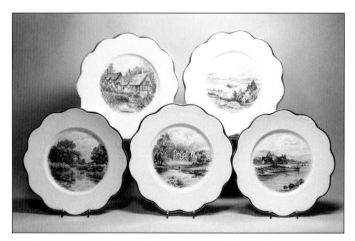

Dixie Shape, plates with English Scenes, 10", MK 25, $25-35 each, "Thames Scenery Cliveden Woods"; "Ann Hathaway's Cottage"; "Abbotsford"; "Grasmere" Lake; "Tintern Abbey".

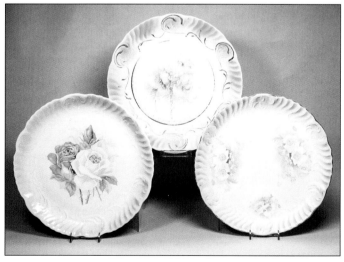

Large Chop Plates, MK 25, $20-40 each, pink & white roses pink blush; pink poppies green & pink blush; pink & white old roses pink blush.

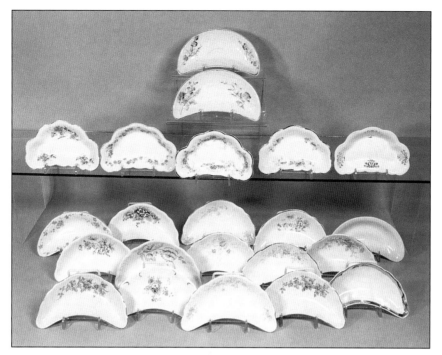

Bone dishes, MKs 14 & 25, $8-15 each, **Top Center** – hand-colored transfers, heavy bone dishes; **Top** – Dixie Shape; **Bottom** – Black & Brown Transfers, most hand-colored.

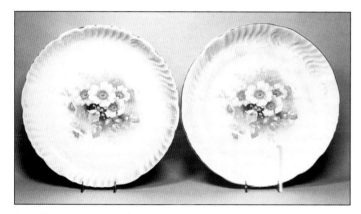

Large Chop Plates, MK 25, $20-40 each, pink & white old roses pink blush; pink & white old roses pink & green blush.

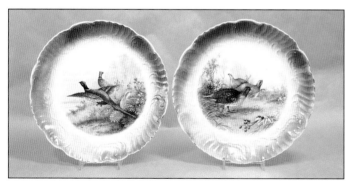

Small Chop Plates, fowl Game Set plates, MK 25, $60-80 each, pheasants pink blush; grouse pink blush.

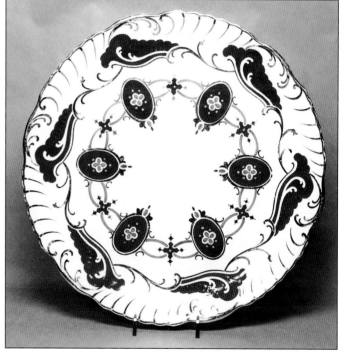

Large Chop Plate, 12", MK 25, $30-40, *Courtesy Rock & Robin Estell.*

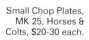

Small Chop Plates, MK 25, Horses & Colts, $20-30 each.

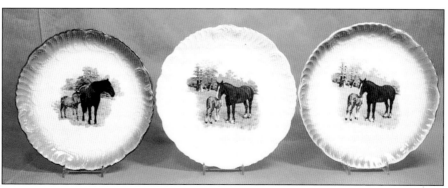

Flow Blue

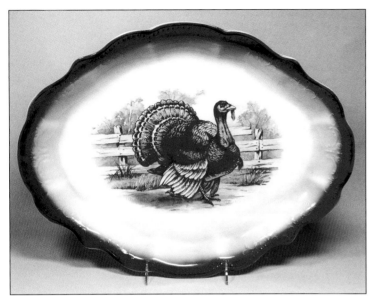

Dixie Shape, 20" Flow Blue turkey platter, MK 25, $500-650.

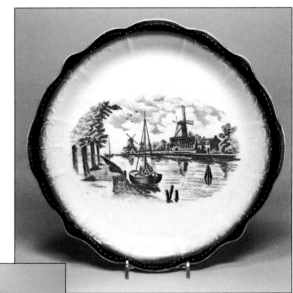

Flow Blue platters, **Top** – 11" Dixie Dutch Scene, MK 25, $60-75; **Bottom** – 12" Dutch Scene, MK 25, $30-45.

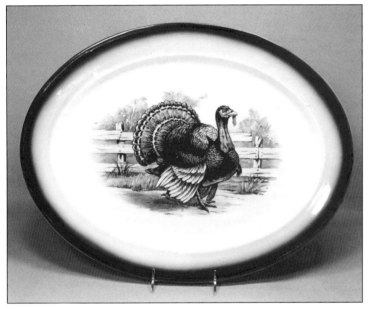

20" Flow Blue turkey platter, MK 25, $215-230.

Flow Blue 10" Dixie Dutch scene cake plate, no mark, $25-40.

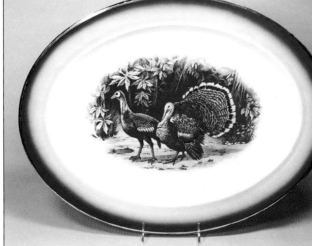

20" Flow Blue turkey platter, MK 25, $215-230.

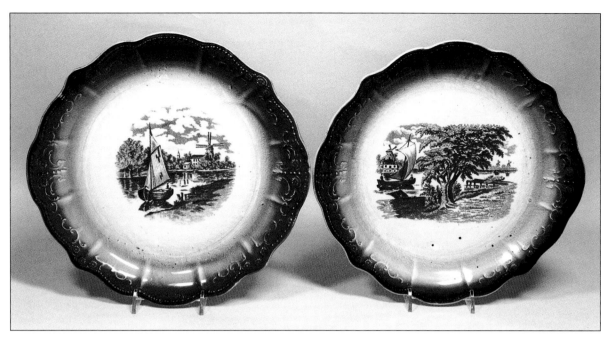

Flow Blue 10" Dixie Dutch scenes cake plates, no mark, $30-50 each.

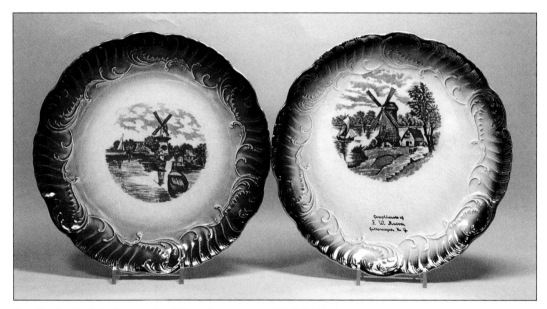

Flow Blue Dutch windmill scenes Small Chop plates, no mark, $25-35 & $30-40.

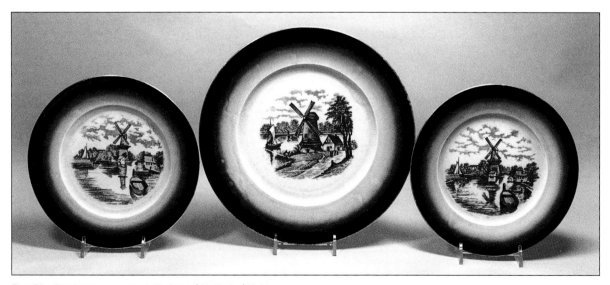

Flow Blue Dutch scenes, no mark, 7" plates, $10-15; 9", $20-30.

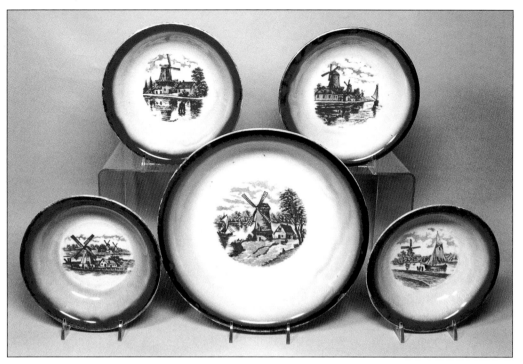

Flow Blue Dutch scenes berry set, no mark, 9" bowl, $35-50; 6" assorted bowls, $20-30 each.

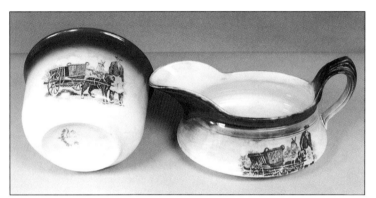

Flow Blue "36" Bowl, 5" W, MK 25, $30-40; Paris Shape gravy, MK 25, $40-50.

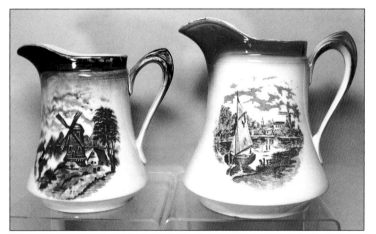

Flow Blue Paris Shape jugs, Dutch Scenes, MK 25, 7" H, $40-60; 9" H, $45-75.

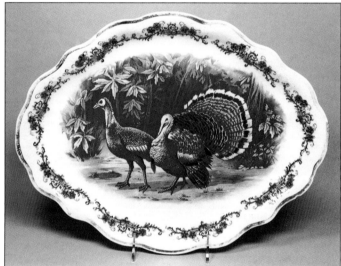

Blue Transfer Dixie Shape 15" Turkey platter, MK 25, $90-125.

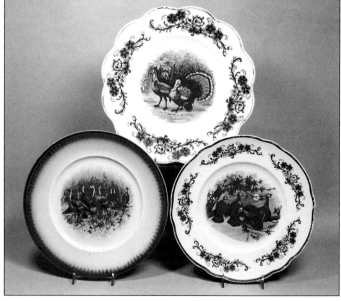

Flow Blue & Blue Transfer turkey plates, MK 25, $40-75 each, 9"; 10" Dixie Shape; 9" Waverly.

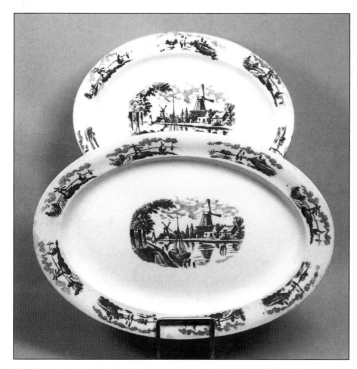

Blue Transfer platters, Dutch Scenes, no mark, 11", $15-25; 13", $20-30.

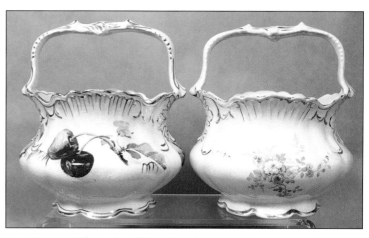

Sugar Baskets, 6" H, Cherries, MK 25, $40-60; blue & white flowers, no mark, $40-60.

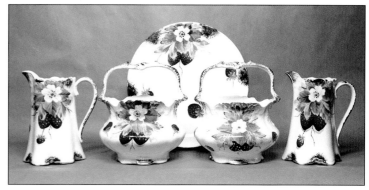

Strawberries, MK 25 (except as noted), 5" H creamer, $25-40; 6" H sugar basket, $75-100; 8" plate, no mark, $20-30; 6" H sugar basket, $75-100; 5" H creamer, $25-40.

Blue Transfer Manila Shape, no mark, 8" H ewer, $175-200; broken toothbrush holder found on Harker Pottery property on River Road, East Liverpool, Ohio, about 1995.

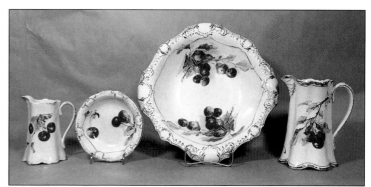

Cherries, MK 25, 5" H creamer, $20-30; 5" berry, $5-10; 11" square bowl, $25-50; 7" H jug, $30-50.

Ladies spittoons, MK 23, 4" H green rim, pink & white flowers, $40-45; 6" H pink blush "Fancy", $70-80; 6" H quilted throat, $60-75.

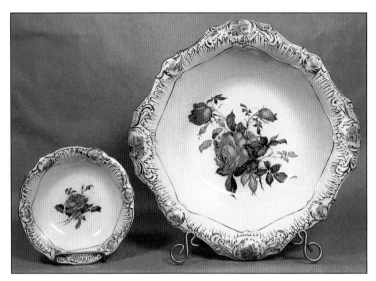

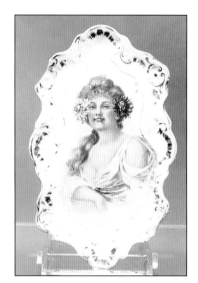

6" Pin Tray/ Card Tray, MK 21, $50-75, *Courtesy Nancy L. Wetzel.*

Pink Roses Berry Set, MK 25, 5" berry, $8-15; 11" square bowl, $25-50.

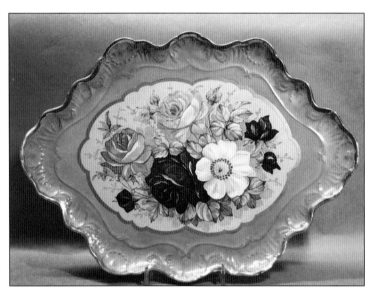

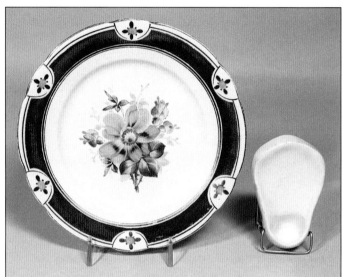

9" Dresser Tray, MK 25, *Courtesy East Liverpool Historical Society.*

7" hand painted plate, MK 15, $15-20; 3.5" x 2.25" gold liner's palette, MK 25, used by Emmaline Golden, 40 year Harker employee, $50-75.

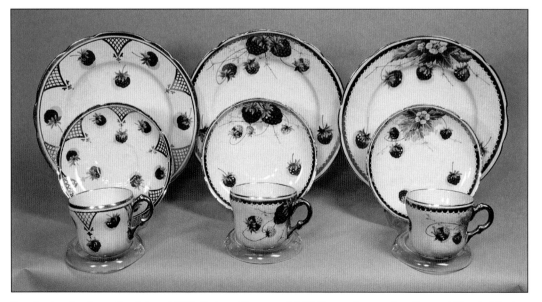

Strawberries, Demitasse, 3 variations, MK 25, 7" plates; 5" saucers, & 2.25" H cups, *Courtesy East Liverpool Historical Society.*

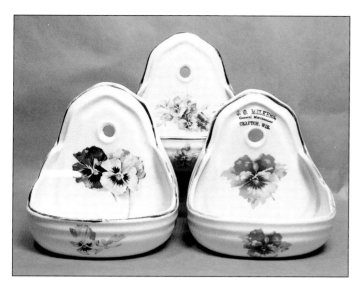

Pansy hanging soap dishes, MK 23, $30-50 each.

Roll tray, 13", MK 25, $30-40.

Green Lily of the Valley, 2.5" H wall mount soap dish, MK 15, $20-30; 3.25" H rose bowl, MK 21, $40-60.

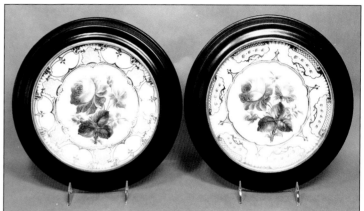

Hand-painted plates, 8.5", MK 25, $90-100 each.

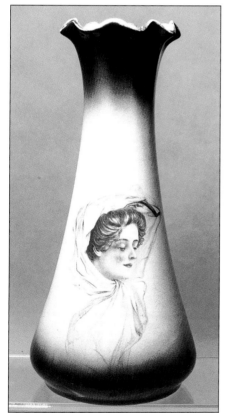

Vase with "Beverly of Graustark", Gibson Girl by Harrison Fisher, 8" H, MK 21, $40-75.

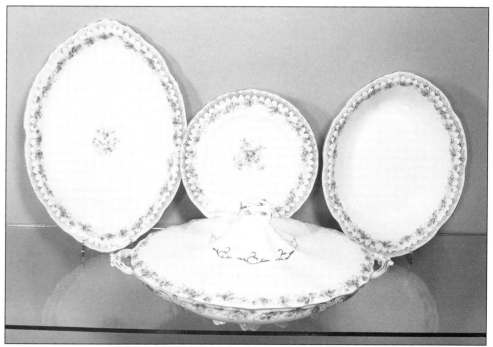

Unknown shapes, MK 25, 12" platter, $10-15; 7" plate, $5-8; 10" bowl, $12-15; 12" L covered vegetable, $25-35, *Courtesy Kathy Eberling.*

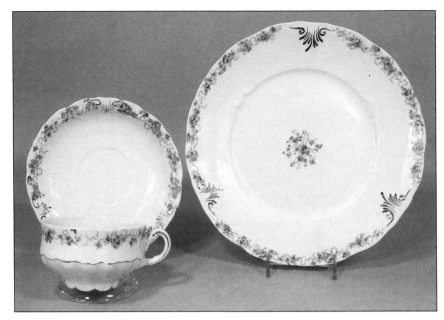

Unknown shape, MK 25, cup & saucer (note fluted base of cup), $18-24; 9" plate, $10-12.

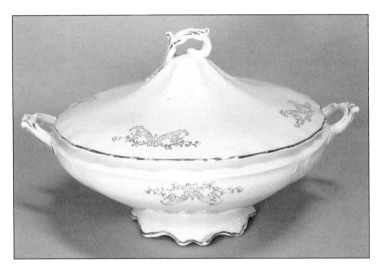

Unknown shape, 12" L covered vegetable, MK 25, $40-60.

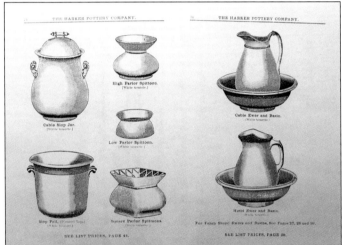

Catalog page, Miscellaneous Toilet shapes & spittoons, c. 1897.

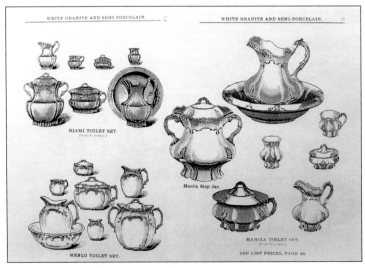

Catalog page, Miami, Menlo & Manila Shape Toilet Sets, c. 1897.

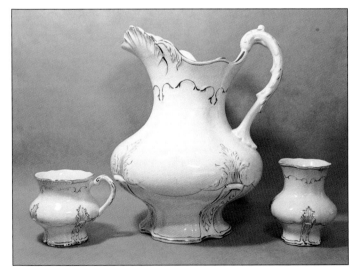

Manila Shape Toilet Set, MK 25, 4" H shaving mug, $20-35; 12" H ewer, $50-65; 5" H toothbrush, $20-35.

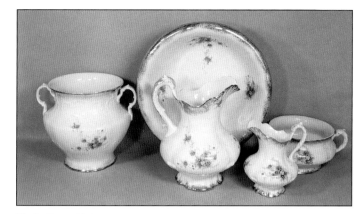

Manila Shape, MK 25, 10" H combinet; 16" Bowl; 13" H ewer; 8" H ewer; chamber pot, $200 set.

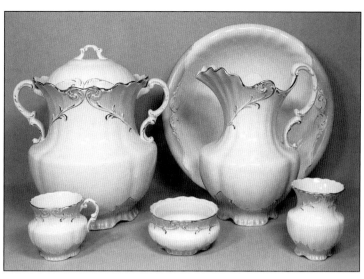

Miami Shape, Inverted Bow & Arrow MK 21, pink & gold trim, **Back Row** – 14" H slop jar with lid; 15" Bowl; 12" H ewer; **Front Row** – 4" H shaving mug; 5" W Soap (no lid); 5" H toothbrush holder, $250-275 set.

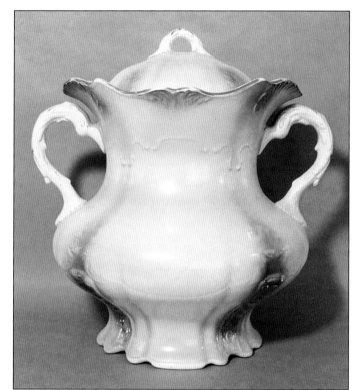

Manila Shape slop jar, MK 25, 13" H yellow & green blush, $60-90.

Miami Shape chamber pots, MK 25, white with gold trim, $20-30; Pink & White Rose Spray, blue trim, $30-40.

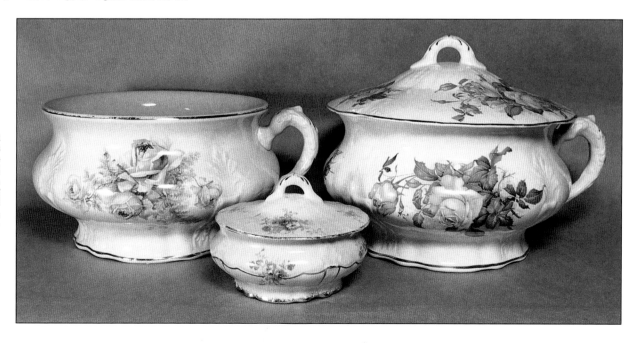

Manila Shape, MK 25, yellow roses chamber pot, $35-50; 5" W covered soap green blush, $25-40; yellow roses covered chamber pot, $60-85.

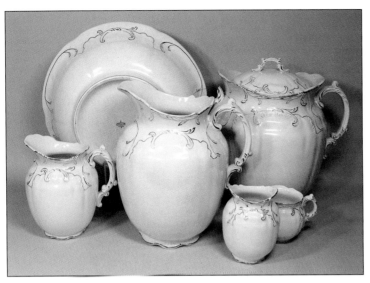

Menlo Shape Toilet Set, MK 15, yellow & white, 7" H ewer, $45-50; 11" H ewer, $60-75; 5" H toothbrush, $25-35; 4" H shaving mug, $25-35; 15" bowl, $30-40; 12" H slop jar, $60-75.

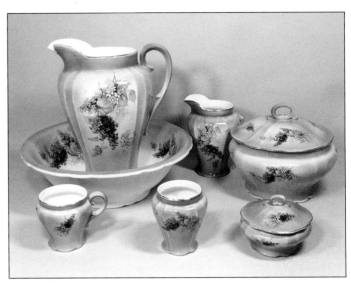

Bennett Shape Toilet Set, MK 25, Lilac on Purple Blush (damaged pieces), 15" bowl, $25-35; 5" H toothbrush, $25-35; 12" H ewer, $35-40; 4" H shaving mug, $35-45; 7" H ewer, $20-25; 10" W chamber pot, $25-30; 5" W covered soap, $30-40.

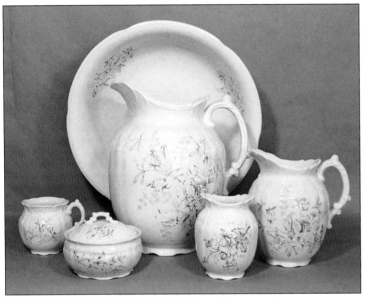

Menlo Shape, MK 15, Green Transfer, 4" H shaving mug; 5" W covered soap; 12" H ewer; 15" bowl; 5" H toothbrush; 7" H ewer, $175-250 set.

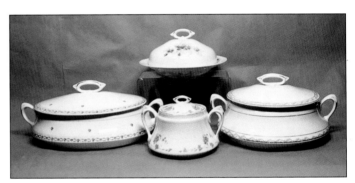

Paris Shape, MK 25, 11" L oval covered vegetable, $20-30; 4" H covered sugar, $20-25; 6" W covered butter, $20-30; 9" round covered vegetable, $25-40.

Mixed Toilet Set, MK 25, Manila Shape 8" H ewer, $60-95; 12" H Western Shape ewer, $70-90; 15" bowl, $20-25; 4" H Republic Shape shaving mug, $25-40.

Catalog page (Paris Shape)
Harker Premiums, c. 1900.

Paris Shape, Classic Band decal, MK 25, 4" H creamer, $15-20; 6" oval bowl, $8-10; 6" plate, $5-8; gravy, $20-25.

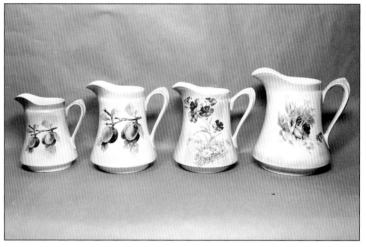

Paris Shape, jugs, MK 25, 6" H, blue & pink blush plums, $50-80; 7" H pink blush plums, $40-60; 7" H carnations iridescent green blush, $40-60; 8" H pink roses pink & yellow blush, $50-80.

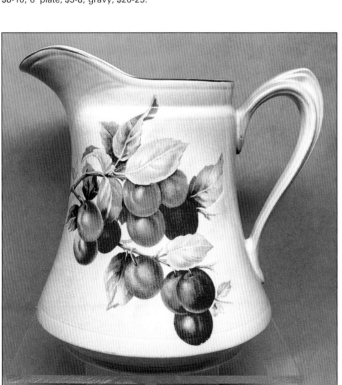

Paris Shape, 8" H jug with Bright Orange Plums, MK 25, $50-75.

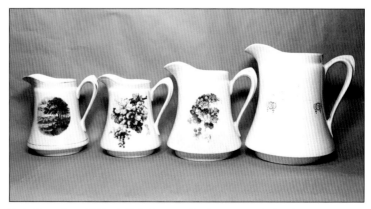

Paris Shape, jugs, MK 25, 6.75" H, blue transfer, $45-65; 6.75" H, Red & Blue Grapes, $30-60; 8" H, Blackberries, $30-60; 9.5" H, Gold filigree, $60-90.

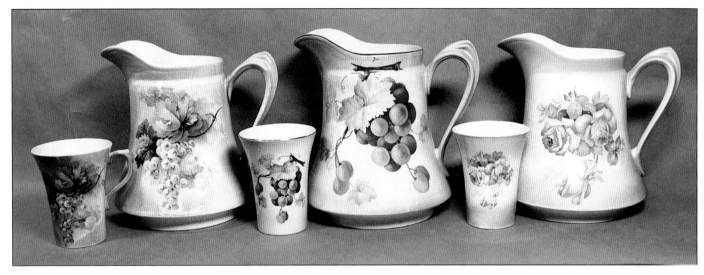

Paris Shape 8" H jugs, $60-80 each, & 4" H tumblers, $12-15 each, MK 25, White Grapes; Concord Grapes, pink & yellow roses.

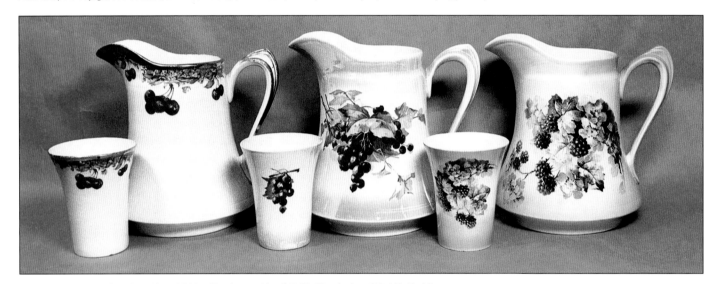

Paris Shape 8" H jugs & 4" H tumblers, MK 25, Cherries tumbler, $15-20; Cherries jug, $75-100; Red Currants tumbler, $10-15; Red Currants jug, $50-80; Blackberries tumbler, $15-20; Blackberries jug, $75-100.

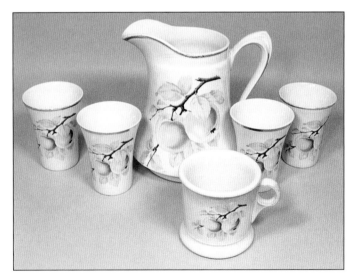

Paris Shape, Yellow Apples set, 8" H jug & four 4" H tumblers, MK 25, $100-125 set; 4" H iridescent orange blush mug, no mark, $15-18.

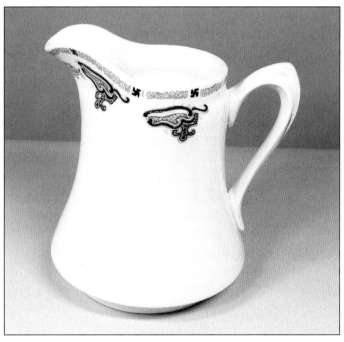

Paris Shape, Swastika Deco decal, MK 25, 6" H jug (rare size), $30-40.

Workman's crafted "Batter Out" tool, incised "Harker 1902", used to flatten ball of clay.

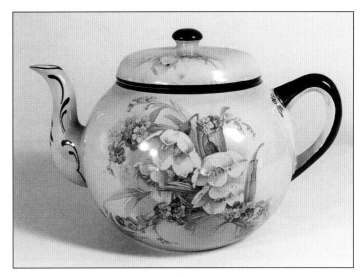

Savoy Shape, blue blush teapot, MK 25, $60-75.

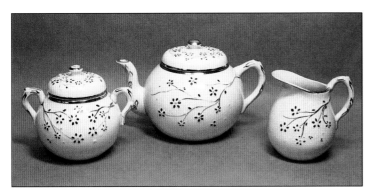

Savoy Shape embossed & twig handle tea set, MK 25, sugar; teapot; creamer, $90-120.

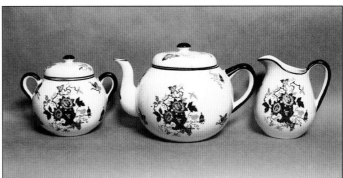

Savoy Shape, tea set, Oriental Garden decal, MK 25, sugar; teapot; creamer, *Courtesy East Liverpool Historical Society.*

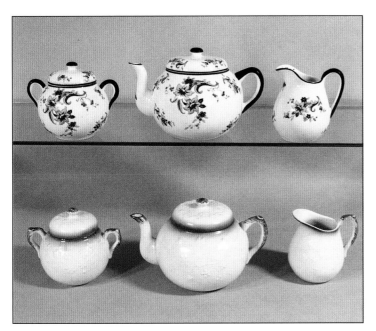

Savoy Shape tea sets, MK 25, smooth body & handles, Oriental Flowers, sugar; teapot; creamer, $80-100 set; embossed & twig handles, blue trim, sugar; teapot; creamer, $80-100.

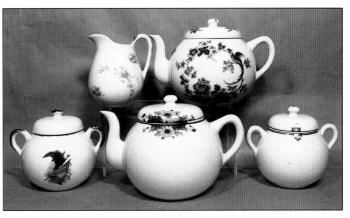

Savoy Shape, MK 25, Bald Eagle & U.S. Flag sugar, $20-30; Shadow Rose creamer, $12-18; Asters teapot, $75-100; Oriental decal teapot, $75-100; Blue Line sugar, $15-25.

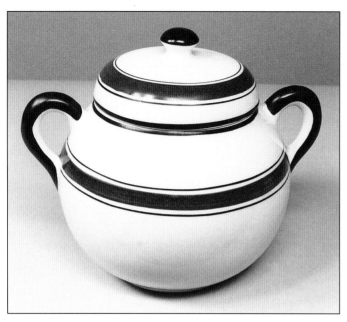

Savoy Shape, MK 214 (on sticker), Red & Black Stripes sugar, $30-40.

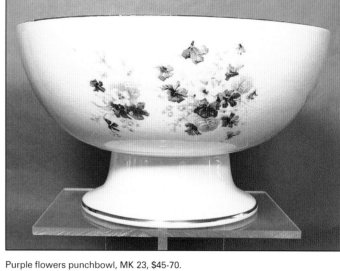

Purple flowers punchbowl, MK 23, $45-70.

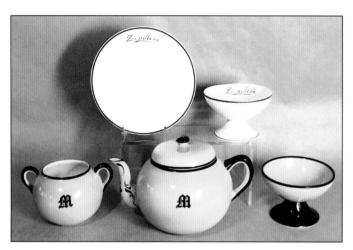

Savoy Shape, MK 25, 3" H green sugar (no lid), $12-15; teapot, $40-60; 3" H footed sundae, no mark, $8-15; 6" "Zendler's" plate, $6-10; 3" H footed sundae, no mark, $8-12.

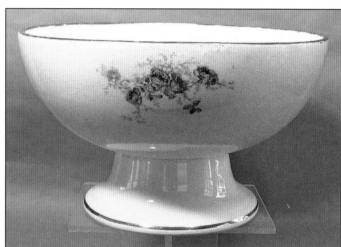

Pink roses punchbowl, MK 23, $45-60.

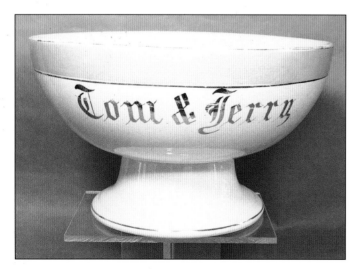

Tom & Jerry punchbowl, MK 23, $50-75.

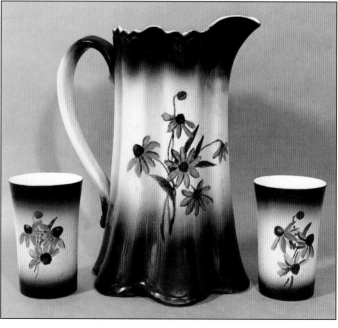

Hand-painted Black-eyed Susan Harker Jug, 10" H, MK 25, $50-60; 4" H, Tumblers, MK 25, $15-20.

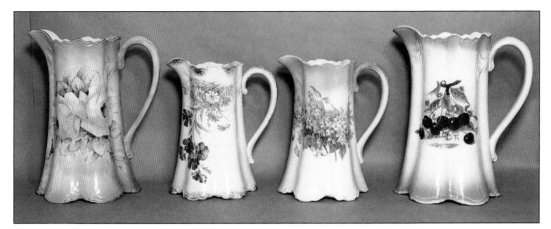

Harker Jugs, MK 25, 9" H yellow roses, $65-90; 7" H red carnations, $45-75; 7" H blue & white hydrangea, $65-90; 9" H cherries, $65-95.

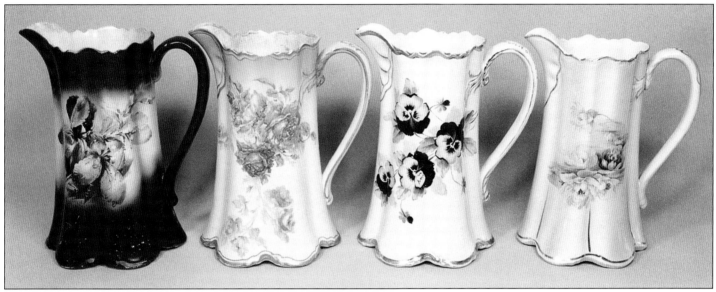

Harker Jugs, 9" H, MK 25, brown blush iris, $75-85; pink roses, $75-85; hand-painted pansies, $100-125; water lily, $90-110.

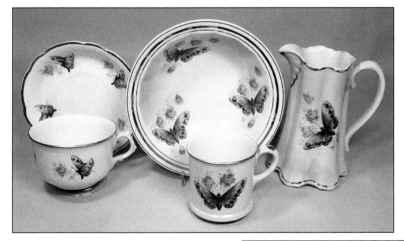

Butterflies, MK 25, Jumbo Cup & Saucer, $25-35; 9" paneled bowl, $25-40; 4" H Republic mug, $35-40; 8" H Harker Jug, $50-80.

Harker Jugs & 4" H tumblers, MK 25, Purple Grapes handled tumbler, $20-25; 9" Purple Grapes jug, $75-90; rose tumbler, $10-20; Pink Poppies jug, $75-100; mixed roses tumbler, $15-25; mixed roses jug, $90-120.

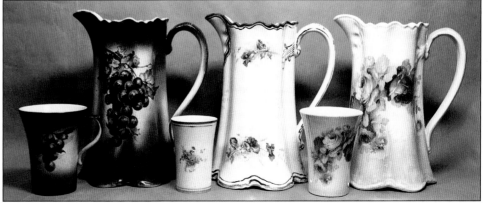

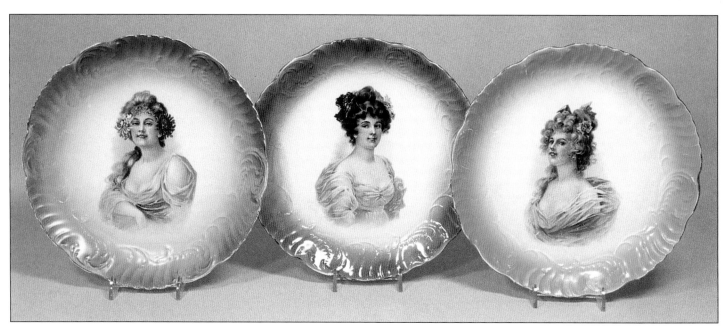

Portrait Plates, Small Chop Plates, MK 25, $35-75 each.

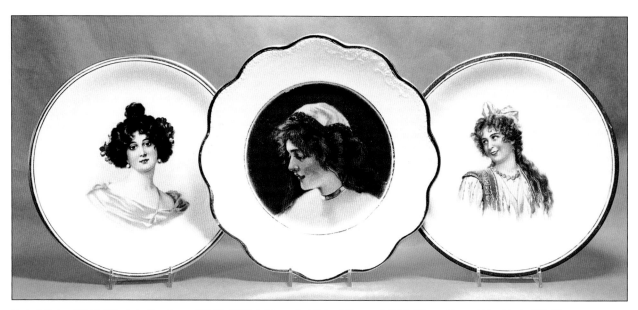

Portrait Plates, MK 25, 9" Lady in Blue Dress, $30-40; 10" Dixie Shape Red Haired Woman, $45-60; 9" Long Brown Haired Lady, $30-45.

Portrait Plates, MK 25, 7" Green Ribbon Lady, $12-18;
7" Lady Fishing, $12-18.

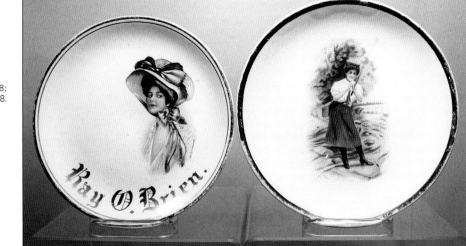

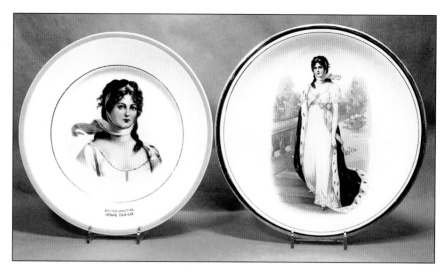

Portrait Plates, MK 25, 10" Crowned Lady, $30-40; 10" Crowned Lady, $45-60.

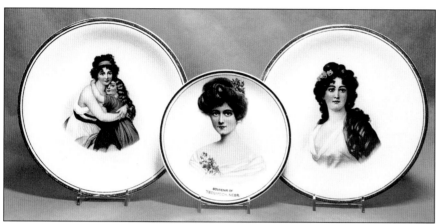

Portrait Plates, MK 25, 9" Mother & Child, $35-50; 7" Brown Haired Lady, $30-40; 9" Black Haired Lady, $35-50.

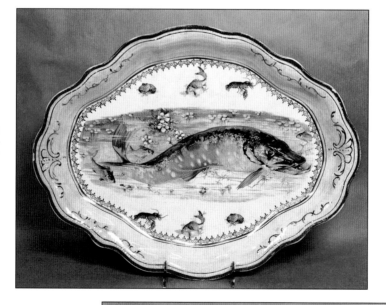

Dixie Shape, 18" green luster Fish Platter, MK 25, $75-125.

Dixie Shape, 8" green luster Fish plates, MK 25, $25-35 each.

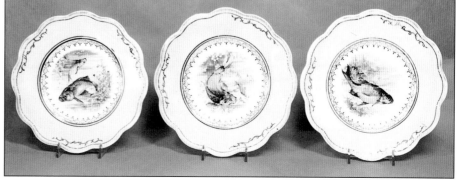

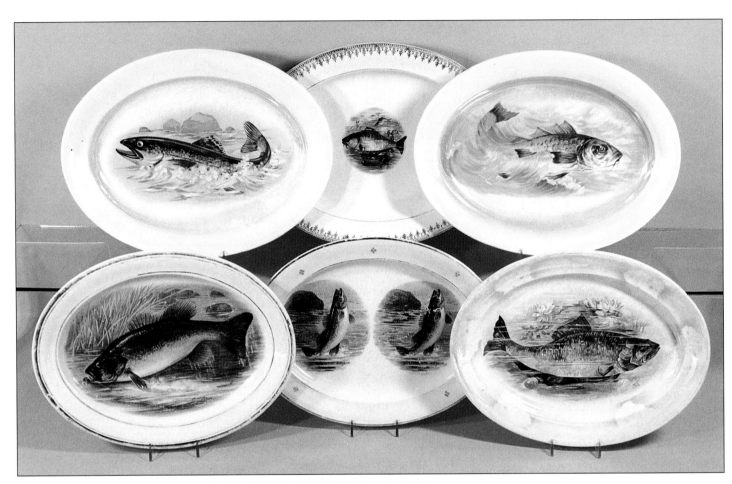

Fish Platters, MK 25, **Top** – 15" facing left, $60-90; 16" gold trim, $40-60; 15" facing right, $60-90; **Bottom** – 14" facing left, $40-60; 14" double decal, $40-60; 13" facing right, $75-90.

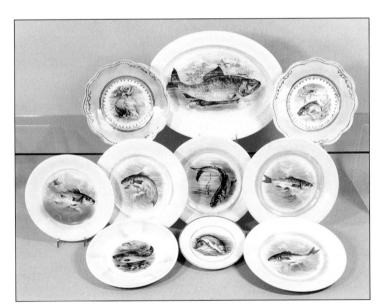

Fish Game Platter & Plates, MK 25, **Top** – 8" Dixie Shape green luster, $15-20 each; 13" platter, $45-60; **Bottom** – plates 6", $15-20; 9" black fish in center, $25-35; 8" & 9", $15-20 each.

Fowl Game Platters & Plates, MK 25, **Top** – 12" Turkey platter, $35-45; 17" luster Turkey platter, $90-110; 9" luster Turkey plate, $20-30; 9" Turkey plate, $20-30; **Bottom** – plates, 9" Mallard, $15-20; 8" Guinea Hen, $15-25; 9" Pheasant, $15-20; 9" Grouse, $20-30; 8" Ornamental Quail, $15-25; 9" Curlew, $20-30.

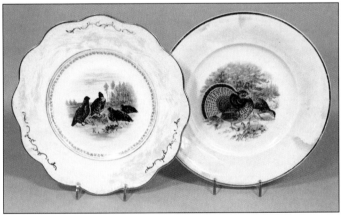

Fowl Plates, luster, MK 25, $18-25 each, 9" Dixie Shape Quail; 9" Grouse plate.

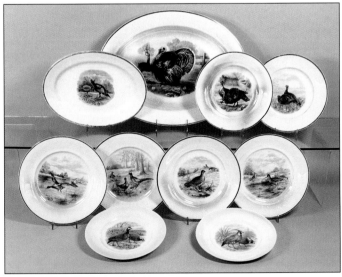

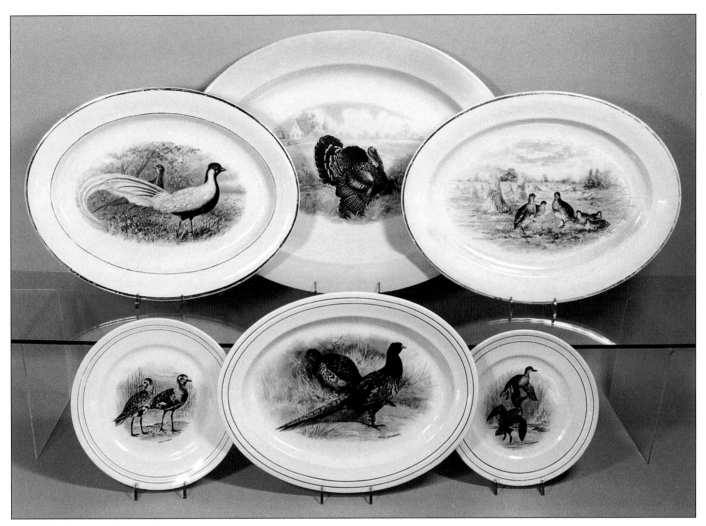

Fowl Game Platters & Plates, MK 25, **Top** – platters, 15" Chinese Pheasant, $60-75; 20" green edge Turkey, $90-120; 16" Grouse, $75-90; **Bottom** – 9" Black Plover plate, $20-30; 13" Pheasants platter, $40-60; 8" Green-winged Teal plate, $15-20.

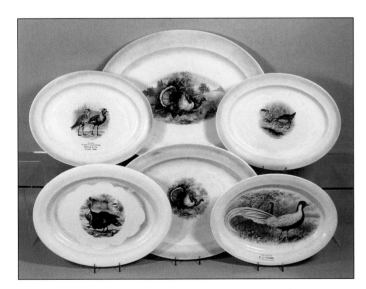

Fowl Platters, MK 25, **Top** – 13" Black Plover, $45-60; 20" Turkeys, $100-130; 13" Virginia Rail, $45-60; **Bottom** – 13" Turkeys, $45-60; 16" Turkeys, $60-75; 13" Chinese Pheasants, $35-45.

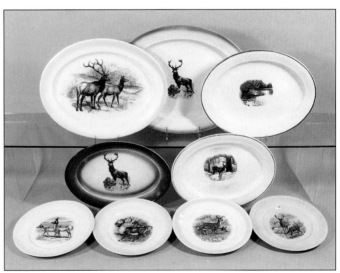

Venison Game Platters & Plates, MK 25, **Top** – 14" Elk platter, $45-60; 15" Elk platter, $60-90; 13" "Surprised" Deer platter, $20-30; **Bottom** – 11" burnt orange Elk platter, $25-35; 11" "Off The Trail" Deer platter, $20-30; 8" plates, Pronghorn Sheep; Caribou Elk; White Tail Deer; Elk, $15-25 each.

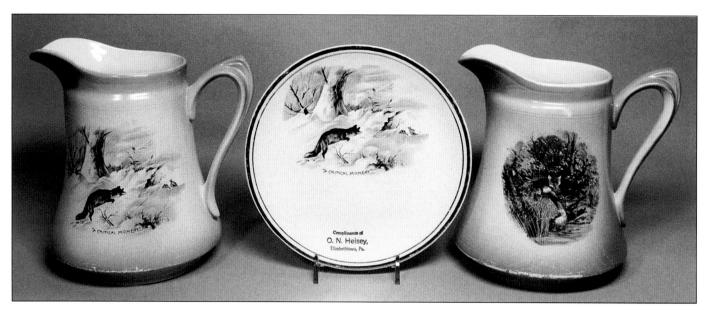

Fox, MK 25, 7" H Paris shape jug, Fox Hunting Quail, "A Critical Moment", $40-60; 7"
"A Critical Moment" plate, $10-15; 7" H Paris shape jug, Fox Hunting Mallard, $40-60.

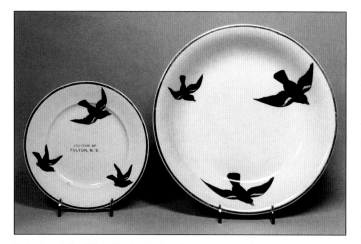

Red-winged Blackbirds, MK 25, 6" plate, $15-25; 9" bowl, $25-35.

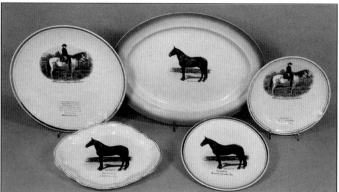

Horses, Sepia Tone Plates & Platters, MK 25, 9" "General Lee On His Famous
Horse Traveler" plate, $25-35; 8" Dixie shape "Dan Patch" platter, $75-85; 13"
"Dan Patch" platter, $40-50; 7" "Dan Patch" plate, $60-70; 7" "General Lee On His
Famous Horse Traveler" plate, $20-25.

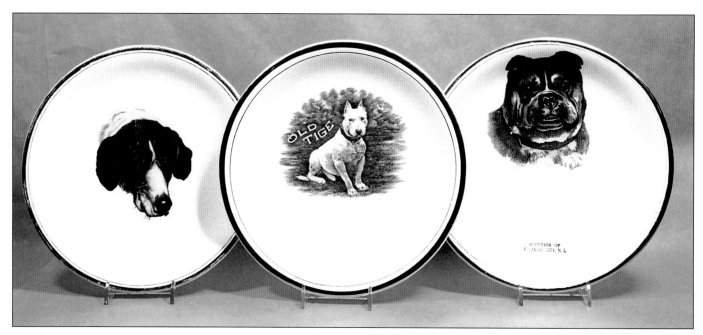

Dogs, 9" Plates, MK 25, Doleful Dog, $20-35; blue "Old Tige" (Buster Brown's Dog), $50-75; Bulldog, $25-45.

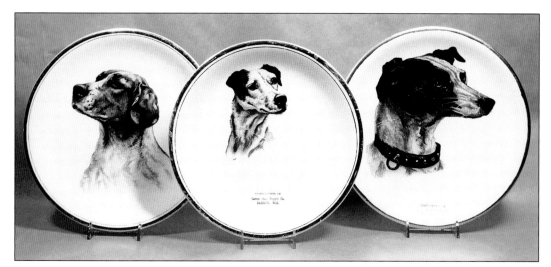

Dogs, MK 25, 10" plates, $20-35 each; 9" plate, $15-25.

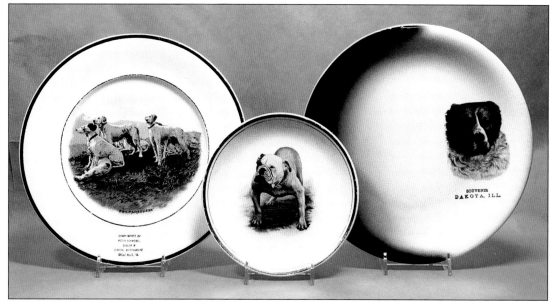

Dogs, MK 25, Sepia Tone, 9" "Preparedness" plate, $25-35; 6" Bulldog plate, $15-25; 9" green & yellow blush St. Bernard plate, $25-35.

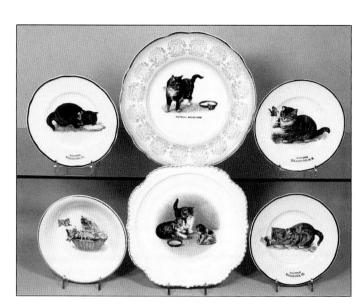

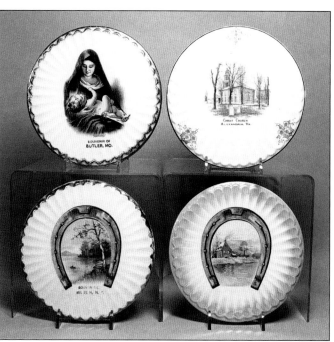

Cats, MK 25, **Top** – plates, 6" Cat & Bowl of Milk, $25-35; 9 Cat & Frog, $30-40; 6" Cat & Butterfly, $25-35; **Bottom** – 6" Basket of Kittens bowl, $25-35; 8" Gadroon square plate, no mark, $8-10; 6" Cat & Blue Ribbon, $25-35.

Flue Covers, MK 25, $30-40 each, Sepia Tone Madonna & Child; blue "Christ Church, Alexandria, Va."; Summer; Fall green luster.

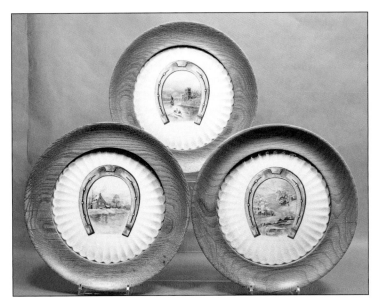

Flue Covers, MK 25, $40-50 each, 3 of 4 seasons, *Courtesy Nancy L. Wetzel*.

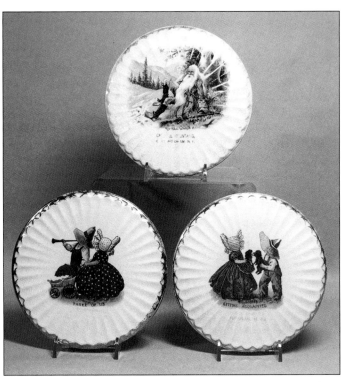

Flue Covers, MK 25, $45-60 each, Sunbonnet Sue "Three of Us"; Rip Van Winkle, "Catskill Mountains"; Sunbonnet Sue "Getting Acquainted".

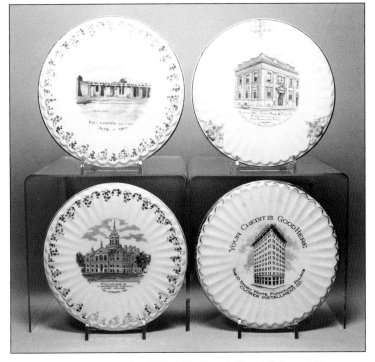

Flue Covers, Blue Transfers, MK 25, $30-40 each, **Top** – "Kit Carson's House, Taos, N.Mex."; "Murphy – Wall State Bank & Trust Co., Pinckney, ILL."; **Bottom** – "Lawrence County Court House, Mt. Vernon, MO."; "The 10 Story White Furniture Palace, Clower Installment Co.".

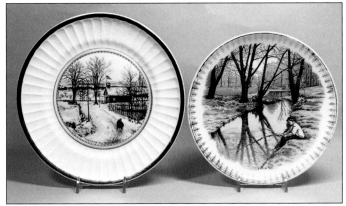

Sepia Tone Plates, MK 25, 9" "The Little Red Schoolhouse", $10-15; 8" "Fishin", $10-15.

Flue Covers, MK 25, $30-40 each, **Top** – 2 Niagara Falls; **Bottom** – blue blush, "B.A. Lutterman General Merchandise, Lennox, SD"; pink blush, "A.M. Fry, Cynthiana, Ohio".

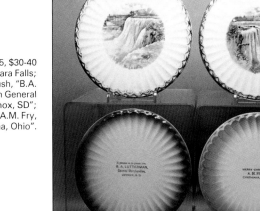

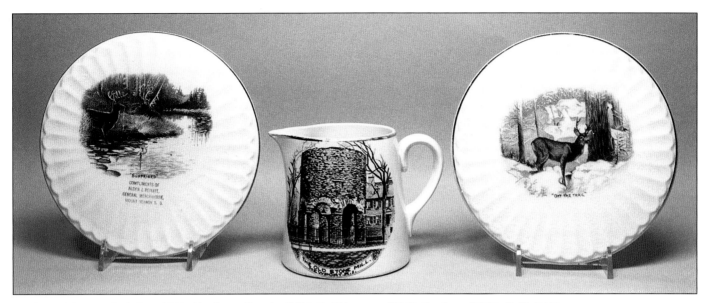

Flue Covers & Creamer, Sepia Tone, MK 25, Flue Cover, "Surprised", $20-40; 4" H creamer, $35-50; Flue Cover, "Off The Trail", $30-50.

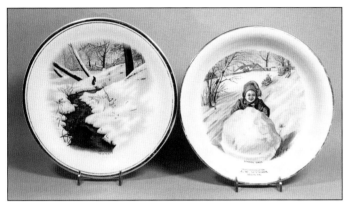

Sepia Tone, MK 25, 9" "Winter" plate, $20-25; 9" "School Days" bowl, $50-80.

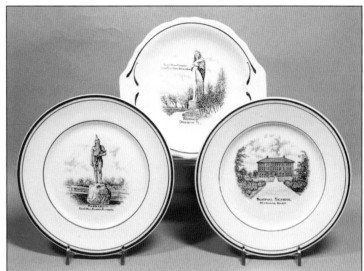

Blue Line Plates, 7" "Massasoit" MK 25, $20-30; 7" Melrose shape tabbed handles, "Black Hawk Monument", MK 31, $15-20; 7" "Normal School", MK 25, $20-25.

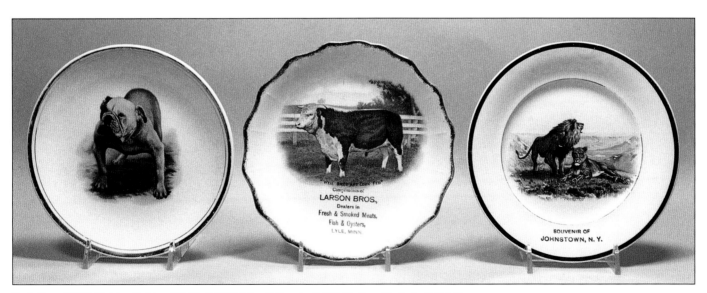

Sepia Tone, MK 25, 6" plates, Bulldog, $15-20; Bull "Well Bred & Corn Fed", $25-40; Lions "Protected", $15-20.

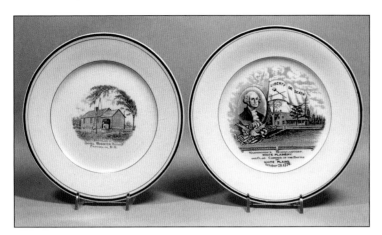

Blue Line Plates, MK 25, $20-30 each, 8" "Birthplace of Daniel Webster"; 8" "Washington's Headquarters, White Plains, NY".

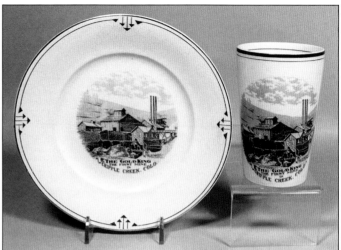

Blue Line 7" Plate, "Gold King, First Mine In Cripple Creek, Colo.", MK 25, $15-20; 4" H tumbler, same as plate, no mark, $15-20.

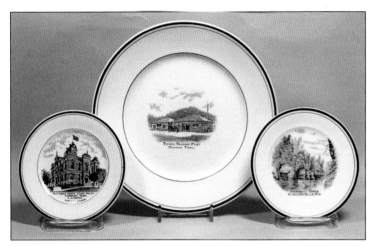

Blue Line Plates, MK 25, $20-30 each, 5" "Jefferson County Court House"; 9" "Totem Trading Post, Mohawk Trail"; 5" "Steamboat Yards".

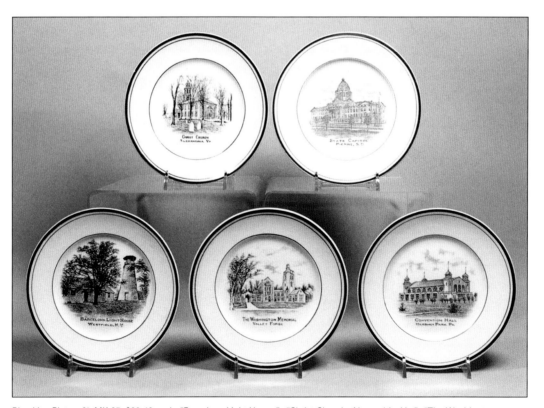

Blue Line Plates, 6", MK 25, $20-40 each, "Barcelona Light House"; "Christ Church, Alexandria, Va."; "The Washington Memorial, Valley Forge"; "State Capitol, Pierre, S.D."; "Convention Hall, Hershey Park, Pa."

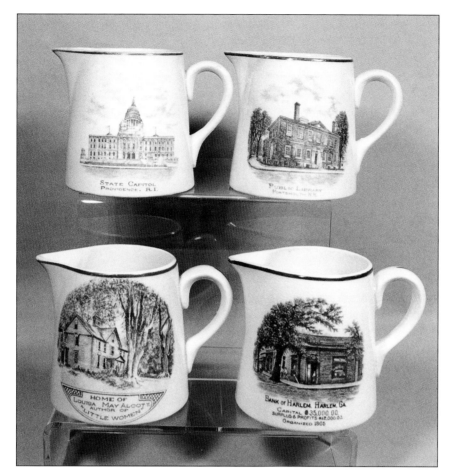

Blue Line 4" H Creamers, MK 25, $45-70 each, **Top** – "State Capitol, Providence, R.I."; "Public Library, Portsmouth, N.H."; **Bottom** – "Home of Louisa May Alcott"; "Bank of Harlem, Harlem, GA".

Blue Line Plates, MK 25, 8" "Foresters of America", $30-45; 6" Puppies & Dog House, $15-25; 9" "Voices of the Night", $25-40.

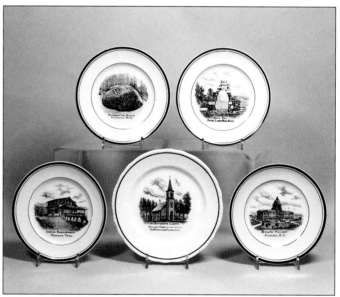

Black Line Plates, $15-25 each, 6" "Indian Encampment, Mohawk Trail", MK 25; 6" "Plymouth Rock", MK 25; 7" Melrose shape "St. Anthony's Chapel, Smallest Church In The World", MK 31; 6" "Rock Pile, Jacob's Ladder", MK 25; 6" "State House, Pierre, S.D.", MK 25.

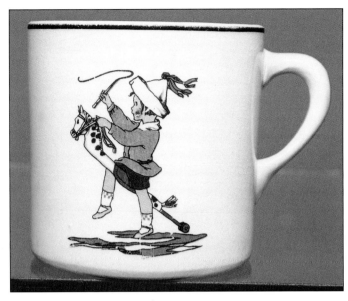

Blue Line 3" H child's cup, MK 25, $30-40.

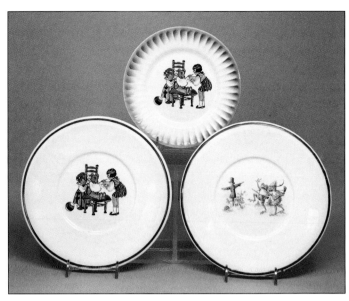

Blue Line Children's Plates, 8" Girls With Teddy Bear, MK 31, $45-60; 6" fluted edge Girls With Teddy Bear, MK 25, $30-40; 8" Frogs & Scarecrow, MK 31, $45-60.

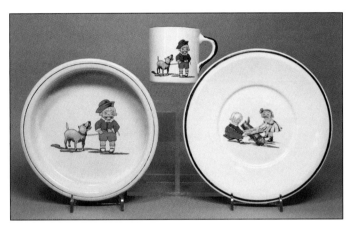

Buster Brown, 7" W baby dish, MK 25, $50-75; 3" H mug, MK 31, $30-40; 8" plate, MK 31, $75-100.

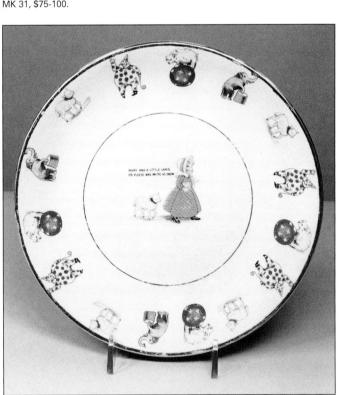

Blue Line Dutch Lemonade Set, MK 25, 9" H Harker Jug & 4" H tumblers, $150-200 set.

Child's Plate, MK 25, 7" "Mary Had A Little Lamb", $20-25.

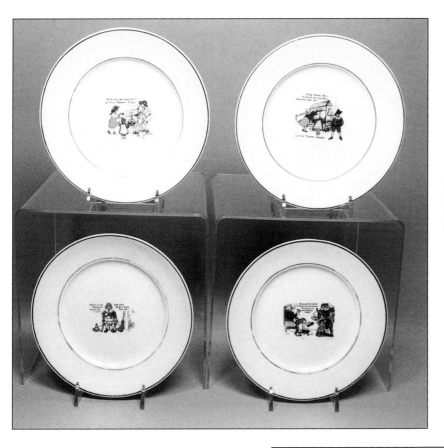

Blue Line 6" Children's Plates, MK 25, $20-40 each, **Top** – "Who Pulled Her Out? Little Johnny Stout"; "Ding Dong Bell, Pussy's In The Well"; **Bottom** – "He Put In His Thumb And Pulled Out A Plum"; "He Called For His Pipe, — Bowl, —His Fiddlers Three".

Blue Line 6" Children's Plates, MK 25, $20-40 each, "Mary Had A Little Lamb"; "Sheep's In The Meadow, Cow's In The Corn"; "Sing A Song Of Sixpence, A Pocket Full Of Rye".

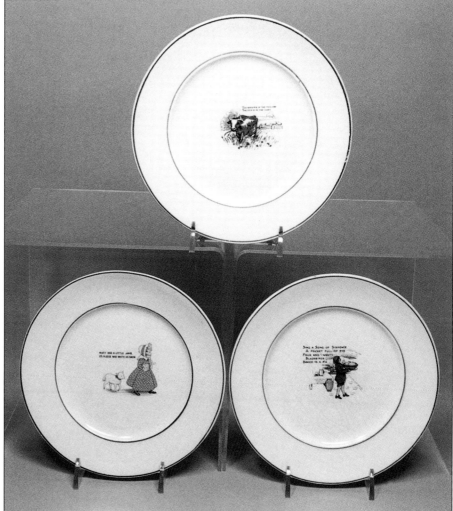

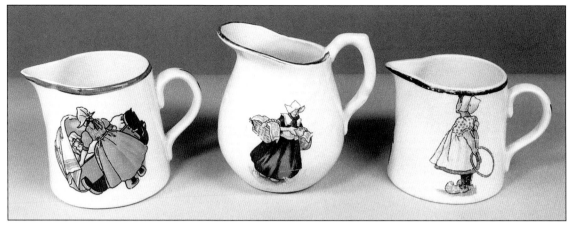

Blue Line Gem & Savoy Shape Dutch Kids Creamers, $25-35 each, Gem Shape, Dutch Girl At Cradle, MK 23; Savoy Shape, Dutch Girl in Blue Dress, MK 25; Gem Shape, Dutch Girl With Hoop, MK 23.

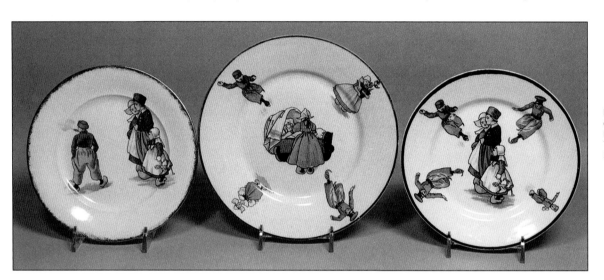

Blue Line Plates, $25-45 each, 6" Smoking Dutchman & Family, MK 25; 7" Dutch Girl At Cradle, MK 23; 6" Dutch Family, MK 23.

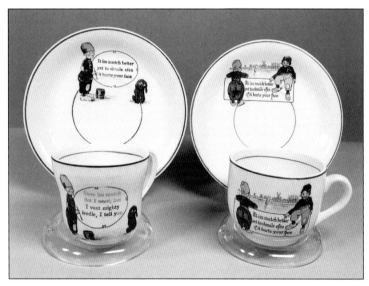

Blue Line Dutch Children's Cup & Saucer Sets, MK 25, $40-50 each.

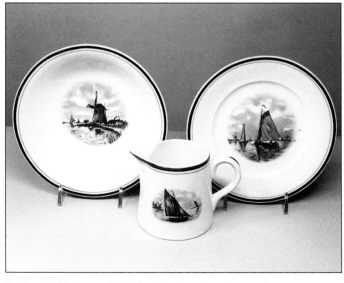

Children's 3 PC Oatmeal Set, MK 25, Blue Line Dutch Scenes, $75-85.

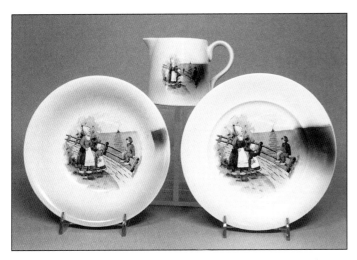

Children's 3 PC Oatmeal Set, Dutch Kids with blue & green blush, MK 25, $75-85.

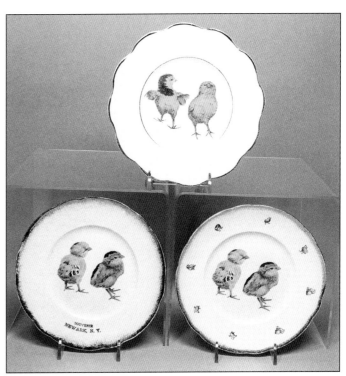

Children's Baby Chicks 6" plates, MK 25, $15-25 each.

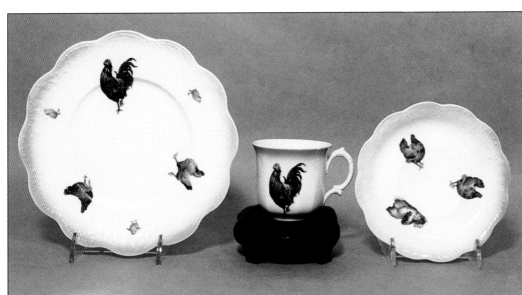

Dixie Shape Chickens
Children's Set, MK 25, 6" plate;
2" H cup; 5" saucer, $50-75.

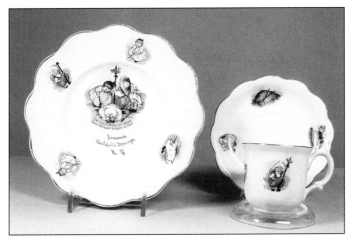

Dixie Shape Tiny Todkins Children's Set, MK 25, 6" plate; 5" saucer; 2" H cup, $70-85.

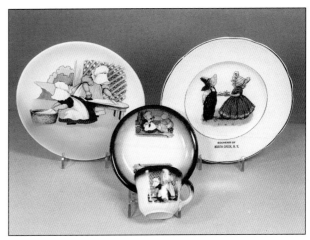

Sunbonnet Sue, MK 25, 7" plate, $80-100; 5" saucer & 2" H cup, $70-80; 7" plate, "T 4 2" (Tea For Two), $50-70.

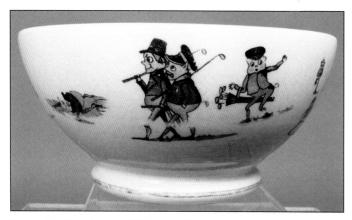

"Palmer Cox Brownies" rare 6" W footed children's bowl, MK 23, $35-45.

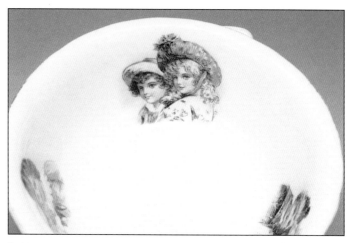

Children's Fluted Bowl, 4" W, detail of one of three decals, MK 15, $45-60.

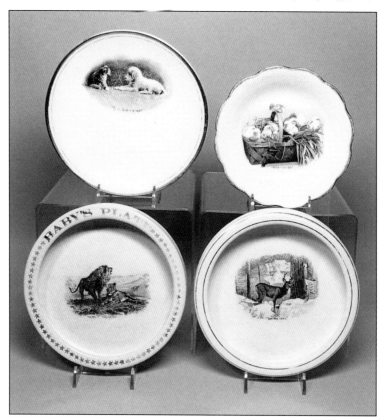

Sepia Tone Children's Dishes, MK 25, **Top** – 7" plate, "Yeow Wars Start", $10-20; 6" bowl, "Their First Day", $20-30; **Bottom** – 7" "Protected" baby dish, $40-60; 7" "Off The Trail" baby dish, $40-60.

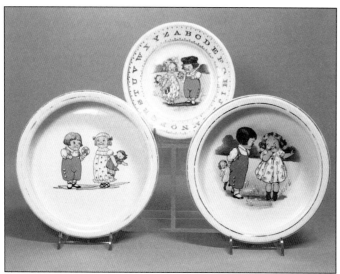

Campbell Kids, 7" baby dish, MK 25, $90-120; 6" ABC plate, MK 26, $85-110; 7" baby dish, MK 25, $75-100.

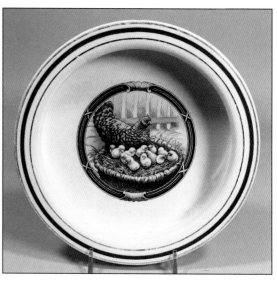

Mother Hen & Chicks, 7" baby dish, MK 25, $35-50.

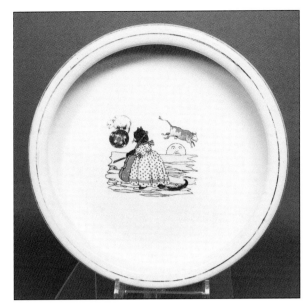

Children's 7" High Diddle Diddle nursery rhyme baby dish, MK 25, $60-80.

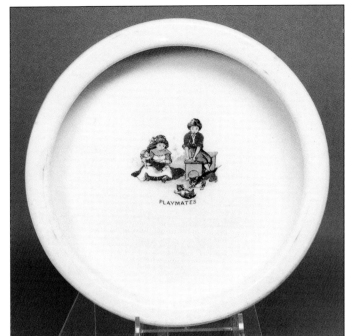

Children's 7" "Playmates" baby dish, MK 25, $40-60.

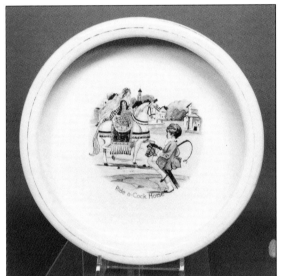

Children's 7" "Ride A Cock Horse" baby dish, MK 25, $50-75.

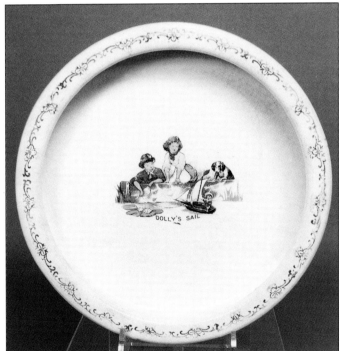

Children's 7" "Dolly's Sail" baby dish, MK 25, $75-100.

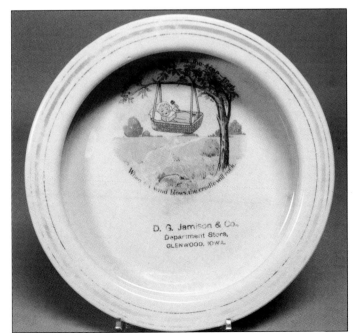

Children's 7" "Hush A Bye Baby,
In The Tree Top" baby dish, MK
25, $40-60.

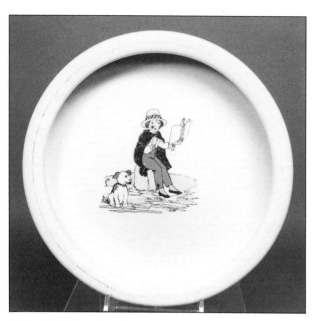

Children's 7" Girl reading to her dog baby dish, MK 25, $50-75.

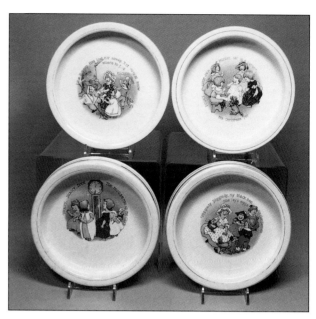

Children's 7" Nursery Rhyme baby dishes, MK 25, $40-60 each, **Top** – "Little Bo Peep"; "Little Jack Horner"; **Bottom** – "Hickory, Dickory, Dock"; "Higgledy, Piggledy".

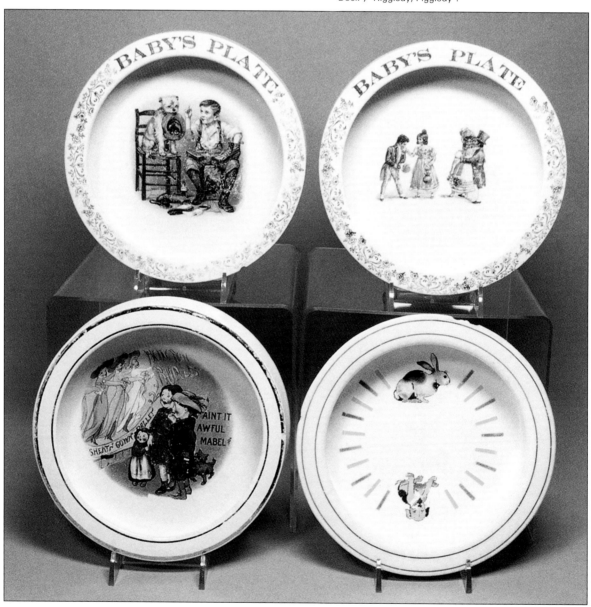

Children's 7" Baby Dishes, **Top** – Boy With Dog, MK 25, $35-50; Courting Couples, MK 25, $45-60; **Bottom** – "Ain't It Awful Mabel?", MK 25, $45-60; Dog & Rabbit, MK 31, $30-45.

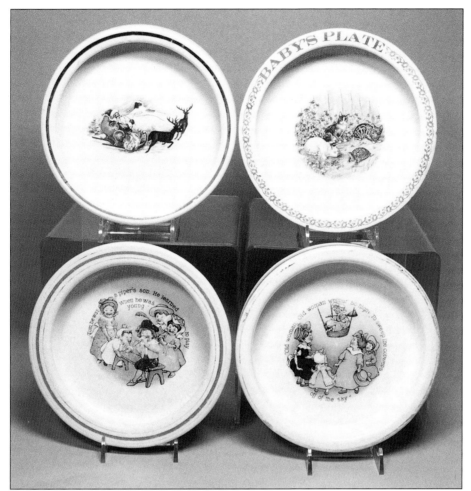

Children's 7" Baby Dishes, MK 25, **Top** – Santa Claus, $40-60; Cats & Turtle, $40-60; **Bottom** – "Tom, He Was A Piper's Son", $40-60; "Old Woman, Old Woman", $50-75.

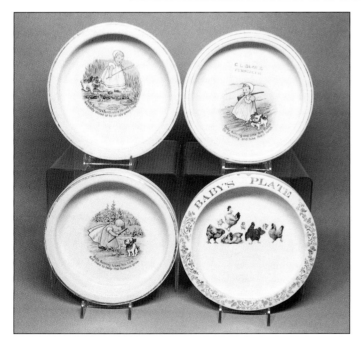

Children's 7" Baby Dishes, MK 25, $40-60 each, **Top** – "Baby Bunting & Bunch While Crossing A Log"; "Baby Bunting And Dog Bunch Go A Hunting"; **Bottom** – "Baby Bunting Takes His Hoe"; Multicolored Chickens & Chicks.

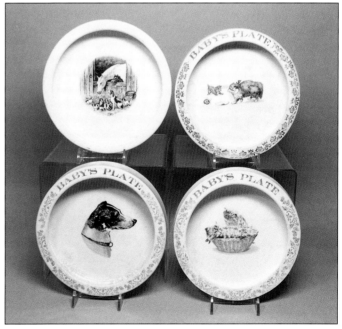

Children's 7" Baby Dishes, MK 25 Horses & Dogs, $40-60; Cat & Puppy, $40-60; Black & White Dog, $50-75; Basket of Kittens, $50-75.

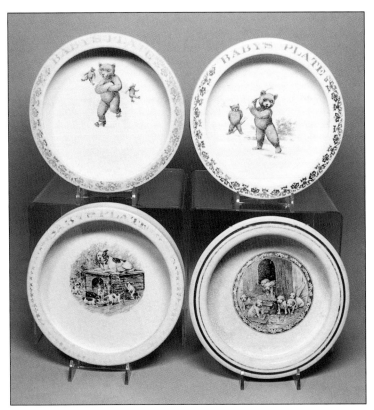

Children's 7" Baby Dishes, MK 25, Skating Bears, $40-50; Golfing Bears, $40-50; Buster Brown's Dog & Puppies, $40-60; Dog House & Puppies, $35-50.

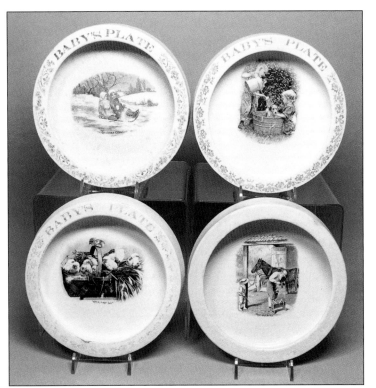

Children's 7" Sepia Tone Baby Dishes, MK 25, **Top** – "Children Coasting", $40-60; "Wash Day", $50-75; **Bottom** – "Their First Day", $40-60; "Interested" (boy & blacksmith), $40-60.

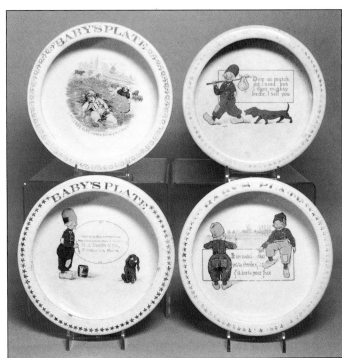

Children's 7" Baby Dishes, MK 25, **Top** – "Little Boy Blue", $40-60; Dutch boy & dog, $30-50; **Bottom** – Dutch boy & dog, $45-65; 2 Dutch boys, $45-65.

ABC Plates

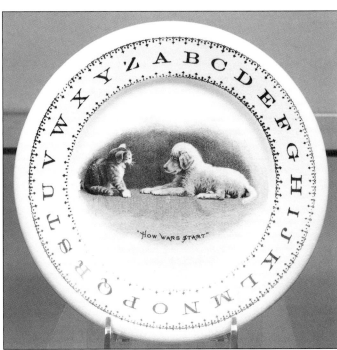

ABC Plate, Sepia Tone, "How Wars Start", MK 26, $75-100.

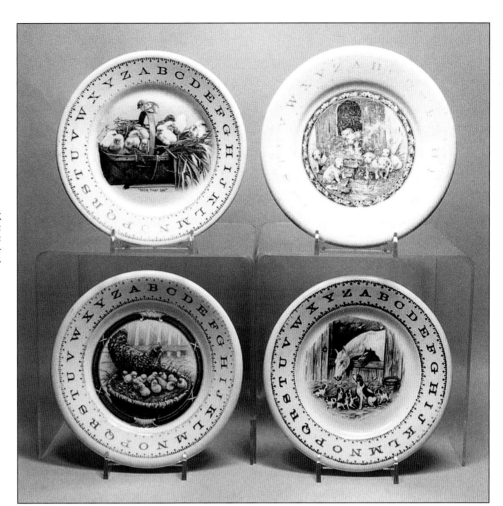

ABC Plates, Sepia Tone & Decal, MK 26, **Top** – "Their First Day", $60-90; Doghouse & Puppies, $30-45; **Bottom** – Mother Hen & Chicks, $80-100; Horses & Dogs, $60-90.

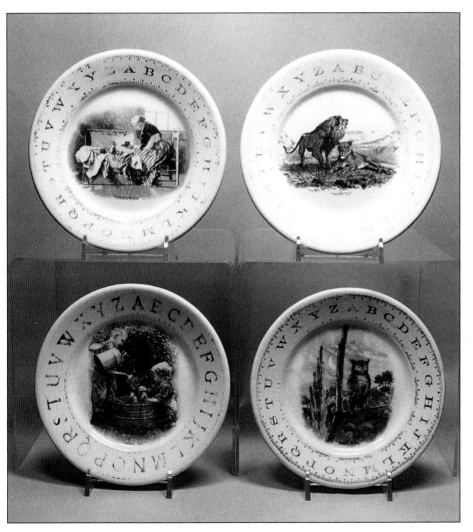

ABC Plates, Sepia Tone, MK 26, **Top** – "Memories", $40-75; "Protected", $50-80; **Bottom** – "Wash Day", $50-80; "Who! Who!", $50-80.

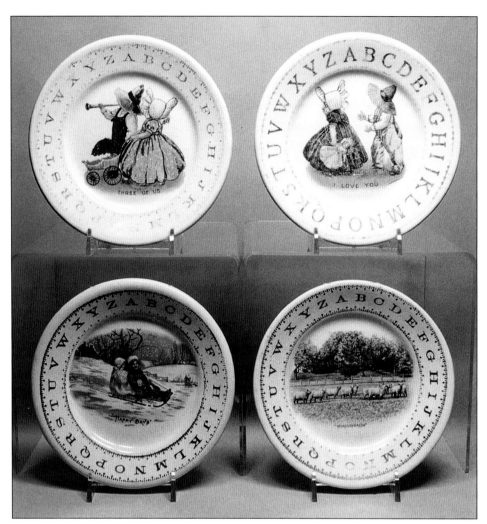

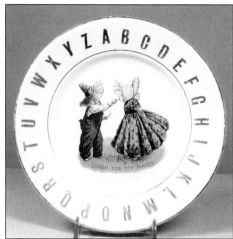

ABC Plate, MK 26, "Candy For My Mandy", $95-125.

ABC Plates, Sepia Tone & Decal, MK 26, $40-80, **Top** – "Three of Us"; "I Love You"; **Bottom** – "Happy Days"; "Thoroughbreds".

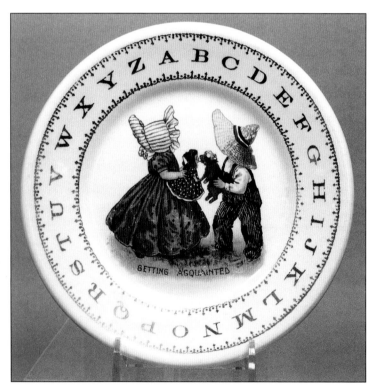

ABC Plate, MK 26, "Getting Acquainted", $85-110.

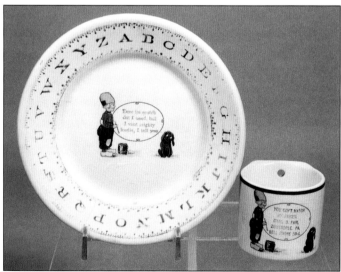

ABC Dutch boy & dog plate, MK 25, $60-80; Match Holder/Striker, no mark, $60-80.

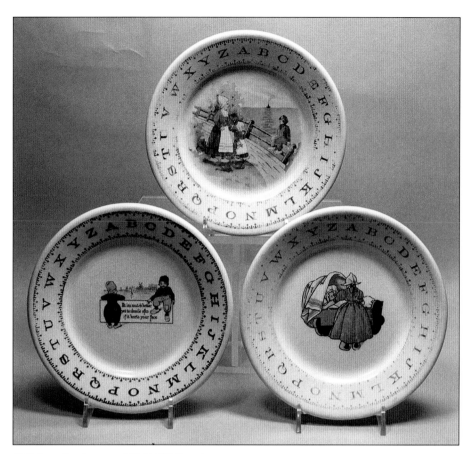

ABC Plates, Dutch scenes, MK 26, $45-60 each.

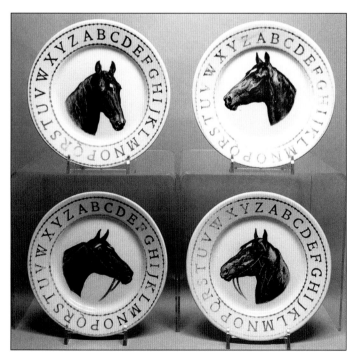

ABC Plates, Horses, MK 26, $45-70 each.

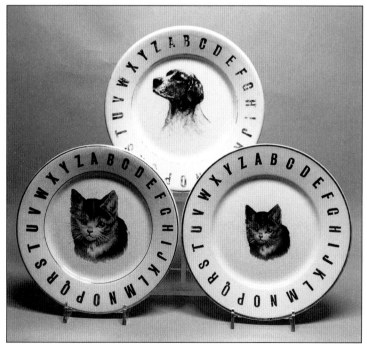

ABC Plates, Cat, MK 26, $45-65; Dog, MK 26, $30-45; Cat, MK 23, $50-75.

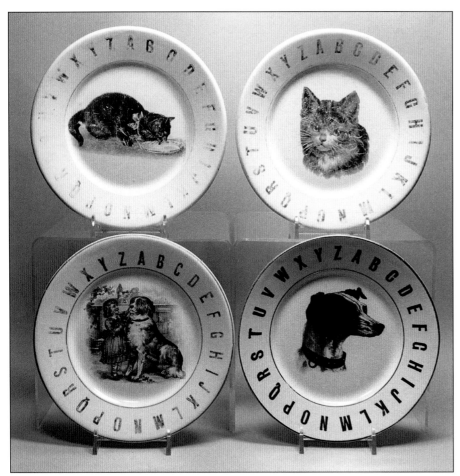

ABC Plate, MK 25, "Ding Dong Bell!", $110-135.

ABC Plates, **Top** – Black Cat, MK 26, $45-60; Calico Cat, MK 26, $30-45; **Bottom** – Girl & St. Bernard, MK 26, $40-50; Black & White Dog, MK 23, $70-85.

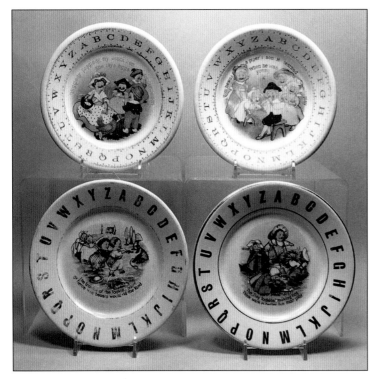

ABC Plates, MK 26, **Top** – "Higgledy Piggledy", $45-75; "Tom, — A Piper's Son", $45-75; **Bottom** – "Bravest Of The Todkins Band", $50-80; "Tiny Todkins Making Hay", $90-145.

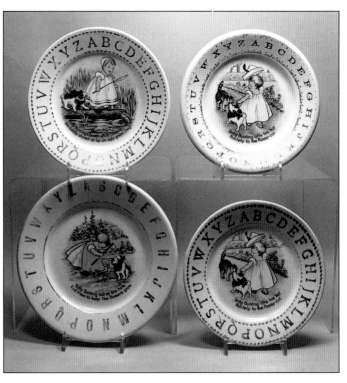

ABC Plates, MK 26, $60-85 Each, **Top** – "Baby Bunting & Bunch"; "Baby Bunting Lifts His Hat"; **Bottom** – "Baby Bunting Takes His Hoe"; "Baby Bunting Lifts His Hat".

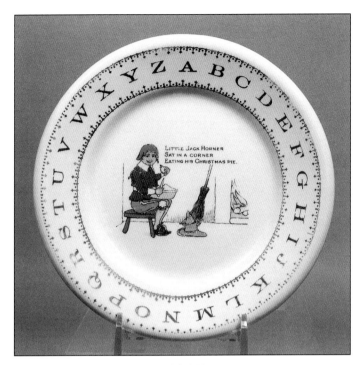

ABC Plate, MK 26, "Little Jack Horner", $40-60.

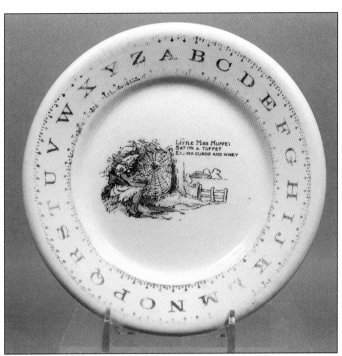

ABC Plate, MK 26, "Little Miss Muffet", $40-60.

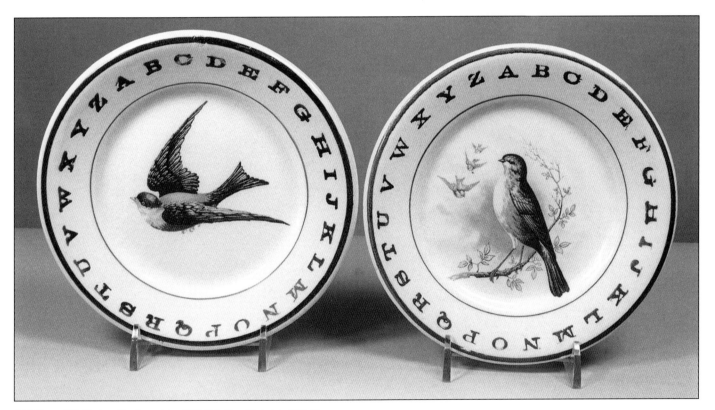

ABC Plates, MK 26, Barn Swallow plate, $125-150; Blue Bird plate, $75-90.

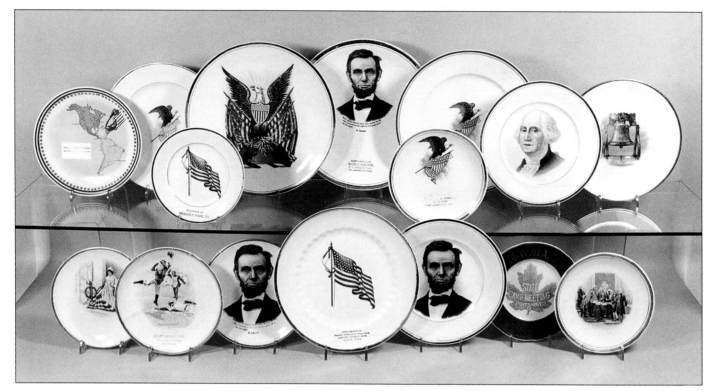

Americana Plates, MK 25 unless noted, **Top** – 7" Panama Canal, $10-15; 9" U.S. Flag & Bald Eagle, $25-35; 6" U.S. Flag, $25-30; 10" Bald Eagle & Crossed Flags, $40-50; 10" Lincoln, $30-35; 6" U.S. Flag & Bald Eagle, "Daughters Of America, East Liverpool, Ohio.", $20-25; 10" Bald Eagle & U.S. Flag, $35-40; 9" Washington, $10-15; 8" Liberty Bell, $15-20; **Bottom** – 6" Betsy Ross, $20-25; 7" Baseball "Won In The Ninth", $85-100; 7" Lincoln, $25-30; 9" Thumbprint U.S. Flag, MK 36, $30-35; 8" Lincoln, $30-35; 6" "M.W. of A., State Camp Meeting 1908", $30-35; 6" "Declaration of Independence", $18-24.

Americana, "Aspirations" White House in clouds, MK 25, 9" bowl & plate, $20-30 each.

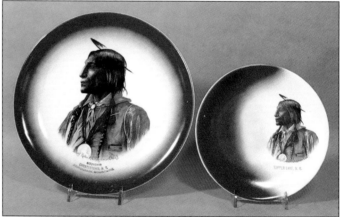

Americana, Indian Art China Plates, MK 25, 9" "Wolf Robe, A Cheyenne Chief", $40-55; 7" "Wolf Robe, A Cheyenne Chief", $25-40.

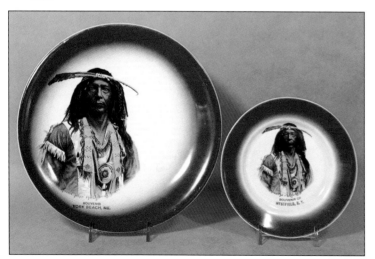

Americana, Indian Art China Plates, 9" "Arrow Maker, Ojibway Brave", MK 25, $45-55; 6" "Arrow Maker, Ojibway Brave", MK 23, $40-55.

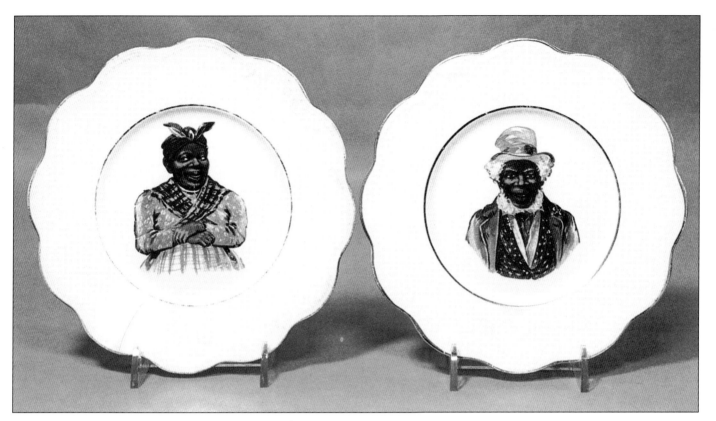

Americana, Black Memorabilia 6" Plates, MK 25, Mammy & Pappy, $60-100 each.

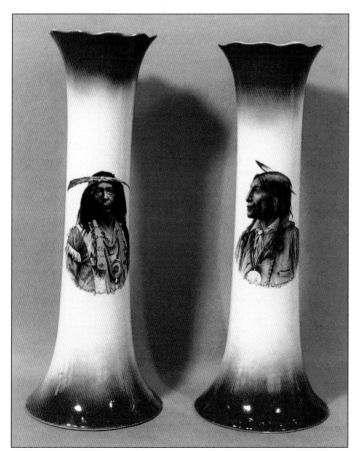

Americana, Indian Art China Vases, 10" H, MK 25, $90-120 each, "Arrow Maker, Ojibway Brave"; "Wolf Robe, A Cheyenne Chief".

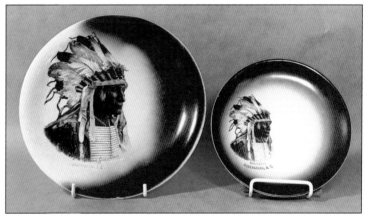

Americana, Indian Art China Plates, MK 25, 9" "Broken Arm, A Noted Sioux Chief", $25-50; 7" "Broken Arm, A Noted Sioux Chief", $25-40.

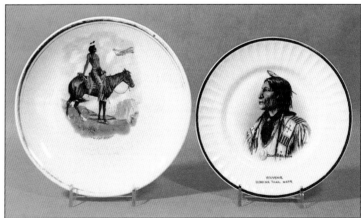

Americana, Indian Plates, MK 25, $15-20 each, 7" "What Next" (Indian looking at early airplane); 6" "Chief Wolf Robe" on fluted plate.

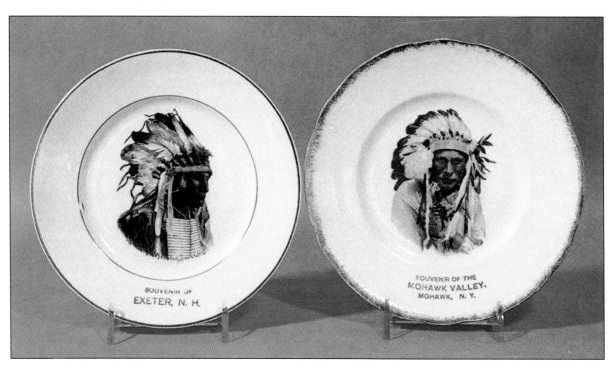

Americana, Indian Plates, MK 25, 6" "Broken Arm, A Noted Sioux Chief", $20-30; 6" "Souvenir of The Mohawk Valley", $10-15.

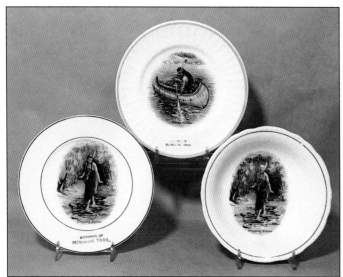

Americana, Indian Plates & Bowl, 6" "Stepping Stones", MK 25, $20-30; 6" fluted "Placid Waters", MK 25, $10-20; 6" "Stepping Stones" bowl, MK 31, $20-30.

Calendar Plates, 6", MK 25, 1915 Panama Canal, $15-25; 1917 "Coasting", $30-50.

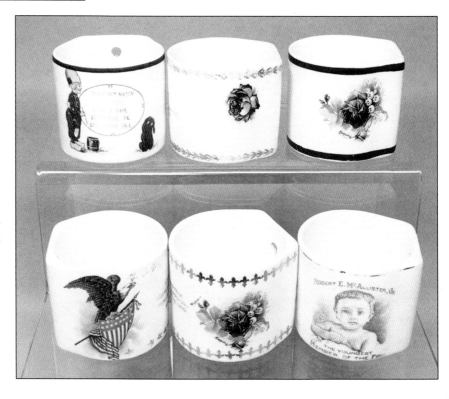

Americana, Match Holders/Strikers, no marks, $75-100 each, **Top** – Dutch boy & dog, "You can't match my prices"; Burgundy rose "I do, do you, trade with Standard Hardware"; Rose & Lily of the Valley; **Bottom** – Bald Eagle & U.S. Flag (President Wilson on reverse); Rose & Lily of the Valley; Blue Transfer, "The Youngest Member of the Firm".

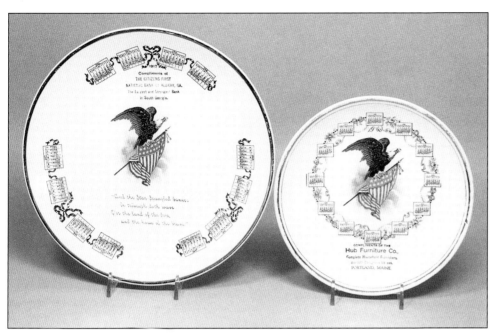

Calendar Plates, MK 25, 9" 1917 "Star Spangled Banner", $45-65; 7" 1916, $35-45.

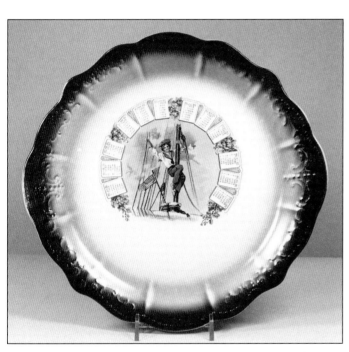

Calendar Plate, Dixie shape 1912 Sailor Climbing Mast of Ship, MK 25, $30-40.

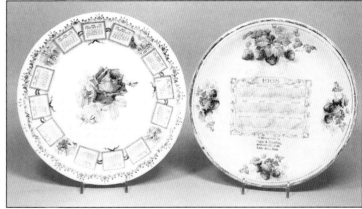

Calendar Plates, MK 25, 9" 1909 Violets, $10-15; 10" 1909 numerous sayings, $15-20.

Calendar Plates, 9", MK 25, 1909 Pink Rose, $35-50; 1908 Strawberries, $30-40.

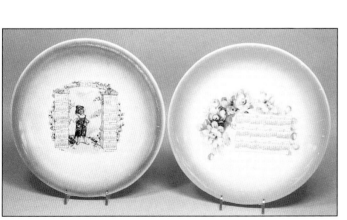

Calendar Plates, 9", MK 25, 1913 Ragged Pants Boy, $25-35; 1912 Old Roses, $15-25.

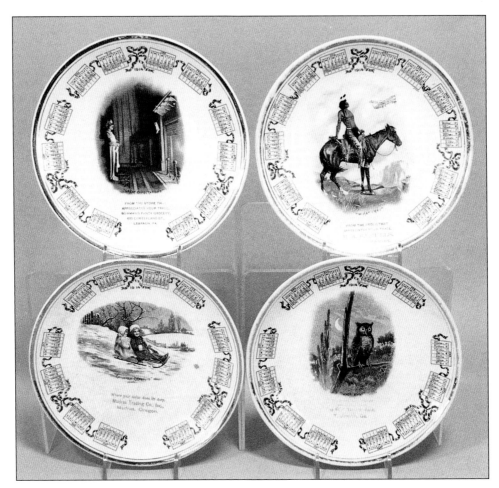

Calendar Plates, 7", MK 25, $25-50 each, **Top** – 1914 Sepia Tone "Great Expectations"; 1914 "What Next?" Indian decal; **Bottom** – 1914 "Children Coasting"; 1914 "Who! Who!".

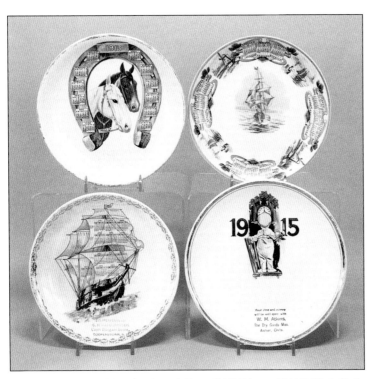

Calendar Plates, MK 25, $15-25 each, **Top** – 7" 1913 Horses; 7" 1910 Windmills & Sailing Ships; **Bottom** – 7" 1911 3 Mast Ship; 7" 1915 Boy With Clock.

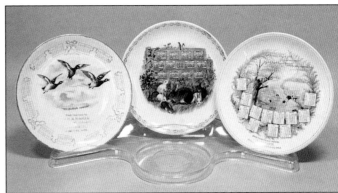

Calendar Plates, MK 25, 7" 1913 Mallards, $20-30; 7" 1911 Rabbits, $30-45; 7" 1910 Swimming Hole, $20-30.

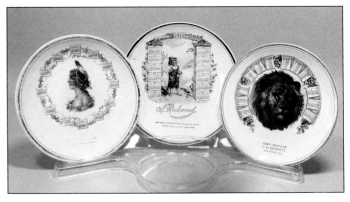

Calendar Plates, MK 25, $20-30 each, 7" 1916 Indian squaw; 7" 1914 raggedy pants boy; 7" 1912 Lion.

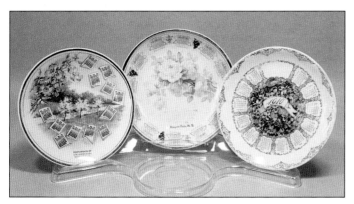

Calendar Plates, MK 25, $20-30 each, 8" 1911 Old Roses; 7" 1914 Pink Roses; 7" 1910 Violets.

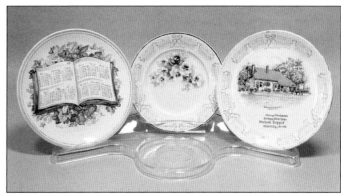

Calendar Plates, MK 25, $20-30 cach, 7" 1910 Open Book; 6" 1913 Pansies; 7" 1913 "Washington's Headquarters".

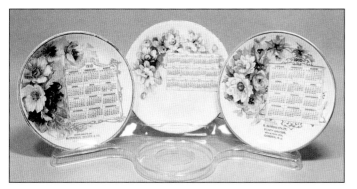

Calendar Plates, 7", MK 25, $20-30 each, 1910 Multicolored Roses; 1912 Pink Roses; 1910 White Roses & Holly.

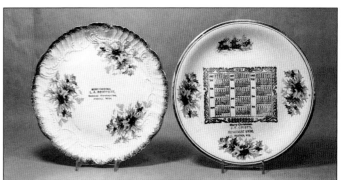

Christmas & Calendar Plate, 9", MK 25, Holly on Small Chop plate, $15-20; 1907 Calendar plate Santa & Sleigh With Holly, $50-75.

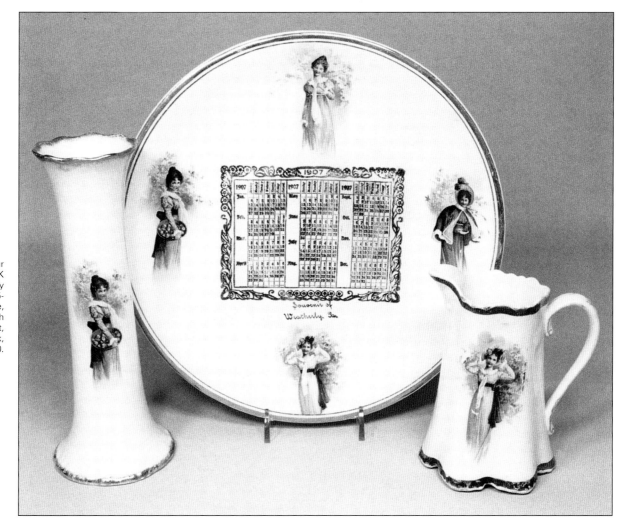

Calendar Plate, Four Seasons Ladies, MK 25, 8" H Summer Lady vase (very rare), $65-100; 10" 1907 plate, $45-60; 5" H jug with Summer on the front, Winter on the back, $25-30.

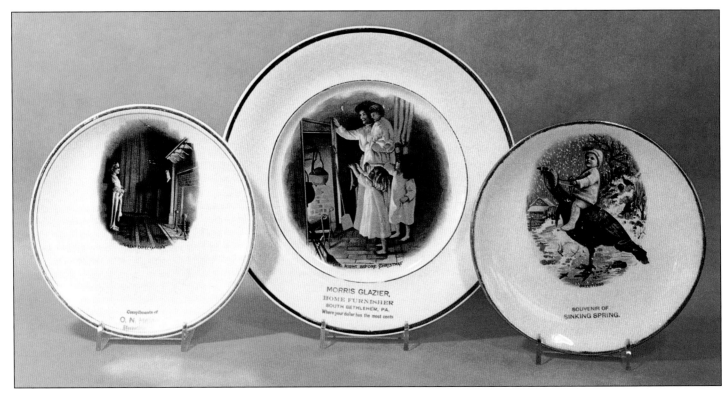

Christmas Plates, Sepia Tone, MK 25, 7" "Great Expectations", $12-20; 9" "The Night Before Christmas", $18-30; 7" Boy Riding Turkey, $25-50.

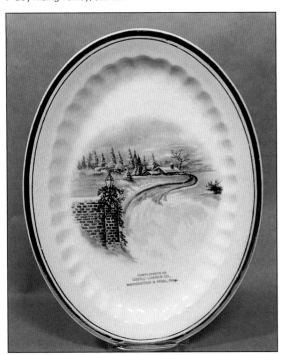

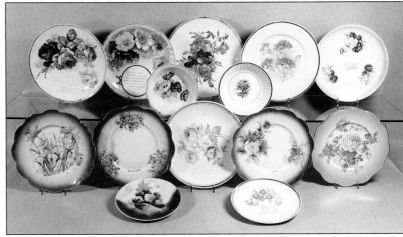

Flower Plates & Bowls, MK 25 (many are advertising plates), $8-25 for all but blue & fuchsia edged plates on bottom row, which are $25-40.

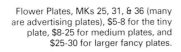

Christmas 11" Thumbprint Platter, MK 36, Snow Scene, $25-35.

Flower Plates, MKs 25, 31, & 36 (many are advertising plates), $5-8 for the tiny plate, $8-25 for medium plates, and $25-30 for larger fancy plates.

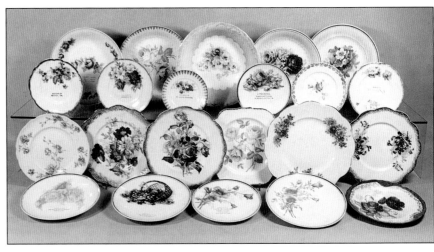

Animal Plates, MK 25, smaller plates, $8-25, larger plates, $30-40.

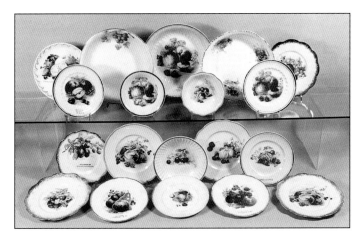

Fruit Plates & Bowls, MKs 25, 31, & 36 (many are advertising plates), $8-25 and $20-30 for larger, more beautiful pieces.

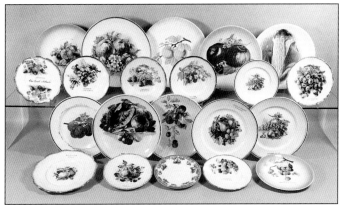

Fruit Plates, MK 25 (many are advertising plates), $8-25 and $20-25 for larger, more beautiful pieces.

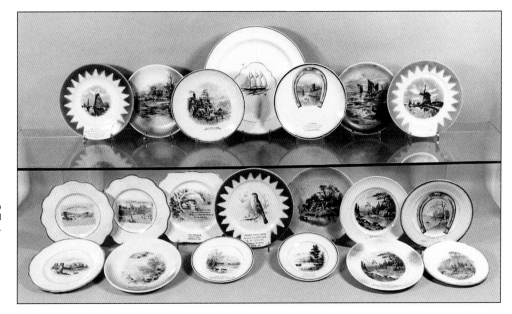

Scenery Plates, MK 25, except 3 mast ship plate MK 84, $10-25 except Blue Diamond Border plates, $40-60.

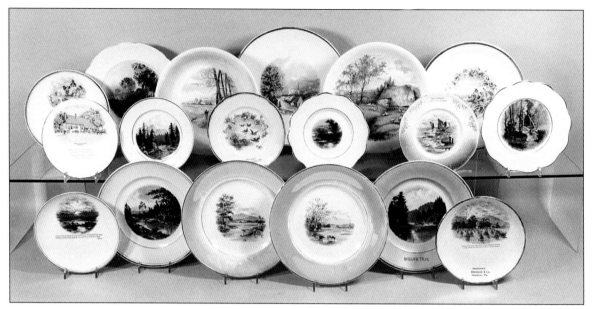

Scenery Plates, MK 25, $8-25 and $20-30 for larger, more beautiful pieces.

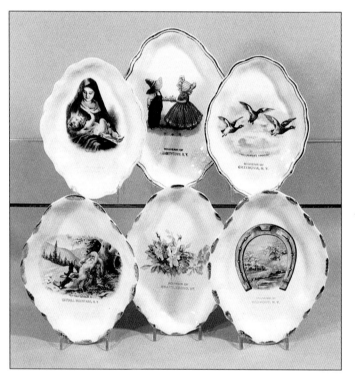

Dixie Shape advertising platters, MK 25, 7" & 9", $20-35, except Sunbonnet Sue, $40-50.

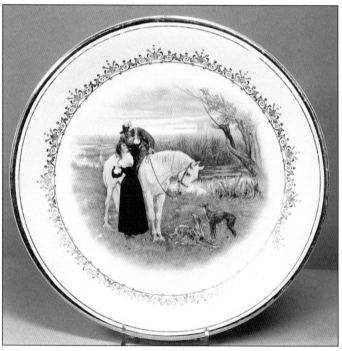

Courting Couple With Greyhounds, 9" plate, MK 25, $25-30.

Watermelon, 10" bowl, unknown shape, MK 25, $30-40.

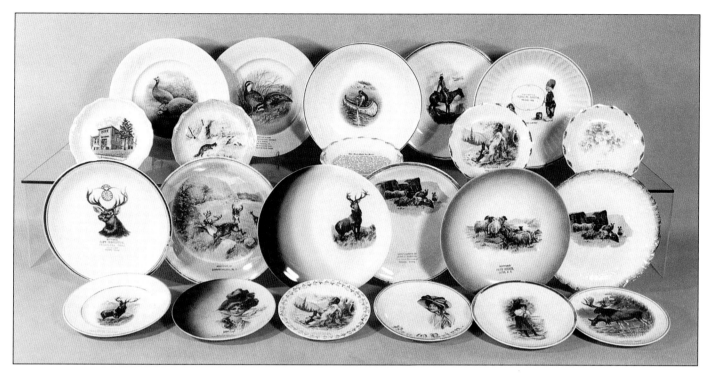

Animal, Portrait & Advertising Plates & Bowls, MK 25, $10-25.

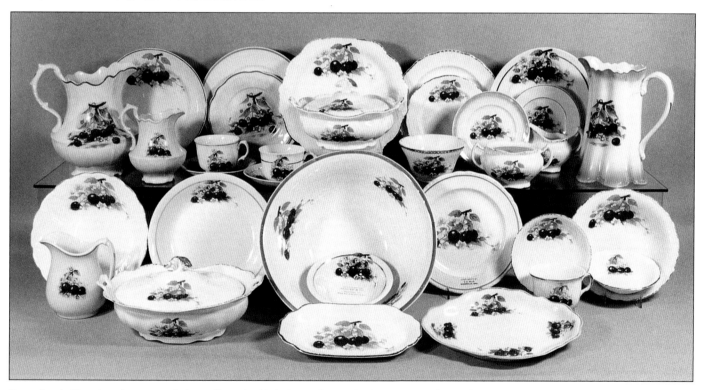

Cherry Decal with variety of treatments & shapes illustrating Harker's use of a popular decal over time, MKs 25 & 31, 8"
& 6" Dixie Shape jugs on upper left, $60-70 & $40-50; green blush Harker Jug upper right, $90-100; 9" square Melrose
covered vegetable top center, $25-35, & 11" L Melrose covered vegetable lower left, $35-45. Most other pieces, $8-20.

Cherries, 10" Fluted Edge bowl, MK 25, $30-40; Peaches, 10" Paneled bowl, $30-40.

Assorted Bowls, MK 25, small bowls, $8-20; larger bowls, $12-25; 10" Paneled bowls either end top row, $25-35.

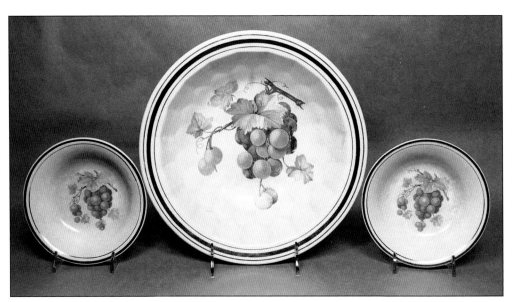

Paneled Concord Grapes berry set, MK 25, 10" bowl, $25-40; Two 5" berries , MK 25, $8-12 each.

Plums, 10" bowl, unknown shape, orange, yellow, & green blush, MK 25, $25-35.

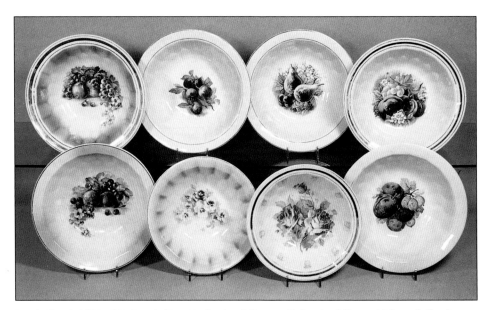

Paneled Bowls, MK 25, $20-30 each, **Top** – 10" Peaches & Grapes; 10" Peaches & Plums; 10" Pears & Cherries; Peach, Grapes, & Plums; **Bottom** – 10" Pears & Cherries; 9" Pansies; 9" Pink Roses; 10" Plums & Gooseberries.

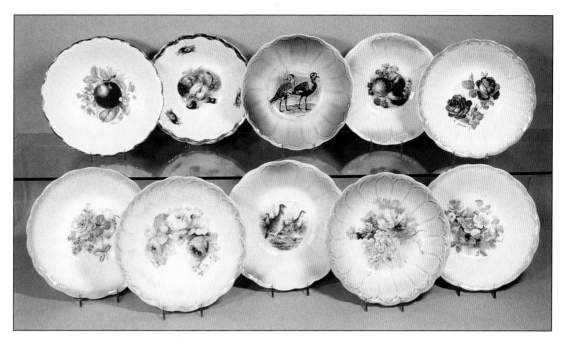

Assorted Fluted Edge Bowls, MKs 25 & 31, $10-25 (except Birds, $30-50).

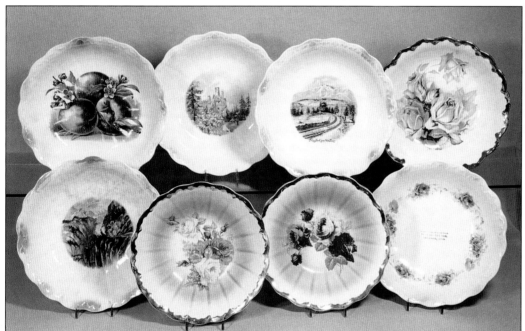

Assorted Fluted Edge Bowls, MKs 25 & 31, $20-40.

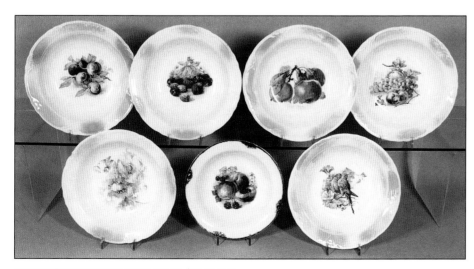

Assorted Embossed Edge Bowls, MK 31, $20-25 each.

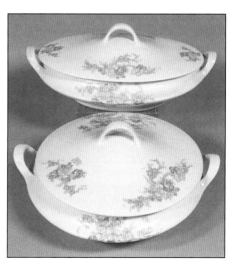

Empress Shape, Lacy Rose II, MK 25, **Top** – 10" W oval covered vegetable, $30-40; 10" round covered vegetable, $30-40.

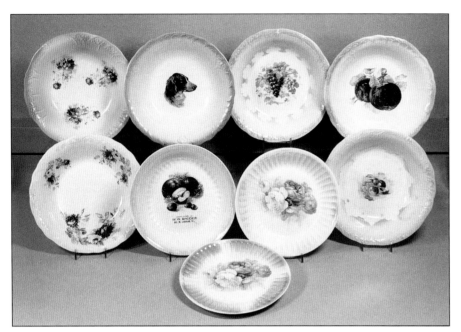

Assorted Bowls & Plate, MKs 25, 31, & 36 (many are advertising pieces), $12-40.

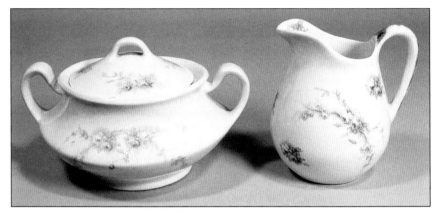

Empress Shape, MK 25, 7" H Celebration decal jug, $45-50.

Empress Shape 6" W Shadow Rose sugar, MK 25, $12-15; Savoy Shadow Rose creamer, MK 25, $12-15.

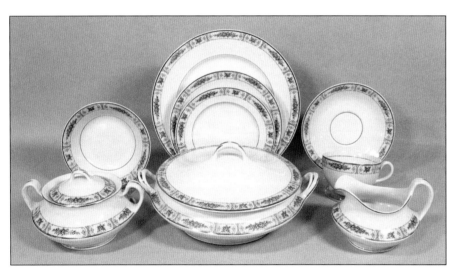

Empress Shape Clifton edge decal, MK 25, **Front** – 6" W sugar, $20-25; 11" round covered vegetable, $30-35; 3" H creamer, $10-15; **Back** – 5" bowl, $4-6; 6", 7", and 9" plates, $2-4, $4-6, and $5-8; cup & saucer, $8-12.

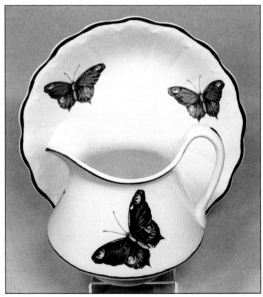

Fluted 10" Blue Butterfly bowl, MK 25, $25-35; 6" H Empress jug, MK 25, $45-65.

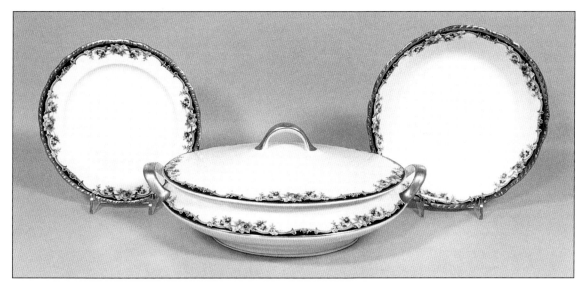

Empress Shape, Black Line Roses decal, 11" oval covered vegetable, MK 25,
$15-25; 7" Melrose plate, MK 31, $12-15; 7" Melrose Shape bowl, MK 31, $12-15.

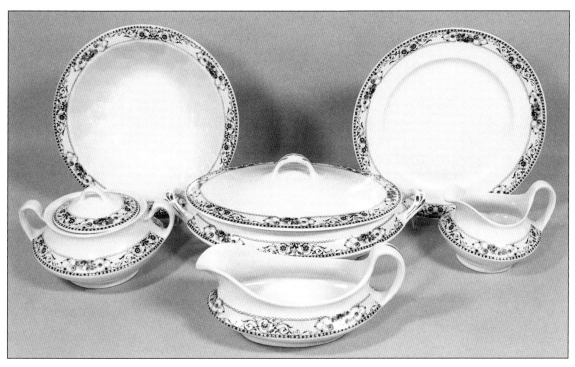

Empress Shape Yellow Band Roses, MK 25, 6" W sugar, $20-25; 9" Paneled bowl, $25-30;
11" L oval covered vegetable, $20-25; gravy, $12-15; 9" plate, $8-10; 3" H creamer, $10-15.

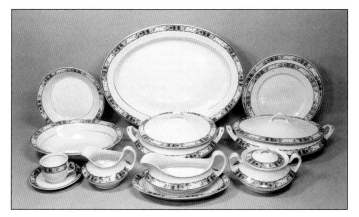

Empress Shape Blue Accent Rose Band decal, MK 25, **Back Row** – 7" bowl, $5-8;
16" platter, $12-15; 8" & 9" plates, $7-10 each; **Middle Row** – 9" oval bowl, $10-15;
10" round covered vegetable, $30-35; 11" oval covered vegetable, $30-35; **Front
Row** – cup & saucer, $10-15; 3" H creamer, $12-15; 9" oval under plate, $8-10;
gravy, $12-15; 6" W sugar, $20-25.

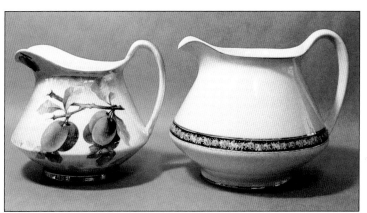

Empress Jugs, 6" H Plums, MK 25, $30-50; 7" H Black Banded Roses, no mark,
$25-40.

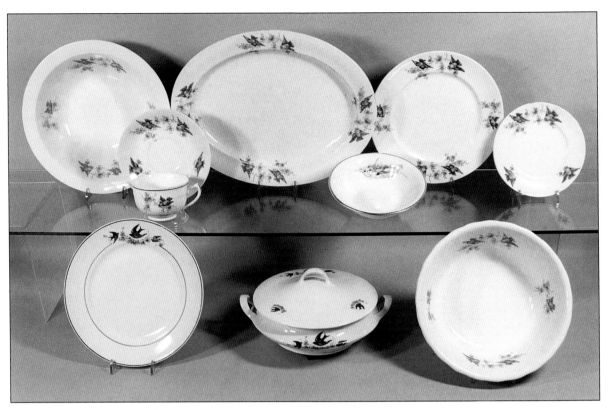

Various Shapes Bluebird & Barn Swallow dishes, MK 25, **Top** – 10" Bluebird Paneled bowl, $35-45; Bluebird cup & saucer, $15-20; 14" Bluebird platter, $30-40; 6" Barn Swallow bowl, $10-15; 9" Bluebird plate, $18-24; 6" Bluebird plate, $8-10; **Bottom** – 9" Barn Swallow plate, $15-18; 10" Barn Swallow Empress round covered vegetable, $45-55; 9" Bluebirds Paneled Ironstone bowl, $60-65 (Barn Swallows have forked tails).

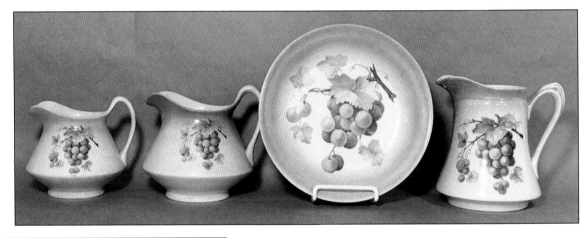

Empress 5" H Concord Grapes Jug, MK 25, $15-30; 6" H Concord Grapes jug, $15-35; 9" Concord Grapes bowl, $20-35; 7" H Paris Shape Concord Grapes jug, $35-60.

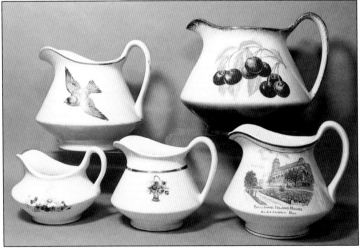

Empress Jugs, MK 25 unless noted, 6" H Yellow Bird, $50-75; 7" H Cherries, no mark, $40-60; 3" H Violets & White Daisies creamer, $10-15; 4" H Basket of Flowers, $15-30; 5" H Blue Line Transfer, $30-60.

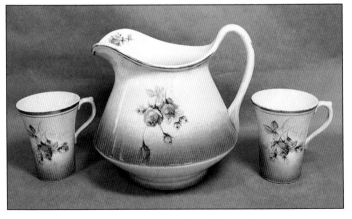

Empress Water Set, 7" H Pink Roses jug, MK 25, $30-45; 4" H tumblers, no mark, $8-15 each.

1926 – 1939

In 1926, the Harker Pottery Company introduced their Hotoven lines. They claimed this was the first decaled cooking, refrigerator, and bake ware produced in America. These decaled lines were very colorful, and were supposed to make the American housewife happy to use them. Harker's Orchard decal, featuring a continuous band of apples and pears, commonly known as Red Apple I, was one of the most popular decals. The Harker decal with a large apple and pear, commonly called Red Apple II by collectors, was advertised as "Colorful Fruit". Mixing bowls and bake ware came in multiple sizes and shapes. Ohio jugs came in five sizes. A 1/2 pint (syrup) and a 3 1/2 pint Ohio jug on a Virginia utility plate was marketed as a "Waffle Set". Bowls, resembling large custards in the GC (or Gem Clay) shape, came in three sizes, plus two custard sizes. Harvey Duke (author of several price guides to American dinnerware) believed this shape was brought to Harker by Kelvinator when the Gem Clay Forming Company could no longer fill Kelvinator orders. The shape has slightly rounded vertical parallel ridges running up the sides of bowls, baking dishes, custards, large coffee pots, and hi-rise jugs. Hotoven large coffee pots came in the GC shape, with the vertical lines mentioned, and were also offered with a fancy swirled surface embossing as well. Hotoven bump-handled teapots came in two sizes. Glass lids for round refrigerator bowls, made by Federal Glass, came in four sizes, and were marked "Harker Kitchenware" in raised letters.

In 1931, the Edwin M. Knowles building, located in Chester, West Virginia, became available. The Harker Pottery Company was at a crossroads, needing to remodel and expand. Ohio River flooding was still a major problem. The Harker Pottery buildings, adjacent to the railroad tracks and the unpredictable Ohio River, were hemmed in by steep hills, precluding the much-needed expansion. The decision was made to acquire the Edwin M. Knowles Pottery on the high plateau across the river. This eliminated the threat of flooding, and met the need for expansion. Sales brochures still said East Liverpool, but eventually, company stationery carried both the East Liverpool and Chester addresses.

The advantageous move to the West Virginia facility spawned new shapes, new marks, and new decals. The Oriental Poppy decal was introduced in 1931 as "American Beauty". The lovely Melrose shape, with its distinctly shaped hollowware and roped edge, was introduced in 1931, with a plethora of new de-

cals. Harker's Bungalow Ware was also marketed in 1931 by the George H. Bowman Company out of Cleveland. Harvey Duke believed the unique Nouvelle shape was acquired from the American China Corporation when it went bankrupt during the Depression. Nouvelle was only made for a brief period, beginning in 1932.

In 1933, the Silhouette and Countryside decals were introduced. In 1934, Harker patented (Pat. No. 91347) the "decorated ice-water porcelain rolling pin". The first decal used on the rolling pins was the Harker Pastel Tulip. We know of around 140 different Harker rolling pins. We own Harker rolling pins bearing Hall, Crooksville, and TS&T decals, among others. We do not know if Harker applied decals for these companies, or sold them blanks. Harker also offered miniature children's rolling pins, often with a small pie baker in a boxed set. Harker never marked their full sized pins and only one miniature (as noted). Currently, China Specialties offers rolling pins with a "Hotoven" mark, but these are certainly not genuine Harker rolling pins.

Charles R. Boyce, who had guided Harker Pottery Company in so many wise, and growth-oriented decisions for forty years, passed away in 1934, leaving three highly qualified men to fill his shoes. His eldest son, Robert E. Boyce, with an engineering degree, became the company's ceramic engineer in 1927. His second son, David G. Boyce, with a law degree, started as a Harker salesman in 1923. Both would eventually become company presidents. Completing this talented leadership trio was John M. Pinney, a childhood neighbor of the Boyce boys who joined the company in 1928. John began as a regular employee, but soon became a foreman, and supervised nearly every department of the Pottery at one time or another before Harker's demise.

In 1935, Harker Pottery created a sales subsidiary, called Columbia Chinaware. It had its own marks with the Statue of Liberty. Harker Autumn Leaf items (when marked) usually bear these Columbia marks. Jewelweed and Calico Ribbon are often marked Columbia. Robert Boyce told Jo Cunningham (author of several books on Homer Laughlin, and American dinnerware) that small towns favored the Columbia pottery, not realizing it was manufactured by Harker. This subsidiary lasted for about twenty years.

Another Harker marketing line, being produced during this same time period, was Sun-Glow Bakerite. The Sun-Glow Bakerite shape had petal shaped plates and bowls, square-handled jugs, segmented

lids on hollowware, and squat round teapots, so this was both a mark and a shape. Sun-Glow Bakerite (hereinafter called Sun-Glow) marks can be found on several decal decorated pieces, including Pastel Tulip, Mallow, Jewelweed, and Jessica, among others. Sun-Glow shape pieces can also be found with at least two other Harker marks. Another of these Harker lines was the rare Oven Ware.

The lovely embossed edge Hostess shape was also introduced in 1935. This seems to be the first of the several embossed edge shapes produced by Harker. In 1936, Harker introduced the Rosemere and Embassy shapes. Rosemere not only has the wide embossed flat roses edge, but carries this theme on the handles of creams, sugars, gravies, and cups. Embassy, on the other hand, is smooth and elegant, with scrolled handles, round pointed finials on lids, and a new short spout on the teapot.

The year 1936 brought at least two more embossed shapes, the names of which we have yet to identify. The following decals were also introduced in 1936: Whistling Teapots (also advertised as Whistling Teakettles, & Tea for Two), Floral Festival, Doily (orange, black, and green), Gingham (Calico) Tulip, Doll's House (commonly known as Honeymoon Cottage), and Checkered Stands on the Windsor shape. Windsor was a round shape with flat perpendicular handles, and rectangular finials on teapots, sugars, and casseroles.

In 1937, Harker began applying pleasing decal borders on ivory edges, often with white plate centers. This was the new vogue, in not only domestic ware, but also foreign ware.

Another new shape, introduced in 1938, was Newport, an informal round shape. Plates, dishes, and bowls have at least three ridges on their circular edges. Creamers, sugars, and cups have circular handles supported from below by a short arm. Lids are round with a ridged ball knob. Platters also bear the ridges with tabbed handles outside the ridges. Tarrytown (decal) was produced on the Newport shape, but must have been an exclusive for a buyer as it has its own backstamp, (see MK102).

The same decal is quite often found on many different Harker shapes. As most collectors concentrate on decals, we have grouped most of our photographs to feature the decal. Harker sometimes advertised different names for the same decal. Unfortunately, many true decal names have been lost. We have used the common name most Harker collectors call the decal, and where known, we have referenced the name Harker used in trade publications or advertisements. Where possible, we have used a photograph to feature a specific shape, but with the mix of decals & shapes, this approach was often impossible to maintain. Photo captions include the shape names, when known. We realize some of our photos also

violate the date sequence of shape manufacture and regret any confusion this may cause, but keeping the decals together seemed the best course for the reasons stated.

Hotoven Plaque, 7" x 7", MK 148, $400-500. Note color reversal on side pots, differing from backstamps on ware.

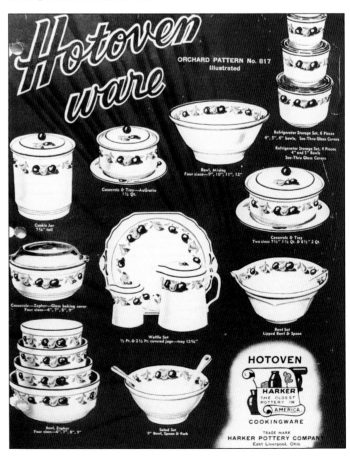

Red Apple I (advertised as "Orchard Pattern"), Hotoven sales brochure page, *Courtesy Cynthia Boyce Sheehan.*

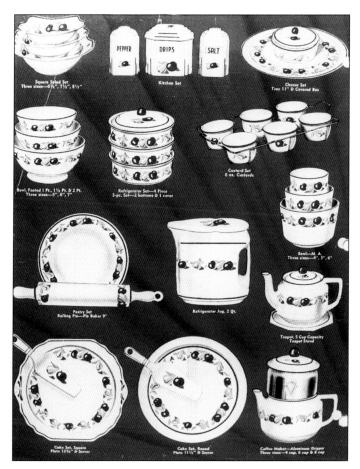

Red Apple I, Hotoven sales brochure page, *Courtesy Cynthia Boyce Sheehan.*

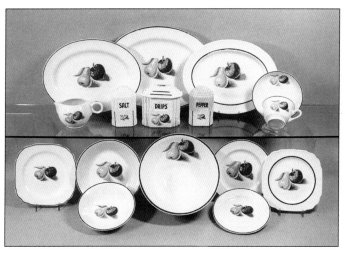

Red Apple II, Hotoven, MKs 37 & 55, **Top** – 12" platter, $20-25; 5" Newport creamer, $15-20; 14" platter, $24-30; Skyscraper Range Set, $40-50; 12" Modern Age platter, $24-30; cup & saucer, $15-20; **Bottom** – 7" square plate, $8-12; 6" & 7" bowls, $8-12 & $10-15; 9" mixing bowl, $20-25; 6" & 7" plates, $6-8 & $8-12; 7" square plate, $8-12.

Red Apple II (advertised as "Colorful Fruit"), Hotoven, MKs 37, 43A, 46, 47, 55, & 84A, **Top Back Row** – 10" plate, $10-15; Square Body Jug, $50-60; Round Body Jug, $45-60; Virginia utility plate, $20-25; **Top Front Row** – "D-Ware" Range Set, $60-70; 3" H sugar (no lid), $12-18; 3" H creamer, $20-25; custard, $8-10; 9" L teapot, $40-50; custard, $8-10; **Bottom Back Row** – 8" & 9" plates, $10-12 & $10-15; Trivet, $40-60; 12" Modern Age mixing bowl, $40-60; 3 bowl set, 3", 4", & 5", $30-40; 8" & 10" plates, $8-12 & $15-20; **Bottom Front Row** – Jumbo cup (small decal) & saucer, $20-30; 10" pie baker, $25-35; lifter, $15-20; fork, $12-18; (2) spoons, $12-18 each; Jumbo cup (large decal) & saucer, $20-30.

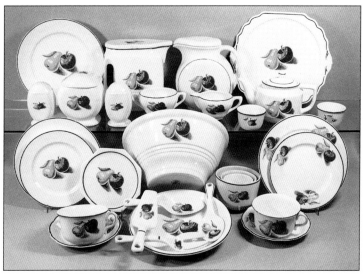

Red Apple I (a.k.a. "Orchard"), Hotoven, MKs 37, 43A, 46, 47, & 84A, **Top** – 10" pie baker, $24-30; Jumbo Cup & Saucer, $20-25; 8" H cookie jar, $50-75; Zephyr 3 bowl set, 6", 7", & 8", $50-75; 9" L Zephyr Lid coffeepot, $60-90; cheese dish (no lid), $10-15; Virginia utility plate, $20-25; 8" L Zephyr Lid teapot, $35-45; **Bottom Back Row** – 9" pie baker, $20-25; 9" Zephyr casserole, $35-45; 9" ball top casserole, $30-45; 9" mixing bowl, $20-30; 8" tabbed Melrose bowl, $20-25; **Bottom Front Row** – 8" W Zephyr casserole, $30-40; 3 bowl set, 3", 4", and 5", $40-50; 2 bowl stack dish set, $25-30; 7" W casserole, $30-40; 7" W casserole, $30-40.

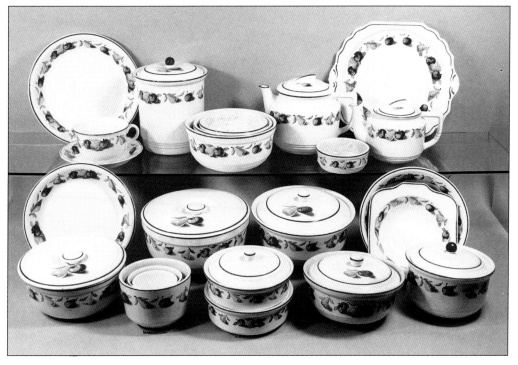

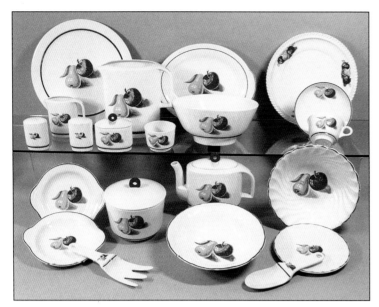

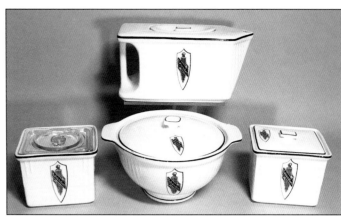

Kelvinator Refrigerator GC Shape Utility Ware, MKs 43 & 45, 10" L jug, no mark, $30-40; 5" W covered dish with glass lid, $12-18; 9" W covered bowl, $25-35; 5" W covered dish, $12-18.

Red Apple II, Modern Age shape except as noted, MKs 37, 55, & 84A, **Top** – salt & pepper, $25-30; 4" H creamer (no lid), $15-20; 11" cake plate, $20-30; 4" sugar, $20-25; 7" H jug (no lid), $40-50; 2" H bowl, $10-15; 12" Newport platter, $30-40; 9" bowl, $20-25; 10" Gadroon plate, $20-30; cup & saucer, $15-20; **Bottom** – 8" large decal lugged plate, $15-25; 8" small decal lugged plate, $15-24; fork, $20-25; 6" W bowl, $40-60; 9" embossed bowl, $30-40; 8" L teapot, $40-60; spoon, $20-25; 9" Shell bowl, $25-30; 7" Shell plate, $8-15.

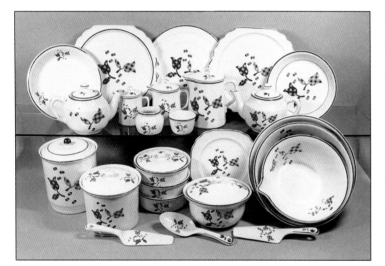

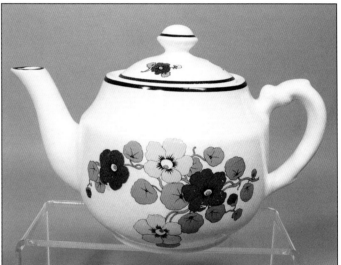

Nasturtiums I, Hotoven 9" L Bump Handled teapot, MK 45, $60-75.

Calico Tulip (advertised as Gingham Tulip), MKs 46 & 84, **Top Back Row** – 9" pie baker, $10-15; Virginia utility plate, $12-20; Concentric Rings Cheese/Cake plate, $15-20; Virginia utility plate, $12-20; 8" pie baker, $12-18; **Top Front Row** – 9" L Bump Handle teapot, $40-50; 4" H paneled Ohio Jug creamer, $15-25; bean pot, $5-8; 5" H paneled Ohio Jug, $35-45; custard, $5-7; 7" H paneled Ohio Jug, $40-50; 9" L Bump Handle teapot, $40-50; **Bottom** – 8" H cookie jar, $35-45; 6" H canister, $30-40; 3 Stack Dish Set, $25-35; lifter, $15-20; spoon, $15-20; 7" Vent Lid casserole, $30-40; 8" square under plate, $8-12; lifter, $15-20; 9" spout mixing bowl, $25-35; 11" mixing bowl, $25-30; 12" mixing bowl, $30-40.

Calico Tulip, MKs 44, 46, 84, & 90, **Top** – set of 4 egg coddlers in wire holder, $40-50; 11" Nouvelle platter, $10-15; 4" & 5" W GC bowls, $12-18 each; Trivet, $25-35; 6" W Zephyr casserole, $20-30; Hi-rise Jug, $60-75; 6" Zephyr Lid casserole, $25-35; 6" Modern Age jug (no lid), $10-15; 5" H Modern Age creamer, $10-15; 13" Nouvelle platter, $15-20; Skyscraper Range Set, $40-50; **Bottom** – 9" L Zephyr Lid coffeepot, $50-75; 9" L GC coffeepot, $50-75; 9" W GC refrigerator bowl, $30-40; 6" & 8" bowls, $8-10 & $12-15; 7" H Modern Age cookie jar, $20-30; 8" W Zephyr Vent Lid casserole, $20-25; Zephyr 4 bowl set 6", 7", 7.5", & 8.5", $35-45; 6" W refrigerator dish with "Harker Kitchenware" embossed glass lid, $20-25.

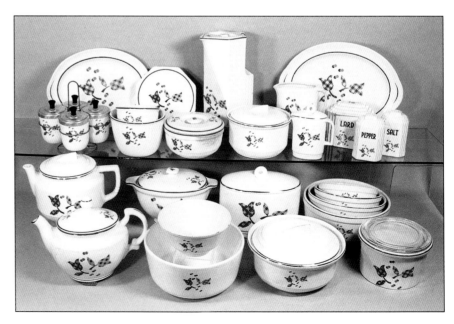

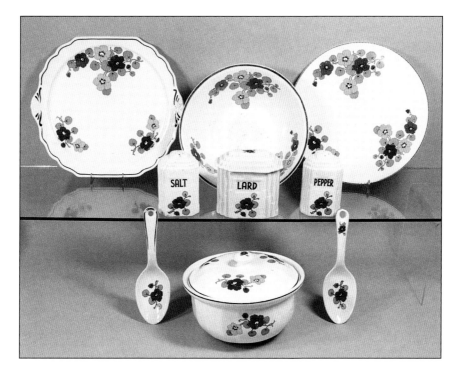

Nasturtiums I, no mark, **Top** – Virginia utility plate, $18-24; 10" GC square bottom mixing bowl, $18-24; 11" cake plate, $18-24; Skyscraper Range Set, $40-50; **Bottom** – spoon, silver trim, $15-20; 8" W paneled Vent Lid casserole, $35-45; spoon, $15-20.

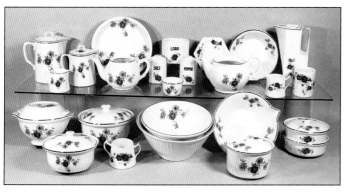

Nasturtiums II, MK 31 but most unmarked, **Top** – 8" H paneled Ohio Jug, $35-45; Gem creamer, $5-8; 6" H paneled Ohio Jug, $20-25; 10" pie baker, $12-18; 9" L Bump Handle teapot (no lid), $25-30; Skyscraper Range Set, $30-35; GC custard, $4-6; 5" ashtray, yellow glaze, $10-15; 10" L GC coffeepot (no lid), $24-30; 8" bowl, $10-15; Gem creamer, yellow glaze, $12-18; Hi-rise Jug, $60-75; 4" H paneled Melrose Jelly Jar (no lid), $30-40; **Bottom** – 9" W GC refrigerator bowl, lid doubles as under plate, $25-35; 7" W covered casserole, $18-24; 8" W covered casserole, $20-25; Gem sugar, $12-18; 10" & 11" G.C. mixing bowls, $12-18 & $20-25; 10" spout mixing bowl, $18-24; 4" H Canister, $25-30; 2 paneled Stack Dish Set, $15-20.

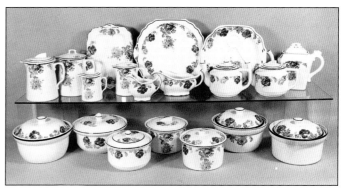

Oriental Poppy, MKs 31, 45, 46, 47, 84, & 90, **Top** – 7" H Ohio Jug with Zephyr Lid, $35-45; 7" H paneled Ohio Jug, $35-45; 5" H Ohio Jug with Zephyr Lid, $25-35; 10" Virginia platter, $12-18; 5" H paneled Ohio Jug, $25-35; 5" W Melrose creamer, $18-24; Virginia utility plate, $25-30; Melrose gravy, $18-24; 10" Melrose Cup Ring Plate, $15-20; 8" L teapot, $40-50; 8" L Zephyr Lid teapot, $40-50; Gargoyle Teapot, $65-75; **Bottom** – 8" W Vent Lid casserole, $25-35; 8" W ball top casserole, $35-45; 6" W ball top casserole, $20-25; 6" W paneled Zephyr Lid casserole, $25-35; 6" W casserole, $20-30; 8" W casserole, $25-35; 8" W casserole, $20-25.

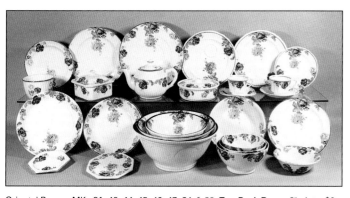

Oriental Poppy, MKs 31, 42, 44, 45, 46, 47, 84, & 90, **Top Back Row** – 8" plate, $6-10; 10" plate, $8-12; Concentric Rings cheese plate, $25-30; 9" Melrose Cup Ring Plate, $10-12; 9" Melrose plate, $6-10; 7" Melrose plate, $4-6; **Top Front Row** – 3" H GC bowl, $12-18; 5" square covered dish, $20-25; 9" L Bump Handle teapot, $45-60; stack dish, $15-20; Melrose cup & square saucer, $10-15; Melrose cup & saucer, $10-15; **Bottom** – 10" pie baker, $15-20; 5" hexagon ashtray, $12-18; 9" pie baker, $15-20; Trivet, $25-30; 8", 11", & 12" Arches mixing bowls, $18-24, $20-25, & $25-30; 9" bowl, $12-18; 3 Footed Bowl set, 6", 6.25", & 7", $60-75; 9" plate, $5-10; 6" bowl, $18-24.

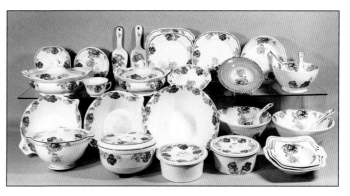

Oriental Poppy, MKs 31, 44, 45, 46, & 90, **Top Back Row** – 6" Melrose square plate, $3-5; 6" Melrose plate, $3-5; lifter, $15-20; lifter, $15-20; 8" & 9" Melrose square plates, $5-10 each; 8" Melrose square plate, $5-10; 8" bowl, $8-12; **Top Front Row** – 11" L Melrose covered vegetable, $35-45; Melrose cup, $5-8; 9" Melrose square covered vegetable, $35-45; 7" Melrose tabbed plate, $4-6; 7" Gadroon plate, $5-8; 7" Footed Bowl, $18-24; blue flower fork "PATPDG", $15-20; spoon, $12-18; **Bottom Back Row** – 10" Arches tab & spout mixing bowl, $35-45; 10" Arches spout mixing bowl, $25-35; 11" Arches mixing bowl, $35-45; 9" Arches mixing bowl, $25-35; lifter, $15-20; 9" GC mixing bowl, $30-40; spoon, $15-20; **Bottom Front Row** – 9" W GC refrigerator bowl, $25-35; 8" W Zephyr covered bowl, $30-35; 7" W covered dish, $15-20; 7" covered dish, $20-25; Melrose 3 bowl set, 6", 7", & 8", $30-45.

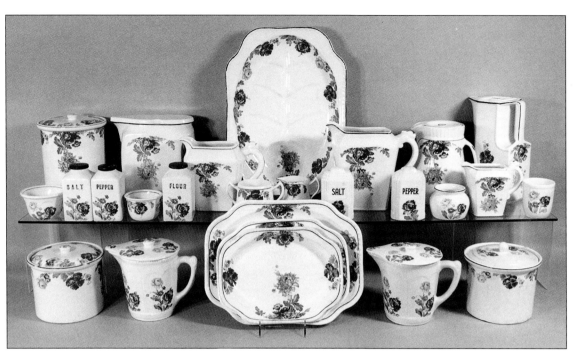

Oriental Poppy, MKs 42, 45, 46, 47, & 84, **Top Back Row** – 8" H cookie jar, $40-50; Square Body Jug, $40-50; 6" H Gargoyle Jug, $25-35; 16" Melrose platter with gravy tree & well, $100-125; 8" H Gargoyle Jug, $40-50; Bulbous Jug, $40-50; Hi-rise Jug, $60-75; **Top Front Row** – flared Arches custard, $8-10; Crimp-top salt, pepper, & flour, $120-140 set; custard, $6-10; Gem sugar, $20-25; Gem creamer, $15-20; Skyscraper salt & pepper, $20-25; bean pot, $6-10; 4" H Gargoyle Jug creamer, $25-35; GC custard, $5-8; **Bottom** – 5" H Canister, $30-45; 6" H batter jug with red flowers on lid & spout, $35-45; 10", 11", & 13" Melrose platters, $15-20, $20-25, & $25-30; 6" H batter jug with yellow flowers on lid & spout, $35-45; 6" H paneled Canister, $45-60.

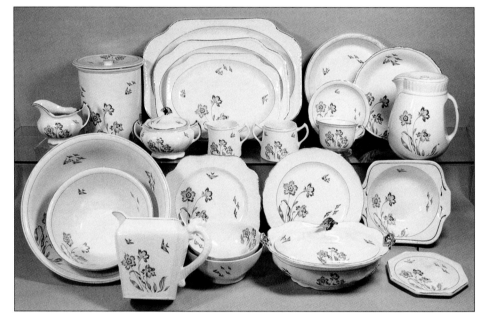

Birds & Flowers, Melrose shape unless noted, MKs 31 & 45, **Top** – 4" H Melrose creamer, $12-18; 8" H cookie jar, $40-60; 6" W sugar, $18-24; 11", 13", & 15" platters, $20-30, $35-45, & $40-50; Gem creamer, $25-35; Gem sugar, $25-35; 10" pie baker, $20-30; cup & saucer, $20-30; 9" bowl, $15-25; Bulbous Jug, $40-50; **Bottom** – 12" mixing bowl, $35-45; 8" mixing bowl, $25-35; 6" H Gargoyle Jug, $25-35; 8" square plate, $12-18; 6" & 6.5" Footed Bowls, $15-20 each; 9" plate, $15-18; 11" L covered vegetable, $35-45; 8" tabbed bowl, $15-20; Trivet, $25-35.

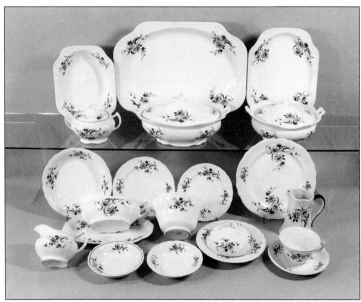

Jacobean, Melrose Shape, & MK 31 unless noted, **Top** – 9" L oval bowl, $8-12; 6" W sugar, $10-15; 15" platter, $60-90; 12" W covered vegetable, $20-30; 11" platter, $25-40; 9" square covered vegetable, $18-24; **Bottom Back Row** – 7" bowl, $4-6; 7" plate, $2-4; 6" plate, $2-3; 9" plate, $4-6; **Bottom Front Row** – 4" H creamer, $5-8; 9" under plate, $4-6; gravy, $8-12; 5" Red Lines bowl, $2-4; 5" bowl, $2-4; 6" bowl, $7-10; 7" covered butter with liner, $12-18; cup & saucer, $5-8; 5" H fluted Harker Jug creamer, MK 25, $15-20.

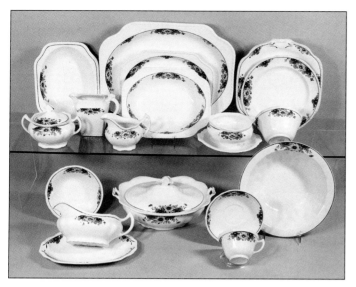

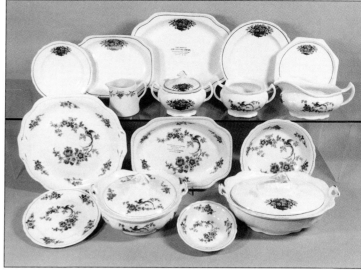

Asters, Melrose Shape, & MK 31 unless noted, **Top** – 6" W Sugar, $10-15; 9" Red Line bowl, $12-15; 5" H Gargoyle Jug creamer, $20-25; 4" H creamer, $6-10; 11" & 15" platters, $12-18 & $25-35; 10" L bowl, $8-12; 7" L attached under plate gravy, $18-24; 10" tabbed plate, $10-15; 9" plate, $8-12; 5" bowl, $8-12; **Bottom** – 6" bowl, $6-10; 9" L under plate, $6-10; gravy, $6-10; 11" L covered vegetable, $25-35; cup & saucer, $8-12; 10" paneled bowl, MK 25, $20-30.

Melrose Shape, Pink & Blue Flower Urn, Bird of Paradise, & Doves & Roses, MK 31, **Top Back Row** – 6" Pink & Blue Flower Urn plate, $2-4; 8" platter, $6-8; 11" platter, $18-24; 8" plate, $8-12; Trivet, $30-40; **Top Front Row** – Doves & Roses Gem creamer, $15-20; 6" W Pink & Blue Flower Urn sugar, $18-24; 6" W Bird of Paradise sugar (no lid), $8-12; gravy, $8-12; **Bottom Back Row** – 10" tabbed Bird of Paradise plate, $12-18; 10" platter, $12-18; 7" bowl, $6-10; **Bottom Front Row** – Bird of Paradise 7" plate, $4-8; 9" square covered vegetable, $20-30; 5" bowl, $3-5; 11" L Pink & Blue Flower Urn covered vegetable, $25-35.

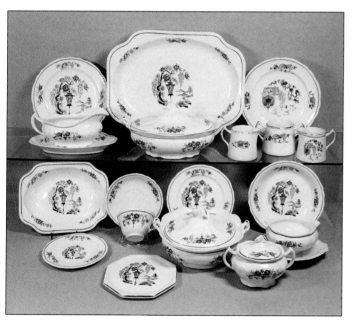

Melrose Shape, Japanese Lantern (yellow) & Japanese Garden (orange), & Tori Gate, MK 31, **Top Back Row** – 9" Japanese Lantern plate, $5-8; 15" platter, $30-40; 9" Japanese Garden plate, $10-15; **Top Front Row** – 9" Japanese Lantern under plate, $5-8; Gravy, $8-12; 11" L Covered Vegetable, $25-35; Tori Gate Gem creamer, $8-12; Tori Gate Gem sugar, $10-15; Japanese Garden Gem creamer, $8-12; **Bottom Back Row** – all Japanese Lantern, 9" L bowl, $8-12; cup & saucer, $8-12; 7" plate, $5-8; 7" bowl, $5-10; **Bottom Front Row** – all Japanese Lantern – 6" plate, $4-6; Trivet, $20-30; 9" square covered vegetable, $25-35; 6" W sugar, $15-20; 7" W attached under plate gravy, $12-18.

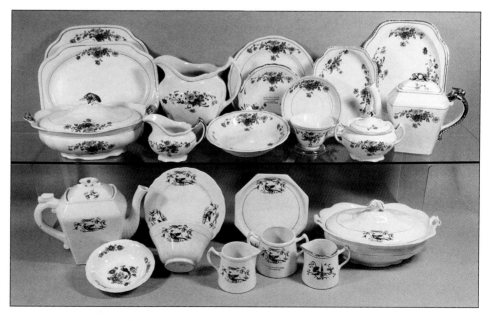

Melrose Shape unless noted, Lillian, Oriental Pheasant, Bird of Paradise, & Phoenix, MK 31, **Top Back Row** – 10" Lillian square plate, $4-8; 11" L platter, $15-20; Melrose jug, $35-45; 9" Plate, $5-8; 7" tabbed plate, $8-12; 8" L platter, $18-24; 11" L platter, $18-24; **Top Front Row** – Lillian 11" L covered vegetable, $20-30; 4" H creamer, $8-12; 8" bowl, $12-18; cup & saucer, $5-10; 6" W sugar, $12-18; Gargoyle Teapot, $50-60; **Bottom** – Oriental Pheasant Gargoyle Teapot, $60-75; 5" Bird of Paradise bowl, $6-10; 7" Oriental Pheasant plate, $5-8; 5" Oriental Pheasant bowl, $12-18; Oriental Pheasant Gem creamer, $12-15; Oriental Pheasant Trivet, $30-35; Oriental Pheasant Gem sugar, $12-15; Phoenix Gem creamer, $15-18; 11" L Oriental Pheasant covered vegetable, $25-35.

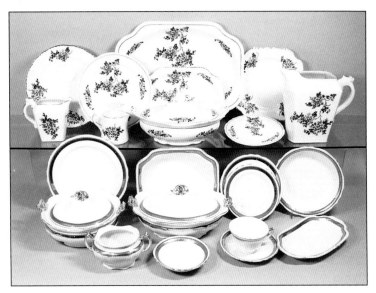

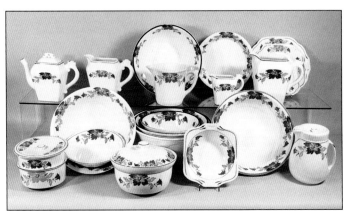

Melrose Shape, Pear Blossoms, Green & Gold Bands, MK 31, **Top** – Pear Blossoms, 5" Gargoyle Jug creamer, $50-70; 9" Cup Ring Plate, $8-12; 9" plate, $6-8; Gem creamer, $10-15; 15" platter, $50-75; 10" platter, $15-20; 11" L covered vegetable, $35-45; 9" square plate, $18-25; 7" plate, $10-15; 7" H Gargoyle Jug, $85-100; **Bottom** – Green & Gold Bands 9" square covered vegetable, $25-35; 9" plate, $5-8; 6" W sugar (no lid), $6-8; 9" bowl, $12-18; 11" L covered vegetable, $35-45; 5" bowl, $3-5; 6" & 7" plates, $6-8 & $8-10; cup & saucer, $8-12; 8" bowl, $6-8; 9" under plate, $5-8.

Lisa (Blue), Melrose & Mixed Shapes, MKs 31 & 45, **Top** – Gargoyle Teapot, $50-60; 6" H Gargoyle Jug, $25-35; 11" Arches mixing bowl (note burgundy side flowers), $30-40; 5" H batter jug, $35-45; 10" pie baker, $25-35; 4" H Gargoyle Jug Creamer, $20-30; 9" & 11" tabbed plates, $8-12 & $15-20; 8" H Gargoyle Jug, $35-45; **Bottom** – 2 stack dish set (note 2 sizes of flowers), $18-24; 12" Arches mixing bowl, $35-45; 9" bowl, $12-18; 8" Vent Lid casserole, $40-50; 3 Arches mixing bowls set, 8", 11", & 12", $80-100; 8" tabbed bowl, $15-20; 12" Arches mixing bowl, green trim, $40-50; Bulbous Jug, $70-80.

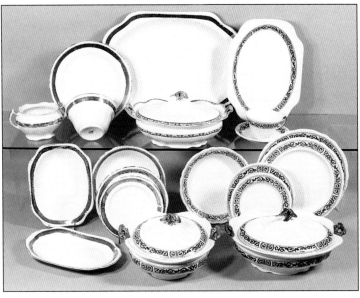

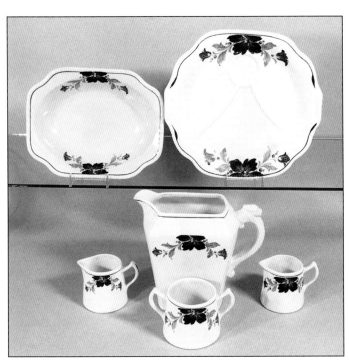

Melrose Shape, Provincial Gold Band, Provincial Band, & Royal Provincial, MK 31, **Top** – 6" W Provincial Gold Band sugar (no lid), $12-15; 9" plate, $5-10; 5" bowl, $4-6; 15" platter, $25-30; 11" L Royal Provincial covered vegetable, $30-40; 11" Provincial Band platter, $8-12; cup & saucer, $8-12; **Bottom** – 9" L Provincial Gold Band under plate, $4-6; 8" L bowl, $6-10; 7" bowl, $5-8; 6" & 7" plates, $3-5 each; 9" square Provincial Band covered vegetable, $25-35; 8" bowl, $8-12; 11" L covered vegetable, $25-35; 6" & 7" plates, $3-5 each; 9" & 10" plates, $5-10 each.

Lisa (Blue), Melrose & Gargoyle, yellow glaze, MK 31, 9" bowl, $15-20; 10" tabbed Cup Ring Plate, $10-15; Gem creamer, small flower, $10-15; 7" H Gargoyle Jug, $50-60; Gem sugar, $10-15; Gem creamer, large flower, $10-15.

Lisa (Red), Melrose & Mixed Shapes, MKs 31 & 45, **Top** – 8" H Gargoyle Jug, $50-60; Melrose jug, $35-45; 10" tabbed Cup Ring Plate, $18-24; 6" Footed Bowl, $20-25; 6" H Gargoyle Jug, $30-40; 10" tabbed plate, $12-18; 6" & 9" square plates, $8-12 each; 4" H Gargoyle Jug Creamer, $50-60; Bulbous Jug, $40-50; 8" H cookie jar, $50-60; **Bottom** – 9" bowl, $20-25; 8" Vent Lid casserole, $35-45; 9" & 11" Arches mixing bowls, $20-25 & $25-35; 8" tabbed bowl, $15-20.

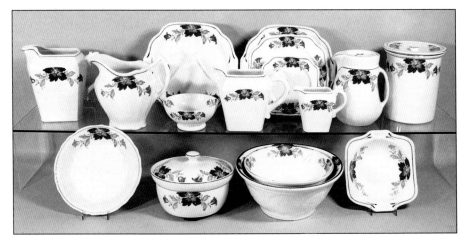

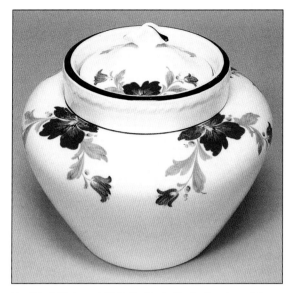

Lisa (Blue), Melrose, MK 31, Cookie Jar/Florist Vase (note lid), $40-60.

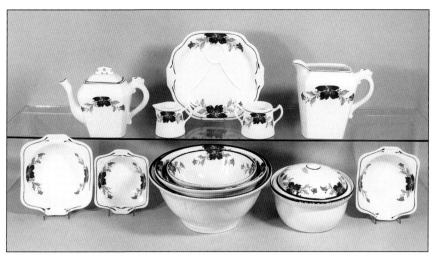

Lisa (Burgundy), Melrose & Mixed Shapes, MK 31, **Top** – Gargoyle Teapot, $125-150; Gem creamer, $25-30; 10" tabbed Cup Ring Plate, $20-25; Gem sugar, $25-30; 8" H Gargoyle Jug, $60-75; **Bottom** – 8" tabbed bowl, $20-25; 6" tabbed bowl, $15-20; 3 Arches mixing bowl set, 9", 11", & 12", $85-110; 8" Vent Lid casserole, $30-40; 7" tabbed bowl, $18-24.

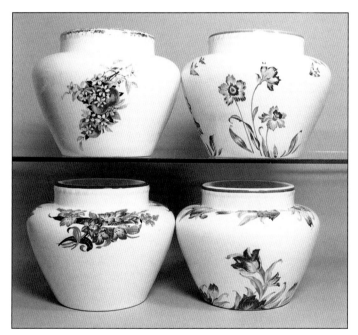

Melrose Shape Florist Vases, mixed decals, MKs 31 & 46, Orange Blossom, $60-75; Birds & Flowers, $70-90; Blue & Red Flowers, $50-70; Ruffled (Shaggy) Tulip, $90-130.

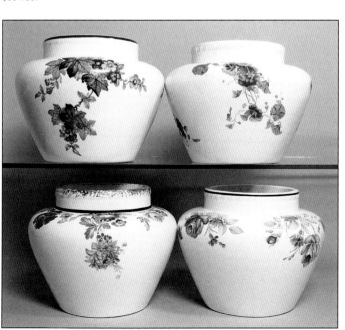

Melrose Shape Florist Vases, mixed decals, MK 31, **Top** – Oriental Flowers yellow glaze, $40-60; burgundy Lisa yellow glaze, $50-70; pink & deep red roses, $50-60; **Bottom** – Blue Lisa yellow glaze, $50-70; burgundy Lisa with black stripe, $50-70; burgundy Lisa, $50-70.

Melrose Shape Florist Vases, mixed decals, MKs 31 & 46, Autumn Ivy, $50-70; Blue Morning Glories & Orange Flowers yellow glaze, $40-60; Oriental Poppy, $40-60; Anti-Q, $50-70.

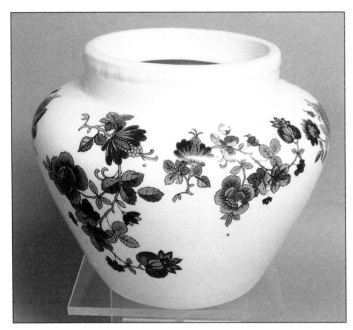

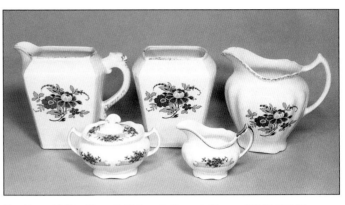

Blue Mums I & Blue Mums II, Melrose & Gargoyle Shapes, MK 31, 7" H Blue Mums I Gargoyle Jug, $35-45; 6" W Blue Mums II Melrose sugar, $20-25; 7" H Blue Mums I Gargoyle Vase, $25-35; 5" W Blue Mums II Melrose creamer, $12-15; Blue Mums I Melrose jug, $25 35.

Melrose Shape Florist Vase, no mark, Stylized blue & orange flowers, $90-120.

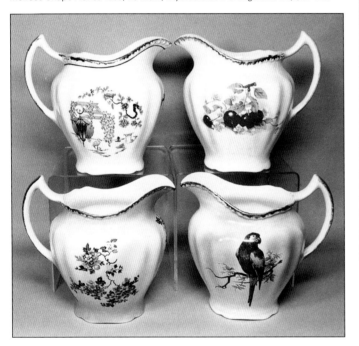

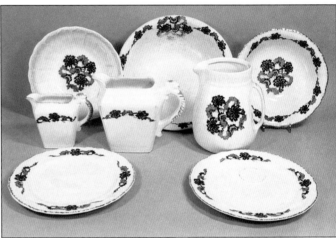

Brim, Melrose & Gargoyle Shapes, MK 31, **Back Row** – 9" fluted bowl, yellow blush, $15-20; 11" Arches mixing bowl, $20-30; 9" Melrose bowl, $15-20; **Center Row** – 5" H Gargoyle Jug creamer, $10-15; 6" H Gargoyle Jug, $15-25; Bulbous Jug (no lid), $20-30; **Front Row** – 9" Melrose plate, $12-15; 9" Cup Ring Plate, $12-15.

Melrose Shape Jugs, mixed decals, MK 31, $40-60 each, Japanese Garden; Cherries; Pears & Blossoms; & Red Parrot.

Melrose Shape Jugs, mixed decals, MKs 31 & 90, **Top** – Red & Purple Tulip, $30-60; Lillian, $30-60; **Bottom** – Red & Yellow Poppies, $30-60; & Autumn Ivy, $45-80.

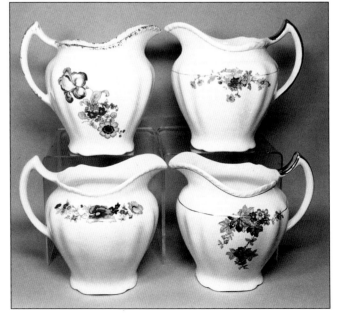

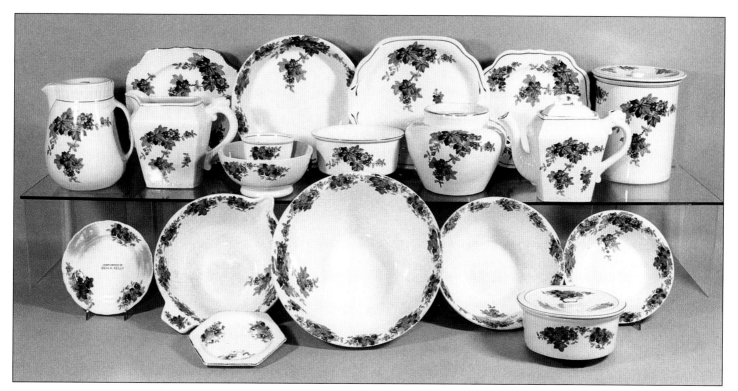

Autumn Ivy, Melrose & Gargoyle Shapes, MKs 31 & 45, **Top** – Bulbous Jug, $50-60; 9" square plate, $10-12; 6" H Gargoyle Jug, $20-30; 6" Footed Bowl, $15-20; custard, $4-6; 10" pie baker, $18-25; 3" H dish (no lid), $8-12; 10" tabbed plate, $20-25; Florist Vase, $40-50; 9" square plate, $10-15; Gargoyle Teapot, $50-60; 7" H cookie jar, $35-45; **Bottom** – 6" brown blush plate, $4-8; 10" Arches tab & spout mixing bowl, $35-45; 5" ashtray, $12-18; 11" Arches mixing bowl, $25-35; 8" Arches mixing bowl, $20-30; 7" W covered dish, $18-24; 7" bowl, $20-25.

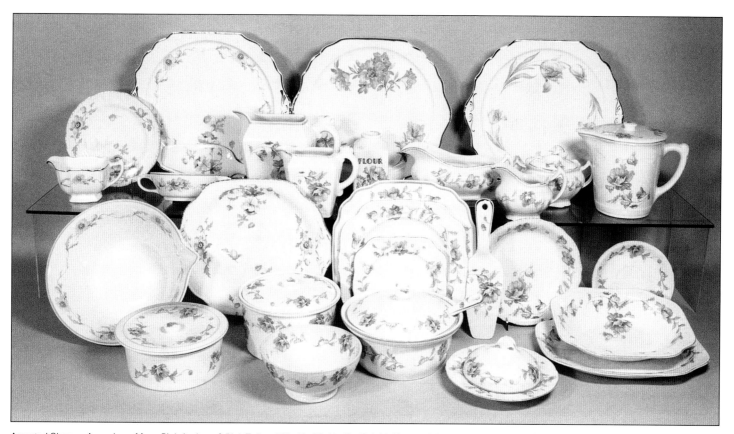

Assorted Shapes, Anna Jane, Mary, Pink Azaleas, & Pink Tulips, MKs 31, 35, 44, 45, 46, & 90, **Top** – 5" L Mary Virginia creamer, $10-12; 7" Plate, $7-10; Virginia utility plate, $18-24; lifter, $15-20; 7" Nouvelle Cream Soup, $15-20; 6" H Anna Jane Gargoyle Jug, $40-45; 5" H Gargoyle Jug, $30-35; Pink Azaleas Virginia utility plate, $18-24; Anna Jane Crimp Top flour shaker (lid missing), $40-50; Anna Jane Melrose gravy, $18-24; 9" under plate, $5-8; Pink Tulips Virginia utility plate, $18-24; 5" L Melrose Anna Jane creamer, $12-15; 6" W Melrose sugar, $18-24; 6" Arches batter jug, $35-45; **Bottom** – 10" Mary spout mixing bowl, $35-45; 7" W Anna Jane covered dish, $20-25; 10" Mary tabbed Melrose plate, $10-12; 4" H Anna Jane covered dish, $35-40; 6" W Footed Bowl, $12-15; 3 PC square plate set, 7", 9", & 10", $25-35; 8" paneled Notch Lid casserole & spoon, $45-60 set; 7" W Melrose Covered Butter with liner, $35-40; lifter, $15-20; 7" Melrose bowl, $5-8; 11" Melrose platter, $8-10; 9" Melrose bowl, $10-12; saucer, $2-3.

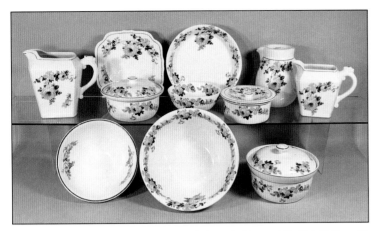

Yellow Roses & Black Leaves, Melrose & Gargoyle Shapes, MKs 31 & 45, **Top** – 8" H Gargoyle Jug, $45-60; 9" Melrose square plate, $20-25; 7" W Vent Lid casserole, $25-35, 10" pie baker, $18-24, 6" Footed Bowl, $12-18; 3" H covered dish, $18-24; Bulbous Jug, $45-60; 6" H Gargoyle Jug, $40-50; **Bottom** – 9" mixing bowl, $15-20; 11" Arches mixing bowl, $30-40; 8" Vent Lid casserole, $35-45.

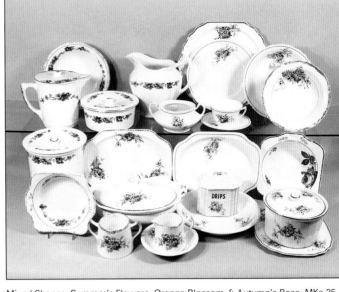

Mixed Shapes, Summer's Flowers, Orange Blossom, & Autumn's Rose, MKs 25, 31, & 90, **Top** – 6" Summer's Flowers batter jug, $25-35; 8" Melrose bowl, $8-12; 3" H covered dish, $18-24; Melrose jug, $30-40; 6" W Orange Blossoms Empress sugar (no lid), $10-15; Virginia utility plate, $20-25; 9" plate, $8-12; Melrose cup & saucer, $10-15; 9" Melrose bowl, $8-12; 8" bowl, $7-10; **Bottom Back Row** – 8" H Summer's Flowers cookie jar, $35-45; 10" Melrose Orange Blossoms platter, $20-25; 10" Melrose platter, $15-20; 8" Autumn's Rose tabbed bowl, $30-40; **Bottom Front Row** – 7" Summer's Flowers tabbed bowl, $18-24; 11" L Orange Blossom Melrose covered vegetable, $40-60; Gem sugar, $25-35; Gem creamer, $20-30; 5" bowl, $8-12; 9" pie baker, $20-25; Skyscraper Drips jar, $25-30; 8" Melrose square plate, $12-18; 6" paneled covered dish, $25-35.

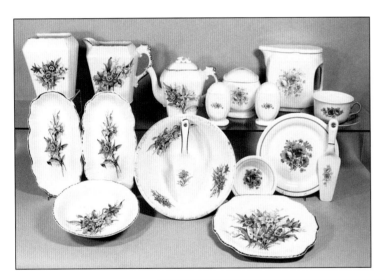

Daffodils & Colored Poppies, Assorted Shapes, MKs 31 & 84A, **Top** – 7" H Daffodils Gargoyle Vase, $35-45; 8" H Gargoyle Jug, $35-45; Gargoyle Teapot, $45-60; Green Poppies D-Ware Range Set, $45-60; Square Body Jug, $40-50; Blue Poppies Jumbo Cup & Saucer, $20-25; **Bottom** – Melrose Daffodils Celery Tray, $25-35; Celery Tray, $25-35; 9" Melrose bowl, $20-25; 11" mixing bowl, $20-30; lifter, $15-20; 10" tabbed Melrose plate, $18-24; Newport Pink Poppies 5" bowl & 9" plate, $5-8 & $8-12; Green Poppies lifter, $15-20.

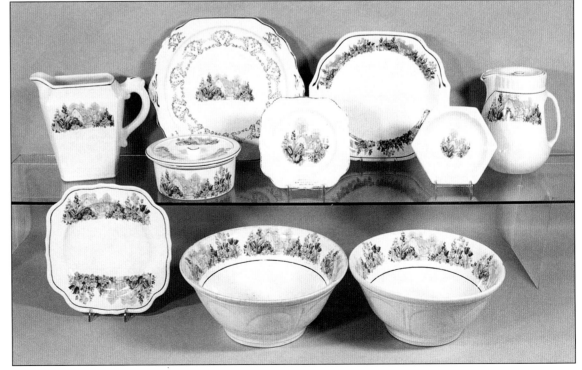

Hollyhock Cottage, Mixed Shapes, MK 31 & 45, **Top** – 7" H Gargoyle Jug, $30-40; 3" H covered dish, $25-30; Virginia utility plate, $18-24; 6" Melrose square plate, $15-20; 11" Melrose tabbed plate, $30-40; 5" ashtray, $20-25; Bulbous Jug, $45-60; **Bottom** – 9" Melrose square plate, $20-25; 11" Arches mixing bowl, $30-40; 10" Arches mixing bowl, $25-35.

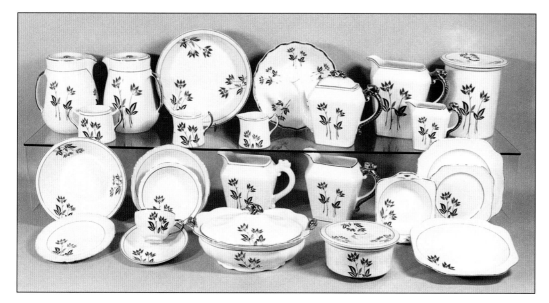

Papyrus, Melrose, Gargoyle, & Nouvelle Shapes, MKs 31 & 45, **Top** – Bulbous Jug (Small Decal), $35-45; Gem Sugar, $12-18; Bulbous Jug (Large Decal), $35-45; 10" Pie Baker, $15-20; Gem Creamer (Large Decal), $10-15; Gem Creamer (Small Decal), $10-15; 9" Bowl, $15-20; Gargoyle Teapot, $90-110; 7" H Gargoyle Jug, $40-50; 4" H Gargoyle Jug Creamer, $30-40; 7" H Cookie Jar, $90-110; **Bottom Back Row** – 8" bowl, $18-24; 6" & 7" Melrose bowls, $8-10 & $12-18; Two 6" H Gargoyle Jugs, $35-45 each; 6" Melrose tabbed bowl, $8-12; 6" & 9" Melrose square plates, $4-6 & $8-12; **Bottom Front Row** – 7" Melrose plate, $4-6; Nouvelle cup & saucer, $15-20; 11" L Melrose covered vegetable, $25-35; 3" H covered dish, $12-18; 9" L Melrose bowl, $25-35.

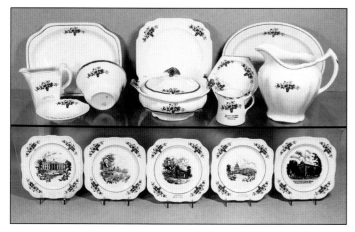

Blue Flower Basket, Assorted Shapes, MKs 25 & 31, **Top Back Row** – 11" Melrose platter, $12-18; 9" plate, $4-6; 12" oval platter, $8-12; **Top Front Row** – 5" Gargoyle Jug creamer, $18-24; 5" square bowl, $4-6; 3" H Melrose bowl, $18-24; 9" square covered vegetable, $25-35; 5" ashtray, $12-18; Gem creamer, $12-18; Melrose jug, $30-40; **Bottom** – 6" Melrose square plates, $18-25 each, "White House, Washington, D.C."; "Mount Vernon"; "Lincoln"; "U.S. Capitol"; "Ripley County Court House".

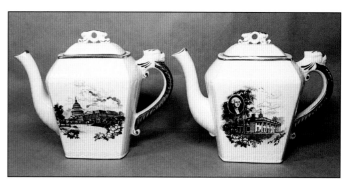

Gargoyle Teapots, MK 31, "U.S. Capitol, Washington, D.C." and Washington, "Mount Vernon", $50-75 each.

Gargoyle Teapots, MK 31, $60-65 each, 7" H Joan & Large Blue Urn.

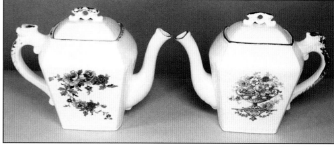

Gargoyle Teapot, MK 31, "White House, Washington, D.C.", $50-75.

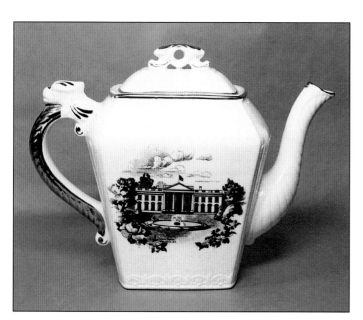

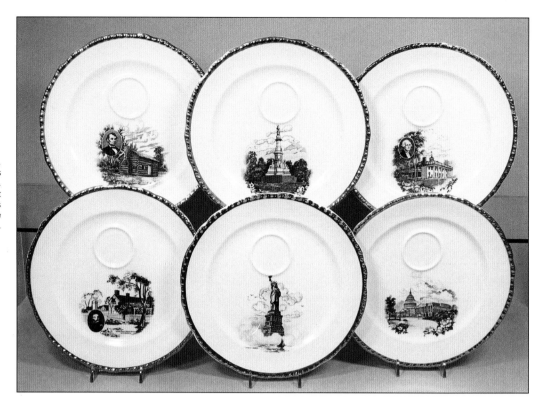

Melrose 9" Cup Ring Plates, MK 31, $8-15 each, **Top** – "Lincoln's Birthplace"; "Soldier's Monument, Gettysburg"; Washington "Mount Vernon"; **Bottom** – "General Meade's Headquarters, Gettysburg"; "Statue Of Liberty"; "U.S. Capitol".

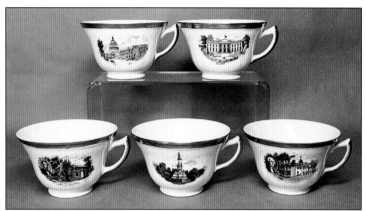

Melrose Cups, No MK, $10-15 each, **Top** – "U.S. Capitol"; "White House"; **Bottom** – "Lincoln's Birthplace"; "Soldier's Monument, Gettysburg"; Washington, "Mount Vernon".

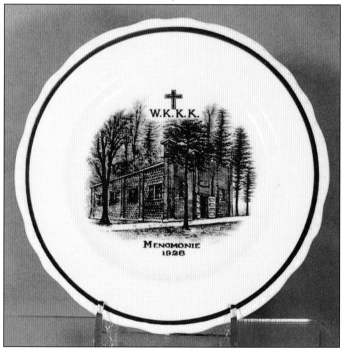

Wisconsin Ku Klux Klan (KKK) 6" Melrose Plate, MK 31, $45-90.

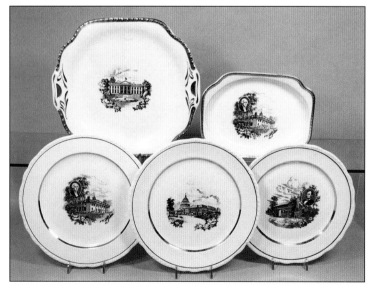

Melrose Plates & Platter, MK 31, **Top** – 10" tabbed "White House" plate, $10-15; 8" Washington "Mount Vernon" platter, $12-18; **Bottom** – 9" plates, $15-25 each, Washington "Mount Vernon"; "U.S. Capitol"; "Lincoln's Birthplace".

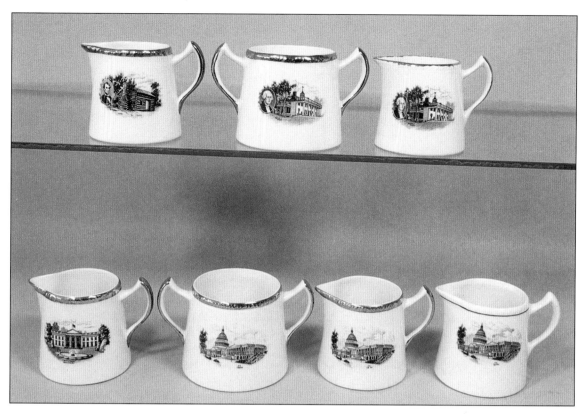

Melrose Gem Creamers & Sugars, MK 31, $15-25 each, **Top** – "Lincoln's Birthplace" creamer; Washington "Mount Vernon" sugar; Washington "Mount Vernon" creamer; **Bottom** – "White House" creamer; "U.S. Capitol" sugar; creamer; creamer (blue trim).

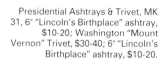

Presidential Ashtrays & Trivet, MK 31, 6" "Lincoln's Birthplace" ashtray, $10-20; Washington "Mount Vernon" Trivet, $30-40; 6" "Lincoln's Birthplace" ashtray, $10-20.

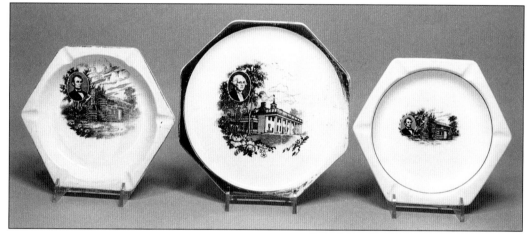

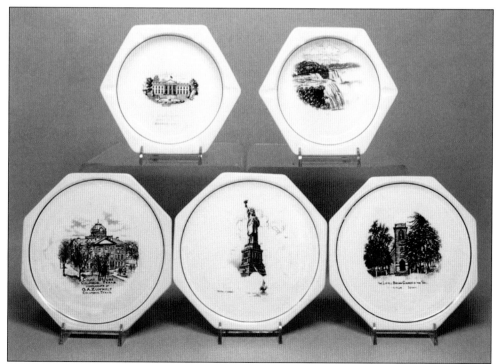

Souvenir Ashtrays & Trivets, **Top** – 6" ashtrays, MKs 31 & 36, $10-20 each, "White House"; "Niagara Falls"; **Bottom** – Trivets, "Court House, Columbus, Texas", $20-30; "Statue of Liberty", $30-45; "The Little Brown Church In The Vale, Nashua, Iowa", $20-30.

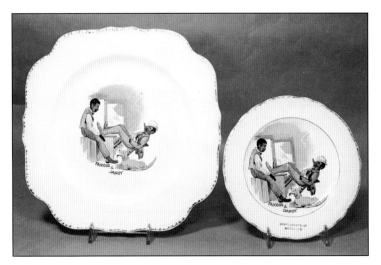

Black Memorabilia, Melrose Plates, MK 31, 9" "Famous & Dandy" square plate, $25-35; 6" "Famous & Dandy" plate, $35-45.

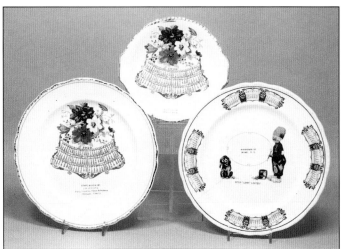

Melrose Calendar Plates, MK 31, 9" 1929 Red, White, & Blue Flowers, $20-30; 7" 1929, $30-45; 9" 1930 Dutch Boy & Dog, $30-45.

Melrose Shape, MK 31, **Top** – Morning Glories Gem yellow glaze creamer, $12-20; Morning Glories Gem yellow glaze creamer, $12-20; **Bottom** – 5" Daisies & Violets paneled Jelly Jar, $20-40; 5" H Morning Glories paneled yellow glaze Jelly Jar (no lid), $20-45; 5" H Shadow Rose paneled Jelly Jar, $25-40.

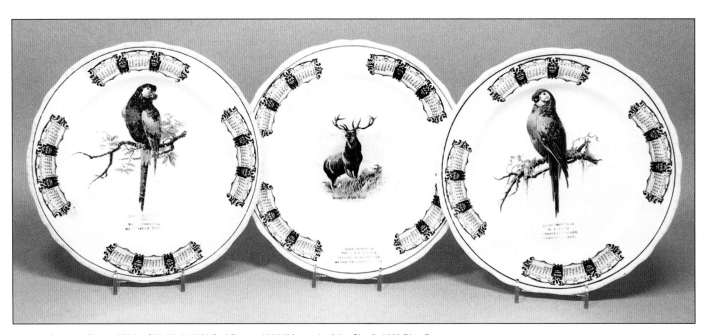

Melrose Calendar Plates, MK 31, $30-50, 9" 1930 Red Parrot; 1930 "Monarch of the Glen"; 1930 Blue Parrot.

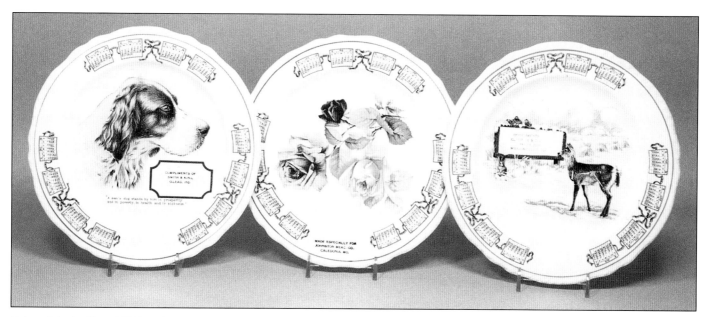

Melrose Calendar Plates, MK 31, 9", $30-50 each: 1928 Spaniel; 1928 Pink & Yellow Roses; 1928 Deer Reading Billboard.

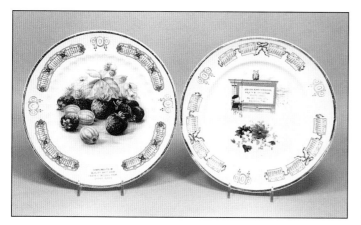

Calendar Plates, 9", $40-55 each, 1929 thumbprint Strawberries, MK 36; 1929 Boy & Owl At Billboard, MK 25.

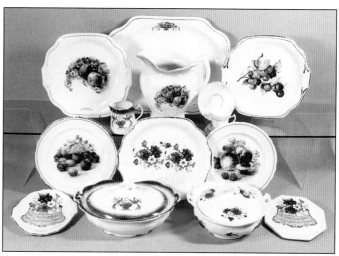

Melrose Store Give Away Items, MK 31, **Top** – 10" Mixed Fruit tabbed plate, $12-15; 15" Morning Glory Urn platter, $30-40; Birds of Paradise Gem creamer, $10-15; Mixed Fruit jug, $40-50; 2" H Gold Lines demitasse cup & 5" saucer, $18-25; 10" tabbed Plum plate, $10-15; **Bottom Back Row** – 9" Strawberries plate, $8-12; 10" Red, White, & Blue Flowers tabbed plate, $10-15; 9" Peaches & Blackberries plate, $15-20; **Bottom Front Row** – 7" tabbed Red, White, & Blue Flowers 1929 Calendar Plate, $25-35; 11" L Birds of Paradise covered vegetable, $35-45; 9" square Red, White, & Blue Flowers covered vegetable, $40-50; Red, White, & Blue Calendar Trivet, $35-45.

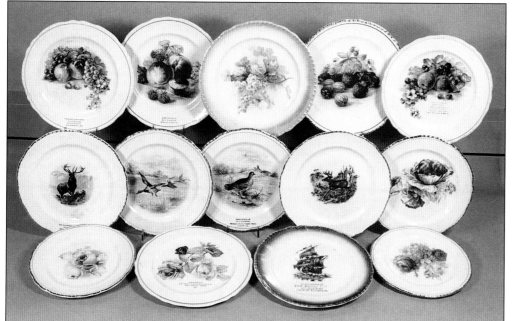

Melrose Store Give Away Plates, MK 31, 8" - 9", $10-25 each.

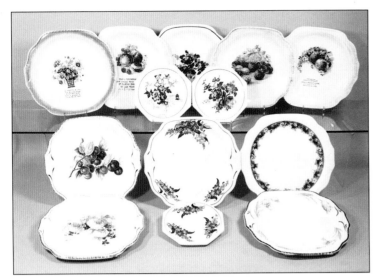

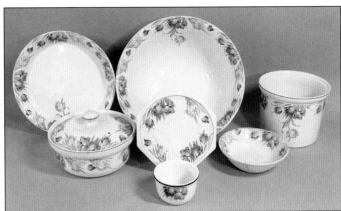

Bungalow Ware, Bungalow Pastel Tulip, MK 40, **Back Row** – 10" pie baker, $15-20; 12" Arches mixing bowl, $40-50; 5" H Canister (no lid), $15-20; **Front** – 7" W Vent Lid casserole, $25-35; Trivet, $35-50; custard, no mark, $4-6; 6" bowl, $8-12.

Melrose Store Give Away Items, MKs 31 & 36, 10" tabbed plates, $15-30 each & Trivets, $20-35 each.

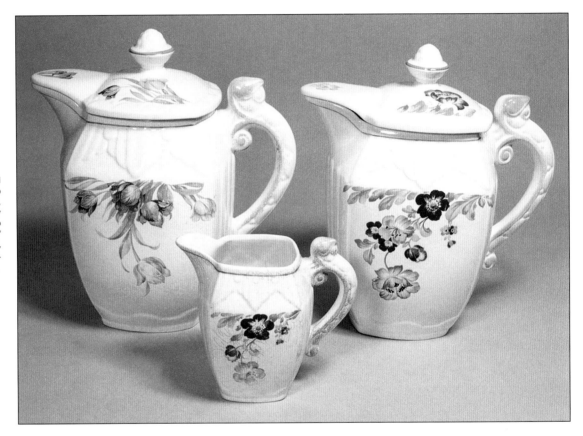

Bungalow Ware, 9" H Bungalow Pastel Tulip covered jug, MK 40, $60-70; 5" H Country Garden creamer (no lid), MK 39, $30-45; 9" H covered jug MK 40, $60-70.

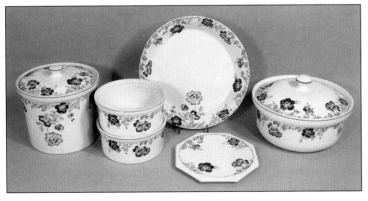

Bungalow Ware, Country Garden, MK 40, 6" H Canister, $30-45; 2 stack dish set, $10-12 each; 9" pie baker, $20-25; Trivet, $35-50; 8" W Vent Lid casserole, $35-45.

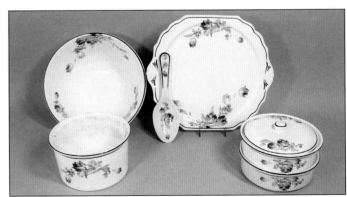

Oven Ware, Vivid Tulips, MK 32, **Back Row** – 10" mixing bowl, $15-20; spoon, $15-20; Virginia utility plate, $15-20; **Front Row** – 4" H dish (no lid), $10-15; 2 stack dish set, $20-25.

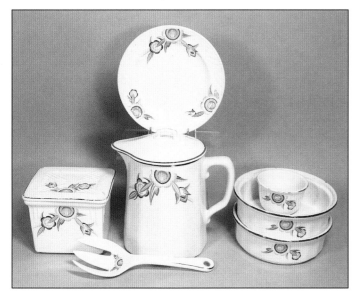

Dundee Ware Deco Posies, MK 41, 7" plate, $4-6; 5" W GC refrigerator covered bowl, $15-20; fork, $15-20; 7" paneled Ohio Jug, $25-35; 2 stack dish set (no lid), $10-15; GC custard, $4-6.

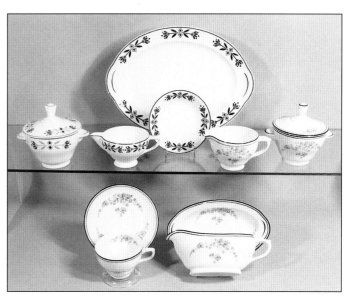

Nouvelle & Windsor Shapes, MK 90, **Top** – 5" H Pastel Deco Flowers sugar, $15-20; 5" W Windsor Shape creamer Red Deco Flowers decal, $10-15; 13" Nouvelle Red Deco Flowers platter, $15-18; 5" bowl, $7-10; 5" W Nouvelle Springtime Spray creamer, $15; 5" H Nouvelle Springtime Spray sugar, $15-20; **Bottom** – Nouvelle Springtime Spray cup & saucer, $15-18; gravy, $15-18; 8" L under plate, $6-8.

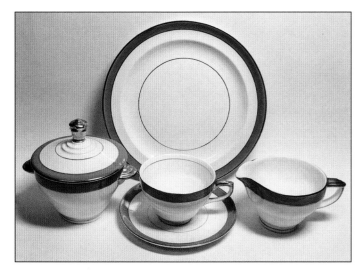

Nouvelle Shape, green & gold trim, MK 90, 5" H sugar; cup & saucer; 9" plate; 6" W creamer, *Courtesy East Liverpool Historical Society*.

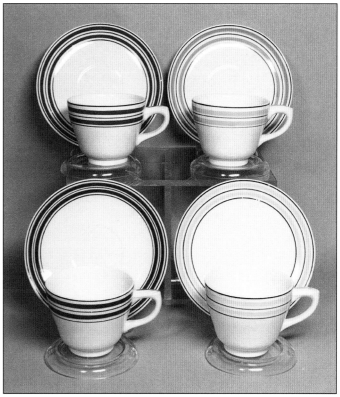

Nouvelle Demitasse Cups & Saucers, MK 84A, $20-30 each.

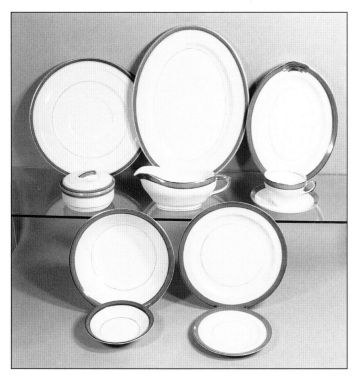

Nouvelle green & gold trim, MK 31B & 90, **Top** – 11" Concentric Rings cheese plate, $18-24; Zephyr Lid Cheese Dish, $18-25; gravy, $10-15; 14" platter, $15-20; 11" platter, $12-15; cup & saucer, $12-15; **Bottom** – 8" bowl, $12-15; 5" bowl, $4-6; 9" plate, $8-10; 6" plate, $4-6.

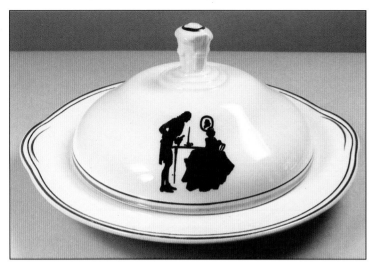

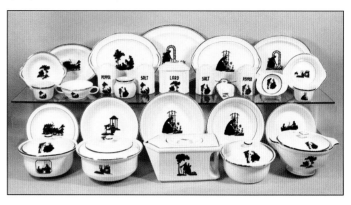

Nouvelle, Silhouette 8" W covered butter, MK 90A, $35-40.

Silhouette, Assorted Shapes, MKs 31, 31A, 37, 43, 45, 84, 90, & 90A, **Top Back Row** – Nouvelle, 7" bowl, $4-6; 9" (Stagecoach) oval bowl, $15-20; 11" platter, $15-20; 13" platter, $18-24; 11" platter, $15-20; 11" platter, $15-20; 7" bowl, $4-6; **Top Front Row** – custard, $8-12; 7" Nouvelle Cream Soup, $10-15; Skyscraper salt & pepper, $20-25; Bean Pot, $15-20; Skyscraper Range Set, $35-50; 6" Scoop, $50-60; 5" W ashtray, $12-18; GC custard, $8-12; **Bottom Back Row** – 7" bowl, $15-20; 8" bowl, $25-30; 9" bowl, $25-30; 8" bowl, $25-30; 7" bowl, $15-20; **Bottom Front Row** – 7" W Vent Lid casserole, $30-40; 9" W casserole, $35-45; 9" L GC Refrigerator Jug, $50-60; 7" Notch Lid casserole, $30-40; 9" W GC Refrigerator Notch Lid bowl, $35-45.

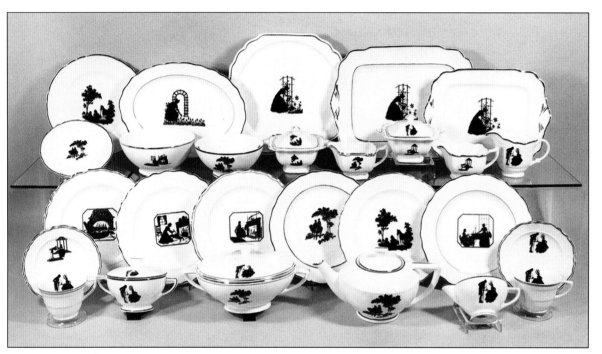

Silhouette, Assorted Shapes, MKs 44, 45, 55, 84, 90, & 90A, **Top Back Row** – 9" Hostess plate, $10-15; 15" Embossed Edge platter, $15-20; Virginia utility plate, $18-24; 14" Virginia platter, $18-24; 11" platter, $18-24; **Top Front Row** – 6" Hostess plate, $3-5; 6" footed bowl, $18-24; 5" footed bowl, $10-15; 6" W Virginia sugar, $18-24; 5" W Virginia creamer, $10-15; 6" W sugar, $18-24; 5" W creamer, $10-15; 4" H Hostess creamer, $18-24; **Bottom Back Row** – 6 Embossed Edge 9" plates, $10-15 each; **Bottom Front Row** – Embossed Edge cup & saucer, $10-15; 6" W Windsor sugar, $15-18; 10" W Windsor covered vegetable, $25-35; 9" L Windsor teapot, $45-60; 6" W Windsor creamer, $10-15; Embossed Edge cup & saucer, $10-15.

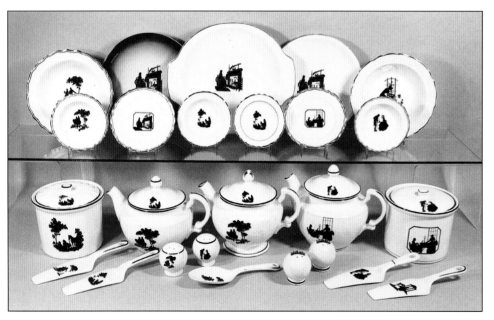

Silhouette, Assorted Shapes, MKs 43, 45, 90, 90A, & 98, **Top Back Row** – 9" Embossed Edge bowl, $20-25; 10" gray blush Aladdin platter, $8-12; 13" lugged platter, $20-25; 10" plate, $6-10; 9" Embossed Edge bowl, $20-25; **Top Front Row** – Embossed Edge, 5" bowl, $8-12; 6" plate, $6-10; 5" bowl, $8-12; 5" ashtray, $6-10; 6" plate, $6-10; 5" Bowl, $8-12; **Bottom Back Row** – 6" H paneled Canister, $35-45; 7" H GC coffeepot, $75-95; 8" H Scrolled coffeepot, $75-90; 8" H GC coffeepot, $75-90; 6" H Canister, $40-50; **Bottom Front Row** – lifters, spoon, ball salt & pepper set, $15-20 each.

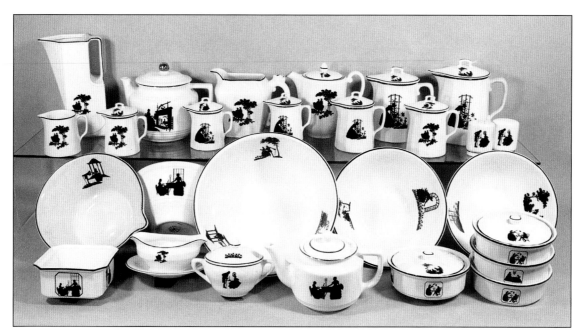

Silhouette, Assorted Shapes, MKs 37, 43, 45, 46, 55, 84, 84A, 90, & 90A, **Top** – 3" H creamer, $18-24; Hi-rise Jug, $45-60; 4" H paneled Ohio Jug creamer, $30-40; 7" H coffeepot, $60-75; 4" H paneled Ohio Jug creamer, $30-40; 6" H Gargoyle Jug, $60-75; 4" H paneled Ohio Jug creamer, $30-40; 7" H Embassy coffeepot, $35-45; 5" H paneled Ohio Jug, $35-45; 7" H paneled Ohio Jug, $40-50; 5" H paneled Ohio Jug, $35-45; 8" H paneled Ohio Jug, $50-60; Modern Age salt & pepper, $8-12; **Bottom** – 10" spout mixing bowl, $30-40; 5" square bowl (no lid), $18-24; 9" mixing bowl, $25-35; 7" L gravy with fused under plate, $20-30; 12" mixing bowl, $40-50; 6" W sugar, $15-20; 9" L teapot, $35-45; 10" mixing bowl, $30-40; stack dish, $18-24; 10" mixing bowl, $30-40; 3 Stack Dish Set, $35-45.

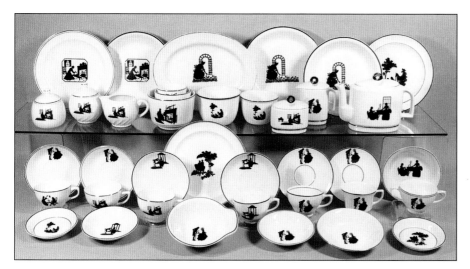

Silhouette, Assorted Shapes, MKs 37, 43, 45, 47, 55, 84, 90, 90A, 98, & 165, **Top Back Row** – 9" plate, $4-8; 9" pie baker, $18-24; 12" platter, $12-18; 10" pie baker, $20-30; 9" pie baker, $18-24; 9" plate, $4-8; **Top Front Row** – 4" H sugar, $10-15; 4" H Shell sugar & cream, $18-24 each; 3 bowl set 3", 4", & 5" W, $25-35; 5" bowl, $12-15; 4" GC bowl, $8-12; 4" W Modern Age sugar, $30-35; 5" H creamer, $30-35; 8" L teapot, $60-75; **Bottom Back Row** – Nouvelle cup & saucer, $12-15; cup & saucer, $12-15; Nouvelle cup & saucer, $12-15; 9" plate, $5-10; two Nouvelle cups & saucers, $12-15 each; Melrose cup & saucer, $12-15; 2.5" H Nouvelle Cream Soup, $20-24; 6" bowl, $5-8; **Bottom Front Row** – 5" bowl, $5-8; 5" bowl, $8-12; 6" tab handle Aladdin bowl, $8-12; 5" bowl, $8-12; 6" bowl, $5-8; 5" bowl, $5-8.

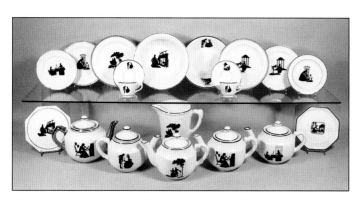

Silhouette, Assorted Shapes, MKs 37, 43, 44, 45, 55, 84A, & 90, **Top** – 6" plate, $4-6; 7" plate, $4-6; 8" plate, $4-6; Nouvelle demitasse cup & saucer, $10-15; 9" bowl, $15-20; 8" bowl, $18-24; Nouvelle demitasse cup & saucer, $10-15; 8" plate, $4-6; 7.5" plate, $4-6; 7" plate, $4-6; **Bottom** – Trivet, $25-35; 9.5" L Bump Handle Teapot (silver), $60-75; four 9" L H Bump Handle Teapots, $50-60 each; 5" H Batter Jug (no lid), $30-35; Trivet, $25-35.

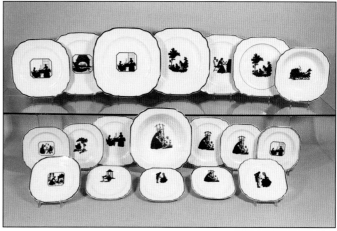

Silhouette, Virginia Shape plates, bowls, $5-15 each; saucers, $4-8 each.

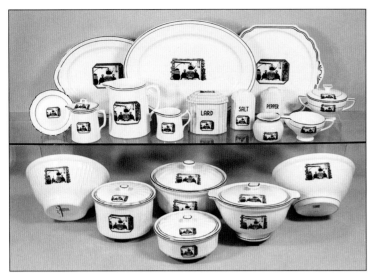

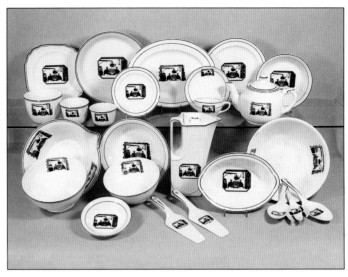

Fire In The Fireplace, Assorted Shapes, MKs 45, 84, & 90, **Top Back Row** – 13" Nouvelle platter, $35-45; 15" platter, $35-45; Virginia utility plate, $25-30; **Top Front Row** – 5" Embossed edge ashtray, $15-20; 4" H paneled Ohio Jug creamer, $35-45; 5" H paneled Ohio Jug (no lid), $40-45; Gem creamer, $20-25; Skyscraper Range Set, $50-60; Bean Pot, $8-12; 6" W Windsor cream & sugar, $25-30 each; **Bottom** – 9" GC mixing bowl, $40-50; 4" H paneled covered dish, $35-45; 8" W paneled Vent Lid casserole, $35-45; 3" H paneled dish, $20-25; 9" W GC refrigerator bowl, $50-60; 9" mixing bowl, $35-45.

Fire In The Fireplace, Assorted Shapes, MKs 45, 46, 84, & 90, **Top Back Row** – 8" Virginia plate, $15-20; 10" pie baker, $25-30; 12" platter, $30-40; 9" plate, $15-20; 7" bowl, $20-25; **Top Front Row** – 4" GC bowl, $20-25; 2 custards, $8-12 each; 6" plate, $8-12; Nouvelle cup & saucer, $15-20; Bump Handle Teapot, $60-75; **Bottom** – 10" spout mixing bowl, $35-45; 7" Footed Bowl, $30-35; 5" bowl, $8-12; 9" bowl, $30-40; 6" Footed Bowl, $25-35; 2 lifters, $25-30 each; Hi-rise Jug, $80-100; 9" Nouvelle oval bowl, $30-40; 10" mixing bowl, $30-40; spoon, $20-25; fork, $35-40; spoon, $20-25.

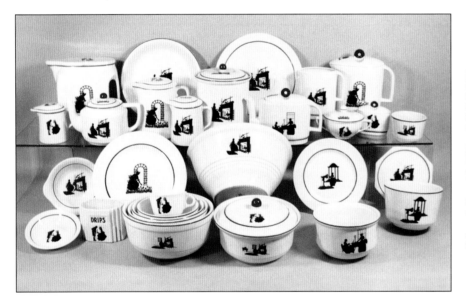

Red Line Silhouette, Assorted Shapes, MKs 47, 55, & 84A, **Top** – 4" H Ohio Jug creamer, $25-30; Square Body Jug, $45-60; 5" H teapot, $50-60; 10" pie baker, $18-24; 6" H Ohio Jug, $40-50; 5" H Ohio Jug, $25-35; 8" H cookie jar, $50-60; Concentric Rings cheese plate, $20-25; 8" L Modern Age teapot, $75-90; 6" H Modern Age jug (no lid), $25-30; 6" W sugar, $20-25; 9" H Modern Age jug, $50-60; 4" W Modern Age sugar, $25-30; 4" bowl, $12-15; **Bottom Back Row** – 7" lugged bowl, $12-18; 10" plate, $8-12; 12" mixing bowl, $40-50; 8" plate, $8-12; Trivet, $35-45; **Bottom Front Row** – 5" bowl, $12-18; Skyscraper Drips (no lid), $12-18; Zephyr 4 bowl set 6", 7", 8", & 9", $40-50; Modern Age cup, $5-8; 8" W casserole, $35-45; 6" bowl, $15-20; 6" bowl, $20-25.

Countryside, Assorted Shapes, MK 46, **Top** – 6" & 9" plates, $8-12 & $10-15; 11" Nouvelle platter, $30-40; 7" W casserole, $40-50; 9" fluted bowl, $25-35; **Bottom** – 3 PC set Footed Bowls, 6", 6.5", & 7.25", $75-90; 6" paneled lid, $8-12; 7" bowl, $15-20.

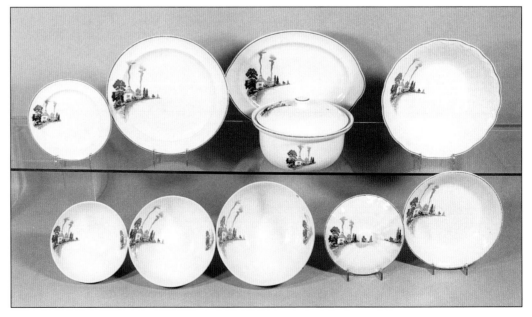

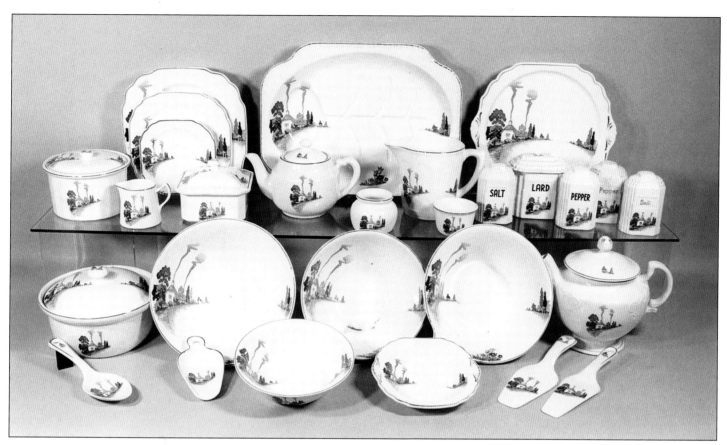

Countryside, Assorted Shapes, MKs 44, 45, 46, & 90, **Top** – 4" H paneled covered dish, $30-40; Gem creamer, $30-40; 6", 8", 10"
Virginia plates, $8-10, $10-15, & $15-20 each; 5" square covered dish, $25-35; Bump Handle Teapot, $100-120; 16" Melrose
platter with gravy tree & well, $90-100; Bean Pot, $8-12; 5" H Batter Jug (no lid), $60-70; custard, $8-12; Skyscraper Range Set,
$60-75; Skyscraper salt & pepper (gold letters), $25-35 set; Virginia Utility Plate, $50-60; **Bottom** – 8" casserole, $45-60; spoon,
$25-30; 10" mixing bowl, $25-35; scoop, $60-80; 7" bowl, $30-40; 9" mixing bowl, $25-35; 7" Virginia bowl, $12-18; 10" spout
mixing bowl, $60-75; 9.25" lifter, $30-35; 9" lifter, $20-25; 8" Scrolled coffeepot, $100-120.

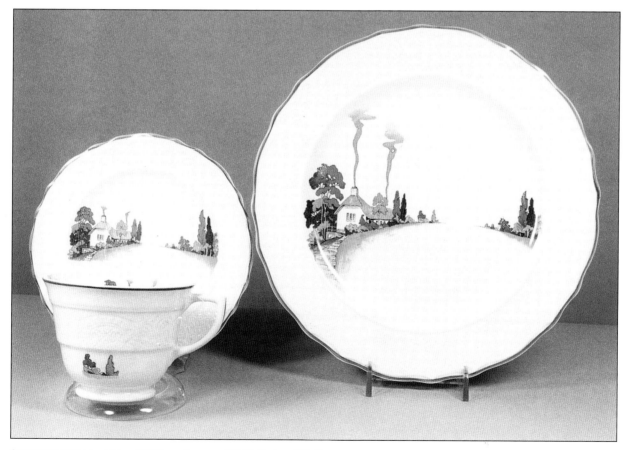

Countryside Embossed Edge, MK 90, cup & saucer, $60-65; 9" plate, $35-40.

Rolling Pins

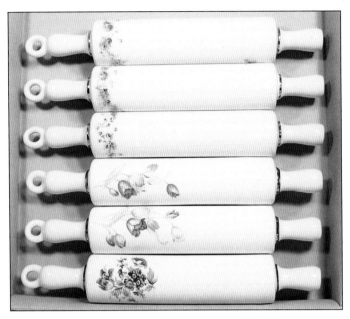

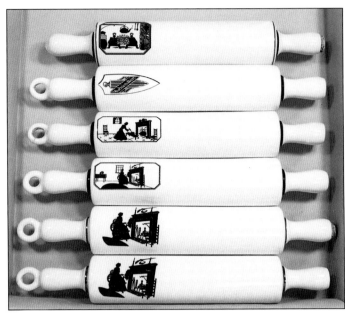

Rolling Pins, **Top To Bottom**, Shadow Rose (variation I), $110-150; Shadow Rose (variation II), $110-150; Bridal Rose, $150-200; Pastel Tulip I, $110-130; Pastel Tulip II, $110-130; Tulip Bouquet, $70-110.

Rolling Pins, **Top To Bottom**, Fire In The Fireplace (missing loop), $110-150; Kelvinator, $75-90; Silhouette (lady stirring pot), $110-150; Silhouette (lady & spinning wheel, framed), $110-150; Silhouette (lady & spinning wheel, no frame) red trim, $110-150; Silhouette (lady & spinning wheel, no frame) silver trim, $110-150.

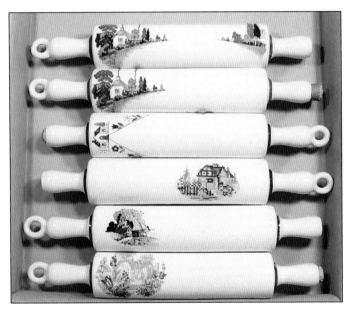

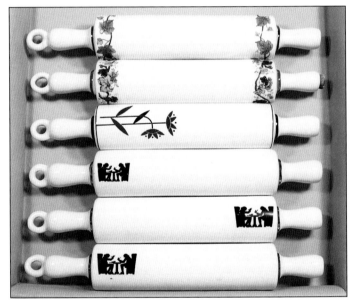

Rolling Pins, **Top To Bottom**, Countryside I, $200-300; Countryside II, $200-300; Honeymoon Cottage (a.k.a. Doll House), $150-220; Petit Point Cottage, (Crooksville decal), $90-120; Coventry, (Crooksville decal), $90-120; Hollyhock Cottage, $90-120.

Rolling Pins, **Top To Bottom**, Ivy, $90-120; Vintage, $110-150; Red Deco Dahlia, $90-120; Tavern (Hall China Co.) (small decal both ends), $90-120; same (large decal both ends), $90-120; same (large decal 1 end, small decal opposite), $90-120.

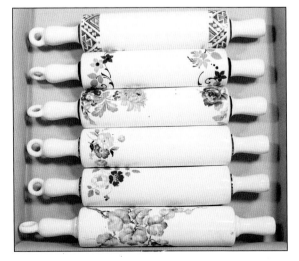

Rolling Pins, **Top To Bottom**, Wampum, $500-650; Carnivale, $150-200; Oriental Poppy, $75-110; Yellow, Pink, & Blue Flowers, $150-200; Red & White Flowers, $150-200; Green Leaves (Hand-painted), $200-250.

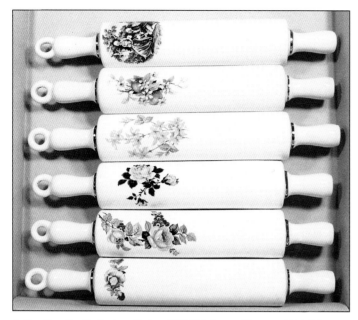

Rolling Pins, **Top To Bottom**, Godey, $110-150; Orange Blossom, $130-200; Forsythia, $130-150; Yellow Roses Black Leaves, $90-120; Yellow Roses Black & Gray Leaves, $90-130; Sweet Pea, $70-110.

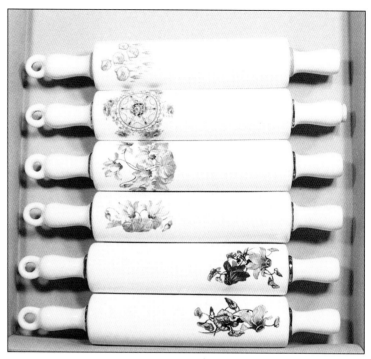

Rolling Pins, **Top To Bottom**, Pastel Posies, $200-300; Southern Rose, $110-160; Pink Cyclamen (large cluster), $150-210; Pink Cyclamen (small cluster), $150-210; Yellow & Orange Cyclamen (double flowers), $150-210; Yellow & Orange Cyclamen (1 flower), $150-210.

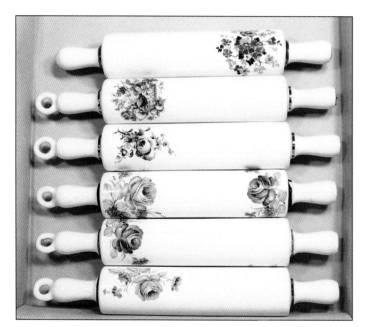

Rolling Pins, **Top To Bottom**, Stylized Red, Yellow, & Purple Flowers (no loop), $70-110; Lovelace, $70-110; Pink Rose & Yellow Daisy, $70-110; Anti-Q yellow & orange roses, $110-160; Anti-Q orange rose, $150-200; Anti-Q yellow rose, $150-200.

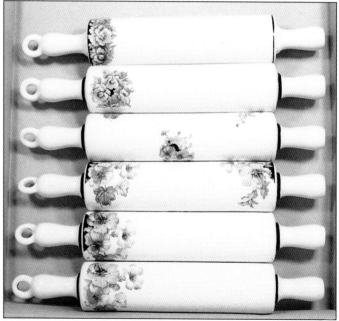

Rolling Pins, $110-160, **Top To Bottom**, Pansies (straight line & black edge); Pansies (triangular shape); Mallow (both ends black edge), (showing small decal on back); Mallow (both ends, additional pink buds); Mallow (one end & black edge); Mallow (one end, no black edge).

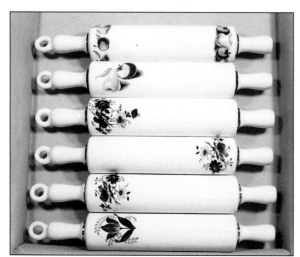

Rolling Pins, **Top To Bottom**, Red Apple I, $90-120; Red Apple II, $90-120; Emmy (both ends & additional red flower), $90-110; Emmy (both ends), $90-110; Emmy (1 end only), $90-120; Modern Tulip, $50-75.

Rolling Pins, **Top To Bottom**, Blue Roses, $150-210; Taffy (both ends), $110-150; Taffy (one end), $110-150; Amy II, $150-210; Amy I (small), $90-130; Amy I (large), $90-130.

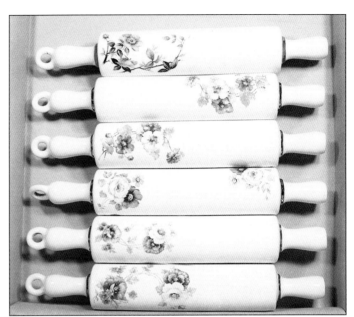

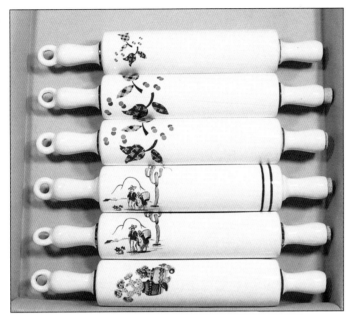

Rolling Pins, **Top To Bottom**, Calico Tulip (small decal on both ends), $110-150; Calico Tulip (large decal on both ends), $110-150; Calico Tulip (large one end, small opposite end), $110-150; Monterey (red & blue trim), $110-150; Monterey (silver), $110-150; Cactus, $125-175.

Rolling Pins, **Top To Bottom**, Small Cluster Multicolored flowers, (TS&T decal), $75-110; Larger Cluster Multicolored flowers, (TS&T decal), $75-110; Oval Cluster Multicolored flowers with gold trim, $75-110; Large pink rose, small yellow & blue flowers, $75-110; Pink roses & Texas bluebells, $90-130; Red, pink, & white poppies (TS&T decal), $90-130.

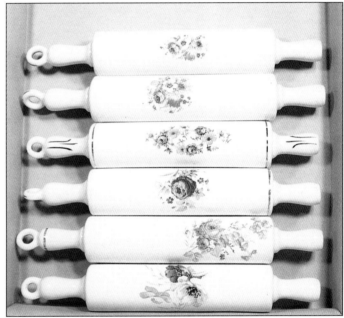

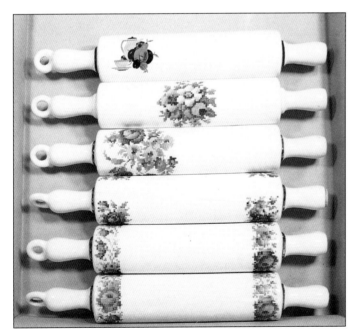

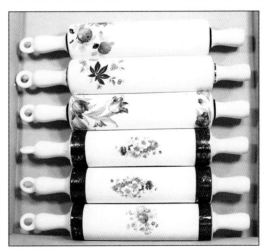

Rolling Pins, **Top To Bottom**, Yellow Coffeepot, Yellow Cup & Mixed Fruit, (Universal decal), $75-110; cross-stitch flowers, (TS&T decal), $75-110; Petit Point I, $90-110; Petit Point II (split decal), $90-130; Petit Point II (variation – single large pink rose on both ends), $90-130; Petit Point II (standard – 2 large pink roses on both ends), $90-130.

Rolling Pins, **Top To Bottom**, Crayon Apple, $200-300; English Ivy, $110-160; Ruffled (a.k.a. Shaggy) Tulip, $110-160; Royal Dresden with multicolored flowers, $110-160; Royal Dresden (reversed decal), $110-160; Royal Dresden (centered multicolored flowers, $110-160.

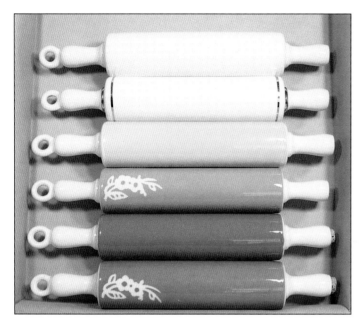

Rolling Pins, **Top To Bottom**, Blank, $40-60; Wedding Band, $50-80; Yellow Cameo Color, $90-120; Pink Cameo Dainty Flower, $90-120; Blue Cameo Color, $90-120; Blue Cameo Dainty Flower, $90-120.

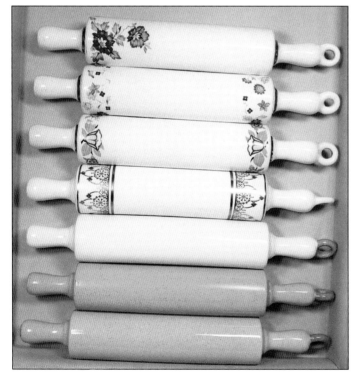

Rolling Pins, **Top To Bottom**, Jewel Weed, $425-500; Spring Meadow, $150-200; Bluebells (stylized blue & red flowers), $250-350; Gold Filigree, $150-200; Golden Dawn (a.k.a. Yellow Oatmeal), $150-200; Blue Mist (a.k.a. Blue Oatmeal), $150-200; Shell Pink (a.k.a. Pink Oatmeal), $150-200.

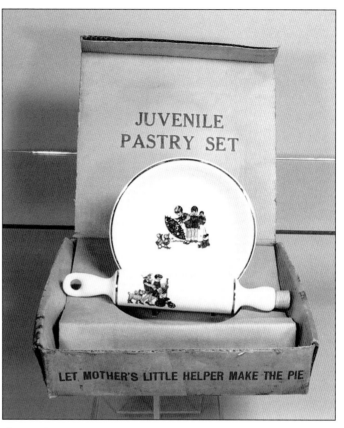

Miniature Rolling Pin, Juvenile Pastry Set, 6" pie baker, MK 31A, & 8.5" child's Rolling Pin, Harker box measuring 9.5" x 9" x 2.5", $600-700.

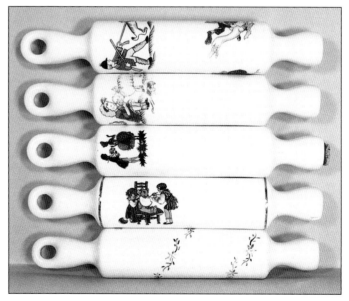

Miniature Rolling Pins, **Top To Bottom**, Hunter With Dog, $200-300; Mary had a little lamb, $175-250; Early American (purple & blue), $175-250; Girls & Teddy Bear, $200-300; hand-painted red & green garland, $175-$250.

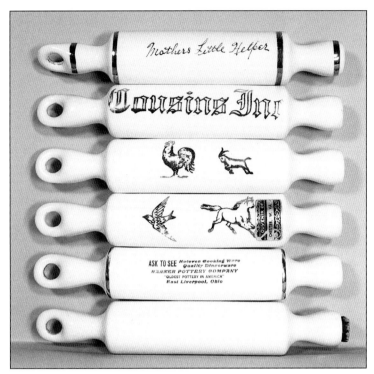

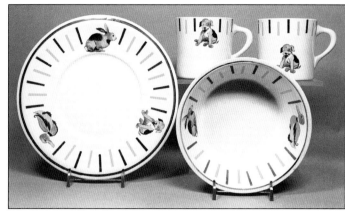

Children's Dishes, 8" plate, MK 31, $85-125; 6" bowl, no mark, $40-70; two 3" H mugs, MKs 31 & 35, $35-50 each.

Miniature Rolling Pins, **Top To Bottom**, "Mother's Little Helper", $250-300; "Cousins Inc", $200-250; Rooster & Goat, $200-250; same (showing reverse side with Barn Swallow and Horse) "Souvenir of Chester, W.VA.", $200-250; "Ask To See Hotoven Cooking Ware, Harker Pottery Company", $200-400; Blank, $90-110.

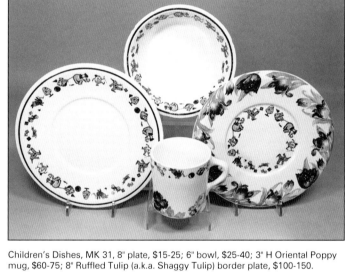

Children's Dishes, MK 31, 8" plate, $15-25; 6" bowl, $25-40; 3" H Oriental Poppy mug, $60-75; 8" Ruffled Tulip (a.k.a. Shaggy Tulip) border plate, $100-150.

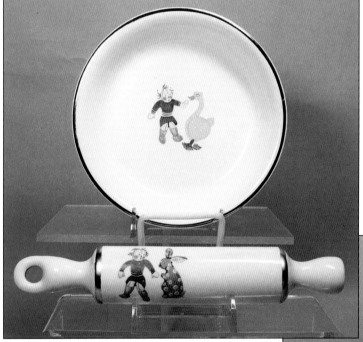

Miniature Rolling Pin, Raggedy Andy & Rabbit, $150-200, 8.5" & 6" Raggedy Andy & Goose pie baker, MK 31A, $25-35.

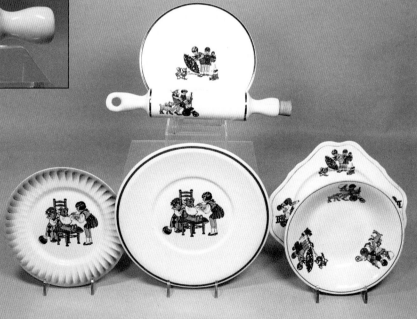

Children's Dishes, **Top** – 6" pie baker, MK 31A, $30-35; Miniature Rolling Pin, $150-200; **Bottom** – 6" fluted edge plate, MK 25, $35-40; 8" Blue Line plate, MK 31, $50-60; 7" square plate, MK 35, $30-35; 6" bowl, MK 35, $20-30.

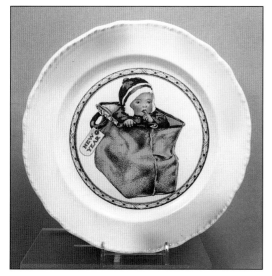

Children's Plate, Melrose Shape, MK 31, Baby In Doctor's Bag, "New Year", $35-45.

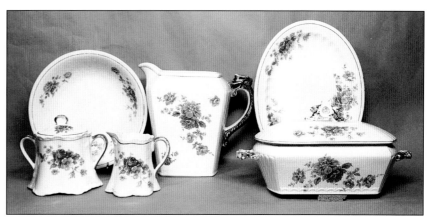

Pink Roses Cache, Assorted Shapes, MK 36, 5" H sugar, $12-18; 8" fluted (outside) bowl, $10-20; 4" H creamer, $10-15; 8" H Gargoyle Jug, $30-40; 11" L Gargoyle covered vegetable, $20-35; 11" thumbprint platter, $12-20.

Calico Ribbon (a.k.a. Gingham Ribbon), MKs 33 & 35, **Top** – 10" green GC square bottom mixing bowl, $25-30; 4" H paneled covered dish, $20-25; 8" under plate, $8-10; 4" H red paneled covered dish, $20-25; 8" under plate, $8-10; 10" red GC square bottom mixing bowl, $25-30; **Center Row** – 11" green Rope Edge cake plate, $15-20; Rope Edge handle lifter, $15-20; 10" pie baker, $15-20; 10" red pie baker, $15-20; 11" Rope Edge cake plate, $15-20; spoon, $15-20; **Front** – 8" W green paneled Vent Lid casserole, $25-35; 6" W covered dish, $10-15; 10" W red paneled Vent Lid casserole, $25-35.

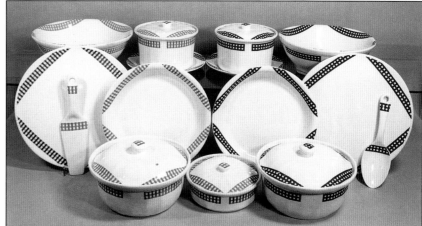

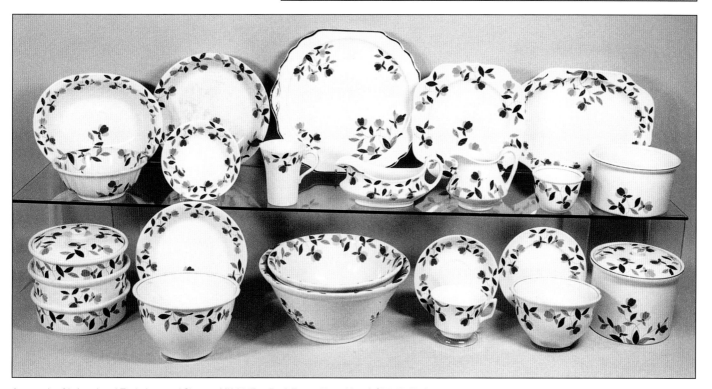

Autumn Leaf (a.k.a. Jewel Tea), Assorted Shapes, MK 35, **Top Back Row** – 9" oval bowl, $35-45; 9" pie baker, $80-100; Virginia utility plate, $200-225; 9" square plate, $15-20; 11 platter, $30-40; **Top Front Row** – 6" fluted bowl, $250-300; 5" bowl, $30-40; 4" H handled Tumbler, $150-200; Empress gravy, $90-110; 4" Empress jug, $250-300; custard, $90-110; 4" H dish (no lid), $325-375; **Bottom Row** – 3 stack dish set, $125-150; 7.5" bowl, $50-75; 7" Handy Style bowl, $80-90; 10" mixing bowl, $75-100; 9" mixing bowl, $80-110; cup & saucer, $50-75; 6" plate, $25-30; 6" Handy Style bowl, $40-60; 5" H Canister, $400-450.

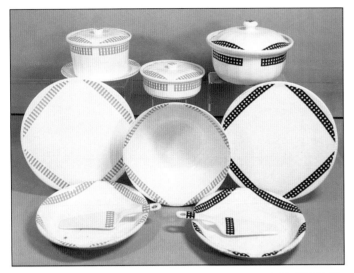

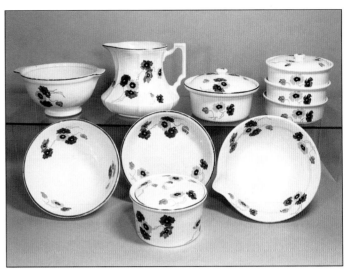

Calico Ribbon, MKs 33 & 35, **Top** – 4" H yellow paneled covered dish, $20-25; 8" under plate, $8-10; 6" W paneled covered dish, $10-15; 8" W brown paneled Vent Lid casserole, $25-35; **Center** – 11" yellow Rope Edge cake plate, $15-20; 10" GC square bottom mixing bowl, $25-35; 11" brown Rope Edge cake plate, $15-20; **Front** – 10" yellow pie baker, $15-20; Rope Edge handle lifter, $15-20; 10" brown pie baker, $15-20; Rope Edge lifter, $15-20.

Anemones, Assorted Shapes, MKs 33 & 34A, **Top** – 9" GC refrigerator bowl (no lid), $15-20; 7" Sun-Glow shape jug (no lid), $50-60; 7" W Vent Lid casserole, $30-40; 3 Stack Dish Set, $25-35; **Bottom** – 9" mixing bowl, $20-25; 9" pie baker, $15-25; 4" H covered dish, $30-40; 10" spout mixing bowl, $25-35.

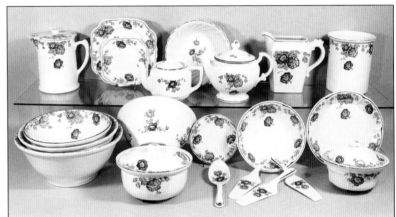

Jewel Weed, Assorted Shapes, MKs 31, 33, 34A, 35, 38, 39, 44, & 45, **Top** – 8" H jug, $40-50; 6" & 9" square plates, $8-12 & $12-18; 8" L Zephyr lid Teapot, $25-35; 9" Shell bowl, $8-12; 8" H Scroll coffeepot, $50-60; 7" H Gargoyle Jug, $40-50; 7" H cookie jar (no lid), $45-60; **Bottom** – Three mixing bowl set 10", 11", & 12", $90-120; 10" Arches mixing bowl, $30-40; 8 Vent Lid casserole, $25-35; 6" Sun-Glow bowl, $10-15; spoon, $15-20; Rope Edge lifter, $15-20; two lifters, $15-20 each; 8" Sun-Glow bowl, $25-35; 10" Sun-Glow pie baker, $30-40; 8" W Sun-Glow covered casserole, $50-60.

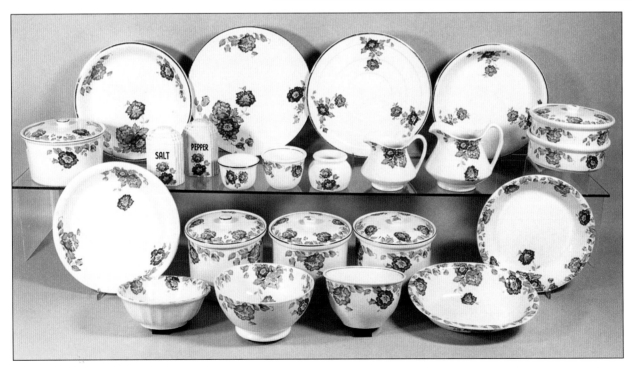

Jewel Weed, Assorted Shapes, MKs 34B, 35, & 45, **Top Back Row** – 10" pie baker, $15-20; 11" Rope Edge cake plate, $15-20; Concentric Rings cake/cheese plate, $15-15; 10" pie baker, $12-18; **Top Front Row** – 4" H covered dish, $20-30; Skyscraper salt & pepper, $20-25; custard, $5-8; custard, $5-10; Bean Pot, $4-6; 4" H Empress jug, $20-25; 5" H Empress jug, $30-40; Two stack dish set, $25-35; **Bottom** – 10" pie baker, $20-25; 6" fluted bowl, $20-25; 6" H Canister, $35-45; 7" Footed Bowl, $35-40; 6" Canister, $35-45; 6" Handy Style bowl, $25-35; 6" Canister, $35-45; 9 oval bowl, $30-40; 9" pie baker, $20-25.

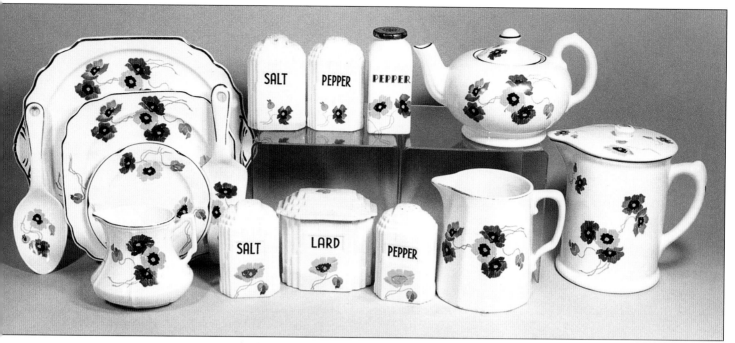

Anemones, Assorted Shapes, MKs 33, 34A, & 35, **Back Row** – Spoon, $15-20; 6" Sun-Glow plate, $10-15; 9" square plate, $12-15; Virginia utility plate, $20-24; lifter, $15-20; Skyscraper salt & pepper, $20-24; Crimp Top pepper, $25-30; 9" L Sun-Glow teapot, $90-120; **Front** – 4" H Sun-Glow creamer (no lid), $40-60; Skyscraper Range Set, $50-60 set; 5" H paneled Ohio Jug, $20-25; 8" H jug, $60-75.

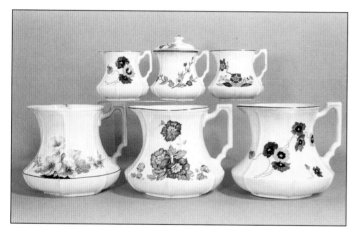

Sun-Glow Jugs (1 with lid), assorted, MKs 33, 34, & 35, **Top** – 4" Anemones creamer, $40-60; 5" H Straw Flowers, $45-65; 4" Jessica, $40-60; **Bottom** – 7" jugs, Mallow, $70-100; Jewel Weed, $125-150; Anemones, $70-100.

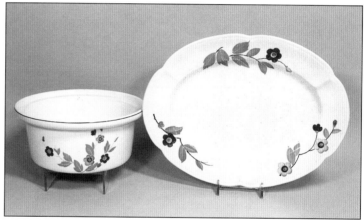

Straw Flowers, Miscellaneous Shapes, 7" casserole (no lid), MK 34A, $12-15; 11" Sun-Glow Shape platter, No Mark, $10-15.

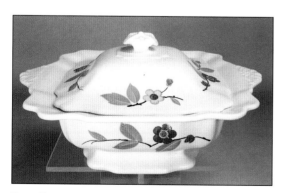

Straw Flowers, Virginia Shape, no mark, 10" W covered vegetable, $30-45.

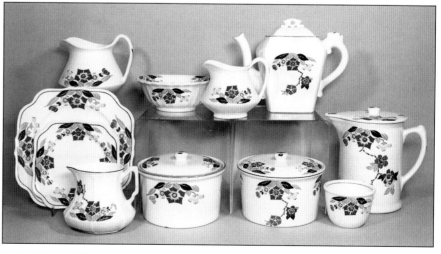

Jessica, Assorted Shapes, MKs 33, 35, & 163; **Top** – 5" H Empress jug, $25-35; 6" fluted bowl, $20-25; 4" H Empress jug, $20-25; Gargoyle Teapot, $40-60; **Bottom** – 6" & 9" square plates, $5-8 & $8-12; 4" Sun-Glow creamer, $20-30; 4" H covered dish (green trim), $25-35; 4" H covered dish, $25-35; custard, $10-15; 8" H jug, $60-75.

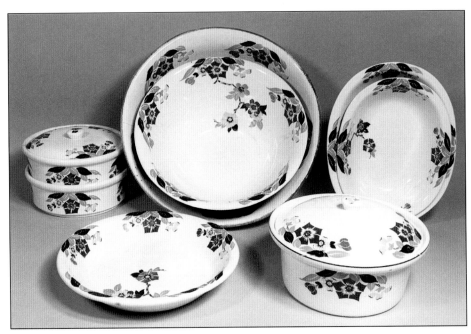

Jessica, MK 35, **Back** – 2 Stack Dish Set, $50-60; 10" mixing bowl, $35-45; 12" mixing bowl (green trim), $30-40; 8" & 9" oval bowls, $20-25 & $30-40; **Front** – 9" pie baker, $20-30; 8" Vent Lid casserole, $35-50.

Pastel Tulip, Assorted Shapes, MKs 33, 35, 37, 84, 84A, 84B, & 90, **Top Back Row** – $18-24 each, Virginia utility plate (1 decal); 11" cake plate (2 decals); 11" cake plate (3 decals); Virginia utility plate (4 decals); **Top Front Row** – Virginia gravy, $18-24; 8" under plate, $5-10; Skyscraper salt & pepper, $12-18; lifter, $12-18; 6" W Embassy sugar, $8-12; 5" W Embassy creamer, $8-12; custard, $8-10; spoon, $15-20; Bean Pot, $5-10; 6" W gray blush bowl, $3-5; 2 square stack dish set, $30-40; **Bottom Back Row** – 13" Virginia platter, $20-25; 9" square plate, $5-10; 10" Gadroon plate, $5-10; 13" Hostess platter, $25-35; **Bottom Front Row** – 8" square plate, $5-10; 6" square saucer, $3-5; 5" square bowl, $3-5; 4" H dish (no lid), $8-12; 7" Gadroon lugged bowl, $3-5; saucer, $2-4; 10" L under plate, $8-12; 6" creamer, $12-18.

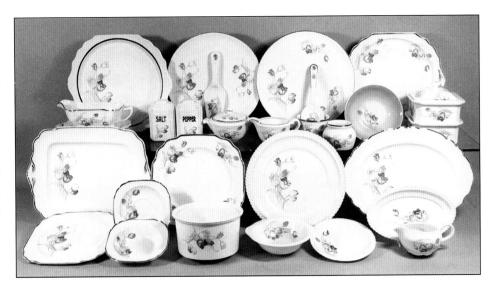

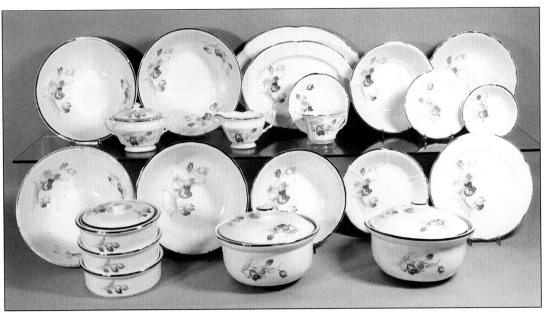

Pastel Tulip, Assorted Shapes, MKs 31A, 44, 45, & 46, **Top** – 10" GC square bottom mixing bowl (2 decals), $10-15; 7" W Sun-Glow sugar, $20-25; 10" square bottom mixing bowl (3 decals), $18-24; 6" W Sun-Glow creamer, $15-20; 11" & 13" Sun-Glow platters, $15-20 & $18-24; Sun-Glow cup & saucer, $10-15; 8" Sun-Glow bowl, $25-30; 6" Sun-Glow plate, $4-6; 9" Embossed edge bowl, $10-15; 5" Sun-Glow bowl, $4-8; **Bottom** – 10" mixing bowl, $15-20; 3 Stack Dish Set, $45-60; 9" fluted bowl, $15-20; 8" W Vent Lid casserole, $20-25; 8" fluted bowl, $15-20; 8" Sun-Glow bowl, $10-12; 8" W Vent Lid casserole, $20-25; 9" Sun-Glow plate, $8-12.

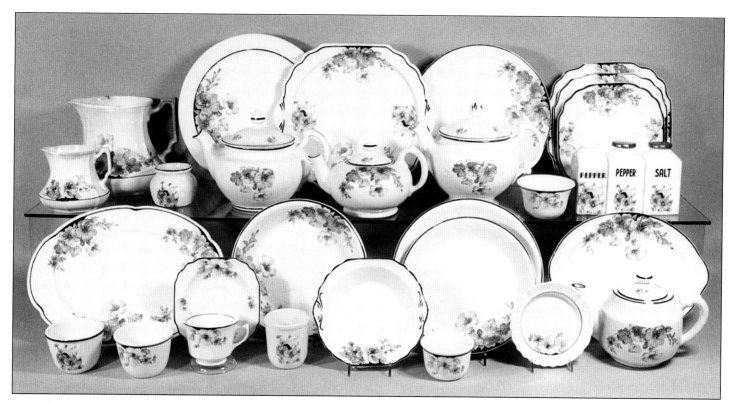

Mallow, Assorted Shapes, MKs 33, 35, 37, 45, 46, 84A, & 90, **Top** – 4" H Sun-Glow creamer (no lid), $30-40; 7" H Sun-Glow jug (no lid), $60-75; Bean Pot, $8-12; 11" Modern Age cake plate, $18-24; 7" H GC coffeepot, $50-60; Virginia utility plate, $15-20; 8" L Sun-Glow teapot, $45-60; Concentric Rings cheese plate, $18-24; 7" H Scroll coffeepot, $50-60; 4" W flared lip custard, $6-10; 8", 9", & 9.5" square plates, $6-10 each; 2" W Crimp Top pepper, $30-40; Crimp Top salt & pepper, $60-80 set, **Bottom** – 13" Sun-Glow platter, $20-25; G.C. custard, $8-10; custard, $8-10; Sun-Glow cup & saucer, $10-15; 9" pie baker (3 decals), $20-25; GC custard, $5-10; 7" Virginia bowl, $5-10; 9" & 10" pie bakers (1 decal), $18-24 each; custard, $5-10; 5" Embossed edge ashtray, $8-10; 11" Nouvelle platter, $18-24; Bump Handle teapot, $45-60.

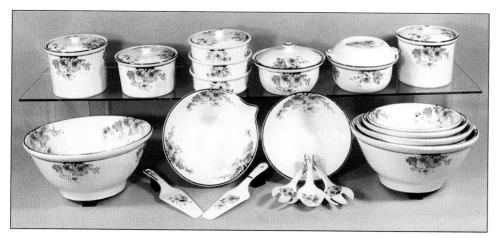

Mallow, Assorted Shapes, MKs 33, 45, & 46, **Top** – 5" H paneled Canister, $35-50; 4" H paneled covered dish, $20-30; 3 stack dish set, $40-50; 7" W paneled Vent Lid casserole, $30-40; 7" W GC casserole (under plate or small bowl lid), $40-50; 6" H Canister, $40-50; **Bottom** – 12" GC mixing bowl, $30-45; lifter, $15-20; 10" spout mixing bowl, $25-35; lifter, $15-20; 9" mixing bowl (inside decal only), $20-25; fork, $18-24; spoon, $12-18; fork, $18-24; 4 mixing bowl set, 9", 10", 11", & 12", $100-120.

Mallow, Assorted Shapes, MKs 35, 44, 46, & 90; **Top Back Row** – 9" (3 decals) plate, $8-12; 7" bowl, $5-8; scoop, $50-75; 7" plate, $5-8; Trivet, $40-50; 7" lid only, $8-10; 9" (1 decal) plate, $5-10; Hi-rise Jug (no lid), $45-60; **Top Front Row** – Gem creamer, $25-35; Nouvelle cup & saucer, $15-20; Gem sugar, $25-35; 3" paneled Ohio Jug creamer (no lid), $30-40; 4" H paneled Ohio jug creamer, $35-45; 5" H paneled Ohio Jug, $25-35; Skyscraper flour shaker, $40-50; Skyscraper Range Set, $40-60; **Bottom** – 9" fluted edge bowl, $18-24; 7" Nouvelle bowl, $15-20, 5" bowl, $3-5; 8" bowl, $30-40; 6" bowl, $4-8; 5" bowl, $3-5; 9" Modern Age bowl, $25-30; 7" W Zephyr casserole, $25-35; 9" W GC Notch Lid refrigerator bowl, $30-40; Celery Tray, $35-45; 8" & 9" fluted bowls, $15-20 each.

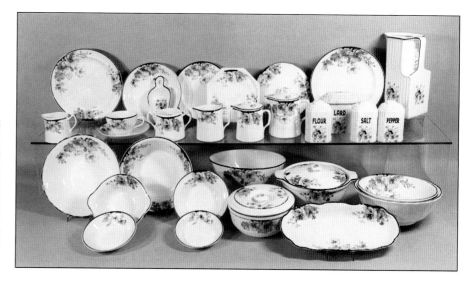

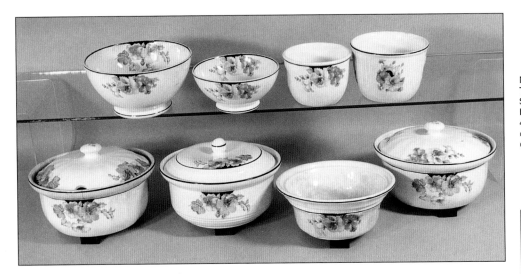

Mallow, Assorted Shapes, MKs 37, 45, 46, & 47, **Top** – 7" Footed Bowl, $18-24; 6" Footed Bowl, $18-24; 3" H bowl, $12-18; 4" H GC bowl, $18-24; **Bottom** – 8" W paneled Notch Lid casserole, $35-45; 8" W casserole, $20-25; 8" Sun-Glow casserole (no lid), $20-30; 8" paneled Vent Lid casserole, $30-40.

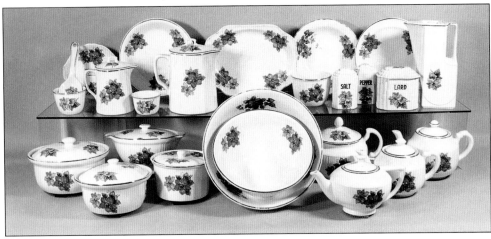

Anna, Assorted Shapes, MK 31, most unmarked, **Top Back Row** – 7" Melrose green blush plate, $8-12; 9" pie baker, $10-15; 11" Melrose platter, $8-12; 9" Embossed Edge bowl, $18-24; 9" plate, $3-5; **Top Front Row** – spoon, $12-18; custard, $5-8; 6" H paneled Ohio Jug, $25-35; custard, $4-6; 7" H paneled Ohio Jug, $25-35; 3" GC bowl, $10-15; Skyscraper Range Set, $35-45; Hi-rise Jug, $60-75; **Bottom** – 8" W paneled Vent Lid casserole, $25-35; 7" paneled Vent Lid casserole, $20-30; 9" W GC refrigerator Notch Lid bowl, $30-40; 4" H paneled covered dish, $20-30; 10" & 12" GC mixing bowls, $20-25 & $35-45; 7" H GC coffeepot, $150-160; 5" H Windsor teapot, $45-60; Bump Handle teapot, $35-50; 9.5" L Bump Handle teapot, $40-60.

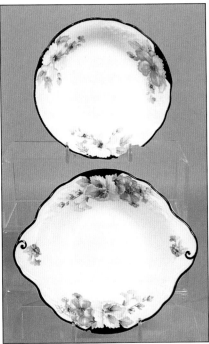

Mallow, Hostess Shape, MK 90, **Top** – 5" bowl, $15-20; **Bottom** – 7" tabbed bowl, $20-25, *Courtesy of Janice Frantz Scovel*.

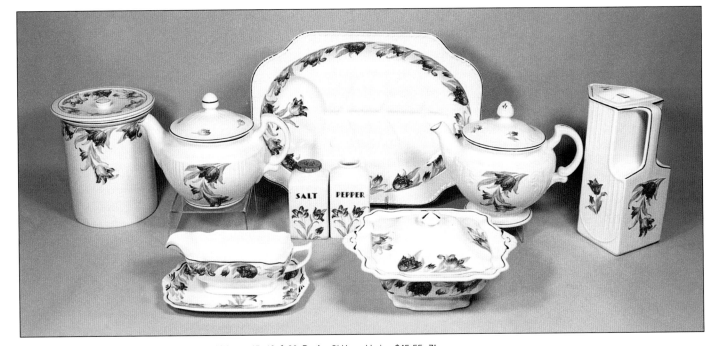

Ruffled (a.k.a. Shaggy) Tulip, Assorted Shapes, MKs 44, 45, 46, & 90, **Back** – 8" H cookie jar, $45-55; 7" H GC coffeepot, $60-80; 15" Melrose platter with gravy tree & well, $100-120; Crimp Top salt & pepper, $75-80; 7" H Scroll coffeepot, $60-80; Hi-rise Jug, $75-90; **Front** – Virginia gravy, $20-25; 8" Virginia under plate, $10-15; 10" W Virginia covered vegetable, $75-90.

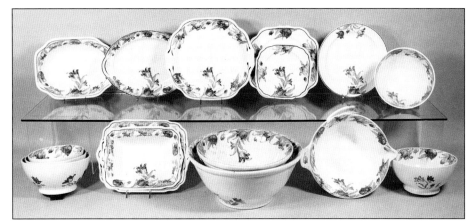

Ruffled Tulip, Assorted Shapes, MKs 31, 44, 45, 46, & 90, **Top** – 9" Melrose bowl, $18-24; 11" Nouvelle platter, $15-20; 10" lugged Melrose plate, $12-15; 7" & 9" square plates, $5-8 & $8-12; 9" plate, $5-8; 7" Footed Bowl, $25-35; **Bottom** – 3 Footed Bowl set, 6", 6.5", & 7", $40-60; 9" & 10" Virginia bowls, $12-18 & $20-30; 12" mixing bowl, $30-40; 10" Arches mixing bowl, $25-35; 10" tab & spout mixing bowl, $30-40; 7" Footed Bowl, $18-24.

Ruffled Tulip, Assorted Shapes, MKs 31, 44, 45, 47, 84, 90, & 190, **Top** – 7" Melrose plate, $5-8; Jumbo Cup & Saucer, $20-25; 10" pie baker, $25-30; Gargoyle Teapot, $60-75; 15" Melrose platter, $50-60; 4" H paneled Ohio Jug, (no lid), $12-18; 8" L Zephyr lid teapot, $40-50; Virginia utility plate, $18-24; Arches custard, $8-10; Trivet, $25-35; 5" square dish (no lid), $18-24; **Bottom** – 6" H Canister, $35-45; Bulbous Jug, $50-60; 7" Vent Lid casserole, $30-40; 8" Melrose bowl, $20-25; 7" Vent Lid only, $10-15; 6" H Gargoyle Jug, $25-35; 7" W covered dish, $25-30; 7" H Gargoyle Jug, $40-50; 3 Stack Dish Set, $40-50.

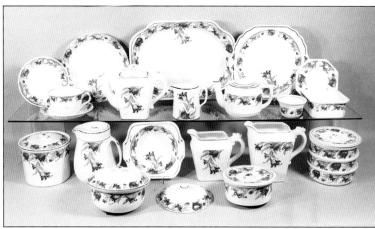

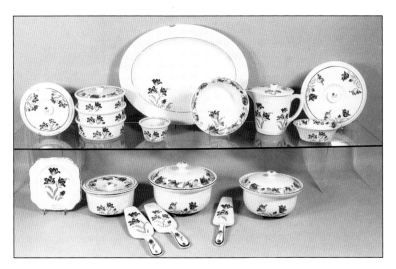

Ruffled Tulip variation, Assorted Shapes, MKs 31, 45, & 46, **Top** – 7" lid only, $8-12; 3 Stack Dish Set, $35-45; Arches custard, $4-6; 17" platter, $18-24; 7" bowl, $15-20; 6" Arches Batter Jug, $35-45; 6" bowl, $20-25; 9" lid only, $10-15; **Bottom** – 6" Melrose plate, $15-20; 3" H covered dish, $18-24; Two lifters, $18-24 each; 8" paneled Vent Lid casserole, $25-35; lifter, $15-20; 8.5" Vent Lid casserole, $35-45.

Tulip Variations, Assorted Shapes, MKs 31 & 45, **Top** – 8" H Gargoyle Red & Blue Tulips jug, $50-60; 3 bowl set Pink & Gray Tulips 4", 5", & 6", $15-20; 5" H Gargoyle Red Ruffled Tulips creamer, $20-30; Skyscraper Range Set, $45-60; 8" H Gargoyle Orange Ruffled Tulips jug, $60-70; 8" Orange Ruffled Tulips bowl, $15-20; **Bottom** – 9" & 12" Arches Red & Blue Tulip mixing bowls, $20-30 & $30-40; Red Ruffled Tulip spoon, $15-20; 12" Arches Ruffled (Shaggy) Tulip mixing bowl, $20-30; Rope Edge Red Ruffled Tulip lifter, $15-20; fork, $18-24; 12" Arches Orange Ruffled Tulip mixing bowl, $35-45.

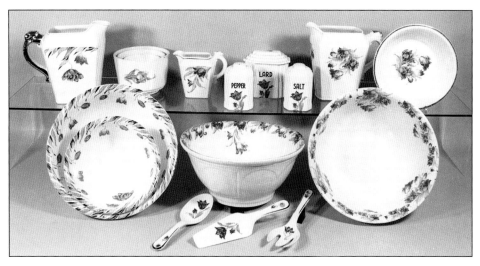

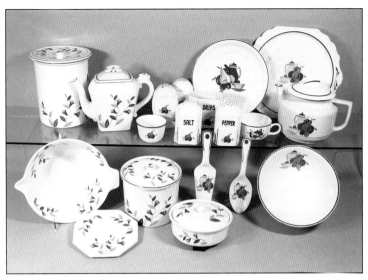

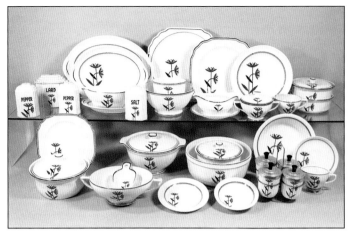

Assorted Shapes, Deco Morning Glories, Yellow Coffeepot (often misidentified as "Tea For Two"), & Red Coffeepot, MKs 31, 37, 45, 46, 84, **Top** – 8" H Deco Morning Glories cookie jar, $35-45; Gargoyle Teapot, $40-50; GC Yellow Coffeepot custard, $3-5; D-Ware salt & pepper, $15-20; Skyscraper Range Set, $20-30; 9" Red Coffeepot plate, $7-10; Red Coffeepot cup, $8-10; Yellow Coffeepot Virginia utility plate, $12-15; 9"L Yellow Coffeepot Zephyr lid coffeepot, $45-60; **Bottom** – 10" tab & spout Deco Morning Glories mixing bowl, $15-20; 5" H Canister, $35-45; Trivet, $25-30; Stack Dish, $10-15; lifter, $12-15; 9" mixing bowl, $18-24; spoon, $12-15.

Red Deco Dahlia, Assorted Shapes, MKs 31B, 45, 46, 84, & 90, **Top** – Skyscraper large decal pepper, $12-18; Skyscraper (small decal) Range Set, $40-50; 11" & 13" Nouvelle platters, $15-20 each; gravy, $20-25; 8" L under plate, $15-20; 7" Footed Bowl, $35-45; 5" GC bowl, $20-25; Virginia utility plate, $20-25; 10" square plate, $12-18; 7" W gravy with fused under plate, $30-40; 6" W Windsor sugar, $20-30; 9" plate, $5-10; 6" Windsor creamer, $15-20; 2 Stack Dish Set, $20-25; **Bottom** – 7" W Vent Lid casserole, $25-35; 8" square under plate, $10-15; 10" Windsor bowl (no lid), $25-30; scoop, $40-60; 9" GC refrigerator bowl, $35-45; 6" plate, $3-5; 8" Zephyr bowl, $15-20; 6" W paneled covered dish, $25-35; 5" bowl, $4-8; set of 4 GC Egg Coddlers in wire carrier, $30-40; 8" bowl, $15-20; Nouvelle cup & Saucer, $12-18.

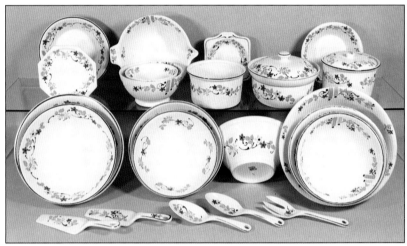

Carnivale I & II, Assorted Shapes, MKs 31 44, & 45, **Top Back Row** – 8" Carnivale II bowl, $15-20; 10" Carnivale I tab & spout mixing bowl, $30-40; 6" Carnivale II Melrose tabbed bowl, $8-12; 8" bowl, $15-20; **Top Front Row** – Carnivale II Trivet, $30-40; Two Carnivale I Footed Bowls, 6" & 7", $20-30 & $25-35; 4" H Carnivale II paneled dish, (no lid), $12-18; 8" W Vent Lid casserole, $35-45; 4" H covered dish, $25-35; **Bottom Back Row** – 10" & 11" Carnivale II mixing bowls, $30-35 each; 9" & 10" mixing bowls (green trim), $20-30 each; 9" Arches mixing bowl, $30-40; Three Carnivale I mixing bowl set, 9", 10", & 12", $80-100; **Bottom Front Row** – Two lifters, $15-20; Two spoons, $15-20; fork, $18-24.

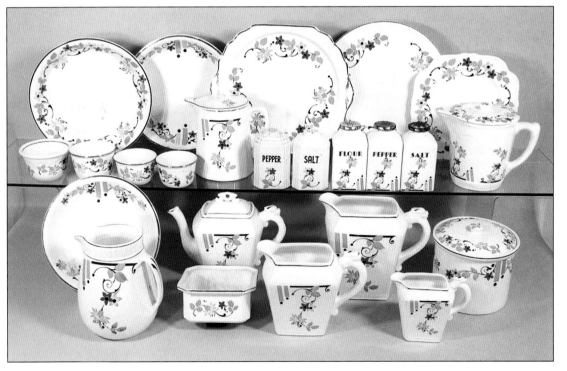

Carnivale I (vertical bars) & II, Assorted Shapes, MKs 31 & 45, **Top Back Row** – 10" Carnivale II pie baker, $15-20; 10" Carnivale I pie baker, $15-20; Carnivale II Virginia utility plate, $18-24; 11" cake plate, $25-35; 9" square plate, $8-12; **Top Front Row** – Arches Carnivale II custard, $4-8; custard, $3-5; custard, $3-5; GC custard, $3-5; 7" H paneled Carnivale I Ohio Jug, $35-45; Carnivale II Skyscraper salt & pepper, $20-24; 3 PC Carnivale I Crimp Top flour, salt, & pepper, $80-90 set; 6" H Arches Batter Jug, $50-60; **Bottom** – 9" Carnivale I pie baker, $12-15; Bulbous Jug (no lid), $45-55; Gargoyle Teapot, $50-70; 2" H square Carnivale II dish (no lid), $10-15; 6" H Gargoyle Carnivale I jug, $35-45; 7" H Gargoyle Jug, $45-60; 5" Gargoyle creamer, $18-24; 6" H Canister, $35-45.

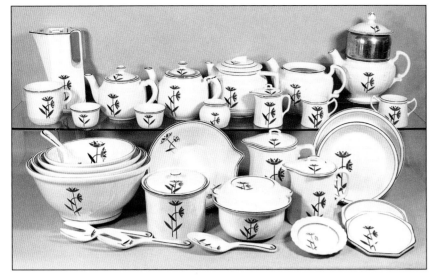

Red Deco Dahlia, Assorted Shapes, MKs 45, 46, 84, & 90, **Top** – 4" H mug, $25-30; Hi-rise Jug, $45-60; GC custard, $5-10; Bump Handle teapot, $40-60; custard, $5-10; 9.5" L Bump Handle teapot, $40-60; Bean Pot, $8-12; 7" H Zephyr lid coffeepot, $50-60; 4" H Ohio Jug creamer, $20-25; 6" H GC coffeepot (no lid), $30-40; Gem creamer, $18-24; Scrolled coffeepot, $60-75; Gem sugar, $20-25; **Bottom** – Four mixing bowl set, 9", 10", 11", & 12", $100-125; Roped Edge handle lifter, $15-20; Two forks (Pat. Pdg.), $25-30; 6" paneled Canister, $40-50; 10" spout mixing bowl, $35-45; spoon, $15-20; 7" W GC casserole with under plate or small bowl lid, $25-35; 8" H paneled Ohio Jug, $40-50; 7" H paneled Ohio Jug, $30-40; 5" Embossed edge ashtray, $10-15; 8" & 10" pie bakers, $18-24 each; Two Trivets (note trim), $20-25 each.

Blue Deco Dahlia & Yellow Deco Dahlia (advertised as Sunflower), Assorted Shapes, MKs 44, 45, 46, 47, 84, 84A, & 90, **Top Back Row** – Three Blue Deco Dahlia plates, 6", 7", & 9", $10-15 each; 15" Nouvelle platter, $35-50; 16" platter, $50-60; 11" Yellow Deco Dahlia Nouvelle platter, $25-35; 9" plate, $20-25; **Top Front Row** – Skyscraper Blue Deco Dahlia Range Set, $50-75; Nouvelle gravy & under plate, $30-40; Bean Pot, $15-20; GC custard, $15-20; Nouvelle cup & saucer, $20-25; Yellow Deco Dahlia custard, $15-20; Skyscraper Range Set, $45-60; **Bottom** – 4" H Blue Deco Dahlia paneled dish (no lid), $18-24; 3" H covered dish with Zephyr lid, $24-30; 10" W Windsor covered vegetable, $50-60; 8" W paneled Vent Lid casserole, $45-60; 8" bowl, $25-30; 9" L Nouvelle oval bowl, $20-25; 7" bowl, $18-24; 5" bowl, $8-10; 10" Yellow Deco Dahlia mixing bowl, $40-50; Scrolled coffeepot, $80-100.

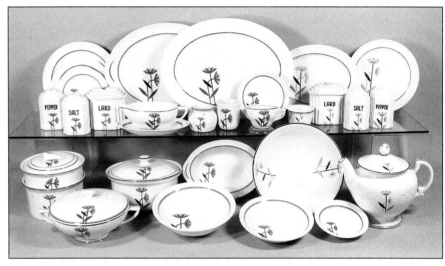

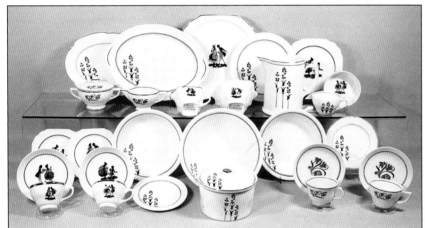

Assorted Decals & Shapes, Red Berries, Blue Berries, Red Deco Flower, & Early American, MKs 35, 45, 77, 84, 84A, & 90, **Top Back Row** – 11" Sun-Glow Red Berries platter, $15-20; 13" Nouvelle Blue Berries platter, $20-25; Early American Virginia utility plate, $15-20; 9" Red Berries plate, $5-8; 8" square Early American plate, $5-8; **Top Front Row** – 6" W Red Deco Flowers Embassy sugar, $10-15; 6" creamer, $8-12; 5" W Virginia Early American creamer, $8-12; 6" W sugar, $8-10; 7" H Red Berries jug (no lid), $25-35; Nouvelle Red Berries cup, $5-8; 5" W Early American Cheese Dish (no lid), $8-10; **Bottom Back Row** – Two 6" square Early American plates, $3-5 each; 8" Blue Berries bowl, $8-12; 10" Red Berries mixing bowl, $20-25; 8" bowl, $10-15; 6" Sun-Glow Red Berries plate, $3-5; **Bottom Front Row** – Two Nouvelle Early American cups & saucers, $8-12 each; 6" Red Berries plate, $2-4; 4" H covered dish, $18-24; Red Deco Flower cup & saucer, $8-12; Red Deco Flower cup & saucer, $8-12.

Crayon Apple, Assorted Shapes, MKs 45, 46, & 84, **Top Back Row** – 10" plate, $25-35; Virginia utility plate, $20-30; Concentric Rings cheese plate, $25-30; 9" pie baker, $18-24; **Top Front Row** – 7" H paneled Ohio Jug, $30-40; paneled stack dish, $30-35; GC coffeepot, $100-110; Bump Handle teapot (no lid), $20-25; GC custard, $5-10; Skyscraper Range Set, $45-60; Bean Pot, $8-12; Hi-rise Jug, $60-75; GC custard, $5-8; **Bottom** – 7" W GC casserole (with under plate or small bowl lid), $30-40; lifter, $15-20; 12" GC mixing bowl, $35-45; 10" (smooth sides) mixing bowl, $20-30; 9" GC mixing bowl, $20-30; fork, $18-24; spoon, $15-20; 8" paneled Vent Hole lid casserole, $30-35.

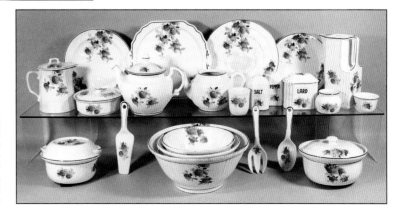

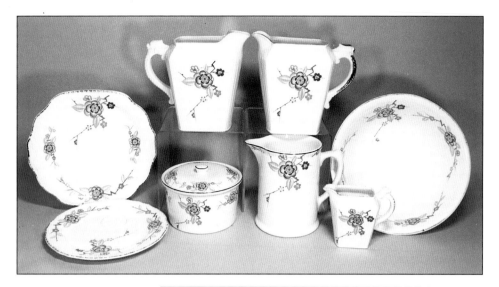

Whirlygig, Melrose & Gargoyle Shapes, MKs 31 & 35, **Back** – 10" Melrose tabbed plate, $15-20; 7" H Gargoyle Jug, $60-75; 7" Gargoyle Jug (gold handle), $70-90; 11" Arches mixing bowl, $25-35; **Front** – 9" Melrose Cup Ring Plate, $10-15; 4" H covered dish, $20-30; 7" H jug (no lid), $45-60; 4" H Gargoyle creamer, $15-20.

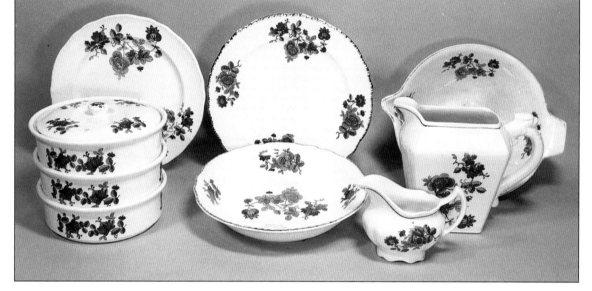

Angelia, Assorted Shapes, MK 31, **Back** – 9" Melrose plate, $8-10; 9" Melrose plate, $12-15; 10" tab & spout mixing bowl, $15-25; **Front** – 3 PC Stack Dish Set, $18-24; 9" Melrose bowl, $15-20; 3" H Melrose creamer, $10-15; 6" H Gargoyle Jug, $25-35.

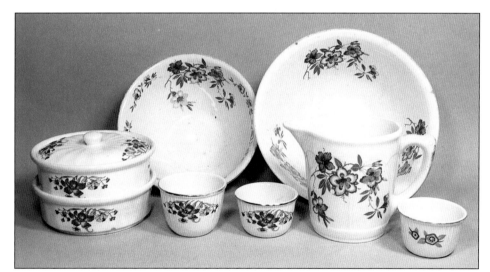

Assorted Decals & Shapes, Lucille, Blue & Orange Lilies, & Blue Bells (stylized red & blue flowers), MK 31, Lucille paneled 2 stack dish set, $15-20; 9" Blue & Orange Lilies mixing bowl, $12-18; Lucille GC custard, $3-5; Lucille GC custard, $3-5; 11" Arches Blue & Orange Lilies mixing bowl, $15-25; 5" H Arches Blue & Orange Lilies Batter Jug (no lid), $18-24; GC Blue Bells custard, $3-5.

Flower Cascade, no mark, 7" H jug, $40-50.

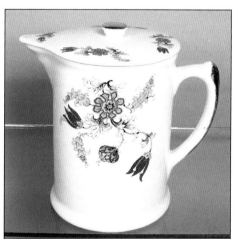

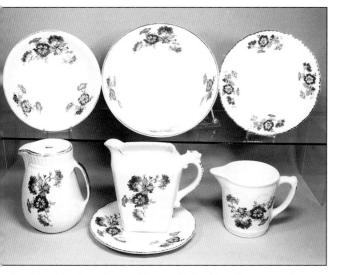

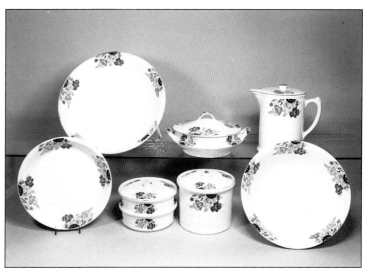

Purple Morning Glory, Assorted Shapes, MK 31, **Top** – 9" pie baker, $15-20; 11" Arches mixing bowl, $35-45; 9" Melrose Cup Ring Plate, $10-12; **Bottom** – Bulbous Jug, $25-35; 7" H Gargoyle Jug, $30-40; 9" Melrose plate, $8-10; 5" H Arches Batter Jug (no lid), $20-25.

Ginger, MKs 25 & 31, **Top** – 12" mixing bowl, $25-30; 10" W Empress covered vegetable, $30-45; 7" H jug, $75-95; **Bottom** – 10" pie baker, $15-20; 2 stack dish set, $15-20; 6" H Canister, $45-60; 11" Arches mixing bowl, $30-40.

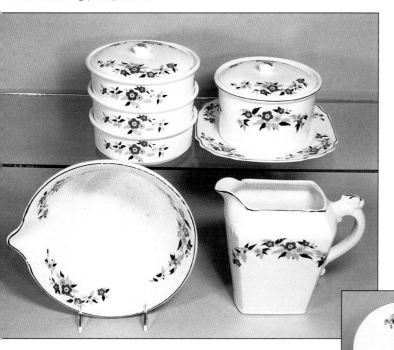

Susan, MK 36, **Top** – 3 stack dish set, $20-25; 5" H covered dish, $20-25; 9" square under plate, $5-10; **Bottom** – 9" spout mixing bowl, $20-25; 7" H Gargoyle Jug, $35-45.

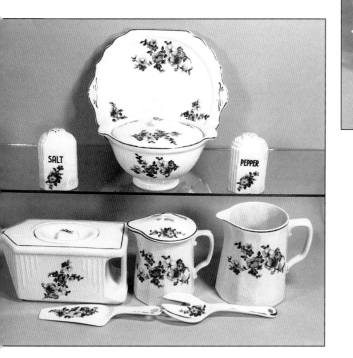

Cyclamen, Assorted Shapes, no mark, **Back** – 11" Roped Edge cake plate, $15-20; 10" GC mixing bowl, $25-35; Virginia utility plate, $25-35; **Center** – Bump Handle teapot, $35-50; 7" H green trim coffeepot, $35-50; 4" H paneled Ohio Jug creamer, $20-25; 5" H Ohio Jug, $25-35; 6" H Ohio Jug, $30-40; **Front** – Two spoons, $12-18 each; Skyscraper salt & pepper, $18-24 set; lifter, $15-20; custard, $3-5.

Helen, Assorted Shapes, no mark, **Top** – Skyscraper salt & pepper, $20-25 set; Virginia utility plate, $12-18; 9" GC refrigerator bowl, $24-30; **Bottom** – 10" L GC refrigerator jug, $30-40; lifter, $12-18; 6" H paneled Ohio Jug, $25-30; fork, $15-20; 7" H paneled Ohio Jug (no lid), $20-25.

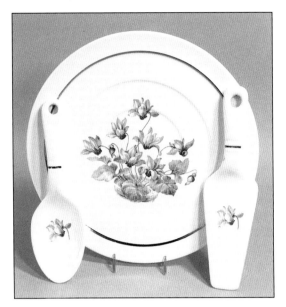

Pink Cyclamen, no mark, 11" Concentric Rings Cheese Plate, $25-35; spoon, $15-20; lifter, $15-20.

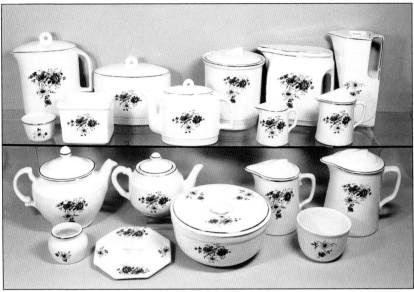

Emmy, Assorted Shapes, no marks unless noted, **Top** – custard, $2-4; 9" H Modern Age jug, $30-40; 4" H GC rectangular refrigerator bowl (no lid), $8-12; 8" W Modern Age cookie jar, $18-24; 9" L Modern Age teapot, $25-35; 8" H Zephyr lid cookie jar, $25-30; 3" H Paneled Ohio Jug creamer, $8-12; Square Body Jug, $40-50; 5" H Zephyr lid Ohio Jug, $20-25; Hi-rise Jug, $40-50; **Bottom** – GC coffeepot, $35-45; Bean Pot, $4-6; Trivet, MK 36, $40-50; Bump Handle teapot, $25-35; 9" W Zephyr casserole, $30-40; 7" H Zephyr lid Ohio Jug, $30-40; 3" H GC bowl, $8-10; 8" H Zephyr lid Ohio Jug, $35-45.

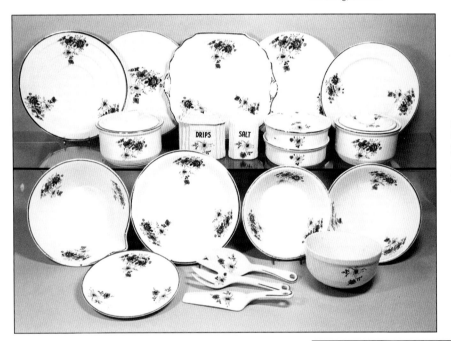

Emmy, Assorted Shapes, no mark, **Top** – Concentric Rings Cheese Plate (3 small decals), $12-18; 6" Zephyr lid covered dish, $12-18; Concentric Rings Cheese Plate (1 decal), $12-18; Virginia utility plate, $12-18; Skyscraper Drips & salt, $25-35; Concentric Rings Cheese Plate, (3 large decals), $12-18; paneled 2 stack dish set, $18-24; 10" plate, $5-8; 4" H covered dish, $18-24; **Bottom** – 10" spout mixing bowl, $18-24; 8" plate, $3-5; 10" pie baker, $8-12; 3 PC Utensil Set, lifter, fork, & spoon, $35-50; 8" bowl, $8-12; 6" Zephyr bowl, $8-12; 9" mixing bowl, $10-15.

Blue Roses, Assorted Shapes, MKs 37, 44, 45, & 90, **Top** – 10" pie baker, $20-25; Bump Handle teapot, $40-50; 11" Rosemere platter, $15-18; 6" W creamer, $8-12; Virginia utility plate, $20-25; 6" W sugar, $10-15; 14" platter, $12-18; 8" Zephyr bowl, $12-18; **Bottom** – 10" plate, $5-8; Trivet, $35-45; 9" mixing bowl, $12-18; 9" pie baker, $18-24; fork, $15-20; spoon, $12-18; 10" spout mixing bowl, $20-25; Skyscraper salt, $12-15; 10" mixing bowl, $25-35.

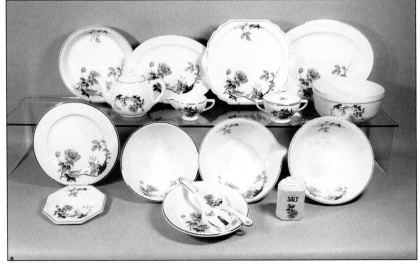

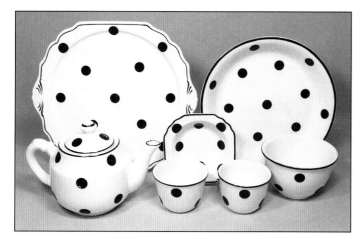

Black Polka Dots, Assorted Shapes, MKs 43, 45, 90A & 180, 6" Bump Handle teapot, $60-75; Virginia Utility Plate, $60-75; two custards, $15-20 each; 5" square bowl, $10-15; 10" pie baker, $40-50; 5" Handy Style bowl, $20-25.

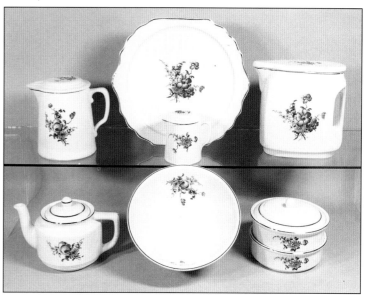

Painted Flowers, Assorted Shapes, no mark, **Top** – 6" Ohio Jug, $20-25; Virginia utility plate, $15-20; 4" H Ohio Jug creamer, $15-20; Square Body Jug, $30-40; **Bottom** – 8" L teapot, $25-40; 9" mixing bowl, $15-20, 2 stack dish set, $18-24.

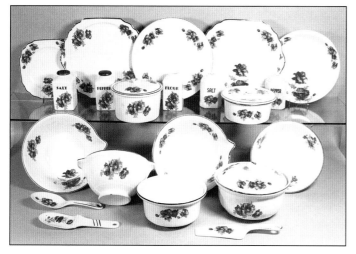

Red Poppies, Assorted Shapes, no marks unless noted, **Top** – 8" square plate, $8-12; 3 PC Crimp Top salt, pepper, & flour, $150-200 set; 5" covered dish, $30-35; Virginia utility plate (4 decals), $20-25; 11" Roped Edge cake plate, $15-20; Virginia utility plate (3 decals), $20-25; Skyscraper salt & pepper, $20-25; 3" H covered dish, $20-25; 10" pie baker, MK 34, $15-20; **Bottom** – 10" spout mixing bowl (3 decals), $20-25; spoon, $18-20; Modern Age spoon, $12-18; 9" W GC refrigerator bowl (no lid), $15-20; 7" W casserole (no lid), $18-24; 10" spout mixing bowl (4 decals), $20-25; lifter, $12-18; 8" W paneled Vent Lid casserole, $35-45; 9" mixing bowl, green trim, MK 31, $12-18.

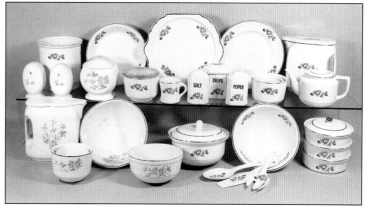

Sweet Pea & Forsythia, Various Shapes, no mark, **Top Back Row** – Sweet Pea, 7" H cookie jar (no lid), $15-20; 9" pie baker, $18-24; Virginia utility plate, $10-15; 10" plate, $4-6; Square Body Jug, $30-40; **Top Front Row** – Forsythia D-Ware Range Set, $30-40; 5" W Sweet Pea bowl (glass lid Embossed "Harker Kitchenware"), $12-18; 3" H mug, $15-20; Skyscraper Range Set, $35-45; 3 bowl set, 3", 4", & 5", $35-45; 9" L teapot, $25-35; **Bottom Row** – Forsythia Square Body Jug, $30-40; 2 bowl set, 4" & 5", $15-20; 9" mixing bowl, $10-15; 7" Zephyr bowl, $8-10; 8" W Sweet Pea casserole, $12-18; 3 PC utensil set, spoon, lifter, & fork, $35-45; 9" mixing bowl, $12-18; 3 Stack Dish Set, $30-40.

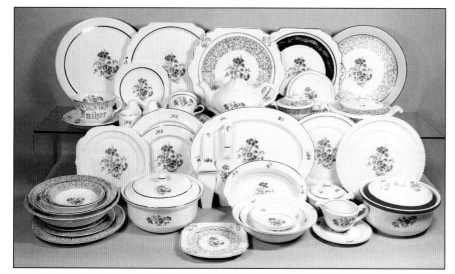

Tulip Bouquet, Various Shapes, MKs 77, 78, 79, 84, 87, 144, 177, 178, **Top Back Row** – $10-15 each, 11" Modern Age cake plate; Virginia utility plate; Virginia utility plate; Virginia utility plate; 11" Modern Age cake plate; **Top Front Row** – Jumbo Cup & Saucer, $20-30; 6" square plate, $3-5; 2" H toothpick holder, $10-15; Gadroon salt & pepper, $8-12; Gadroon cup & saucer, $8-12; 9.5" L Gadroon teapot, $35-45; 6" W Embassy sugar, $8-12; 6" Gadroon plate, $2-4; 10" W Embassy covered vegetable, $18-24; **Bottom Back Row** – 8" Gadroon square plate, $6-10; 8" & 10" plates, $3-5 & $6-10; 14" platter, $10-15; Modern Age lifter, $15-20; lifter, $12-18; Two 10" Gadroon plates, $8-12 each; **Bottom Front Row** – 5 bowl set, 5", 6", 7", 9", & 9.5", $25-35; 3 plate set, 6", 7", & 9", $10-15; 8" W casserole, $18-24; 6" square plate, $2-4; 9" oval bowl, $8-12; 3 bowl set, 5", 7", & 9", $15-20; 6" W Embassy sugar, $8-12; 6" plate, $2-4; 5" W Embassy creamer, $6-10; 8" W casserole, (red trim), $12-18.

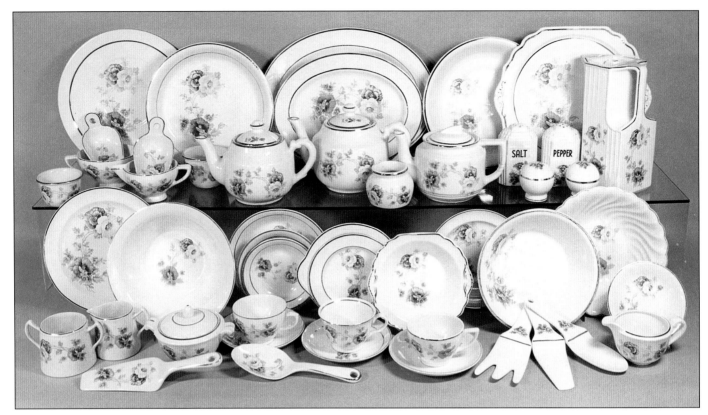

Amy I, Assorted Shapes, MKs 37, 38, & 45, **Top Back Row** – Concentric Rings Cheese Plate, $12-18; 10" pie baker, $15-20; 12" & 14" platters, $12-18 & $18-24; 10" pie baker, $12-18; Virginia utility plate, $15-20; **Top Front Row** – custard, $5-8; 6" W sugar (no lid), $8-12; scoop (flowers curve left), $35-45; 6" W creamer, $8-12; scoop (flowers curve right), $35-45; custard, $5-8; Bump Handle teapot, $40-50; 9.5" L Bump Handle teapot, $45-60; Bean Pot, $5-10; 8" L Zephyr lid teapot, $35-45; Skyscraper salt & pepper, $18-24; Ball salt & pepper, $8-12; Hi-rise Jug, $75-85; **Bottom Back Row** – 9" plate, $4-8; 9" bowl, $8-12; 3 bowl set, 6", 7", & 9", $20-30; 8" Nouvelle bowl, $8-12; 6" plate, $4-6; 7" Virginia (lugged) bowl, $8-12; 7" plate, $3-5; 8" bowl, $10-15; 9" Shell bowl, $12-18; **Bottom Front Row** – Gem sugar & creamer, $8-12 each; lifter, $15-20; 6" W Embassy sugar, $10-15; Nouvelle cup & saucer, $8-12; spoon, $12-15; Two cups & saucers, $8-12 each; 3PC Modern Age utensil set, fork, lifter, & spoon, $50-70; 5" W Embassy creamer, $10-15; 5" bowl, $3-5.

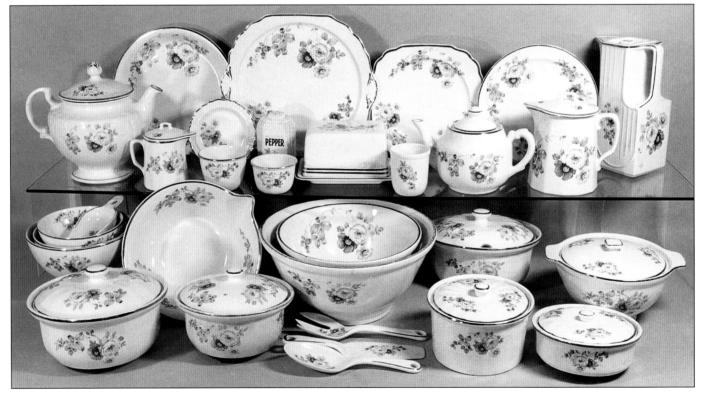

Amy II, Assorted Shapes, MKs 45, 46, 84, & 90, **Top Back Row** – 10" pie baker, $25-30; Virginia utility plate, $18-24; 9" square plate, $8-12; 9" plate, $8-12; Hi-rise Jug, $60-75; **Top Front Row** – 8" H Scrolled coffeepot, $70-80; 4" H paneled Ohio Jug creamer, $25-35; 5" Embossed edge ashtray, $8-12; custard, $8-10; GC custard, $5-8; Skyscraper pepper, $10-15; 7" L covered butter, $60-75; GC custard, $5-8; Bump Handle teapot, $50-60; 6" H paneled Ohio Jug, $40-50; **Bottom Back Row** – 3 Footed Bowl set, 5.75", 6.25", & 7.25", $50-75; scoop, $60-75; 10" paneled spout mixing bowl, $30-40; 10" & 12" mixing bowls, $30-40 & $35-45; 8" W paneled Notch Lid casserole, $30-40; 9" W GC refrigerator bowl, $25-35; **Bottom Front Row** – 8" paneled Vent Lid casserole, $30-40; 7" W paneled Vent Lid casserole, $30-40; 3 PC utensil set, spoon, lifter, fork, $40-60; 4" H paneled covered dish, $25-30; paneled stack dish, $15-20.

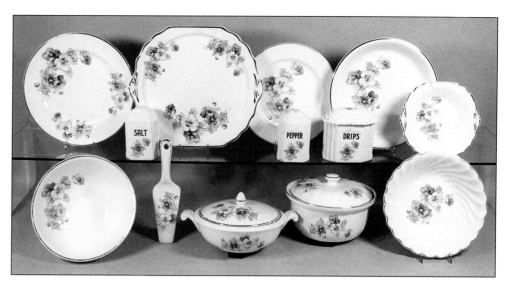

Taffy, Assorted Shapes, MKs 37 & 38, **Top** – 10" plate, $5-8; Virginia utility plate, $18-24; 9" plate, $4-6; 10" pie baker, $12-18; Skyscraper Range Set, $40-50; 7" Virginia bowl, $5-8; **Bottom** – 9" W GC mixing bowl, $12-18; lifter, $15-20; 10" W Embassy covered vegetable, $18-24; 8" W paneled Vent Lid casserole, $25-35; 12" Shell bowl, $15-20.

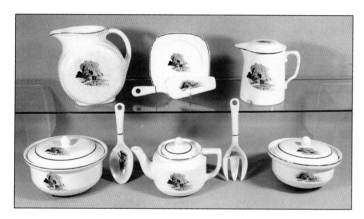

Coventry (Crooksville Decal), Assorted Shapes, no mark, **Top** – Round Body Jug, $20-30; 6" square plate, $2-4; lifter, $10-15; 6" H Ohio Jug, $20-30; **Bottom** – 8" W casserole, $20-25; spoon, $10-15; 9" L teapot, $50-60; fork, $12-15; 7" W casserole, $20-25.

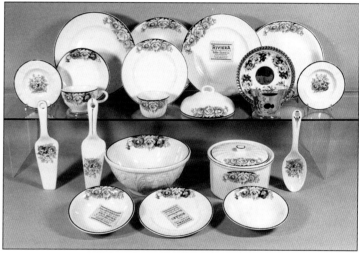

3 Pansies Decals, Assorted Shapes, MKs 45 & 159 (most no mark), **Top** – 5" Triangle Pansies embossed ashtray, $5-8; Straight Line Pansies cup & saucer, $20-25; 9" plate, $18-24; 9" bowl, $15-20; 7" plate, $8-10; custard, $10-15; 9" plate (theater give away – "Eddie Cantor In Kid Millions", $18-24; 6" butter top, $18-24; Gadroon Purple Pansies cup & saucer, $18-24; 9" Straight Line Pansies pie baker, $15-20; 5" Triangle Pansies embossed ashtray, $5-8; **Bottom** – Triangle Pansies lifter, $15-20; lifter, $15-20; 6" Straight Line Pansies plate (theater give away – "Joe E. Brown In 6 Day Bike Rider", $18-24; 9" Scrolled mixing bowl, $25-30; 7" plate "Will Rogers In David Harum", $18-24; 4" H paneled covered dish (inside "Bing Crosby, Joan Bennett" & inside lid "Reckless With Jean Harlow & William Powell", $30-40; 6" bowl, $10-15; Triangle Pansies spoon, $18-24.

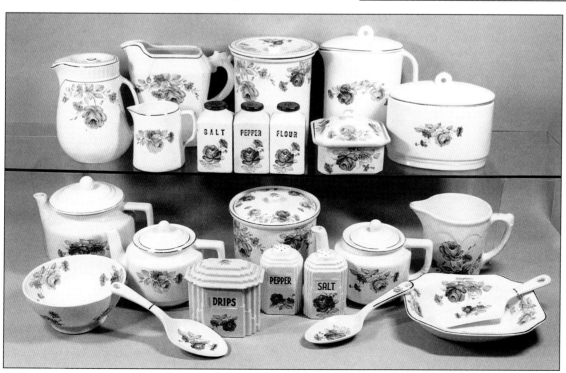

Anti-Q, Assorted Shapes, MKs 44, 45, & 46, **Top** – Bulbous Jug, $40 50; 4" H Ohio Jug creamer (no lid), $10-15; 8" H Gargoyle Jug, $45-60; 3 PC Crimp Top salt, pepper, & flour, $75-90; 8" H cookie jar, $45-60; 5" square covered dish, $30-40; 9" H Modern Age jug, $30-40; 8" W Modern Age cookie jar, $25-35; **Bottom** – 6" Footed Bowl, $18-24; 8" L coffeepot, $50-60; spoon, $12-18; 8" L teapot, $35-45; Skyscraper Range Set, $40-50; 6" H Canister, $30-40; spoon, $15-20; 8" L teapot (note additional Batchelor Buttons), $35-45; 9" L Melrose bowl, $18-24; lifter, $12-18; 5" H Arches Batter Jug (no lid), $30-35.

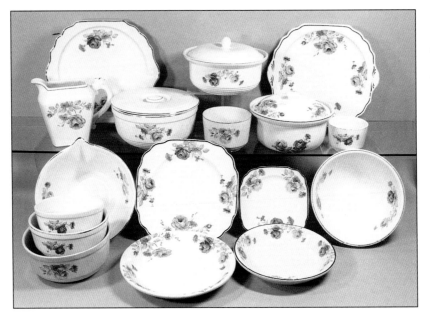

Anti-Q, Assorted Shapes, MKs 44, 45, & 90, **Top** – 6" H Gargoyle Jug, $35-45; Virginia utility plate (2 orange rose decals) $12-18; 9" W Zephyr casserole, $25-30; 8" casserole, $20-25; 5" W bowl, $5-10; 8" W Vent Lid casserole, $30-40; Virginia utility plate (4 yellow roses decals), $20-30; 4" W bowl, $8-12; **Bottom** – Zephyr 3 bowl set, 6", 7", & 7.5", $30-40; 10" spout mixing bowl, $35-45; 9" square plate, $10-15; 10" pie baker, $15-20; 7" square plate, $6-8; 9" pie baker, $12-18; 9" mixing bowl, $10-15.

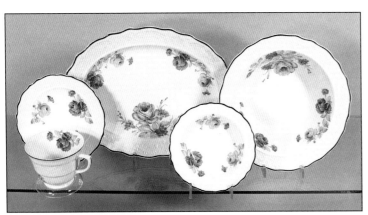

Anti-Q, Embossed Edge Shape, MK 90, cup & saucer, $12-18; 11" platter, $15-20; 5" bowl, $4-6; 9" bowl, $18-24.

Hostess Shape, Janice, MK 84, **Top** – 8" & 8.5" bowls, $5-10 each; 4" H sugar, $10-15; 16" platter, $18-24; 10" W covered vegetable, $20-25; 6", 7", & 9" plates, $4-8 each; **Bottom** – cup & saucer, $8-12; 9" oval bowl, $8-12; 5" bowl, $3-5.

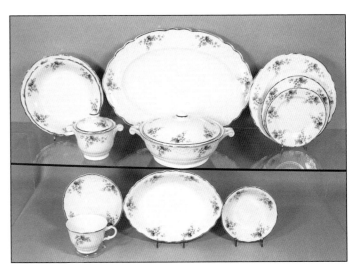

Hostess Shape, Shadow Rose, MKs 90 & 90A, cup & saucer, $10-15; 10" W covered vegetable, $25-35; 11" & 13" platters, $10-12 & $12-15; 3" H creamer, $5-8; 5" bowl, $3-5; 9" plate, $5-8; 4" H sugar, $10-15.

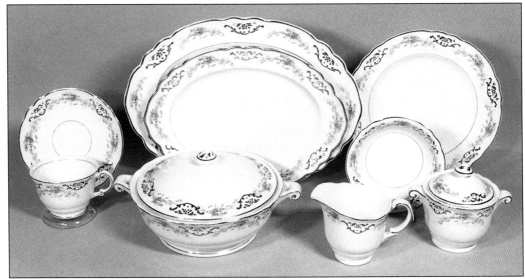

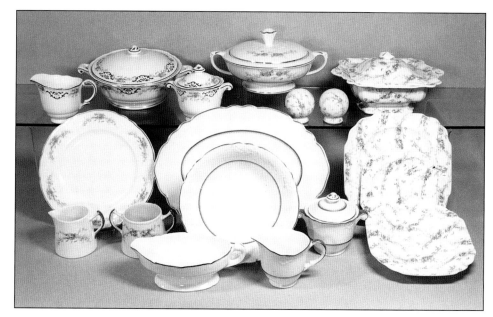

Assorted Decals & Shapes, MKs 31, 31B, 87, 90, & 90A, **Top** – 3" H Hostess gold embellished Shadow Rose creamer, $5-10; 10" W Hostess covered vegetable, $30-40; 5" H sugar, $10-15; 10" W Nouvelle Shadow Rose covered vegetable, $30-40; Ball Chintz Shadow Rose salt & pepper, $25-35 set; 10" W Virginia Chintz Shadow Rose covered vegetable, $40-50; **Bottom Back Row** – 9" Hostess Shadow Rose plate, $7-10; 13" Gold Wedding Band platter, $15-20; 6" & 9" square Chintz Shadow Rose plates, $6-10 & $18-25; **Bottom Front Row** – Gem Shadow Rose creamer, $8-12; Gem sugar, $8-12; unknown shape Gold Wedding Band gravy, $7-10; 8" Hostess bowl, $8-12; 3" H Hostess creamer, $8-12; 5" H Hostess sugar, $8-12; 7" square Chintz Shadow Rose bowl, $18-24.

Assorted Embossed Shapes, MKs 31A, 84, & 90, **Top Back Row** – 11" Rosemere Peony Spray platter, $15-20; 13" Hostess Janice platter, $10-15; 15" Rosemere Tri-color Roses Band platter, $18-24; 14" Hostess Tulip, Rose, & Mum platter, $12-18; 11" Rosemere Bird of Paradise platter, $5-10; **Top Front Row** – 10" W Rosemere Silver Wedding Band covered vegetable (also mark inside lid), $15-20; 5" W creamer, $5-10; gravy, $15-20; Hostess cup, $4-6; 6" W Embossed Edge Black Sailboat sugar, $8-12; 6" W creamer, $8-12; 5" W Rosemere Tri-color Roses Band creamer, $8-12; 6" W sugar, $8-12; 10" W covered vegetable, $15-20; **Bottom** – 6" Embossed Edge Pink & Yellow Mums sugar, $12-18; 11" platter, $8-12; 6" plate, $3-5; 6" W creamer, $12-18; 11" Rosemere Tri-color Roses platter, $8-12; 9" L oval bowl, $10-15; cup & saucer, $8-12; 3 plates, 6", 7", & 9", $4-8 each; gravy, $10-15; 9" under plate, $5-8; 5" & 8" bowls, $4-8 each.

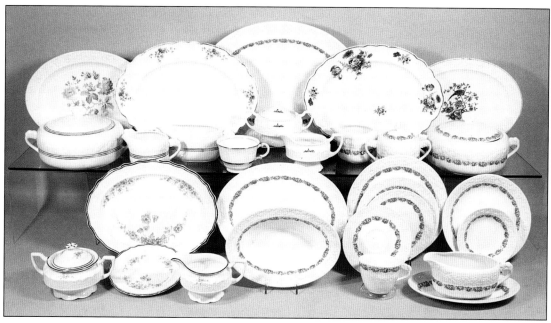

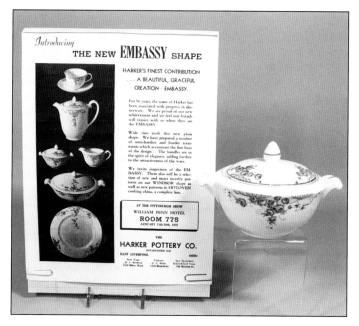

"New Embassy Shape" ad, Trailing Roses, MK 31A, 6" W sugar, $12-15.

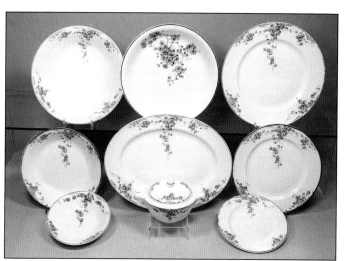

Trailing Roses I & II, Embassy, MKs 31A, 45, & 84, **Top** – 8" Bowl, $12-15; 9" Trailing Roses II pie baker, $10-15; 9" plate, $10-15; **Bottom** – 7" bowl, $8-12; 5" bowl, $7-10; 11" platter, $15-20; 6" sugar, $12-15; 6" plate, $2-4; 8" plate, $10-15.

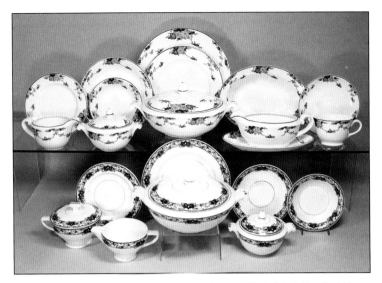

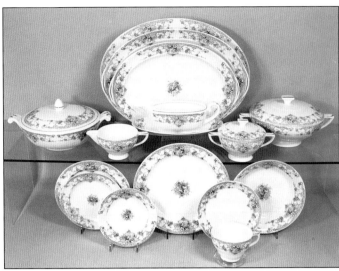

Embassy & Windsor Shapes, Vivid Spray & Ester, MKs 84 & 84A, **Top Back Row** – Embassy Vivid Spray, 6" plate, $2-4; 5" & 7" bowls, $2-4 & $5-8; 8" & 10" plates, $4-8 & $6-10; 9" oval bowl, $12-18; **Top Front Row** – 5" W creamer & 6" W sugar, $5-10 each; 10" W covered vegetable, $15-20; gravy, $8-12; 9" L under plate, $4-6; cup & saucer, $8-10; **Bottom** – Ester, 6" W Windsor sugar, $8-12; 6" plate, $2-4; 6" W Windsor creamer, $5-8; 10" W Embassy covered vegetable, $18-24; 8" plate, $3-5; 6" W sugar, $5-8; saucer, $2-4; 5" bowl, $2-4.

Arched Roses, Assorted Shapes, MKs 84 & 90, **Top** – 10" Embassy covered vegetable, $20-25; 6" Windsor creamer, $15-20; 15" platter, $20-25; 13" & 15" Nouvelle platters, $15-18 each; Embassy gravy, $8-12; 9" L under plate, $4-6; 6" W Windsor sugar, $15-20; 10" W covered vegetable, $20-25; **Bottom** – 6" & 7" plates, $3-5 each; 5" bowl, $4-6; 9" plate, $6-8; Nouvelle cup & saucer, $8-10; 7" bowl, $8-10.

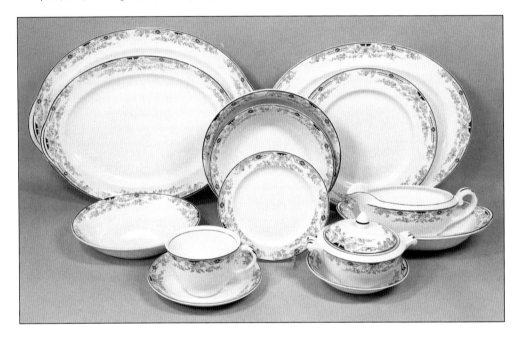

Carla decal, Embassy & Nouvelle Shapes, MKs 31B, 84, & 90, **Back Row** – 13" & 15" Nouvelle platters, $10-15 & $15-20; 7" & 8" bowls, $5-10 each; 14" platter, $10-15; 9" plate, $3-5; **Front Row** – 7" bowl, $8-10; Embassy cup & saucer, $5-8; 6" plate, $2-4; 6" W Embassy sugar, $5-10; 5" bowl, $2-4; Embassy gravy, $5-10; 9" Nouvelle oval bowl, $10-15.

Rose Band, Embassy Shape, MKs 84 & 84A, **Top** – 6" plate, $3-5; 7" bowl, $5-8; cup & saucer, $8-12; 15" platter, $15-20; 5" L creamer, $5-8; cup & saucer, $8-10; 6" W sugar, $8-10; 10" plate, $5-8; gravy, $8-12; 9" under plate, $8-10; 5" bowl, $2-4; **Bottom** – 10" Variation covered vegetable, $25-30; 9" oval bowl, $10-15; 10" covered vegetable, $25-30.

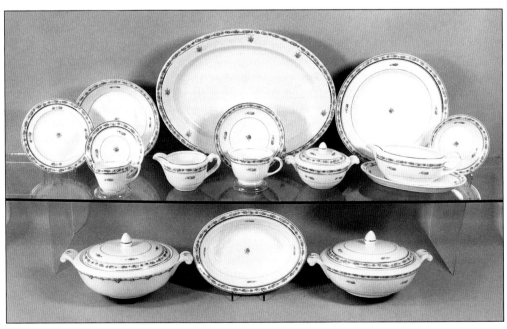

Trivets

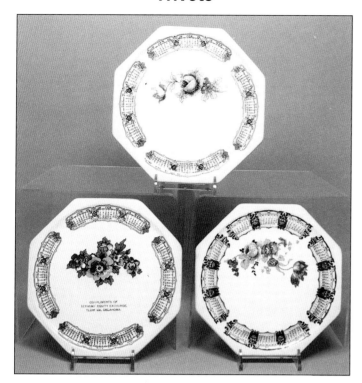

Calendar Trivets, MK 36, $35-50, **Top** – 1929 Roses; **Bottom** – 1929 & 1930 Multicolored Flowers.

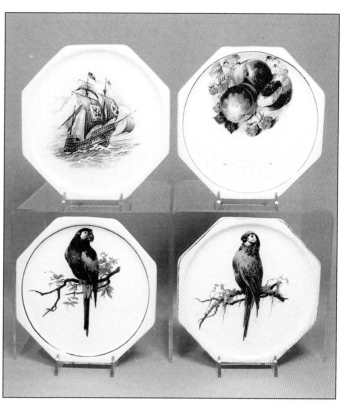

Trivets, MKs 31 & 36, $25-40 each, Sailing Ship; Peaches & Blackberries; Red Parrot; Blue Parrot.

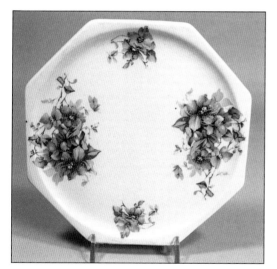

Pink & Blue Flowers Trivet, MK 36, $25-40.

Trivets, "Townsend Plan" (forerunner of Social Security), MK 36, $50-75 each.

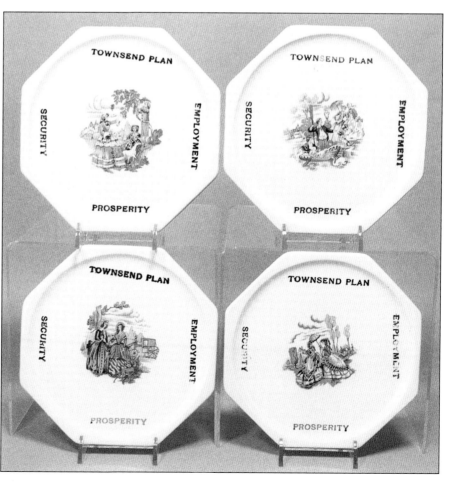

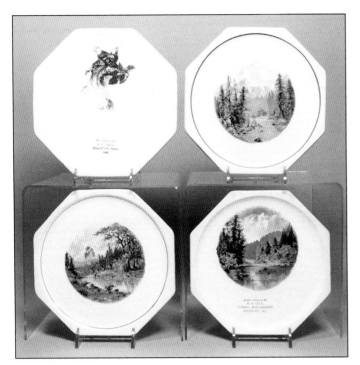

Trivets, MK 31, $20-30 each, 2 Birds (1933); 3 Wooded Scenes.

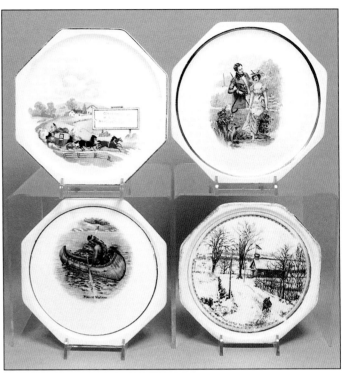

Trivets, MKs 31 & 36, **Top** – English Coach, $20-30; Courting Couple, $20-30; **Bottom** – "Placid Waters", $50-75; "The Little Red Schoolhouse", $20-30.

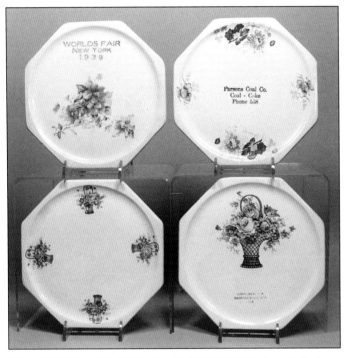

Trivets, MK 36, **Top** – "World's Fair, New York, 1939", $50-75; "Parson's Coal Co.", $50-75; **Bottom** – Flower Baskets, $15-25; Flower Basket "1934", $15-25.

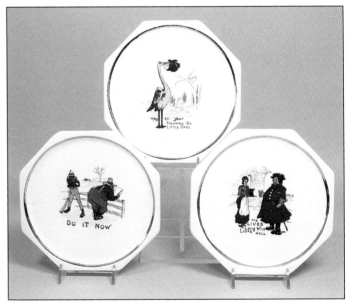

Trivets, MK 36, $30-40 each, "Do It Now"; "May All Your Troubles Be Little Ones"; "He Lives Long Who Lives Well".

Trivets, MK 36, $25-40 each, Boy & Dog At Sign; Dutch Boy & Dog.

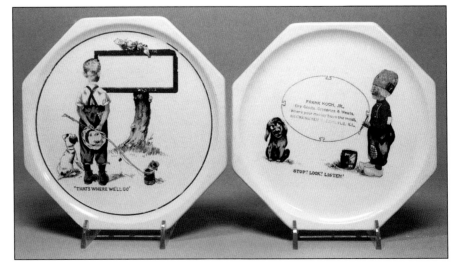

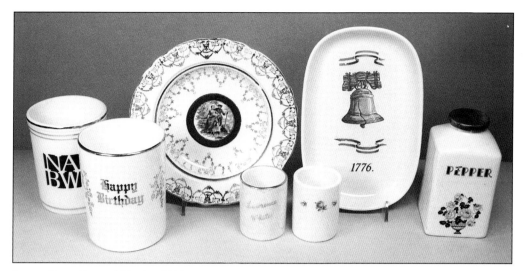

Assorted Items, **Top** – 4" H Tumbler "NABW 1969", MK 98B, $15-20; 4" H "Happy Birthday" Tumbler, MK 100B, $10-15; 7" Melrose Colonial Medallion plate, MK 31, $6-8; 2.5" H Pearlized toothpick holder, no mark, $20-25; 2.5" H Rose Spray toothpick holder, no mark, $20-25; 8" L TWA Airline meal tray, MK 111, $8-12; Yellow Roses & Black Leaves Crimp Top pepper, $25-30.

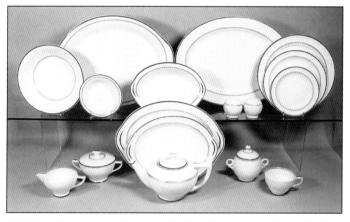

Red & Black Lines, Assorted Shapes, MKs 31B, 84A, & 90, **Top** – 8" bowl, $8-12; 16" Newport platter, $15-20; 5" bowl, $3-5; 9" Nouvelle oval bowl, $8-12; 16" Windsor platter, $15-20; Ball salt & pepper, $12-18 set; 6", 8", & 10" Windsor plates, $3-5 each; **Bottom** – 6" W Windsor creamer, $8-12; 6" W Windsor sugar, $10-15; 11" & 13" Nouvelle platters, $8-12 & $10-15; 9.5" L Windsor teapot, $45-60; 5" Newport sugar, $15-18; Nouvelle cup, $4-6.

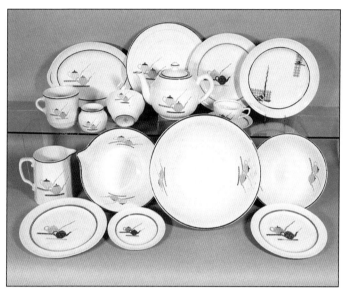

Whistling Teapots (3 decals), MK 44, 45, 46, 90, & 90A, **Top** – 4" H Whistling Teapots I (Yellow & Green) mug, $40-50; 11" Nouvelle platter, $12-18; Bean Pot, $10-12; 5" W bowl, $12-18; Concentric Rings Cheese Plate, $18-24; Bump Handle teapot, $70-90; 10" Whistling Teapots II (Red & Blue) plate, $8-12; cup & saucer, $12-15; 10" Blue Teapot plate, $12-15; **Bottom Back Row** – 5" H paneled Whistling Teapots I Ohio Jug (no lid), $25-35; 9" spout mixing bowl, $40-50; 12" mixing bowl, $45-60; 9" mixing bowl, $25-40; **Bottom Front Row** – 9" Whistling Teapots II plate, $8-12; 6" plate, $5-8; 8" plate, $8-12.

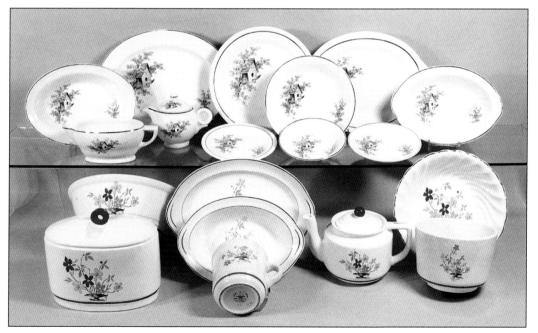

Birdhouse & Flower Basket, Assorted Shapes, MKs 38, 55, 84, 84B, & 85, **Top** – Birdhouse, 9" oval bowl, $10-15; gravy, $15-20; 12" platter, $10-15; 4" H Newport lidded creamer, $15-20; 6" Newport plate, $3-5; 9" plate, $12-15; 7" bowl, $10-15; 5" bowl, $5-8; 11" Nouvelle platter, $25-35; 6" saucer, $5-8; 9" Nouvelle oval bowl, $15-20; **Bottom** – 8" Modern Age Flower Basket cookie jar, $35-45; 9" Modern Age mixing bowl, $20-25; 11" Nouvelle platter, $8-10; 9" oval bowl, $8-10; 4" H mug, $20-30; 8" L teapot, $40-50; 9" Shell bowl, $12-18; 6" Modern Age bowl, $12-18.

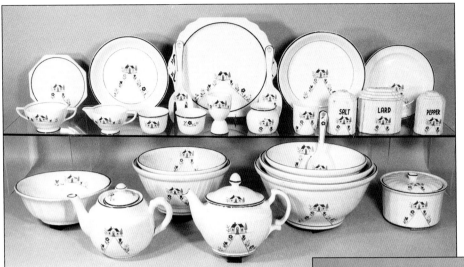

Honeymoon Cottage (a.k.a. Doll House), Assorted Shapes, MKs 45, 46, & 90, **Top Back Row** – Trivet, $35-45; 9" pie baker, $25-35; Virginia utility plate, $20-25; 10" pie baker, $25-30; 8" plate, $8-12; **Top Front Row** – 6" W Windsor sugar (no lid), $12-18; 6" W Windsor creamer, $15-20; custard, $8-10; fork, $18-24; custard, $8-10; 4" H egg cup, $20-25; Bean Pot, $10-15; spoon, $12-18; GC custard, $8-12; 3 PC Skyscraper Range Set, $45-60; **Bottom** – 9" fluted bowl, $25-30; Bump Handle teapot, $75-85; 9" & 10" GC mixing bowls, $20-25 each; 6.5" H GC coffeepot, $175-200; 3 PC mixing bowls set, 10", 11", & 12", $100-125; spoon, $12-18; 4" H paneled covered dish, $25-35.

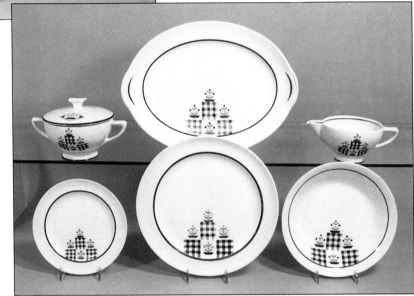

Checkered Stands, Windsor & Nouvelle Shapes, MK 90, **Top** – 6" W Windsor Blue Checkered Stands sugar, $20-25; 11" Nouvelle platter, $15-20; 6" W Windsor creamer, $15-20; **Bottom** – 6" Blue Checkered Stands plate, $4-8; 9" Red Checkered Stands plate, $6-10; 7" Blue Checkered Stands bowl, $10-15.

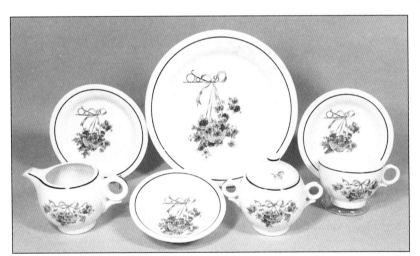

Newport Shape, Blue Ribbon Roses, no mark, 3" H creamer, $5-8; 6" plate, $2-4; 5" bowl, $2-4; 9" plate, $3-5; 4" H sugar, $8-10; cup & saucer, $8-10.

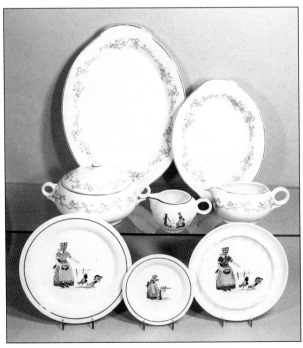

Pastel Flower Spray & Peasant, Newport, MKs 84 & 105, **Top** – 9" W Pastel Flower Spray covered vegetable, $25-30; 16" platter, $20-25; 5" W Peasant creamer, $10-15; 11" Pastel Flower Spray platter, $12-15; gravy, $12-15; **Bottom** – Peasant, 9" plate, $10-12; 6" plate, $8-12; 9" ashtray, $35-50.

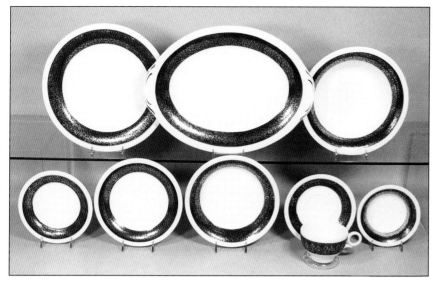

Blue Royal Dresden, Newport, **Top** – 10" plate, $4-6; 14" platter, $12-18; 9" Bowl, $8-12; **Bottom** – 6" plate, $2-4; 7" plate, $3-5; 8" bowl, $4-6; cup & saucer, $5-8; 5" bowl, $2-4.

Tarrytown, Newport, MK 102, 3" H creamer, $10-15; 6" plate, $5-8; 9" W covered vegetable, $25-35; 5" bowl, $5-8.

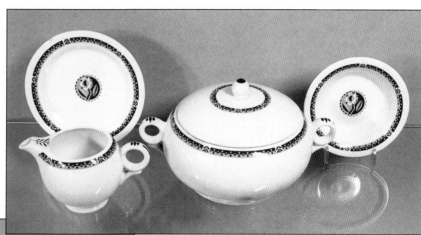

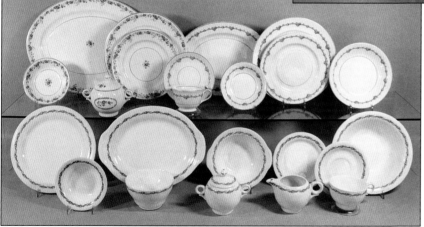

Rose Decals, Assorted Shapes, MKs 84 & 84A, **Top** – 5"Blue Lines Roses bowl, $2-4; 15" platter, $15-20; 4" H Newport Circle Roses sugar, $15-20; 8" & 10" Blue Lines Roses plates, $4-8 each; Thin Ribbon Roses cup & saucer, $8-10; 12" platter, $8-12; 5" bowl, $2-4; 8" & 10" plates, $5-8 each; 7" bowl, $5-10; **Bottom** – Newport, Rose Ribbon, 9" plate, $4-6; 5" bowl, $2-3; 12" platter, $8-10; 5" bowl, $3-5; 4" H sugar, $8-10; 7" lugged bowl, $4-6; 3" H creamer, $5-8; 6" plate, $2-4; cup & saucer, $6-8; 9" bowl, $8-10.

Duchess (a.k.a. Gold Wedding Band) & Multiple Wedding Bands, Newport unless specified, MKs 75 & 87, **Top** – 9" bowl, $5-8; 9" pie baker, $8-12; 5" H sugar, $6-10; Virginia utility plate, $8-12; Windsor Multiple Wedding Bands gravy, $15-20; 5" H creamer, $6-10; 3 plate set, 6", 7", & 9", $6-12; 6" bowl, $3-5; **Bottom** – cup & saucer, $4-8; 9" W Multiple Wedding Bands covered vegetable, $20-25; 8" W Zephyr Vent Lid casserole, $15-20; GC custard, $2-4; 5" bowl, $2-4;

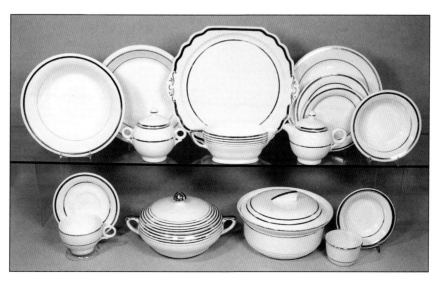

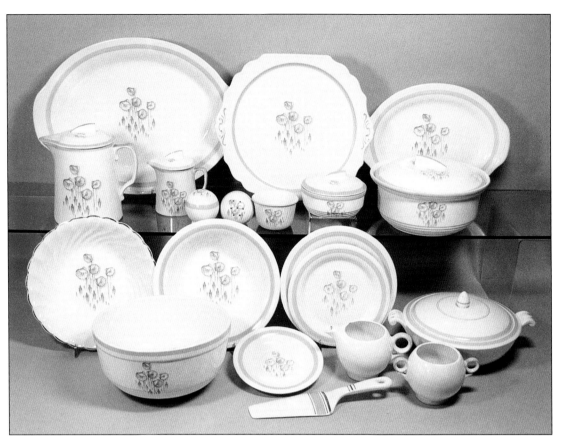

Pastel Posies & Celestial Blue, Assorted Shapes, MKs 31B, 38, 46, 47, 84, & 174, **Top Back Row** – 16" Newport Pastel Posies platter, $35-45; Virginia utility plate, $25-35; 12" Newport platter, $18-24; **Top Front Row** – Pastel Posies, 7" H Zephyr lid Ohio Jug, $35-45; 4" H Zephyr lid Ohio Jug creamer, $30-40; Ball salt & pepper, $20-25 set; GC custard, $8-10; 5" W Zephyr lid Cheese Dish, $25-35; 8" W casserole, $40-50; **Bottom** – 9" Pastel Posies Shell bowl, $35-45; 9" Zephyr bowl, $25-35; 9" Newport bowl, $35-45; 6" Newport plate, $5-8; Blue Trim lifter, $8-12; 7" & 8" Pastel Posies plates, $5-10 each; 3" H Newport Celestial Blue creamer, $5-8; 3" H Newport Celestial Blue sugar (no lid), $5-8; 10" W Embassy blue covered vegetable (marked inside lid), $25-35.

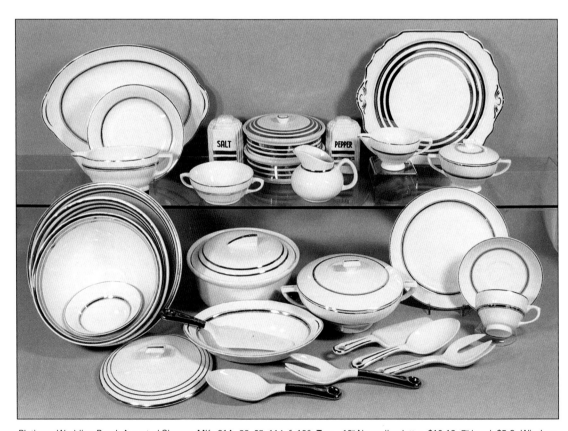

Platinum Wedding Band, Assorted Shapes, MKs 31A, 33, 35, 114, & 120, **Top** – 13" Nouvelle platter, $12-18; 7" bowl, $5-8; Windsor gravy, $12-18; 6" Nouvelle Cream Soup, $15-20; Skyscraper salt & pepper, $15-20; 2 stack dish set, $18-24; 4" H creamer, $5-10; 6" W Windsor creamer, $8-12; Virginia utility plate, $12-18; 6" Windsor sugar, $8-12; **Bottom** – 9", 10", & 11" mixing bowl set, $40-60; 5" bowl, $2-4; 7" W Windsor lid only, $5-8; 7" Zephyr Vent Lid casserole, $10-15; 9" L Nouvelle oval bowl, $5-10; 3 PC Platinum Handled utensil set, $30-45; 10" W Windsor covered vegetable, $20-30; 3 PC utensil set, $30-45; 9" plate, $5-8; Nouvelle cup & saucer, $10-15.

1939 – 1959

In 1939, Harker introduced the Modern Age shape. This shape was intended to mark Harker's 100 year anniversary of continuous operation from 1840 to 1940. The Modern Age shape featured vertical arrow shafts and feather vanes impressed into the sides of bowls, cake plates, and hollowware, and "life-saver" finials on the lids. The Modern Age backstamp also features arrow shafts and feathers. We have never found an explanation for Harker's frequent use of a bow and arrow, or just arrows, in their marks and on their pottery. Harker chose some of its most popular Hotoven decals to introduce their Modern Age shape. Decals used on the Modern Age shape for 1940 were Petit Point Rose, English Ivy, Modern Tulip, Flower Basket, Tulip (a.k.a. Shaggy Tulip or Ruffled Tulip), Navajo (a.k.a. Wampum), Monterey, Spring Meadow, and Mallow. Red Apple II and Calico Tulip decals were also used on the new Modern Age shape. Many of these items may be marked with the Modern Age or Hotoven backstamps, as several of the decals were first offered with the earlier Hotoven line, still in production. Generally, we have tried to keep same-decal items together. Keep in mind, a popular decal could and often was used on a variety of shapes for an extended period of time.

When the Bennett Pottery in Baltimore closed in 1936, German immigrant George Bauer brought his patented cameo process to Harker, where it was first used in 1940, in a pattern called Dainty Flower. Local old-timers will tell you that Cameo Ware was first made by dipping a piece of greenware in blue glaze. Then a copper shield (stencil) was placed against the piece. The over-glaze was sandblasted away using ground up walnut shells under pressure, to expose the original white body of the piece. We don't know if this method was really used. We do know that a custom-built spray machine was ordered from the Switzer Company, especially for the Cameo Ware line. Dupont supplied the Cameo blue color. Copper masks were placed on greenware and three thin coats of glaze were sprayed on each item. The mask was then removed, exposing the design on the underbody. A whole new department was created at Harker Pottery to manufacture Cameo Ware. At its peak, one hundred, twenty-five dozen pieces of Cameo Ware per hour could be produced.

Intaglio is the technical name for the Cameo Ware process, meaning a design that has been carved into the surface. In June of 1941, pink Cameo Ware was introduced. Dainty Flower was made primarily in blue and pink, but yellow and teal green also went into

regular production. We also own rare Dainty Flower items in chartreuse, gray, and pumpkin. Kathy Eberling, a Boyce family descendant, owns a gorgeous set of black Dainty Flower mixing bowls, which were made only for the family. Carv-Kraft White Rose, in both blue and pink, was marketed exclusively through Montgomery Ward. This intaglio process was used by Harker on Cameo Ware, on their Wild Rice line in blue, gray, and salmon, and on many later intaglio patterns offered on their stoneware. A plain blue body, with no intaglio carving, was marketed as "Delft", but is marked with their American Engobe mark (MK52).

The Gadroon shape was introduced in 1946. The first colors were Celedon ("Chinese gray green"), Charcoal ("gray black"), Chesterton ("silver mist gray"), and Corinthian ("teal green"). Jack Nichols was the color shed engineer responsible for these colors. In 1948, Harker introduced Cameo Shellware, featuring swirl-shaped bowls, creams, sugars, and cups and saucers. Harker utilized this shape just a little later, bearing popular decals on white bodies. Also in 1948, Harker began calling the Gadroon shape "Royal Gadroon". This name change applied to plain colored as well as decal ware. This shape can be found with a variety of Royal Gadroon, Pate Sur Pate or other marks. The new decals featured on Royal Gadroon in 1949 were Bermuda, Bouquet, Bridal Rose, and Sweetheart Rose (a.k.a. Shadow Rose).

The famed modern designer Russel Wright designed his first decorated dinnerware, White Clover, for Harker Pottery. White Clover was manufactured from 1953 to 1958. The shapes and colors (Meadow Green, Coral Sand, Golden Spice, and Charcoal) were widely advertised as being both pleasing and "sensible". Harker sold Russel Wright clock faces in all four colors to General Electric. It has been said that the Russel Wright line was produced for such a short time because Harker reportedly refused to ship less than a full boxcar load to California, where this ultra-modern line would have sold best.

Mr. Nichols formulated a new color for the Gadroon shape in 1951 – Chicory (dark brown). Later colors on Gadroon shape were Sun Valley (Chartreuse, see MK72), Bermuda Blue (MK53), Pink Cocoa (beige), Pumpkin, Avocado, Charcoal with pink interiors, White, White with both gold and platinum burnished edges, Pink, and two shades of Yellow, one called Golden Harvest. This same year, Harker introduced the Gadroon pitchers, tumblers, divided vegetables, and double eggcups. Utilizing the pumpkin

and yellow colors, Harker produced a line called Barbeque. It was supposed to look like mustard and catsup on the swirl shapes. The year 1951 also saw the advent of the lovely Aladdin shape, with its tab-handled platters and gently shaped hollowware. The Aladdin teapots were particularly pleasing.

The year 1955 was a busy year at Harker Pottery. In January, *Retailing Daily* took a buyer preference survey. Eighty stores in twenty-seven key cities were polled. Of twenty-nine domestic potteries listed, only Franciscan and Homer Laughlin were preferred over Harker Pottery.

We believe Laurelton shape was introduced in 1955. The glazing process was similar to the colored Gadroon shaped items. Greenware was sprayed with the appropriate color. Then the laurel wreath edges were lightly hand-wiped, leaving color in the recesses of the wreath. Laurelton has the distinction of having two creamer shapes. The first has the laurel leaf imprint on a curved open handle. The second creamer shape has no leaves at all. It simply matches the teapot and salt and pepper shapes. Laurelton hollowware is white on the outside and colored on the inside with colored laurel leaf rimmed lids.

The labor-intensive Seafare stoneware was also introduced in 1955. Each piece has three glaze colors, hand applied, to complete the Seafare pattern. Russel Wright designs were in full production at this time. In August, Wild Oats (commonly known as Donna) was introduced on the new Aladdin shape. Aqua Abstract (intaglio boats) was also introduced on this new shape. In September, Harker introduced their Aluminum Foil-Cover Casseroles in two stone china sizes, to utilize the recently invented aluminum foil. In October, Harker came out with a smaller size, they advertised as customer requested. These heavy baking casseroles were produced in 1.5 quart, 2.5 quart, and 4 quart sizes in golden dawn, white cap, blue mist, and shell pink.

Contadinesca, Harker's accessory line for their stone china baking and dinnerware, was introduced in 1956. This line included salts, peppers, drips, pitchers in two sizes, various sized covered casseroles, rolling pins, pie bakers, bean pots, the foil-covered casseroles, vinegar and oil sets, salad sets, and eventually, carafes, creamers, sugars, butters, coffee pots, gravies (oval bowls) with small ladles, and even ash trays. All of these items were produced in the colors of the foil-covered casseroles. The Coupe shape was also introduced in 1956. The first decals used on this new shape were Golden Bows and Harmony. That year Harker marketed Christmas decals on both the Gadroon and Coupe shapes. In 1956, President Robert E. Boyce wrote a letter to his employees, outlining his concerns about the decreased earnings of the company, in spite of their best efforts. He wrote, "We have invested consider-

able money in new items, new lines, new designs, which do not seem to be the answer. WE HAVE NOT GIVEN UP ON DINNERWARE…" Mr. Boyce was telling his employees that Harker Pottery was going to try to produce sanitary ware, sinks, and toilets. This venture must not have proved successful, as the only references we have are Mr. Boyce's letter and a copy of an advertisement.

Harker introduced a plethora of stoneware in 1957. Tutti Fruit was a decal on Coupe shape stoneware. Orange Tree was an intaglio design with dots of yellow slip for the oranges. Collectors commonly call this Lemon Tree because the dots are yellow. Interestingly, we own plates with both pink fruit and blue fruit. Neva Colbert, author of *The Collectors' Guide to Harker Pottery*, called these "Forbidden Fruit". Other intaglio designs introduced in 1957 were Brown-Eyed Susan, Rocaille, Alpine, Daisy Lane (daisies with blue center), Viking (white diamonds on yellow), and Ivy Lace. A green stoneware set with a plain white border was called Holiday.

Heritance shape, with its classic panels, was introduced in 1958 in plain white, and with Country Garden, Blue Dane, and Petit Fleurs decals. Several new Christmas decals were introduced in 1958.

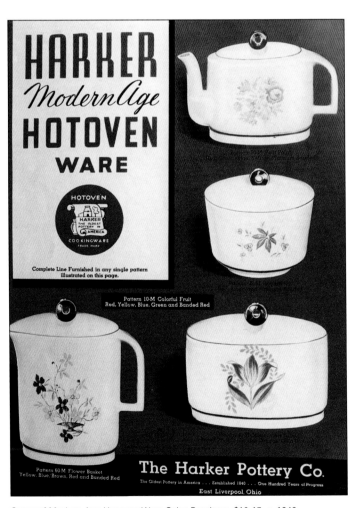

Cover of Modern Age Hotoven Ware Sales Brochure, $10-15, c. 1940.

The year 1959 was another busy year at Harker. Their new decals, Cynthia, Flora, Heaven Pink, Rosebud Bouquet, and Cortland decals were used on both the Royal Gadroon shape and the new Whitechapel Translucent China. Although these shapes look similar, the translucent china is real china, finer and harder than the clays Harker had been utilizing. Harker Pottery was also producing thousands of ash trays in a wide variety of shapes, assorted two and three tier tidbit trays, and assorted hostess pottery with brass holders and/or handles. Godey and the lovely Wild Rose decals were introduced on Royal Gadroon. Shellridge translucent china was also introduced in 1959. The first decals seen on this new translucent china shape were Forest Flower, Leaf Swirl, Forever Yours, and Garden Trail.

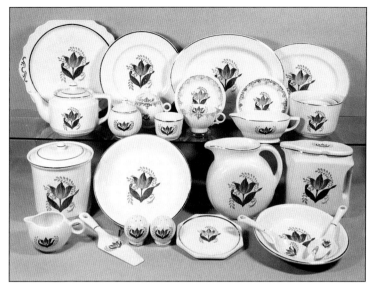

Modern Tulip, Assorted Shapes, MKs 38 & 47, **Top** – Virginia utility plate, $10-15; 9" L teapot, $25-35; 10" plate, $4-6; 4" ball sugar, $5-8; 5" H Newport sugar, $5-8; 3" H bowl, $4-6; 13" platter, $8-12; Newport cup & saucer, $4-8; Windsor gravy, $5-10; 6" plate, $2-4; 12" platter (MK 38 & Homer Laughlin backstamp), $5-8; 3 bowl set, 4", 5", & 6" W, $15-25; **Bottom** – 3" H ball creamer, $5-8; 8" H cookie jar, $50-60; lifter, $8-12; 10" pie baker, $18-24; Ball salt & pepper, $12-18 set; Trivet, $25-30; Round Body Jug (no lid), $25-35; spoon, $8-12; fork, $15-20; 9" pie baker, $10-15; Square Body Jug, $35-40.

5" L 100 Year Anniversary Ashtray, "100 Years of Progress", MK 158, $35-50.

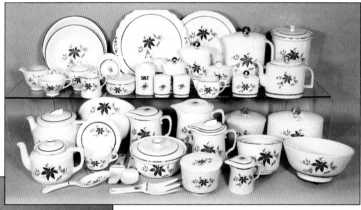

English Ivy, Assorted Shapes, MKs 37, 55, & 84A, **Top Back Row** – 9" & 10" pie bakers, $18-24 each; 5" L Modern Age ashtray, $20-30; Virginia utility plate, $35-40; 7" H Modern Age jug, $30-40; Concentric Rings Cheese Plate, $12-18; 9" H Jug, $40-50; 8" H cookie jar, $60-70; **Top Front Row** – 6" H Newport creamer, $10-15; 6" Windsor creamer, $10-15; 5" W Newport sugar, $10-15; Gem creamer, $8-12; Cheese Dish, $30-40; Skyscraper salt & pepper, $18-24; Modern Age salt & pepper, $6-10; 5" H Modern Age creamer, $25-35; 5" W creamer, $6-10; 4" W Modern Age sugar, $18-24; 4" W sugar (silver top), $18-24; 9" L teapot, $35-45; **Bottom Back Row** – 7" H Zephyr Lid coffeepot, $50-75; Modern Age cup & saucer, $20-30; 9" mixing bowl, $15-20; 6" H Ohio Jug, $50-60; 7" H Ohio Jug, $50-60; 5" H Modern Age covered bowl, $45-60; 8" W Modern Age cookie jar, $40-50; **Bottom Front Row** – 8" L teapot, $40-50; spoon, $10-15; 3 PC Modern Age utensil set, lifter, spoon, spaghetti fork, $45-60; 7" W casserole, $20-25; 3" H Modern Age covered bowl (flat lid), $20-30; 7" H Zephyr lid Ohio Jug, $35-45; 4" H Ohio Jug creamer, $25-35; 3 bowl set, 3", 5", & 6", $24-30; 9" Modern Age bowl, $20-25.

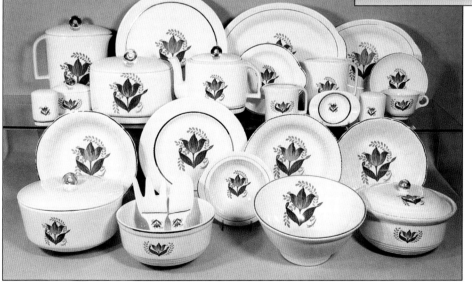

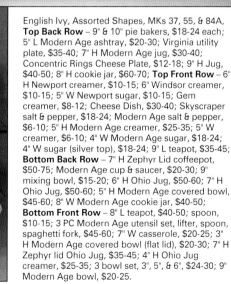

Modern Tulip, Modern Age shape unless noted, MKs 38, 55, & 84A, **Top Back Row** – 9" H jug, $30-40; 11" cake plate, $12-18; 14" Newport platter, $10-15; 12" Newport platter, $8-12; **Top Front** – salt, $4-6; 4" H sugar, $8-12; 8" L cookie jar, $20-30; 9" L teapot, $30-40; 8" lugged plate, $3-5; 4" H creamer (no lid), $3-5; 6" H jug (no lid), $15-20; 5" ashtray, $5-8; pepper, $4-6; cup & saucer, $5-8; **Bottom Back Row** – 9" Embossed bowl, $12-18; 10" plate, $5-8; 9" slight swirl Embossed bowl, $15-18; 9" Embossed Petal Edged bowl, $8-12; **Bottom Front Row** – 9" W covered vegetable, $25-35; 8" Zephyr bowl, $10-15; fork, $15-20; spoon, $15-20; 7" Newport lugged bowl, $8-12; 9" mixing bowl, $12-15; 8" casserole, $18-24.

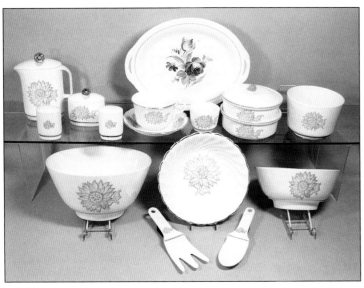

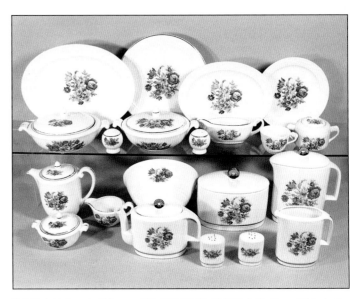

Pastel Sunflower & Spring's Beauty, Modern Age unless noted, MKs 38, 55, & 84A, **Top** – 7" H Pastel Sunflower Modern Age jug, $30-40; salt & pepper, $12-18 set; 4" W sugar, $12-18; Jumbo Cup & Saucer, $50-60; 14" Newport Spring's Beauty platter, $30-35; Modern Age Pastel Sunflower custard, $8-12; 2 stack dish set, $25-35; 6" W bowl, $20-25; **Bottom** – 10" Modern Age bowl, $35-45; fork, $18-24; 9" Shell bowl, $30-40; 8" Modern Age spoon, $18-24; 9" bowl, $30-40.

Petit Point I, Assorted Shapes, MKs 31B, 37, 38, 55, 84A, & 90, **Top** – 10" Embassy covered vegetable, $25-30; 14" Rosemere platter, $20-25; Ball salt & pepper, $18-24 set; 10" Embassy covered vegetable, $25-30; 11" Modern Age cake plate, $15-20; 11" Rosemere platter, $15-20; Embassy gravy, $10-15; Rosemere cup, $3-5; 9" plate, $8-12; 4" H sugar, $12-18; **Bottom** – 7" H Embassy teapot, $25-35; 6" W sugar, $12-15; 5" L creamer, $5-10; 9" L Modern Age teapot, $25-35; 9" mixing bowl, $20-25; Modern Age salt & pepper, $8-12 set; 8" W cookie jar, $40-50; 6" H jug (no lid), $10-15; 9" H jug, $40-50.

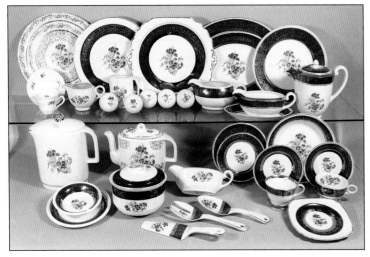

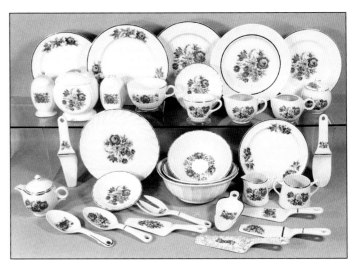

Tulip Bouquet & Tulip Bouquet on Royal Dresden, Assorted Shapes, MKs 56, 73, 74, 76, 77, 84A, & 150, **Top Back Row** – Concentric Rings Cheese Plate, $15-20; Concentric Rings Royal Dresden Cheese Plate, $15-20; Virginia utility plate, $10-15; 12" & 14" platters, $10-15 each; 10" plate, $5-10; **Top Front Row** – Tulip Bouquet Variation demitasse cup & saucer, $8-12; 6" W Newport Tulip Bouquet creamer, $5-8; Five Ball salt & peppers, 3 different decals, $4-6 each; 4" H Modern Age creamer (no lid), $5-8; Newport Royal Dresden Tulip Bouquet gravy, $10-15; Embassy Royal Dresden Tulip Bouquet gravy, $12-15; 9" under plate, $5-8; 7" H Embassy teapot, $30-40; **Bottom Back Row** – 9" H Modern Age Tulip Bouquet jug, $35-45; 8" L Modern Age teapot, $35-45; Embassy gravy, $8-10; 6" & 7" Royal Dresden plates, $7-10 each; cup & saucer, $5-8; 9" bowl, $8-12; Newport cup & saucer, $5-8; **Bottom Front Row** – 7" plate, $3-5; 5" bowl, $2-4; 5" H Zephyr lid Blue Royal Dresden casserole, $15-20; 3 PC Royal Dresden utensil set, lifter, fork, & spoon, $35-45; 6" square plate, $4-6.

Petit Point I & II, Assorted Shapes, MKs 38, 45, 47, 55, 84, & 84A, **Top Back Row** – 9" Petit Point II plate, $3-5; 10" plate, $5-8; 10" Petit Point I plate, $5-8; 10" plate, $5-8; 9" plate, $3-5; **Top Front Row** – D-Ware Range Set, $25-40; Jumbo Cup, $8-12; Shell cup & saucer, $10-15; 5" L Shell creamer, $5-8; 5" L ball creamer, $5-10; 4" H ball sugar, $8-12; **Bottom Back Row** – Modern Age lifter, $12-18; 9" Shell Petit Point I plate, $3-5; 3 PC fluted bowl set 7", 8", & 9", $45-60; 8" Petit Point II plate, $3-5; Modern Age spoon, $12-18; **Bottom Front Row** – 6" L Newport covered creamer, $10-15; spoon, $10-15; 3 PC utensil set spoon, lifter, & fork, $30-45; 5" Shell bowl, $2-4; Gold Filigree lifter, $10-15; scoop, $60-75; Petit Point House (Crooksville decal) lifter, $10-12; lifter, $10-15; Gem creamer, $10-15; Gem sugar, $10-15.

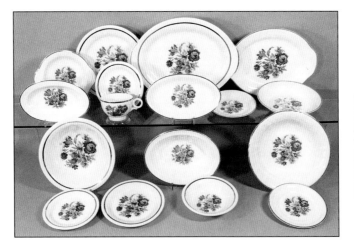

Petit Point I, Assorted Shapes, MKs 38, 84A, & 175, **Top** – 8" L under plate, $3-5; 8" Nouvelle plate, $5-10; 9" Newport plate, $5-8; Newport cup & saucer, $4-8; 14" Newport platter, $8-12; 9" under plate, $5-10; 6" Green Trim Newport plate, $3-5; 11" Green Trim Newport platter, $10-15; 8" Green Trim bowl, $5-10; **Bottom** – 9" Newport bowl, $8-12; 6" plate, $2-4; 7" plate, $3-5, 9" oval bowl, $8-10; 6" bowl, $3-5; 9" Embossed edge bowl, $10-15; 6" plate, $2-4.

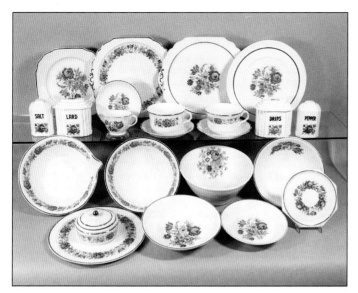

Petit Point I & II, Assorted Shapes, MKs 37, 38, 43A, 45, 46, 47, & 84A, **Top Back Row** – 9" Petit Point I square plate, $10-12; Petit Point II Virginia utility plate, $15-20; Petit Point I Virginia utility plate, $15-20; Concentric Ring Cheese Plate, $20-25; **Top Front Row** – Skyscraper Range Set, $35-45; cup & saucer, $7-10; Petit Point I Jumbo Cup & Saucer, $25-35; Petit Point II Jumbo Cup & Saucer, $25-35; Skyscraper Drips, $20-25; **Bottom** – 10" Petit Point II spout mixing bowl, $40-50; Concentric Rings Cheese Plate & 5" W cheese dish, $50-65 set; 9" mixing bowl, $25-35; 8" Petit Point I bowl, $8-12; 9" Virginia Petit Point (Crooksville decal) mixing bowl, $12-18; 7" Petit Point I bowl, $8-12; 9" mixing bowl, $20-30; Petit Point II Trivet, $25-35.

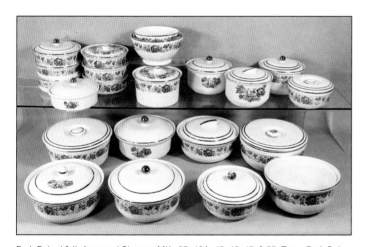

Petit Point I & II, Assorted Shapes, MKs 37, 43A, 45, 46, 47, & 55, **Top** – Petit Point II 3 stack dish set, $25-35; Petit Point I covered dish, $15-20; Petit Point II 3 stack dish set, $30-40; 3 PC set Footed Bowls 6", 6.5", & 7.25", $60-80; 4" H paneled covered dish, $25-35; 5" H Petit Point I (small decal) covered dish, $20-30; 4" H (large decal) Zephyr lid covered dish, $20-30; 5" H Petit Point II covered dish, $20-30; 3" H Zephyr covered dish, $19-24; **Bottom Back Row** – 9" W Petit Point II Zephyr casserole, $35-45; 8" W Petit Point I casserole, $30-40; 8" W Petit Point II Zephyr lid casserole, $30-40; 9" W Zephyr casserole, $50-60; **Bottom Front Row** – 8" W Petit Point II casserole, $35-45; 8" W casserole, $25-35; 7" W casserole, $30-40; 8" W paneled casserole (no lid), $15-20.

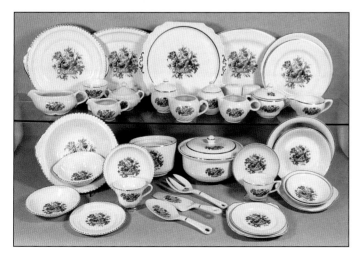

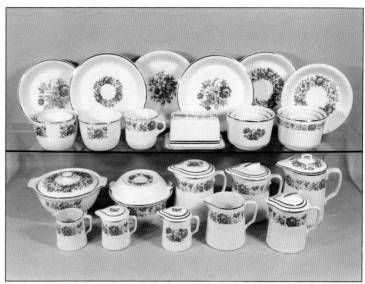

Petit Point I & II, Assorted Shapes, MKs 37, 38, 43A, 45, 46, 47, 55, & 84, **Top Back Row** – 9" Petit Point I pie baker, $18-24; 10" Petit Point II pie baker (small decal), $18-24; 10" Petit Point (Crooksville decal) pie baker, $10-15; 10" Petit Point I pie baker, $18-24; 10" Petit Point II pie baker (large decal), $18-24; 9" Petit Point II pie baker, $12-18; **Top Front Row** – 3 PC GC Petit Point I bowl set (4 decals) 4", 5", & 5.25", $25-35; 5" GC bowl (single decal), $10-15; 4" H Petit Point II mug, $60-70; 7" L Petit Point II covered butter, $50-60; 4 PC Petit Point I bowl set 3", 4", 5", & 6", $30-45; 4 PC Petit Point II bowl set, $30-45; **Bottom Back Row** – 9" W GC Petit Point I refrigerator bowl & Petit Point II lid, $30-40; 8" W Petit Point II casserole (lid is small bowl or under plate), $35-45; 6" H Ohio Jug, $40-50; 7" H Zephyr lid Ohio Jug, $35-45; 8" H paneled Ohio Jug, $40-50; **Bottom Front Row** – 3" H Petit Point II Ohio Jug creamer (no lid), $10-15; 4" H Ohio Jug creamer, $20-30; 4" H Petit Point I Ohio Jug creamer, $30-40; 5" H Petit Point II Ohio Jug (no lid), $15-20; 6" H Zephyr lid Ohio Jug, $35-45.

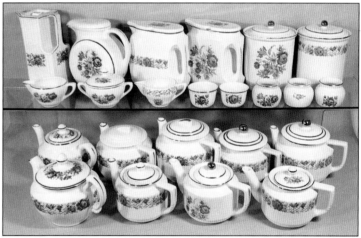

Petit Point I & II, Assorted Shapes, MKs 43A, 45, 46, 47, 55, 84, & 84A, **Top Back Row** – Petit Point II Hi-rise Jug, $40-50; Petit Point I Round Body Jug, $45-60; Petit Point II Square Body Jug, $40-50; Petit Point I Square Body Jug, $40-50; 8" H Petit Point I cookie jar, $35-45; 8" H Petit Point II cookie jar, $35-45; **Top Front Row** – 6" W Petit Point I creamer, $4-8; 6" W sugar, $8-12; 6" W small decal & Gold Filigree creamer, $4-8; 2 GC Petit Point I custards, $4-6 each; 3 Bean Pots, $5-8 each; **Bottom Back Row** – Petit Point II, Assorted Shapes, Bump Handle teapot, $45-60; 6" H Zephyr lid coffeepot, $45-60; 7" H Zephyr lid coffeepot, $50-60; 6" H coffeepot, $50-60; 7" H coffeepot, $50-60; **Bottom Front Row**, 7" H GC Petit Point II coffeepot, $50-60; 9" L teapot, $35-45; 9" L Petit Point I teapot, $35-45; 8" L Petit Point II teapot, $35-45.

Lovelace, Assorted Shapes, MKs 38 & 141, **Top Back Row** – 10" Gadroon lugged plate & 10" Gadroon plate, $8-12 each; 13" platter, $12-18; Virginia utility plate, $15-20; 14" platter, $8-12; 9" & 10" plates, $4-6 each; **Top Front Row** – Royal Gadroon gravy, $8-12; 4" H egg cup, $8-10; 5" W creamer, $8-12; 5" W sugar, $8-12; 4" H Shell sugar, $10-15; 5" W Shell creamer, $4-6; 4" H ball sugar, $8-12; 6" W sugar, $8-12; Modern Age salt & pepper, $10-15 set; 6" W sugar, $8-12; 6" L creamer, $8-12; **Bottom Back Row** – 10" Gadroon lugged bowl, $18-24; 7" lugged bowl, $5-8; Gadroon cup & saucer, $8-12; 4 PC bowl set, 3", 4", 5", & 6", $35-45; 8" W casserole, $30-40; Cup & Saucer, $8-12; 7" & 9" bowls, $10-15 each; 8" lugged bowl, $8-12; 5" & 6" bowls, $4-8 each; **Bottom Front Row** – 6" Gadroon bowl, $3-5; 6" plate, $2-4; 3 PC utensil set, spoon, lifter, & fork, $25-35; 6" square plate, $4-6; 6" plate, $3-5.

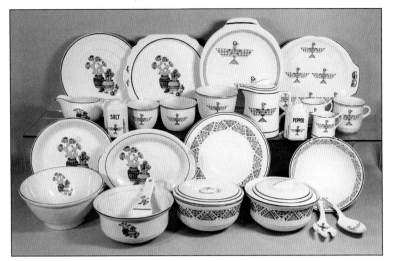

Cactus & Wampum I & II (a.k.a. Navajo), Assorted Shapes, MKs 37, 47, 84, 84A, 87, & 98, **Top Back Row** – Concentric Rings Cactus Cheese Plate, $18-24; Virginia utility plate, $20-25; Two 13" Aladdin Wampum I platters, $40-50 each; **Top Front Row** – Newport Cactus gravy, $25-35; (rest is Wampum I), Skyscraper salt & pepper (far end), $30-40; 3 PC GC bowl set, 4", 5", & 5.25" W, $45-60; 7" H Zephyr lid Ohio Jug (decal on handle & fin), $130-140; Gem creamer & sugar set, $50-60; 4" H mug, $65-75; **Bottom** – 9" Cactus mixing bowl, $15-20; 10" pie baker, $20-25; 12" Newport platter, $15-20; 8" W casserole (no lid), $12-18; Modern Age spoon, $15-18; (rest is Wampum II except utensils), 8" W Zephyr casserole (decal on knob), $35-45; 11" Concentric Rings Cheese Plate, $25-30; 8" Zephyr lid casserole (decal on fin), $50-60; 9" mixing bowl, $20-25; Wampum I fork, $15-18; Wampum I spoon, $12-15.

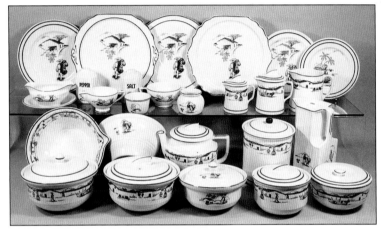

Monterey I & II, Assorted Shapes, MKs 46, 84, & 84B, **Top Back Row** – (Monterey I), 10" plate, $18-24; Virginia utility plate, $18-24; Concentric Rings Cheese Plate, $15-20; Virginia utility plate, $15-20; 9" plate, $10-15; 8" plate, $8-12; **Top Front Row** – Monterey I gravy & fused under plate, $24-30; Skyscraper salt & pepper, $18-24; 6" W Windsor creamer, $20-30; custard, $5-8; 6" W Windsor sugar (no lid), $20-25; Bean Pot, $18-24; 4" H Zephyr lid Monterey II Ohio Jug creamer, $40-50; 5" H Zephyr lid Ohio Jug, $35-45; 5" H Ohio Jug (no lid), $35-45; **Bottom Back Row** – 10" Monterey II spout mixing bowl, $30-40; 9" Monterey I mixing bowl, $15-20; 7" H Zephyr lid Monterey II coffeepot, $45-60; 8" H cookie jar, $40-50; Monterey I Hi-rise Jug, $60-75; **Bottom Front Row** – 8" W Monterey II casserole, $30-40; 8" Zephyr lid casserole, $25-35; 8" Monterey I casserole, $20-30; 6" Virginia Monterey II Zephyr lid covered dish, $25-35; 7" Zephyr covered dish, $30-40.

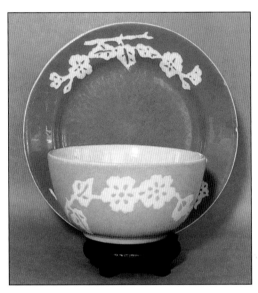

Bennett Bakeware Pottery Blue & Pink Cameo "Apple Blossom" Pattern. Patent held by George A. Bauer, who brought process to Harker in 1940. 6" W pink bowl, MK 153, $8-15; 9" Blue plate, no mark, $18-12. This pattern and Lily of the Valley are often mistaken for Harker Cameo Ware.

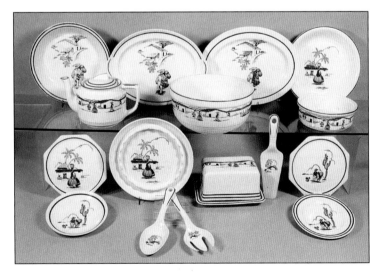

Monterey I & II, Assorted Shapes, MKs 46, 84, & 106, **Top Back Row** – (Monterey I), 9" pie baker, $18-24; 11" Nouvelle platter, $20-25; 11" platter, $18-24; 9" pie baker, $18-24; **Top Front Row** – (Monterey II), 8" L Zephyr lid teapot, $35-45; 9" Zephyr casserole (no lid), $18-24; stack dish (no lid), $12-18; **Bottom** – (Monterey I except covered butter), Trivet, $20-30; saucer, $3-5; 9" ashtray, $15-20; spoon, $10-15; fork, $12-18; 7" Monterey II Covered Butter, $35-45; lifter, $10-15; Trivet, $25-35; 6" plate, $8-10.

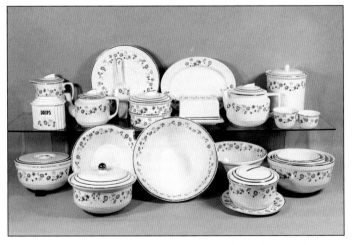

Spring Meadow, Assorted Shapes, MKs 46, 47, & 84, **Top Back Row** – 7" H Zephyr lid Ohio Jug, $35-45; Concentric Rings Cheese Plate, $18-24; lifter, $15-20; 12" platter, $8-12; 8" H cookie jar, $40-50; **Top Front Row** – Skyscraper Drips, $35-45; 5" H Zephyr lid teapot, $65-75; Zephyr lid 2 stack dish set, $25-30; 4" H Covered Butter, $60-70; 6" H Zephyr lid coffeepot, $70-80; 2 custards, $5-8 each; **Bottom** – 9" W Zephyr casserole, $30-45; 8" W casserole, $35-45; 10" spout mixing bowl, $25-30; 11" GC mixing bowl, $30-40; 9" mixing bowl, $18-24; 8" under plate, $6-8; 4" H Zephyr lid covered dish, $25-30; Zephyr 4 bowl set, 6", 7", 8", & 9", $45-60.

Cameo Ware

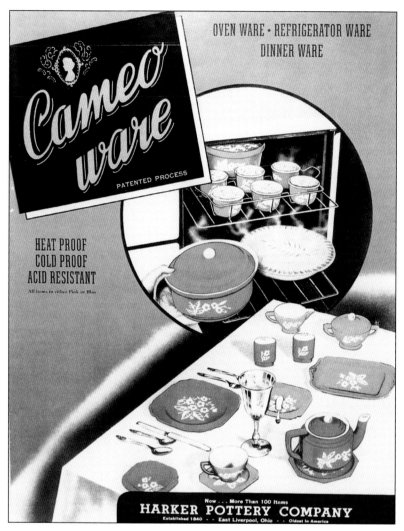

Harker Cameo Ware Sales Brochure (Dainty Flower Pattern), c. 1940, *Courtesy Cynthia Boyce Sheehan.*

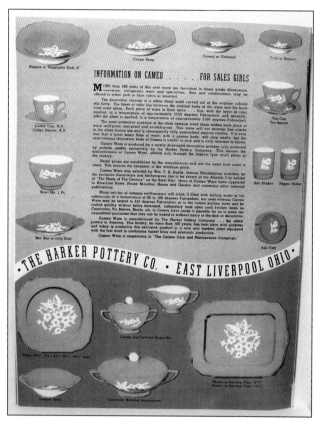

Back of Harker Cameo Ware Sales Brochure (Dainty Flower), *Courtesy Cynthia Boyce Sheehan.*

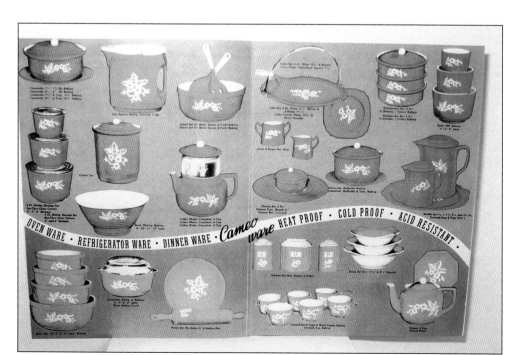

Inside of Harker Cameo Ware Sales Brochure (Dainty Flower), *Courtesy Cynthia Boyce Sheehan.*

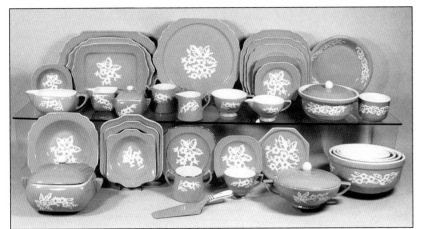

Blue Cameo Dainty Flower, MK 48, **Top Back Row** – 5" square bowl, $3-5; 3 PC Virginia platters set, 10", 11", & 14", $45-60, Virginia utility plate, $15-20; 5 PC square plates set, 6", 6.5", 8", 9" & 10", $20-30; 9" pie baker, $12-18; **Top Front Row** – gravy, $10-15; 5" W square creamer, $8-12; 5" W sugar, $10-15; Gem sugar & creamer, $6-12 each; 6" W sugar (no lid), $5-10; 6" L creamer, $5-10; 7" W casserole, $30-40; 4" W bowl, $10-15; **Bottom** – 9" W square covered vegetable, $40-50; 8" square bowl, $18-24; 3 PC Melrose bowls set, 6", 7", & 8", $40-50; 7" square plate (gold trim), $8-10; Gem sugar (gold trim), $8-12; lifter (gold trim), $15-18; cup & square saucer, $5-10; Trivet, $15-25; 10" W covered vegetable, $35-45; Zephyr 4 PC bowls set, 6", 7", 8", & 9", $75-90.

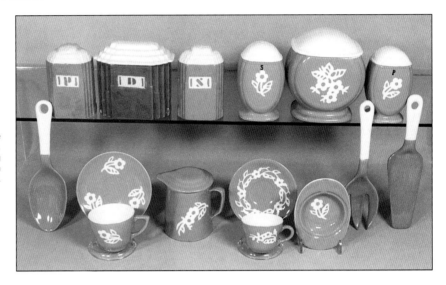

Blue Cameo Dainty Flower, MK 48, **Top** – Skyscraper Range Set, $25-35; D-Ware Range Set, $40-50; **Bottom** – spoon, $12-18; demitasse cup & saucer, $12-18; 4" H Ohio Jug creamer, $20-30; demitasse cup & saucer, $15-20; 5" Modern Age ashtray, $12-18; fork, $12-18; lifter, $12-18.

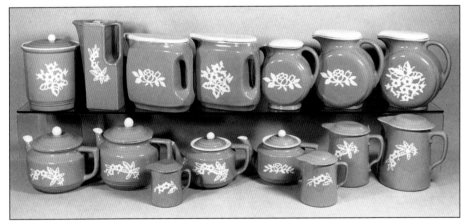

Blue Cameo Dainty Flower & White Rose (Carv-Kraft), MK 48, 49, & 50, **Top** – 8" H Dainty Flower cookie jar, $35-45; Hi-rise Jug, $50-70; White Rose Square Body Jug, $35-45; Dainty Flower Square Body Jug, $35-45; White Rose Round Body Jug (very rare, square lid & ice retainer), $80-100; Round Body Jug, $40-50; Dainty Flower Round Body Jug, $35-45; **Bottom** – (Dainty Flower unless noted), 6" H coffeepot, $50-60; 7" H coffeepot, $60-75; 4" H Ohio Jug creamer, $18-24; 9" L teapot, $30-40; 9" L White Rose teapot, $40-45; 5" H Ohio Jug, $20-30; 6" H Ohio Jug, $40-50; 7" H Ohio Jug, $60-75.

Blue Cameo Dainty Flower, MKs 48, 49, & 216, **Top** – Shell Ware except custards, 6" & 7" plates, $2-4 each, 7" lugged bowl, $5-10; 11" lugged plate, $15-20; custard, $4-6; cup & saucer, $5-10; 12" & 13" platters, $10-15 each; 4" H sugar, $8-12; 3" H creamer, $10-15; 5" bowl, $2-4; 9" plate, $5-8; custard, $3-5; 9" bowl, $12-18; **Bottom** – 3 PC bowl set, 4", 5", & 6", $30-45; 6" & 7" Zephyr bowls, $10-15 each; 8" W casserole, $30-45; 7" W casserole, $20-30; 3 PC white edge mixing bowl set, 9", 10", & 12", $75-90; Jumbo Engobe cup & saucer, $15-20; 6" W dish (no lid), $12-15; Jumbo "Dad" cup & saucer, $18-24; 2 stack dish set, $20-30; Jumbo Dainty Flower cup & saucer, $18-24.

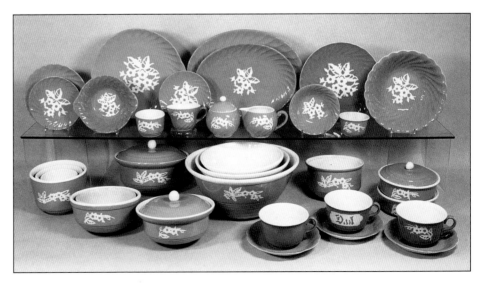

Blue & Pink Cameo Dainty Flower vases, 5.5" H, very rare, no mark, $400-500 each.

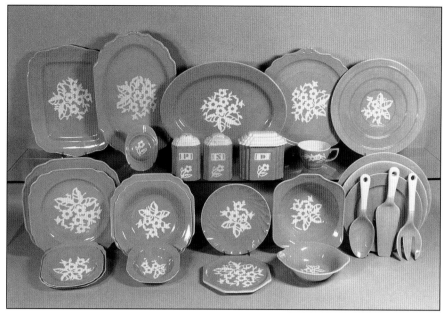

Pink Cameo Dainty Flower, MKs 48 & 49, **Top Back Row** – 12" Virginia platter, $10-15; 14" Virginia platter, $10-15; 14" platter, $25-35; Virginia utility plate, $18-24; Concentric Rings Cheese Plate, $20-25; **Top Front Row** –5" Modern Age ashtray, $18-24; Skyscraper Range Set, $40-55; cup, $5-8; **Bottom Back Row** – 9" & 9.5" square plates, $6-10 each; 7" & 8" square bowls, $10-18 each; 7" Shell plate, $3-5; 8 Melrose bowl, $15-20; 3 PC Engobe plate set 8", 9", & 10", $12-18; 3 PC utensil set, spoon, lifter, fork, $35-50; **Bottom Front Row** – 5.75" & 6" square plates, $2-4 each; 5" square bowl, $3-5; Trivet, $20-25; 7" lugged bowl, $4-6.

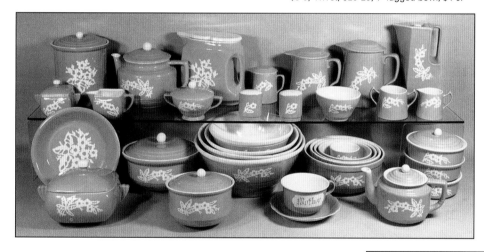

Pink Cameo Dainty Flower, MKs 48 & 49, **Top Back Row** – 8" H cookie jar, $35-45; 7" H coffeepot, $50-60; Square Body Jug, $50-75; 4" H Ohio Jug creamer, $30-45; 6" H Ohio Jug, $30-40; 7" H Ohio Jug, $60-75; Hi-rise Jug, $80-90; **Top Front Row** – 4" H square sugar, $20-25; 2" H creamer, $12-18; 6" W sugar, $15-20; Modern Age salt & pepper, $8-12 set; 5" W bowl, $8-12; Gem sugar & creamer, $12-18 each; **Bottom Back Row** – 9" pie baker, $18-24; 8" W casserole, $20-25; 4 PC white edge mixing bowls set, 9", 10", 11", & 12", $120-150; Zephyr 4 PC bowls set, 6", 7", 8", & 9", $60-80; custard, $8-10; 3 stack dish set, $30-45; **Bottom Front Row** – 9" W square covered vegetable, $50-60; 5" H covered dish, $18-24; Jumbo "Mother" cup & saucer, $18-24; 8" L teapot, $40-50.

Blue Cameo Carv-Kraft, MK 50, **Top Back Row** – 9" pie baker, $18-24; 10" pie baker, $20-25; 12" & 14" platters, $18-24 each; Trivet, $25-35; Virginia utility plate, $18-24; 9" bowl, $18-24; **Top Front Row** – 6" W creamer, $5-10; 6" W sugar (no lid), $5-10; 10" W covered vegetable, $50-60; Skyscraper Range Set, $35-45; 10" covered vegetable, $40-50; gravy, $20-25; 9" under plate, $5-10; **Bottom Back Row** – Zephyr 3 PC bowl set, 6", 7", & 8", $45-60; 7" bowl, $5-10; 3 PC plate set, 7", 9", & 10", $12-25; cup & saucer, $5-10; 4" W bowl, $6-12; 3 PC bowl set, 4", 5", & 6", $45-60; **Bottom Front Row** – D-Ware Range Set, $50-65; 6" plate, $3-5; 5" bowl, $4-6; 9" oval bowl, $18-24; 7" lugged bowl, $15-18.

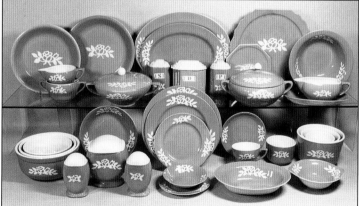

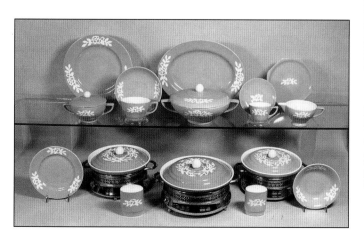

Pink Cameo Carv-Kraft, & Pink & Blue Cameo "Wellesley Ware"™ casseroles, MKs 50 & 51, **Top** – (Carv-Kraft), 6" W Pink Cameo sugar, $12-18; 9" plate, $5-10; cup & saucer, $8-12; 12" platter, $15-20; 10" W covered vegetable, $50-60; demitasse cup & saucer, $25-35; Trivet, $25-35; 6" W creamer, $8-12; **Bottom** – 6" Pink Carv-Kraft™ plate, $4-8; 7" W Blue Cameo Wellesley casserole, $25-35; Pink Carv-Kraft Modern Age salt & pepper, $10-15 set; 8" W Blue Cameo™ Wellesley casserole, $35-50; 7" W Pink Cameo™ Wellesley casserole, $30-40; 5" Pink White Rose bowl, $5-8.

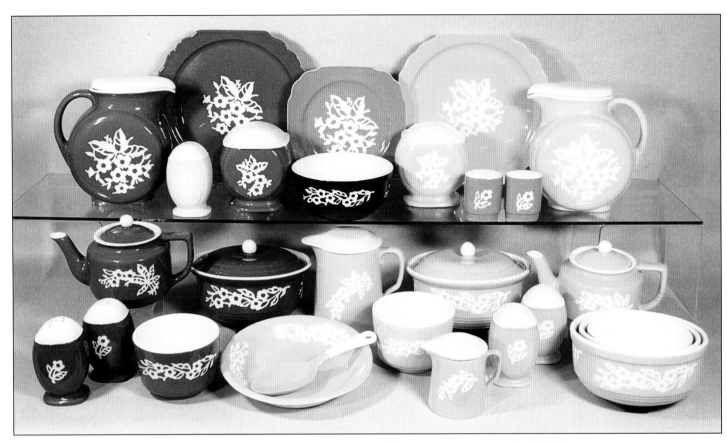

Six Colors of Cameo Dainty Flower, MKs 48, 69, 70, & 71, **Top** – Teal Round Body Jug, $90-100; Teal Virginia utility plate, $90-120; Chartreuse D-Ware pepper, $50-60; Teal D-Ware Drips, $50-75; 9" Gray square plate, $50-75; 7" Black Zephyr bowl, $75-100; Yellow D-Ware Drips, $40-50; Yellow Virginia utility plate, $35-45; Pumpkin Modern Age salt & pepper, $40-50 set; Yellow Round Body Jug, $50-75; **Bottom** – Teal D-Ware salt & pepper, $50-60 set; 9" L Teal teapot, $140-160; 5" Teal bowl, $30-40; 8" W Teal casserole, $100-120; 9" Yellow pie baker, $40-50; Yellow spoon, $12-18; 6" H Yellow Ohio Jug, $40-50; 5" Yellow bowl, $25-35; 8" W Yellow casserole, $40-50; 4" H Yellow Ohio Jug creamer, $30-40; Yellow D-Ware salt & pepper, $30-40 set; 9" L Yellow teapot, $80-90; Zephyr 3 Yellow bowls set, 6", 7", & 8", $120-130.

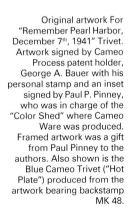
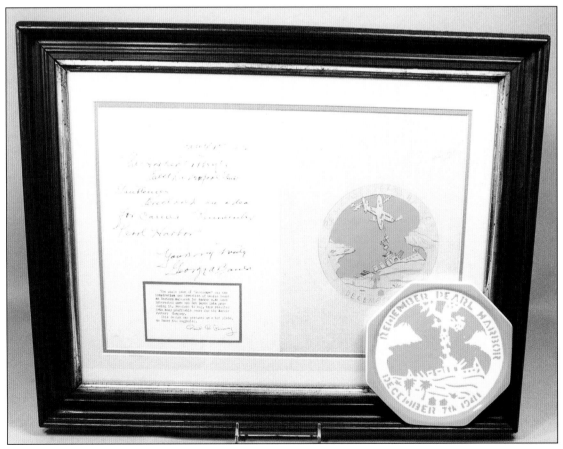

Original artwork For "Remember Pearl Harbor, December 7th, 1941" Trivet. Artwork signed by Cameo Process patent holder, George A. Bauer with his personal stamp and an inset signed by Paul P. Pinney, who was in charge of the "Color Shed" where Cameo Ware was produced. Framed artwork was a gift from Paul Pinney to the authors. Also shown is the Blue Cameo Trivet ("Hot Plate") produced from the artwork bearing backstamp MK 48.

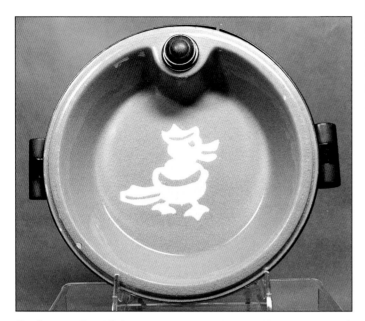

Blue Cameo 7" (Donald?) Duck baby plate in metal holder with bakelite handles & stopper, circa 1940-48, *Courtesy M. Nurmi – Daughter of Eugene Seeley.*

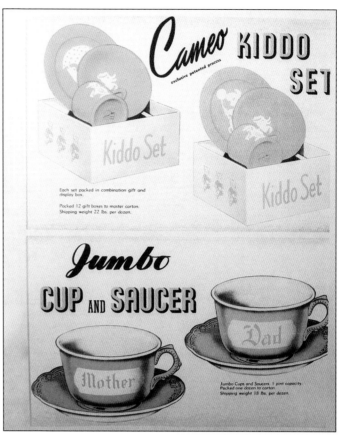

Cameo Kiddo Set & Jumbo Cup and Saucer ad, $20.

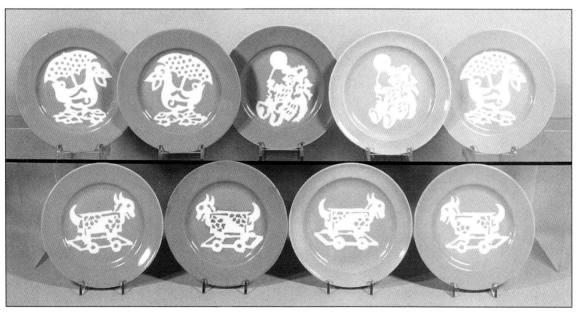

Pink & Blue Cameo 7" Children's Plates, MK 48, **Top** – Blue Cameo Duck with umbrella facing right, (on back – "Golden Star Dairy Picnic 1949"), $30-40; Blue Cameo Duck, facing left (same on back), $30-40; Blue Cameo Bear With Balloon, $20-30; Pink Cameo Bear With Balloon, $20-30; Pink Cameo Duck With Umbrella facing right, $20-30, **Bottom** – Blue Cameo Goat Cart facing right, $20-30; same facing left, $20-30; Pink Cameo Goat Cart facing right, $20-30; same facing left, $20-30.

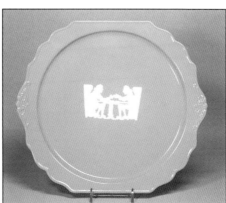

Blue Cameo Virginia utility plate "Hall" Tavern scene, (rare), MK 49, $40-50.

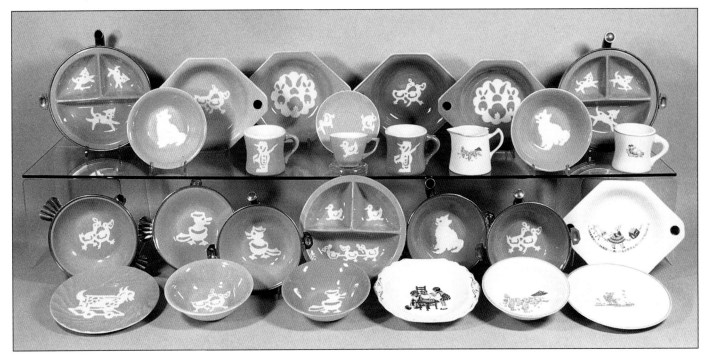

Children's Ware, Pink & Blue Cameo, & White Ware **Top** – 8" Pink Cameo Cavorting Lambs divided dish, $60-75; 6" Cat bowl, $20-30; 9" Double Ducks hollow dish, $40-50; 3" H Toy Soldier (Circus Elephant on reverse) mug, $12-15; 9" Bunny Butts hollow dish, $40-50; demitasse Ducks cup & saucer, $70-80; 9" Blue Cameo Double Ducks hollow dish, $60-75; 3" H mug, $12-15; 9" Bunny Butts hollow dish, $60-75; Baby Chicks white Gem creamer ("Mary, Mary, Quite Contrary" on reverse), $15-20; 6" Blue Cameo Cat bowl, $20-30; 8" Cavorting Lambs divided dish, $60-75; 3" H Baby Lamb white mug, $25-30; **Bottom Back Row** – 6" Pink Cameo Double Ducks bowl, $40-50; 6" Duck (facing right) bowl, $60-75; 6" Duck (facing left) bowl, $60-75; 8" Pink Cameo Ducks divided dish, $35-45; 6" Blue Cameo Cat bowl, $35-45; 6" Double Ducks bowl, $45-60; 9" "Mary Had A Little Lamb" white bowl, $40-50; **Bottom Front Row** – 7" Pink Cameo Shell Goat Cart plate, $40-50; 6" Double Ducks bowl, $20-30; 6" Blue Cameo Duck bowl ("Golden Star Dairy Picnic 1948" on back), $20-30; 7" Virginia bowl, Girls With Teddy Bear, $15-25; 8" Baby Chicks bowl, $20-25; 7" "Mary, Mary, Quite Contrary" plate, $15-20.

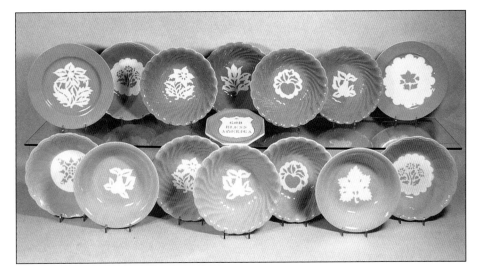

Blue & Pink Cameo, MKs 48 & 49, **Top** – Blue 9" Poinsettia plate, $12-18; 9" Surface Embossed Daisies bowl, $20-30; 9" Shell Poinsettia bowl, $20-30; 9" Shell Tulips bowl, $20-30; "God Bless America" Trivet, $40-50; 9" Shell Apple bowl, $20-30; 9" Shell Pear bowl, $20-30; 9" Five Petal Flower plate, $12-18; **Bottom** – Pink Cameo 9" Surface Embossed Snowflake bowl, $18-24; 9" Pear bowl, $18-24; 9" Shell Poinsettia bowl, $20-30; 9" Shell Pear bowl, $20-30; 9" Shell Apple bowl, $20-30; 9" Grape Leaf bowl, $20-30; 9" Surface Embossed Daisies bowl, $20-30.

Wild Rice & Cameo Ware In Multiple Colors & Patterns, MKs 60, 61, 70A, 71, 101, **Top Back Row** – 12" Blue Wild Rice platter, $18-24; Chicory Lace Virginia utility plate, $40-45; 7" square plate, $8-12; Corinthian Lace Virginia utility plate, $25-35; 7" square plate, $8-12; Teal lifter, $12-18; 12" & 13" Gray Wild Rice platters, $18-24 & $25-30; **Top Front Row** – Jumbo Cups & Saucers, Blue Father, $18-24; Brown Mother, $8-12; Brown Mother, $25-30; Pink Mother, $12-15; Mother, $20-25; Teal Father, $25-30; Teal Dad, $15-20; Teal Dad, $25-30; Gray Grandpa, $20-25; Gray Mom, $35-40; **Bottom Back Row** – 9" Blue Wild Rice plate, $5-10; 9" bowl, $25-30; 9" Gray Wild Rice bowl, $30-35; 9" plate, $8-12; **Bottom Front Row** – Jumbo Celadon Green Mother cup & saucer, $20-25; Blue Wild Rice cup & saucer, $15-20; 6" plate, $5-10; 5" bowl, $5-10; 4" ball top sugar, $12-18; 4" H creamer, $40-50; 5" Salmon Wild Rice bowl, $12-18; 3" H sugar, $20-25; 4" H Gray Wild Rice creamer, $50-60; 6" plate, $10-12; 5" bowl, $8-12; 3" H sugar, $25-30; cup & saucer, $25-30; Jumbo Blue Dad cup, $12-15; Jumbo Blue Engobe cup & saucer, $15-20.

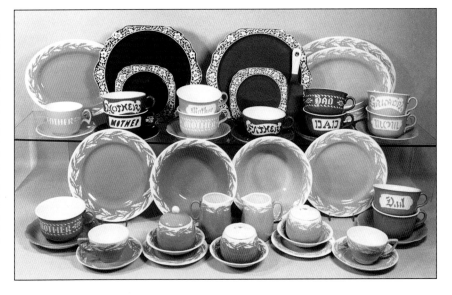

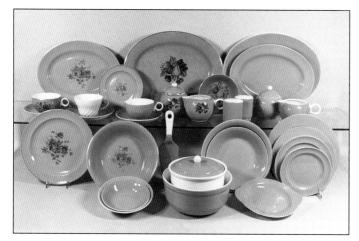

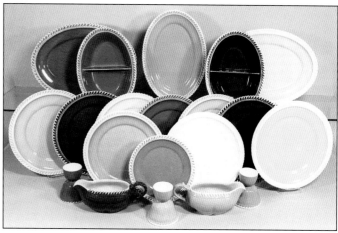

American Engobe, Engobe Roses, Engobe Fruit, all blue, MKs 52 & 101, **Top Back Row** – 12" Engobe Roses platter, $8-10; 14" Engobe Fruit platter, $15-20; 12" & 14" Engobe platters, $8-12 & $20-25; **Top Front Row** – Engobe Roses cup & saucer, $4-8; White Shell cup & blue Engobe saucer, $4-8; 6" Engobe Roses plate, $2-4; Engobe cup & saucer, $4-8; 4" H Engobe Fruit ball sugar, $5-8; 6" L ball creamer, $5-8; 5" bowl, $2-4; Modern Age Engobe salt & pepper, $4-8; 3" H Engobe ball sugar, $5-8; 6" L ball creamer, $3-5; **Bottom** – 9" Engobe Roses plate, $2-4; 9" bowl, $8-10; 5" & 6" Engobe bowls, $2-3 each; lifter, $10-12; 8" Zephyr bowl, $15-20; 5" H white covered dish (blue Engobe lid), $12-18; 7" & 8" Engobe bowls, $5-8 each; 8" lugged plate, $8-10; 4 plates set, 6", 7", 8", & 9", $15-25.

Royal Gadroon Colors, MKs 69, 71, 98, & 101, **Top** – 13" Avocado platter, $8-12; 10" Corinthian Green divided bowl, $12-15; 12" Celadon Green platter, $12-15; 10" Chicory divided bowl, $12-15; 13" Pink platter, $10-15; **Bottom Back Row** – 10" plates, Chesterton Gray (Silver Mist), $4-7; Charcoal Gray, $5-8; Chartreuse (a.k.a. Sun Valley), $4-7; Corinthian Green, $4-7; Bermuda Blue, $5-8; Chicory, $5-8; Golden Harvest, $7-10; **Bottom Front Row** – 9" Pink Cocoa (Beige) & White plates, $3-5 each; 7" Pumpkin plate, $5-8; Three 4" H egg cups, Corinthian Green, Chesterton Gray (Silver Mist), & Celadon Green, $12-15 each; Two gravy boats with pink throats, Charcoal Gray & Chesterton Gray (Silver Mist), $15-18 each.

4" Square "Harkerware Since 1840" sales counter signs in Yellow & Charcoal Gray, *Courtesy East Liverpool Historical Society*.

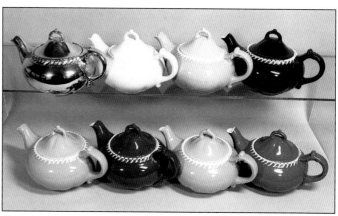

Royal Gadroon 9" L Teapots, MKs 71 & 98, **Top** – Gold, White, Pink Cocoa (Beige), & Chicory, $30-50 each; **Bottom** – Chesterton Gray (Silver Mist), $30-40; Charcoal Gray, $50-70; Celadon Green, $30-40; Corinthian Green, $35-50.

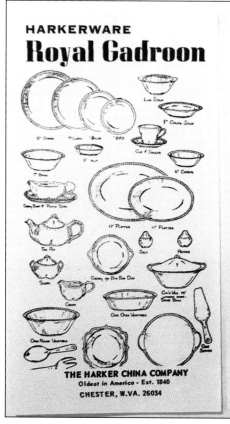

Harkerware Royal Gadroon Sales Brochure, c. 1948, *Courtesy Cynthia Boyce Sheehan*.

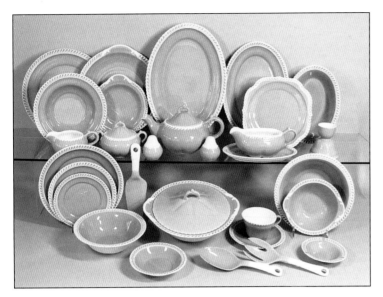

Chesterton (Silver Mist), Royal Gadroon, MKs 68, 69, & 101, **Top Back Row** – 10" plate, $4-6; 8" soup, $6-9; 11" lugged plate, $6-8; 8" lugged bowl, $3-5; 13" platter, $10-12; 12" platter, $8-12; 8" square plate, $3-5; 9" oval bowl, $7-10; **Top Front Row** – 6" W creamer, $4-8; 6" W sugar, $5-8; salt & pepper, $4-8 set; 9" L teapot, $30-40; gravy, $5-8; 9" under plate, $3-5; 4" H egg cup, $8-12; **Bottom** – 3 PC plate set, 6", 7", & 9", $9-15; 9" bowl, $5-8; lifter, $10-15; 5" bowl, $2-4; 10" covered lugged bowl, $10-15; spoon, $8-12; cup & saucer, $7-10; fork, $10-15; 6.75" bowl, $5-8; 7" lugged bowl, $3-5; 4" ashtray, $5-8.

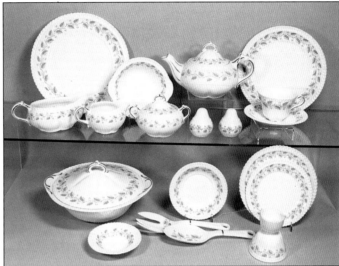

Bermuda on Royal Gadroon, MK 66, **Top** – gravy, $8-10; 10" plate, $4-8; creamer, $8-10; 7" lugged bowl, $4-6; sugar, $12-15; teapot, $70-90; salt & pepper, $8-12 set; 9" plate, $3-6; cup & saucer, $12-15; **Bottom** – 10" W covered lugged vegetable, $25-35; ashtray, $8-10; fork, $15-20; spoon, $15-20; 5" bowl, $3-5; 6" & 7" plates, $3-5 each, egg cup, $12-18.

1943 Harker YMCA Basketball Pottery League First Round Trophy, 13.5" H, $75-100; 1948 Harker's Royal Gadroon basketball jersey, gift from Harker employee Charles (Chuck) Horton.

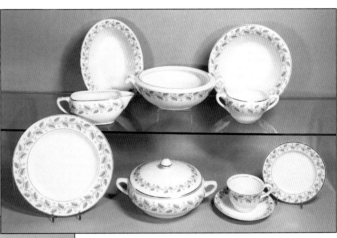

Bermuda, MK 85, **Top** – gravy, $12-18; 9" oval bowl, $10-15; 10" Embassy vegetable (no lid), $15-20; 6" sugar (no lid), $7-10; 9" bowl, $12-15; **Bottom** – 9" plate, $8-10; 10" covered vegetable, $25-35; cup & saucer, $12-15; 6" plate, $3-5.

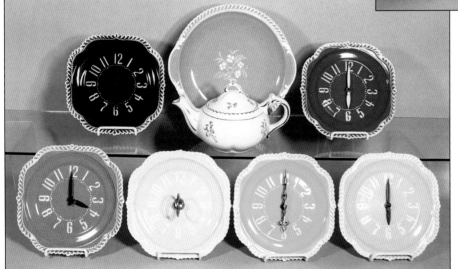

Royal Gadroon Misc., MKs 98 & 100, 8" square Clock plates, Charcoal Gray, Corinthian Green, Pumpkin, Pink, Celeste Blue, & Golden Spice, $35-55 each; 11" Gray Intaglio lugged Rhythm plate, $10-12; teapot (gold decorated teapot, silver on lid), $20-30.

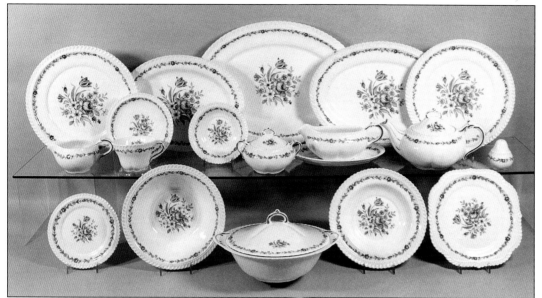

Rose Bouquet on Gadroon, MKs 64, 66, & 100B, **Top** – 10" plate, $8-12; creamer, $4-6; cup & saucer, $8-10; 12" platter, $10-15; 5" bowl, $3-5; 16" platter, $18-24; sugar, $8-12; gravy, $8-12; under plate, $5-10; 13" platter, $12-15; teapot, $70-80; 10" plate, $8-12; salt, $8-10; **Bottom** – 6" plate, $2-4; 9" bowl, $18-24; 10" covered lugged vegetable, $30-35; 8" soup, $8-10; square plate, $5-8.

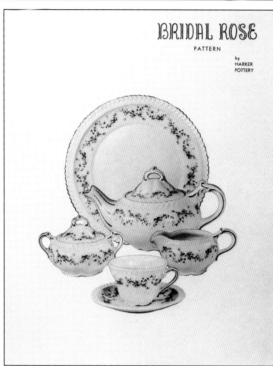

Bridal Rose Sales Brochure, c. 1949, *Courtesy Cynthia Boyce Sheehan.*

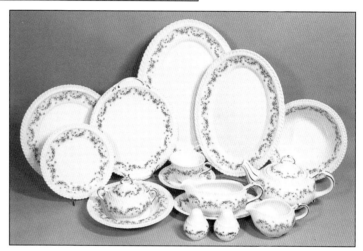

Bridal Rose on Gadroon, MKs 63, 64, & 161, 10" plate, $6-8; 7" plate, $4-6; 8" soup, $8-10; sugar, $18-24; 11" lugged plate, $8-12; 16" platter, $18-24; cup & saucer, $8-10; gravy, $10-15; under plate, $8-10; salt & pepper, $12-18 set; 13" platter, $12-18; creamer, $8-12; teapot, $50-60; 9" bowl, $12-18.

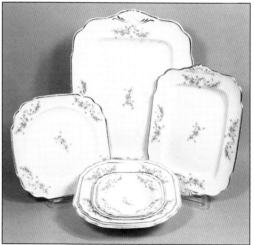

Bridal Rose variation, Virginia Shape, no mark, **Back** – 9" square plate, $8-12; 15" platter, $12-18; 11" platter, $10-15: **Front** – 4 PC square bowl set, 5", 6", 7", & 8", $20-30.

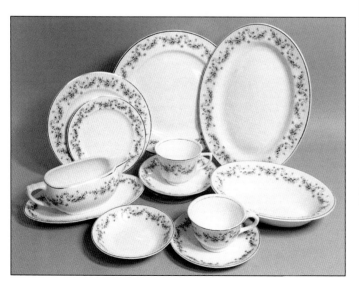

Bridal Rose, MK 86, **Back** – 6" & 8" plates, $5-8 & $8-12; 10" plate, $12-15; 12" platter, $15-18: **Center** – gravy, $12-15; 9" under plate, $5-8; cup & saucer, $15-18; 9" oval bowl, $12-15; **Front** – 5" bowl, $3-5; cup & saucer, $15-18.

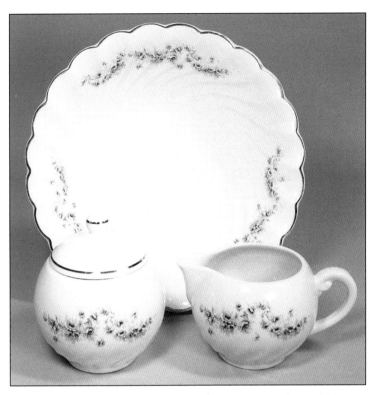

Bridal Rose, Shell Shape, MK 38, 9" bowl, $10-15; 4" H sugar, $12-15; 3" H creamer, $8-12.

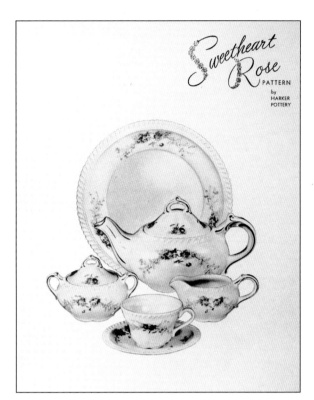

Sweetheart Rose Sales Brochure, c. 1949, *Courtesy Cynthia Boyce Sheehan.*

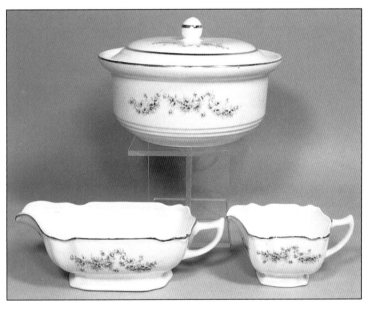

Bridal Rose, MK 38, 9" casserole, $35-45; Virginia gravy, $18-24; Virginia 5" L creamer, $12-18.

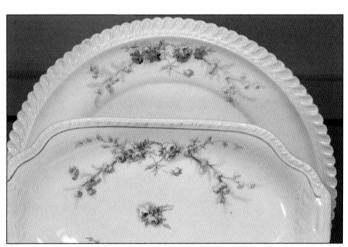

Top – Detail of Sweetheart Rose decal on Gadroon plate; **Bottom** – Shadow Rose decal on Melrose platter. These decals are often confused.

Bridal Rose, Assorted Shapes, MKs 31 & 38, lifter, $15-18; Modern Age salt & pepper, $12-15 set; 4" bowl, $6-8; Virginia utility plate, $24-30; 9" pie baker, $20-24; 5" bowl, $12-15; spoon, $15-18; 7" H Gargoyle Jug, $40-60; Nouvelle gravy, $18-24.

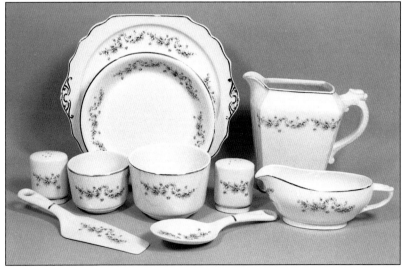

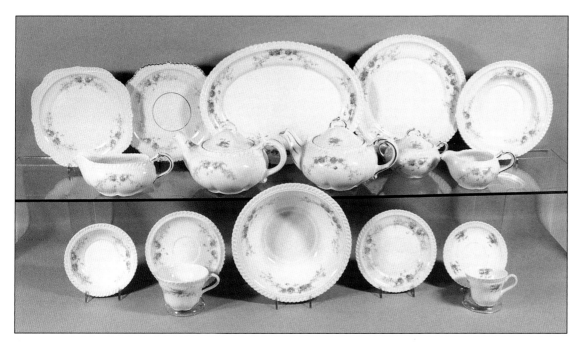

Sweetheart Rose on Gadroon, MKs 65, 65A, 84A, 87, & 192, **Top** – square plate, $5-8; gravy, $8-12; square plate, $5-8; teapot, $40-50; 13" platter, $18-24; teapot, $40-50; 10" plate, $5-10; sugar, $10-15; creamer, $10-15; 9" soup, $10-15; **Bottom** – 5" bowl, $3-5; cup & saucer, $8-12; 9" bowl, $12-18; 6" plate, $3-5; demitasse cup & saucer, $12-18.

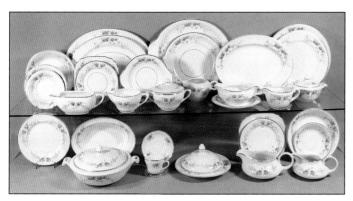

Sweetheart Rose, Assorted Shapes, **Top Back Row** – 3 PC bowl set, 5", 6", & 7", $12-18; 12" & 13" platters, $8-12 & $10-15; 7" square plate & 6" round plate, $2-4 each; 8" lugged shallow bowl, $4-6; 13" Aladdin lugged platter, $18-24; 9" plate, $8-12; 12" platter, $8-12; 9" & 10" plates, $4-6 & $5-8; **Top Front Row** – gravy, $10-15; 6" W creamer, $5-10; 6" W sugar, $8-12; 5" W ball creamer, $5-10; 7" W gravy & fused under plate, $18-24; 6" Embassy creamer, $4-8; 6" W Embassy sugar, $5-10; **Bottom** – 7" plate, $3-5; 10" W Embassy covered vegetable, $18-24; 9" oval bowl, $8-12; demitasse cup & saucer, $10-15; 7" W Embassy Covered Butter, $20-25; Aladdin gravy, $12-18; 6" square plate & 6" round plate, $3-5 each; 6" W Aladdin creamer, $10-15; 5" & 7" bowls, $2-4 & $5-10.

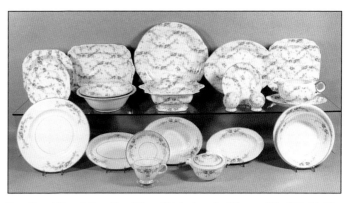

Sweetheart Rose & Sweetheart Rose Chintz, Assorted Shapes, MKs 84A, 87, 90, & 90A, **Top Back Row** – Sweetheart Rose Chintz, 8" square bowl, $20-25; 11" Virginia platter, $20-25; 12" Hostess lugged plate, $25-30; 11" platter, $20-25; 9" square plate, $20-25; **Top Front Row** – Sweetheart Rose Chintz, 6" square plate, $8-12; 8" & 9" Hostess bowls, $15-20 & $20-25; 10" W Virginia covered vegetable, $45-60; 6" Hostess plate, $5-8; Hostess Ball salt & pepper, $30-40 set; Newport gravy, $20-25; 9" Newport under plate, $15-20; **Bottom** – Sweetheart Rose Cream Colored Edge, 10" plate, $5-8; 9" under plate, $4-6; cup & saucer, $8-10; 9" oval bowl, $10-15; 6" W Embassy sugar, $20-25; 8" Nouvelle under plate, $8-10; 8" & 9" bowls, $12-18 each.

Sweetheart Rose & Shadow Rose, Assorted Shapes, MKs 31, 38, 84A, & 87, **Top** – Sweetheart Rose Square Body Jug, $35-45; Virginia utility plate, $15-20; 6" saucer, $2-3; 4" H ball sugar, $10-15; cup & saucer, $5-10; 11" & 15" Melrose Shadow Rose platters, $10-15 & $30-40; 9" L Sweetheart Rose teapot, $35-45; Melrose Shadow Rose gravy, $12-15; 9" L Melrose Shadow Rose under plate, $15-20; 10" Melrose lugged plate (green accents), $10-15; 7" plate, $5-8; 5" bowl, $10-15; 8" H Sweetheart Rose cookie jar, $30-40; **Bottom** – 9" Sweetheart Rose pie baker, $15-20; 10" Melrose Shadow Rose bowl, $12-18; 3 PC Sweetheart Rose Bowl set, 3", 4", & 5", $20-25; 9" mixing bowl, $20-25; 9" Melrose Shadow Rose bowl, $10-15; Melrose saucer, $2-4; 9" Shell Sweetheart Rose bowl, $12-18.

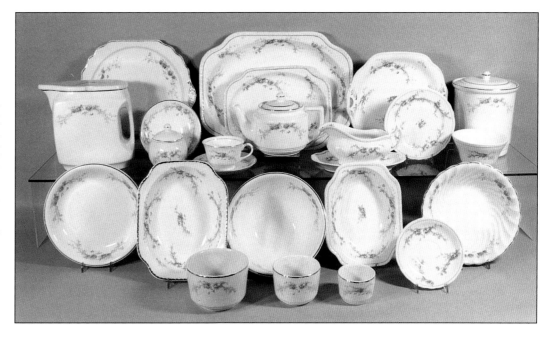

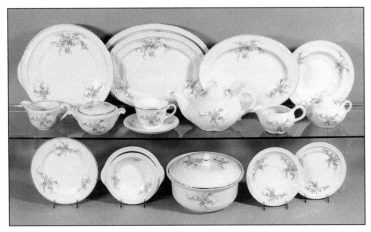

Lacy Rose, Assorted Shapes, **Top Back Row** – 11" Gadroon lugged plate, $8-10; 10" plate, $5-7; 12" & 13" platters, $10-12 & $12-15; 12" platter, $8-12; 8" soup, $8-10; **Top Front Row** – 5" W Embassy creamer, $4-6; 6" W Embassy sugar, $5-8; cup & saucer, $4-8; Gadroon teapot, $35-45; creamer, $5-8; sugar, $6-10; **Bottom** – 7" plate, $2-4; 7" Gadroon lugged bowl, $4-6; 5" bowl, $2-4; 8" W casserole, $45-55; Gadroon saucer, $2-3; 6" plate, $2-3.

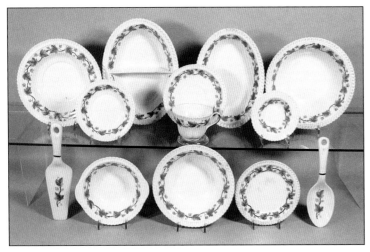

Ivy on Gadroon, MKs 100B & 160, **Top** – 8" soup, $12-15; 5" bowl, $3-5; 10" divided oval bowl, $10-15; cup & saucer, $8-12; 9" oval bowl, $8-12; 5" ashtray, $3-5; 9" bowl, $5-10; **Bottom** – lifter, $10-15; 7" lugged bowl, $4-6; 7" bowl, $4-8; 6" plate, $2-4; spoon, $12-18.

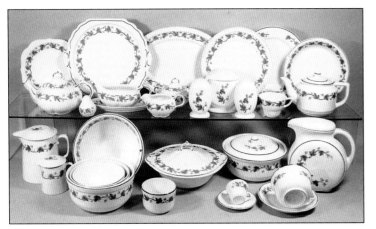

Ivy, Assorted Shapes, MKs 43A, 84A, 160, & 187, **Top Back Row** – Gadroon square plate, $3-5; Virginia utility plate, $20-25; 14" Gadroon platter, $20-25; 10" Gadroon plate, $5-8; 10" plate, $5-8; 9" pie baker, $12-20; **Top Front Row** – Gadroon teapot, $35-45; salt, $5-8; gravy, $8-12; under plate, $8-12; creamer, $5-10; sugar, $12-18; 3 PC D-Ware Range Set, $35-45; cup, $4-8; teapot, $30-40; **Bottom** – 6" H Ohio Jug, $30-40; 4" H Ohio Jug creamer, $20-30; Zephyr 3 PC bowl set 6", 7", & 8", $45-60; 9" mixing bowl, $18-24; 4" bowl, $5-10; 10" W Gadroon covered vegetable, $35-45; demitasse cup & saucer, $12-18; 9" W casserole, $30-40; Jumbo Cup & Saucer, $20-30; Round Body Jug, $30-40.

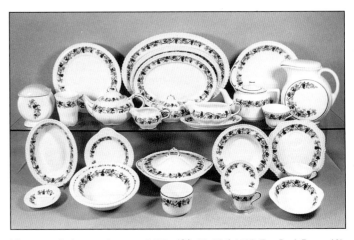

Vintage on Gadroon unless noted, MKs 43A, 62, 63, & 100B, **Top Back Row** – 10" plate, $4-8; 3 PC platter set 12", 13", & 16", $35-50; 11" lugged plate, $8-12; **Top Front Row** – D-Ware Drips, $25-30; 4.5" H Tumbler, $15-20; teapot, $80-90; creamer, $10-12; sugar, $10-15; gravy, $12-18; under plate, $4-8; teapot, $30-40; cup, $5-8; Round Body Jug, $40-50; **Bottom Back Row** – 9" oval bowl, $8-12; 8" lugged shallow bowl, $5-8; covered vegetable, $20-30; 8" soup, $8-12; 8" square Cup Ring Plate & cup, $12-15 set; **Bottom Front Row** – ashtray, $5-8; 7" & 9" bowls, $8-12 each; 4" bowl, $8-12; demitasse cup & saucer, $8-12; 7" lugged bowl, $5-10.

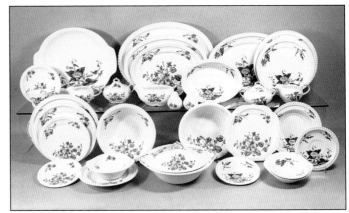

Morning Glory & Violets on Gadroon unless noted, MKs 98 & 159, **Top Back Row** – 13" Aladdin Morning Glory lugged platter, $20-25; 3 PC Violets platter set, 11", 13", & 16", $60-75; 13" Morning Glory platter, $20-25; 9" & 10" Morning Glory plates, $5-10 each; **Top Front Row** – Violets cup & saucer, $10-15; creamer, $15-20; sugar, $20-25; gravy, $12-18; salt & pepper, $8-12 set; 9" Morning Glory oval bowl, $15-20; sugar, $20-25; creamer, $15-20; **Bottom Back Row** – 4 PC Violets plate set, 7", 9", 10", & 11" lugged, $30-45; 9" bowl, $12-20; 9" Aladdin bowl, $12-20; square plate, $5-8; 8" Morning Glory soup, $8-12; saucer, $2-4; **Bottom Front Row** – 6" Violets plate, $4-8; 8" Violets soup, $8-12; 7" lugged bowl, $5-8; covered vegetable, $40-45; 6" Morning Glory plate, $3-5; 7" lugged bowl, $10-15; 5" bowl, $3-5.

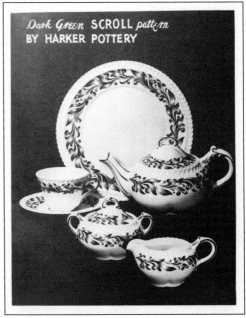

Scroll on Gadroon Ad, *Courtesy Cynthia Boyce Sheehan.*

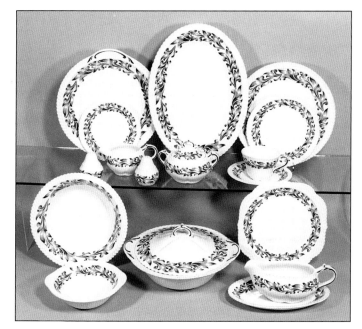

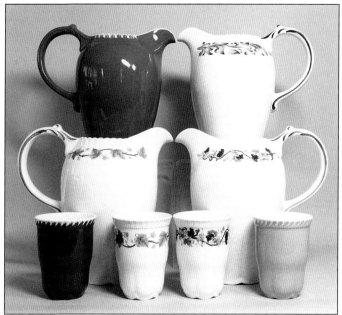

Scroll on Gadroon, MK 159, **Top Back Row** – 11" lugged plate, $8-12; 6" plate, $3-5; 14" platter, $15-20; 10" plate, $5-8; 7" plate, $3-5; **Top Front Row** – salt & pepper, $10-15 set; creamer, $8-12; sugar, $10-15; cup & saucer, $10-15; **Bottom Back Row** – 9" bowl, $10-15; covered vegetable, $20-25; square plate, $5-8; **Bottom Front Row** – 7" lugged bowl, $4-6; gravy, $10-12; under plate, $4-8.

Gadroon Shape Jugs & Tumblers, **Top** – 9" H jugs, Corinthian, MK 70, $90-120; Scroll, MK 159, $75-100; **Center** – Ivy, MK 160, $175-200; Vintage, MK 62, $175-200; **Bottom** – 4" H Tumblers, no marks, $20-30 each, Corinthian; Ivy; Vintage; Chesterton.

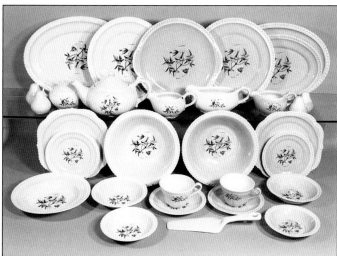

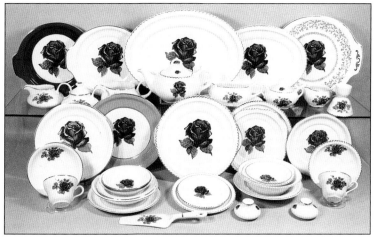

Regal on Gadroon, *Photo Courtesy Cynthia Boyce Sheehan.*

White Thistle on Gadroon, MK 101 unless noted, **Top Back Row** – 13" Yellow platter, $10-12; 10" plate, $6-10; 11" Pink lugged plate, $7-10; 10" plate, $6-10; 11" & 13" platters, $5-8 & $10-12; **Top Front Row** – Yellow salt & pepper, $8-12 set; sugar, $10-15; teapot MK 100, $35-45; creamer, $4-6; gravy, $4-6; Pink creamer, $4-6; salt & pepper, $8-10 set; **Bottom Back Row** – Yellow square plate, $4-6; 6" plate, $2-4; 9" bowl, $12-15; 9" Pink bowl, $12-15; square plate, $4-6; 6" plate, $3-5; **Bottom Front Row** – 8" Yellow soup, $6-8; 6" bowl, $2-4; 5" bowl, $2-4; cup & saucer, $8-12; lifter, $8-12; Pink cup & saucer, $8-12; 5" bowl, $2-4; 6" bowl, $2-4.

Royal Rose on Aladdin & Gadroon Shapes, MK 87 unless noted, **Top Back Row** – 11" Aladdin lugged Teal Edge platter, $15-20; 11" lugged platter, $15-20; 16" Gadroon platter, $18-24; 13" platter, $15-20; 13" Aladdin lugged Gold Filigree platter, $18-24; **Top Front Row** – 6" W Aladdin creamer, $8-12; 5" W sugar, $8-12; Aladdin gravy, $8-12; Gadroon teapot, $45-60; gravy, $8-12; under plate, $5-8; sugar, $8-12; creamer, $5-10; 4" H egg cup, $12-15; **Bottom Back Row** – 9" Aladdin plate, $5-8; 10" gray edge plate, $10-15; 10" Gadroon plate, $5-10; 11" lugged plate, $10-15; 9" plate, $4-8; square plate, $3-5; 8" Aladdin Cup Ring Plate, $4-8; **Bottom Front Row** – Aladdin cup & saucer, $8-12; 8" plate, $4-8; 7" soup, $8-10; 7" shallow bowl, $4-8; 5" & 6" bowls, $4-8 each; lifter, $10-15; 6" Gadroon plate, $2-7; 7" plate, MK 100B, $3-5 each; Aladdin salt & pepper, $10-15 set; 8" Gadroon soup, $4-8; 7" bowl, $8-10; 7" lugged bowl, $4-6; 5" bowl, $2-4; cup & saucer, $8-10.

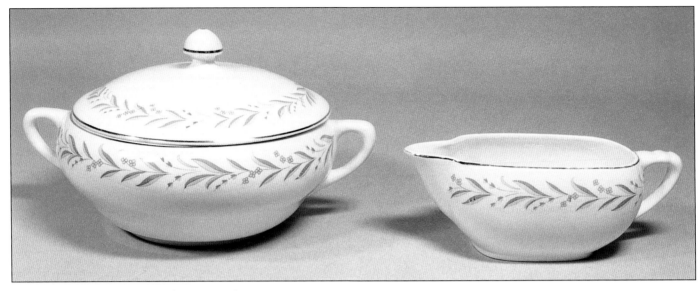

Regal, MK 189, 10" covered vegetable, $20-30; gravy, $10-15.

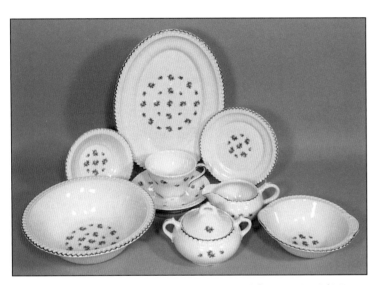

Rose Spray (Clustered) on Gadroon, MK 100, 9" bowl, $12-15; 5" bowl, $3-5; cup & saucer, $10-12; 12" platter, $12-15; sugar, $10-12; creamer, $8-10; 6" plate, $3-5; 7" lugged bowl, $6-10.

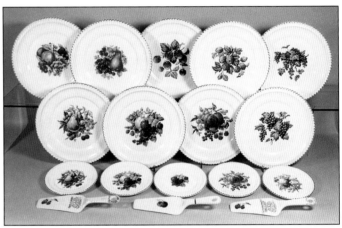

Gadroon Plates, Mixed Fruit, & Lifters, MK 100B, **Top** – 10" plates, $15-20 each; **Bottom Back Row** – 10" plates, $15-20 each; **Bottom Center Row** – 6" plates, $5-10 each; **Bottom Front Row** – lifters, $12-18 each.

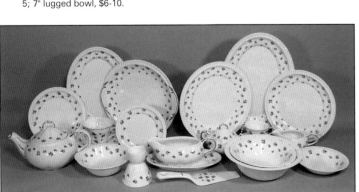

Rose Spray (Wreath) on Gadroon, MKs 100 & 159, teapot, $60-75; 7" plate, $4-8; 12" platter, $10-12; cup & saucer, $10-12; lugged bowl, $6-10; 4" H egg cup, $8-12; 6" plate, $3-5; 11" lugged plate, $8-12; lifter, $12-15; gravy, $12-15; under plate, $4-6; sugar, $10-12; 10" plate, $7-10; 7" bowl, $10-12; 9" bowl, $12-15; demitasse cup & saucer, $15-20; 13" platter, $15-20; 9" plate, $7-10; creamer, $8-10; 6"bowl, $3-5.

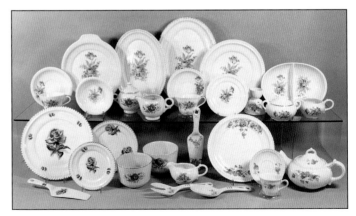

Assorted Roses, Assorted Shapes, MKs 84A, 87, 98, 100B, & 106, **Top Back Row** – 11" Aladdin Striped Tulip lugged plate, $5-8; 12" Gadroon platter, $5-8; 13" platter, $10-15; 10" plate, $3-5; 10" divided bowl, $12-18; **Top Front Row** – Aladdin Striped Tulip cup & saucer, $5-10; 5" Aladdin bowl, $2-4; 4" H Newport Centered Rose sugar, $5-10; 3" H creamer, $5-10; Gadroon Striped Tulip cup & saucer, $5-8; 6" plate, $2-4; Gadroon egg cup, $10-15; sugar, $8-10; creamer, $5-8; **Bottom** – 10" Gadroon Royal Pink Rose plate, $4-8; lifter, $10-15; 6" Gadroon plate, $2-4; 7" plate, $3-5; 2 different Centered Rose bowls, $3-5 each, Rose Garland fork, $10-15; 5" Gadroon Pink Rose creamer, $5-8; Rose Garland spoon, $10-15; Pink Rose lifter, $10-15; 9" Gadroon Rose Garland plate, $5-8; demitasse cup & saucer, $18-24; Gadroon teapot, $35-45.

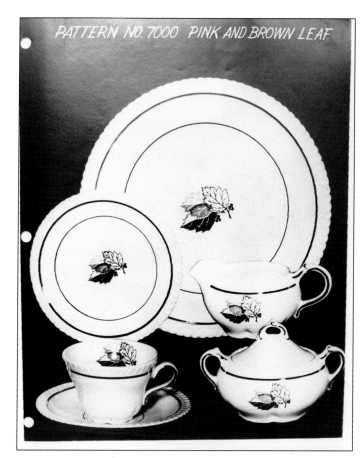

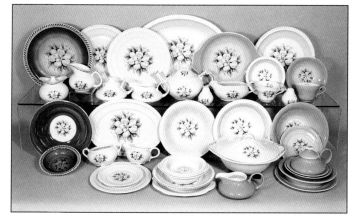

Pink & Brown Leaf Sales Brochure, Gadroon Shape, *Courtesy Cynthia Boyce Sheehan.*

Magnolia, Assorted Shapes, MKs 70, 71, 84A, 100B, 114, 129B, 141, & 159, **Top Back Row** – 10" Gadroon green blush plate, $8-10; 10" plate (small decal), $5-8; 10" plate (large decal), $5-8; 16" gray edge platter, $25-35; 11" Aladdin gray blush lugged plate, $25-35; 10" Gadroon gray edge plate, $5-8; **Top Front Row** – 4" H sugar, $10-15; 4" H creamer, $10-15; 5" W Aladdin sugar, $5-8; 6" W creamer, $5-8; Gadroon teapot, $30-45; salt & pepper, $8-12 set; gravy, $8-12; cup & saucer, $8-12; Aladdin gray cup & saucer, $8-12; **Bottom Back Row** – 9" Aladdin teal green bowl, $10-15; 11" Gadroon platter, $8-12; 8" bowl, $8-12; 9" gray edge bowl, $10-15; 8" Aladdin gray blush bowl, $25-35; 6" plate, $3-5; **Bottom Front Row** – 5" Gadroon green blush bowl, $4-6; sugar (no lid) & creamer, $10-15; 6" & 8" plates, $2-4 & $6-8; square gray edge plate, $4-8; 8" gray edge soup, $8-12; 7" lugged gray edge bowl, $5-10; 5" & 6" gray edge bowls, $3-5 each; gray band covered vegetable, $25-30; 6" W Aladdin gray creamer, $5-8; 8" gray blush plate, $3-5; 7" gray blush bowl, $8-12; 5" & 6" gray blush bowls, $3-5 & $5-8; 5" W gray sugar (decal on lid), $4-8.

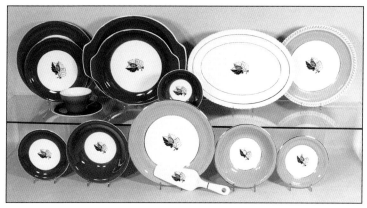

Pink & Brown Leaf on Aladdin & Gadroon, MKs 87 & 101, **Top** – 8" & 10" Aladdin teal edge plates, $4-6 & $5-8; cup & saucer, $6-8; 11" & 13" platters, $10-12 & $12-15; 5" bowl, $2-4, 13" Gadroon white platter, $18-24; 10" Gadroon Pink Cocoa edge plate, $6-8; **Bottom** – Aladdin except lifter, 6" teal edge plate, $2-4; 7" bowl, $8-10; 10" celadon edge plate, $5-8; white lifter, $12-15; 7" celadon edge bowl, $8-10; 6" plate, $2-4.

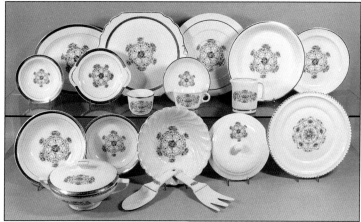

Southern Rose & Geometric Rose, Assorted Shapes, MKs 38, 80, 81, 84A, & 87, **Top** – 6" bowl, $3-5; 11" platter, $8-10; 8" Nouvelle lugged bowl, $4-6; Virginia utility plate, $18-24; Modern Age custard, $3-5; cup & saucer, $15-18; Concentric Rings Cheese Plate, $12-18; 4" H Modern Age creamer (no lid), $4-6; 10" pie baker, $12-18; 9" plate, $4-6; **Bottom** – 9" bowl, $8-10; 10" W Windsor covered vegetable, $25-30; 7" bowl, $5-8; Modern Age spoon & fork, $12-18 each; 9" Shell bowl, $10-15; 8" ball top lid, $8-10; 10" Gadroon Geometric Rose plate, $12-18.

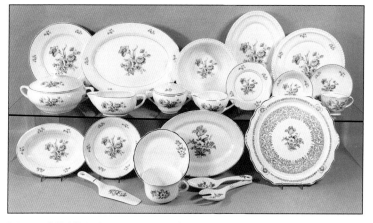

Primrose & Pink Tulip Bouquet, Assorted Shapes, MKs 84A & 193, **Top Back Row** – Primrose, 10" plate, $10-12; 14" platter, $15-20; 9" Gadroon bowl, $12-15; 12" platter, $10-12; 10" plate, $5-8; **Top Front Row** – Primrose decal, 9" covered vegetable, $20-25; gravy, $8-12; 6" W sugar, $8-12; 6" L creamer, $6-12; 6" plate, $5-7; 5" bowl, $4-6; cup & saucer, $10-12; **Bottom** – 9" Primrose oval bowl, $10-15; 7" bowl, $8-12; Pink Tulip lifter, $15-20; Jumbo cup & saucer, $15-20; 11" platter, $8-10; spoon & fork, $25-35 set; Virginia utility plate, $18-24.

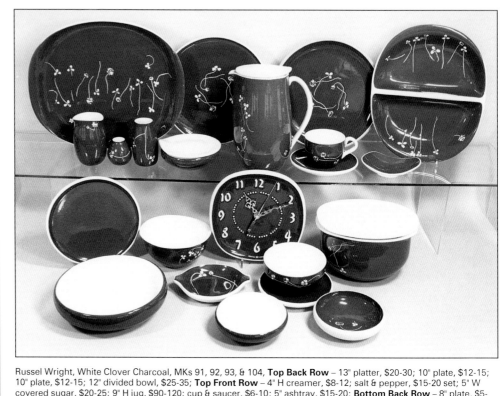

Russel Wright, White Clover Charcoal, MKs 91, 92, 93, & 104, **Top Back Row** – 13" platter, $20-30; 10" plate, $12-15; 10" plate, $12-15; 12" divided bowl, $25-35; **Top Front Row** – 4" H creamer, $8-12; salt & pepper, $15-20 set; 5" W covered sugar, $20-25; 9" H jug, $90-120; cup & saucer, $6-10; 5" ashtray, $15-20; **Bottom Back Row** – 8" plate, $5-10; 6" oval bowl, $20-25; 8" clock face, $50-60; 8" W covered bowl, $45-60; **Bottom Front Row** – 8" bowl, $6-10; 6" ashtray, $35-45; 5" bowl, $4-6; 5" bowl (with Clover), $12-15; 6" plate, $4-6; 5" bowl (Clover Inside), $8-10.

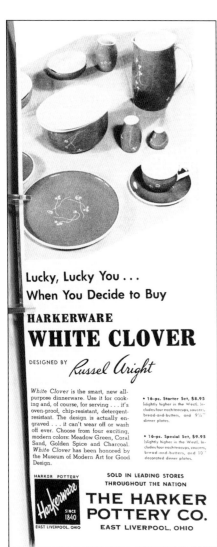

Lucky, Lucky You . . .
When You Decide to Buy

HARKERWARE

WHITE CLOVER

DESIGNED BY *Russel Wright*

White Clover is the smart, new all-purpose dinnerware. Use it for cooking and, of course, for serving . . . it's oven-proof, chip-resistant, detergent-resistant. The design is actually engraved . . . it can't wear off or wash off ever. Choose from four exciting, modern colors: Meadow Green, Coral Sand, Golden Spice and Charcoal. *White Clover* has been honored by the Museum of Modern Art for Good Design.

• **16-pc. Starter Set, $8.95** (slightly higher in the West). Includes four each teacups, saucers, bread-and-butters, and 9¼" dinner plates.

• **16-pc. Special Set, $9.95** (slightly higher in the West). Includes four each teacups, saucers, bread-and-butters, and 10" decorated dinner plates.

SOLD IN LEADING STORES
THROUGHOUT THE NATION

Harkerware HARKER POTTERY SINCE 1840 EAST LIVERPOOL, OHIO

THE HARKER POTTERY CO.
EAST LIVERPOOL, OHIO

Russel Wright Shape, White Clover Intaglio Ad, c. 1953, $8-12.

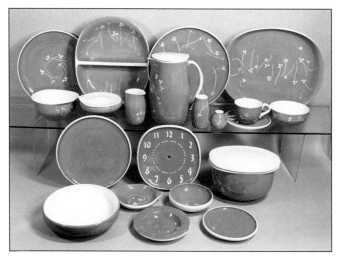

Russel Wright, White Clover Coral Sand, MKs 91, 92, & 93, **Top Back Row** – 10" plate, $12-15; 12" divided bowl, $25-35; 11" plate, $12-15; 13" platter, $20-30; **Top Front Row** – 6"oval bowl, $20-25; 5" covered sugar, $20-25; 4" H creamer, $8-12; 9" H jug, $90-120; salt & pepper, $15-20 set; cup & saucer, $6-10; 5" bowl (with Clover), $12-15; **Bottom Back Row** – 9" plate, $8-10; 8" clock face, $50-60; 8" covered bowl, $45-60; **Bottom Front Row** – 8" bowl, $6-10; 6" ashtray, $35-45; 6" notched ashtray, $8-10; 5" bowl (Clover inside), $8-10; 6" plate, $5-8.

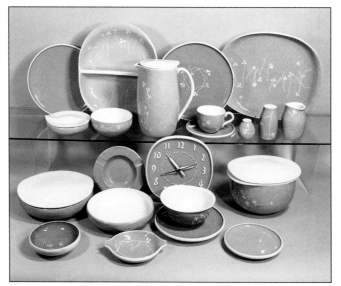

Russel Wright, White Clover Meadow Green, MKs 91, 92, & 93, **Top Back Row** – 9" plate, $8-10; 12" divided bowl, $25-35; 10" plate, $12-15; 13" platter, $20-30; **Top Front Row** – 5" covered sugar, $25-35; 5" bowl (with Clover), $12-15; 9" H jug, $90-120; cup & saucer, $6-10; pepper & salt, $15-20 set; 4" H creamer, $8-12; **Bottom Back Row** – 8" covered bowl, $30-35; 7" bowl, $5-8; 6" notched ashtray, $8-12; 8" clock face, $50-60; 6" oval bowl, $20-25; 8" plate, $5-10; 8" W covered bowl, $45-60; **Bottom Front Row** – 5" bowl (Clover inside), $12-15; 6" ashtray, $35-45; 6" plate, $5-8.

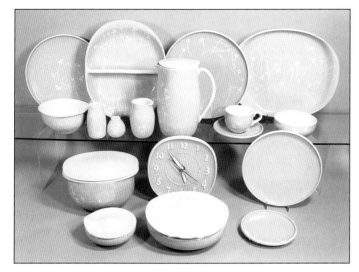

Russel Wright, White Clover Golden Spice, MKs 91, 92, & 93, **Top Back Row** – 10" plate, $12-15; 12" divided bowl, $25-35; 11" plate, $12-15; 13" platter, $20-30; **Top Front Row** – 6" oval bowl, $20-25; salt & pepper, $15-20 set; 4" H creamer, $8-12; 8" H jug, $90-120; cup & saucer, $6-10; 5" bowl (with Clover), $12-15; **Bottom Back Row** – 8" covered bowl, $45-60; 8" clock face, $50-60; 9" plate, $8-10; **Bottom Front Row** – 5" covered sugar, $20-25; 8" covered bowl, $30-35; 6" plate, $5-8.

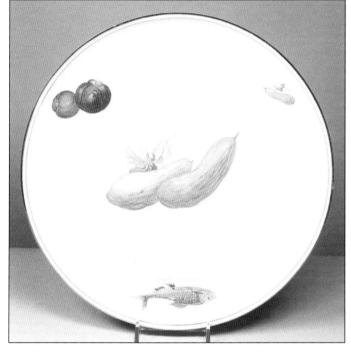

Russel Wright, Unusual Vegetable decal, MK 91, 11" plate, $25-35.

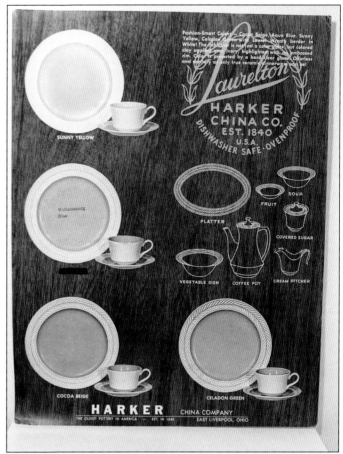

Laurelton Shape Ad showing Sunny Yellow, Williamsburg Blue, Cocoa Beige, & Celadon Green Colors, c. 1955, *Courtesy Cynthia Boyce Sheehan.*

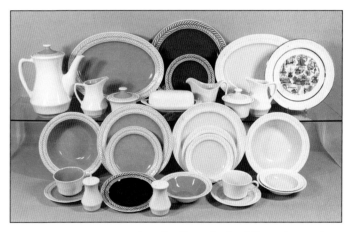

Laurelton Shape, 4 colors & Vermont souvenir plate, MKs 70 & 82, **Top Row** – 9" H Cocoa Beige coffeepot, $25-35; 14" platter, $10-15; 5" H creamer, $5-10; 4" H sugar, $8-12; 8" L covered butter, $10-15; 12" Teal plate, $20-25; 7" Teal plate, $8-10; 4" H Sunny Yellow creamer, $10-15; 14" Sunny Yellow oval platter, $10-15; 4" H sugar, $8-12; 5" H creamer, $4-6; 10" white "Vermont" plate, $10-15; **Bottom Back Row** – 9" Cocoa Beige bowl, $8-12; 7" & 10" plates, $4-6 & $6-10; 3 PC Sunny Yellow plates set 6", 7", & 10", $10-18; 9" bowl, $8-12; **Bottom Front Row** – Cocoa Beige cup & saucer, $4-8; 3" H salt & pepper, $5-10 set; 7" Chocolate Brown plate, $3-5; 6" Cocoa Beige bowl, $4-8; Sunny Yellow cup & saucer, $5-8; 6" & 7" bowls, $4-6 each.

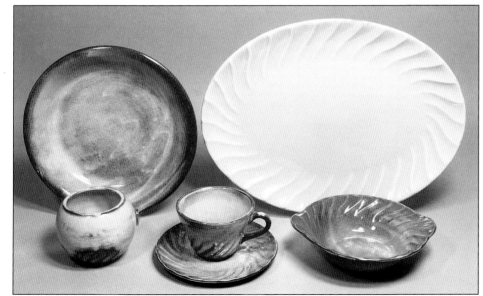

Barbecue (catsup & mustard effect), MK 109, 9" pie baker, $15-20; 3" H Shell sugar (no lid), $8-10; cup & saucer, $12-18; 14" platter, $20-30; 7" tabbed bowl, $10-12.

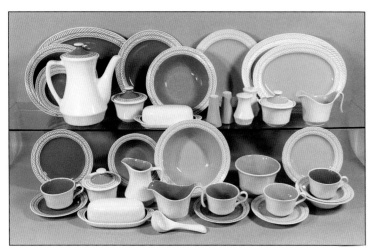

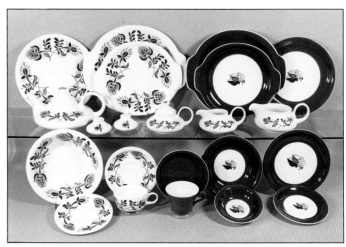

Laurelton Shape, 3 colors, MK 82 unless noted, **Top** – 3 PC Gray bowls set 5", 7", & 9", $10-20; 14" Gray platter, $10-15; 9" H coffeepot, $45-60; 4" H sugar, $5-10; 10" plate, $4-8; 8" L Gray covered butter, $10-15; 9" Celadon Green bowl, $8-12; 10" Williamsburg Blue plate, $4-8; Olympic Shape salt & pepper, $6-10 set; salt & pepper, $10-15; 12" & 14" platters, $10-15 each; 4" H sugar, $4-6; 4" H creamer, $5-10; **Bottom** – 7" Gray plate, $3-5; Gray cup & saucer, $5-10; 8" L Celadon Green covered butter, $10-15; 4" H sugar, $5-10; 6" bowl, $5-7; 5" H creamer, $5-10; (note shape difference) 4" H creamer, $8-12; 6" white ladle, $2-4; 9" Williamsburg Blue bowl, $7-10; Celadon Green cup & saucer, $5-10; 5" H Williamsburg Blue bowl, $4-8; Williamsburg Blue cup & saucer, $5-10; 7" plate, $2-4; 5.75" & 6.5" bowls, $3-5 each; Blue (inside) cup, $1-3.

Aladdin shape, Desert Flower & Pink & Brown Leaf, MK 84A, **Top Back Row** – 10" Desert Flower plate, $5-8; 11" & 13" platters, $15-20 & $18-24; 11" & 13" Pink & Brown Leaf teal edge platters, $12-18 & $15-20; 10" plate, $7-10; **Top Front Row** – 9" L Desert Flower teapot, $35-45; salt & pepper, $15-20 set; 4" H sugar, $8-10; 6" L creamer, $8-10; gravy, $15-20; **Bottom** – 8" Desert Flower bowl, $10-15; 6" plate, $2-4; cup & saucer, $6-10; teal cup & saucer, $4-8; 7" Pink & Brown Leaf teal edge bowl, $5-8; 5" bowl, $3-5; 8" plate, $4-8; 6" plate, $2-4.

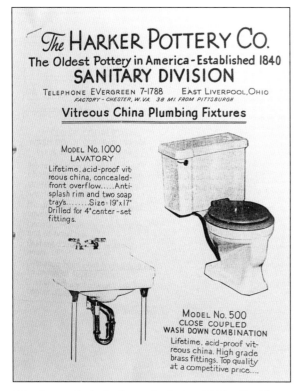

Advertisement for Harker Pottery Co. Sanitary Division Plumbing Fixtures, (Manufactured under "Royal" brand name), c. 1956.

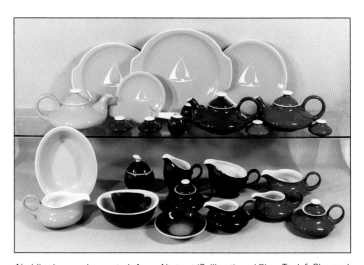

Aladdin shape unless noted, Aqua Abstract (Sailboat), and Blue, Teal, & Charcoal solid colors, MKs 87, 98, & 105, **Top Back Row** – 11" Aqua Abstract platter, $15-20; 6" plate, $7-10; 13" platter, $20-25; 10" plate, $8-12; **Top Front Row** – 9" L Blue teapot, $30-40; Blue lifter, $12-15; Charcoal salt & pepper, $15-20 set; Coupe Charcoal salt & pepper, $8-12 set; 9" L Charcoal teapot, $30-40; Teal salt & pepper, $15-20 set; 9" L Teal teapot, $30-40; **Bottom** – 9" Blue oval bowl, $6-10; gravy, $8-12; 7" Charcoal oval bowl, $5-8; Charcoal cup, $3-5; 5" H Coupe sugar, $8-12; 5" bowl, $1-3; 3" H sugar, $6-10; 5" H Coupe creamer, $10-15; 6" W creamer, $6-10; Coupe gravy, $12-18; 6" L Teal creamer, $8-12; gravy, $8-12; 3" H sugar, $8-12.

Aladdin Shape, Assorted Decorations, MKs 84A, 87, 100, & 172, **Top Back Row** – 13" Royal Rose & Gold Filigree platter, $12-18; 13" Royal Rose teal edge platter, $20-25; 13" teal edge platter, $10-15; 13" Ivy On Teal platter, $20-25; **Top Front Row** – 5" Gold Slender Leaf teal edge bowl, $4-6; 6" Royal Rose gray edge plate, $4-6; 6" Royal Rose teal edge plate, $4-6; Ivy On Teal salt & pepper, $18-24 set; 3" H sugar, $12-18; 6" W creamer, $18-24; cup, $8-10; 9" L teapot, $75-85; **Bottom Back Row** – 10" celadon green edge Queen Elizabeth plate, $20-25; 8" Mixed Fruit teal edge Cup Ring Plate, $8-12; Teal cup with Strawberries, $4-6; 9" Ivy On Teal bowl, $25-35; 11" platter, $15-20; 10" plate, $12-15; **Bottom Front Row** – 6" Ivy On Teal plate, $4-6; gravy, $35-45; 8" plate, $8-10; cup & saucer, $12-15 (Note 2 cup shapes); 5" & 7" bowls, $4-8 & $8-10.

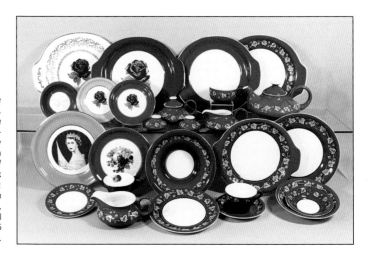

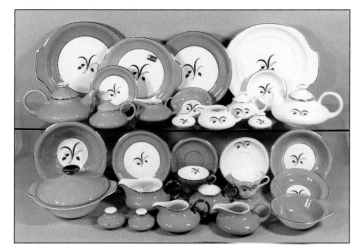

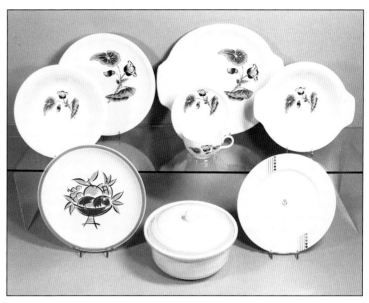

Slender Leaf on Aladdin, MK 172 on Gray Edge & MK 87 on White, **Top Back Row** – 13" gray platter, $20-30; 6" plate, $3-5; 11" "Souvenir of Chester, W.Va." platter, $18-25; 10" plate, $5-10; 13" white platter, $18-24; 5" bowl, $2-4; **Top Front Row** – 9" L gray teapot, $40-50; 4" H sugar, $8-10; 6" L creamer, $8-10; 5" bowl, $3-5; white salt & pepper, $12-18 set; white cream & sugar, $10-20 set; white teapot, $40-50; **Bottom Back Row** – 9" gray bowl, $8-12; 7" plate, $4-8; cup & saucer, $6-10; white cup & saucer, $6-10; 6.75" & 7.5" gray bowls, $5-8 & $6-10; **Bottom Front Row** – 10" gray lugged covered vegetable, $25-35; gray salt & pepper, $12-18; silver handle gravy, $10-15; silver handle creamer, $8-12; silver handle sugar, $8-12; gray creamer, $6-10; 6" lugged bowl, $5-8.

Assorted Shapes & Decals, MKs 84, 98, & 100, **Top** – Aladdin shape, Wood Flower, 8" bowl, $6-8; 10" plate, $3-5; 13" platter, $8-12; cup & saucer, $8-10; 10" lugged bowl, $7-10; **Bottom** – 10" Tutti Fruiti Stone Ware plate, $8-12; 8" W Yellow Bands casserole, $15-20; 9" Blue Tulip plate, $6-10.

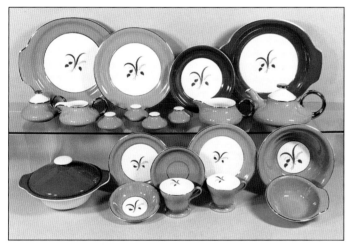

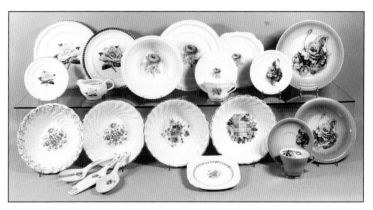

Slender Leaf on Aladdin, MK 172 on Celadon Green & MK 87 on Teal Green unless noted, **Top Back Row** – 13" celadon green platter, $15-18; 10" plate, $6-10; 8" Teal green plate, $5-8; 13" platter, $15-18; **Top Front Row** – 4" H celadon green sugar, $8-12; 6" L silver handle creamer, $8-12; 2 celadon salt & pepper sets (one silver trim), $10-15 per set; silver handle gravy, $12-15; 9" silver handle & white lid teapot, $50-65; **Bottom** – 10" W Teal lugged covered vegetable, $30-40; 7" celadon plate, $4-6; 5" bowl, $3-5; cup & saucer, $8-12; cup & 8" Cup Ring Plate, $10-15; 8" bowl, $8-12; 6" lugged bowl (MK s 84B & 98), $5-8.

Assorted Shapes & Decals, MKs 38, 84A, & 87, **Top** – 6" Gadroon White Rose plate, $2-4; 10" plate, $8-10; 6" creamer, $5-10; 9" gold edge plate, $5-8; 9" Gadroon large Pink Rose decal bowl, $12-18; 10" plate, $5-8; 6" plate, $2-4; Gadroon cup, $3-5; square plate, $3-5; 6" Aladdin Full Bloom Pink Rose, $2-4; 10" Aladdin Full Bloom Pink Rose gray plate, $8-12; **Bottom** – 9" Shell Rose Cluster bowl Gold Flower Spray edge, $8-10; 3 PC Rose Cluster utensil set, $30-45; Shell Rose Cluster bowl, $8-10; Rose Cluster II bowl, $8-10; 7" square Rose Cluster plate, $3-5; Shell Tartan bowl, $8-10; Aladdin Full Bloom Pink Rose gray cup & saucer, $8-12; 9" Aladdin bowl, $8-10.

Ivy on Aladdin Shape, MK 84, **Top** – 13" platter, $8-12; 6" W creamer, $5-8; cup, $3-5; 5" W sugar, $5-8; **Bottom** – 5" bowl, $2-4; 7" soup, $5-8; cup, $3-5.

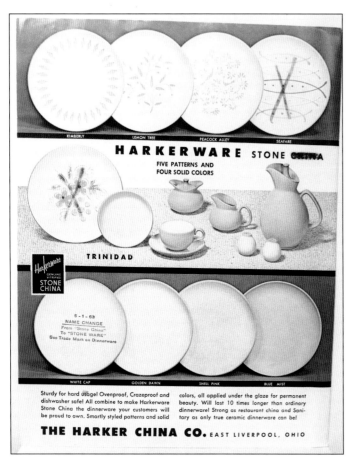

Stone China (a.k.a. Stone Ware) Ad showing Kimberly, Lemon Tree, Peacock Alley, Seafare, Trinidad, (& Solid Colors), White Cap, Golden Dawn, Shell Pink & Blue Mist, c. 1957, *Courtesy Cynthia Boyce Sheehan.*

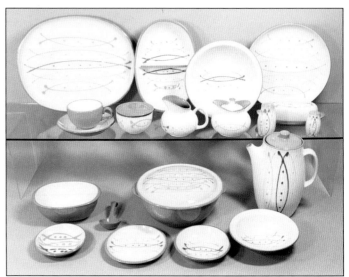

Seafare, Stone China, MKs 104, 105, & 107, **Top Back Row** – 13" platter, $8-12; 10" divided bowl, $12-18; 8" bowl, $6-10; 10" plate, $2-4; **Top Front Row** – cup & saucer, $5-8; 4" W covered condiment, $12-15; 4" H creamer, $6-10; 4" H sugar, $8-12; 7" L covered butter, $12-18; salt & pepper, $18-24 set; **Bottom Back Row** – 7" oval bowl, $8-10; 5" gray ladle, $2-4; 9" covered lugged vegetable, $20-25; 9" H coffeepot, $35-45; **Bottom Front Row** – 5" bowl, $3-5; 6" plate, $2-3; 5" bowl, $2-4; 6" bowl, $2-4.

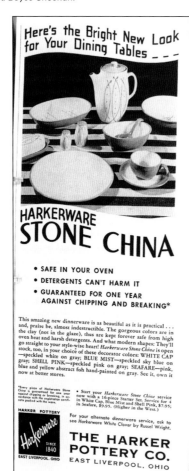

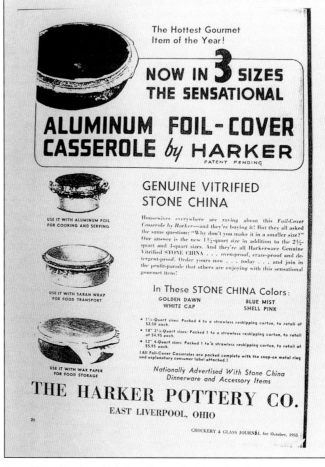

Stone China Aluminum Foil-Cover Casserole Ad, c. 1955, $5-8.

Seafare Ad, Stone
China (Stone Ware),
c. 1955, $8-12.

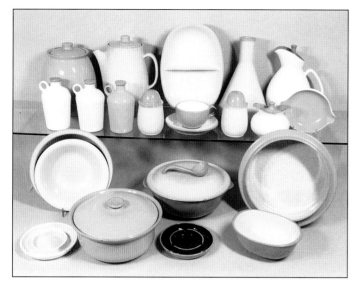

Stone China, 4 colors (a.k.a. Oatmeal), plus Charcoal, MKs 91, 103, 104, 105, 106, 107, & 114, **Top Back Row** – 8" H Blue Mist cookie jar, $35-50; 9" H Shell Pink coffeepot, $30-40; 10" Golden Dawn divided bowl, $10-15; 9" H Shell Pink carafe, $30-40; 9" H White Cap stopper jug, $25-35; **Top Front Row** – 5" H White Cap, Golden Dawn, & Blue Mist cruets, $8-12 each; Shell Pink salt & pepper, $12-18 set; White Cap cup & saucer, $3-5; 4" H White Cap sugar, $5-10; 6" Blue Mist ashtray, $10-15; **Bottom** – 5" Shell Pink ashtray, $10-15; 8" Shell Pink bowl, $8-12; 7" Golden Dawn bowl, $5-10; 8" Blue Mist casserole, $20-30; 9" Shell Pink lugged bowl & flat lid, $30-35; 5" gray ladle, $2-4; 5" Charcoal ashtray, $30-40; 7" Golden Dawn oval bowl, $5-10; 10" Shell Pink Aluminum Foil-Cover Casserole, $18-24.

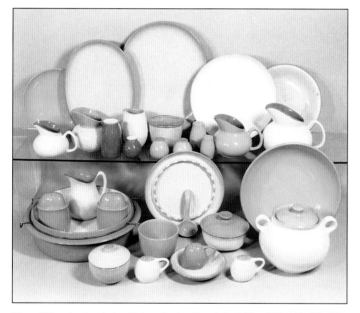

Stone China, 4 colors (a.k.a. Oatmeal), plus Gray & Dark Blue, MKs 103, 105, 106, 107, 108, 110, & 114, **Top Back Row** – 8" Blue Mist plate, $2-4; 11" Shell Pink platter, $5-8; 13" Shell Pink platter, $8-12; 10" White Cap plate, $4-6; 9" Golden Dawn pie baker, $5-10; **Top Front Row** – 3" White Cap creamer, $5-8; 4" Shell Pink jug (note Gray throat), $10-15; 4" H Dark Blue salt & 2.25" H pepper, $15-20 set; 4" H Golden Dawn creamer, $5-10; 4" H Shell Pink bowl with "Harker Kitchenware" glass lid, $12-18; 2.25" H Blue Mist salt & pepper, $4-8 set; 3.25" H Blue Mist salt & 2.25" H pepper, $10-15 set; 4" H Blue Mist jug, $10-15; 5" H Golden Dawn jug, $18-25; **Bottom** – 12" Golden Dawn Aluminum Foil-Cover Casserole (wire handle holds foil), $15-20; 5" H White Cap jug, $5-8; 5" H Gray salt & pepper, $12-15 set; 4" Shell Pink covered bowl, $12-15; 2.5" H Golden Dawn coupe salt & pepper, $8-10 set; 4" H Blue Mist bowl, $5-8; 8" Shell Pink ashtray, $12-18; 5" Gray ladle, $2-4; 5" Shell Pink bowl, $2-4; Coupe Gray salt, $3-5; 5" W Golden Dawn covered bowl, $10-15; 10" Blue Mist bowl, $5-10; 6" H Golden Dawn handled cookie jar, $40-50.

Macintosh (Apple) & Trinidad, Stone China, MKs 104, 107, 110, & 114, **Top** – 8" Macintosh plate, $5-8; 13" platter, $18-24; cup & saucer, $8-12; 8" H Trinidad stopper jug, $35-45; 13" platter, $18-24; 3" H creamer, $8-10; 8" plate, $5-8; 4" sugar, $8-12; 11" platter, $10-12; cup & saucer, $10-15; **Bottom** – 6" Macintosh bowl, $5-8; 11" platter, $12-18; 5" bowl, $3-5; 8" bowl, $15-20; 4" H creamer, $8-12; 8" Trinidad bowl, $12-15; 6" bowl, $5-8; 10" plate, $8-12; 6" plate, $3-5.

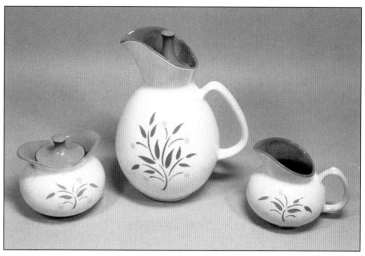

Lemon Tree Intaglio (a.k.a. Orange Tree), Stone China, MK 114, 3" sugar, $8-10; 8" H stopper jug, $35-45; 3" H creamer, $8-10.

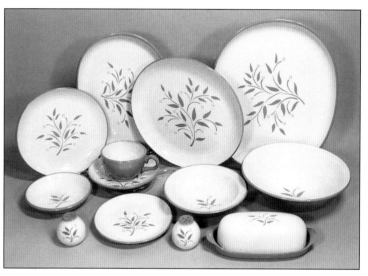

Lemon Tree Intaglio (a.k.a. Orange Tree), Stone China, MKs 105 & 107, **Back** – 7" plate, $6-10; 11" platter, $15-20; 10" plate, $8-10; 13" platter, $20-30; **Middle** – 5" bowl, $8-10; cup & saucer, $10-12; 6" bowl, $5-8; 8" bowl, $20-25; **Front** – 2" H salt & pepper, $12-15 set; 6" plate, $4-6; 8" L Covered Butter, $18-24.

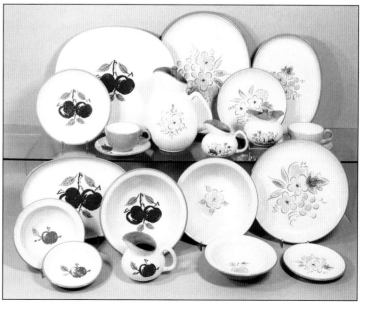

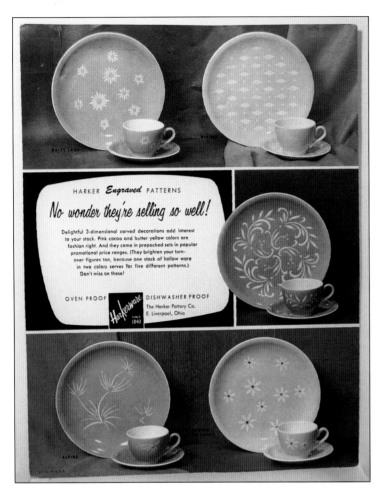

Intaglio (Engraved) Ad Showing Daisy Lane, Viking, Rocaille, Alpine, & Brown Eyed Susan Patterns, c. 1957, *Courtesy Cynthia Boyce Sheehan.*

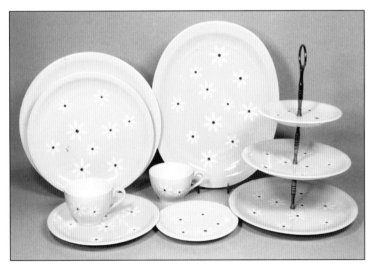

Brown Eyed Susan, Intaglio, Yellow Coupe Shape, MK 101, 10" & 11" plates, $3-5 & $5-8; cup & 8.25" Cup Ring Plate, $5-8; cup, $2-4; 6" plate, $1-3; 13" platter, $8-10; 3 tier tidbit (6", 8", & 10"), $10-15.

Ivy Wreath (celadon green), Assorted Shapes, MKs 101 & 114, **Top Back Row** – 13" Olympic platter, $10-15; 11", $5-8; 10" & 11" Coupe plates, $5-10 each; 13" Coupe platter, $10-15; **Top Front Row** – 4" H Stone China creamer, $5-8; 3" H sugar, $5-8; 8" L Covered Butter, $8-12; Coupe cup & saucer, $10-12; 9" H Olympic stopper jug, $20-25; **Bottom Back Row** – 7" & 10" Olympic plates, $2-4 & $4-8; 6" & 8" Coupe plates, $3-5 each; 9" Coupe bowl, $8-12; **Bottom Front Row** – Coupe Shape, 6" bowl, $2-4; 8" bowl, $3-5; 6" bowl, $2-4; 5" bowl, $2-4.

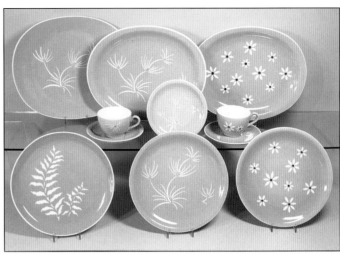

Pink Cocoa, Assorted Intaglio Patterns & Shapes, MK 101, **Top Back Row** – 13" Olympic Alpine platter, $10-15; 13" Coupe Alpine platter, $10-15; 13" Coupe Brown Eyed Susan platter, $10-15; **Top Front Row** – Alpine cup & saucer, $8-12; 6" Coupe Alpine plate, $3-5; Brown Eyed Susan cup & saucer, $12-15; **Bottom** – 10" Olympic Fern plate, $10-15; 10" Coupe Alpine plate, $6-10; 10" Coupe Brown Eyed Susan plate, $6-10.

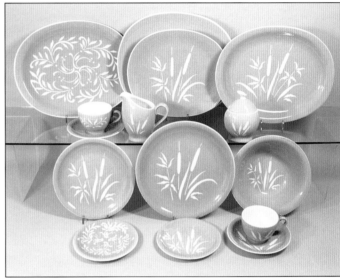

Pink Cocoa, Assorted Intaglio Patterns & Shapes, MKs 58 & 101, **Top Back Row** – 13" Coupe Rocaille platter, $12-15; 11" & 13" Olympic Everglades platters, $7-10 & $12-15; 13" Coupe Everglades platter, $12-15; **Top Front Row** – Rocaille cup & saucer, $7-10; 5" H Coupe Shape Everglades creamer, $5-8; 5" H Coupe sugar, $5-8; **Bottom** – Coupe Shape, 8" Everglades plate, $10-15; 6" Rocaille plate, $2-4; 10" Everglades plate, $10-12; 6" plate, $2-4; 8" bowl, $10-15; cup & saucer, $7-10.

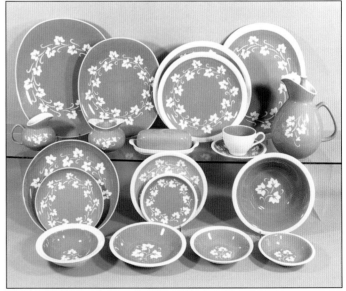

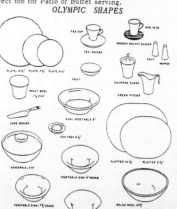

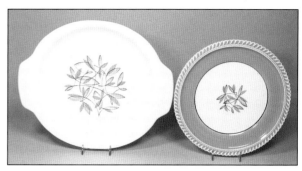

Olympic –

Exclusive hand–engraved underglaze to remain eternally mar–free and dishwasher safe.
Pottery itself is sheer food flattery–bold colors–Yellow, Coral, Green, Blue or Cocoa.
OVENPROOF so you can keep food warm–perfect too for Patio or Buffet serving.

OLYMPIC SHAPES

1969

PETITE FLEURS – BLUE	WHITE DAISY – YELLOW
EVERGLADES – BEIGE	IVY WREATH – GREEN
SPRINGTIME – BEIGE	SNOW LEAF – BLUE
CORONET – GREEN	BAMBOO – BEIGE
PROVINCIAL – GREEN	DOGWOOD – BEIGE
CLOVER – AVOCADO	ROOSTER – YELLOW
AMERICANA (OVIDE) – GREEN	EUROPA – GREEN
QUAKER MAID – BROWN	

	Retail Each
Tea Cup	$.95
Tea Saucer	.75
Plate, 6¼" B & B	.80
Plate, 7¼" Salad	1.30
Plate, 10¼" Dinner	1.90
Soup	1.25
Fruit	.80
Platter, 11¼"	2.75
Platter, 13½"	3.95
Vegetable Dish, 9" Round	1.75
Vegetable Dish, Oval	2.65
Vegetable Dish, 7¾", Round	1.65
Gravy Bowl, 1½ Pint	1.90
Ladle	.95
Cream Pitcher	2.15
Covered Sugar	2.95
Casserole, 2 Qt.	5.95
Beverage Server, Covered, 8 Cup	6.95
Salt & Pepper, Pair	2.65
Divided Vegetable Dish	4.75
Covered Butter Dish	3.95
Salad Bowl, 10¾"	3.50
Mug, 10 oz.	1.15
Ash Tray	.85
Cake Server	.95

HARKER CHINA CO.
OLDEST IN AMERICA–EST. 1840
CHESTER, WEST VIRGINIA 26034

Olympic Shape Sales Brochure & Price List, c. 1957, $4-8.

Harmony on Aladdin & Gadroon, 13" Aladdin platter, MK 100A, $12-18; 10" Gadroon gray edge plate MK 98A, $5-8.

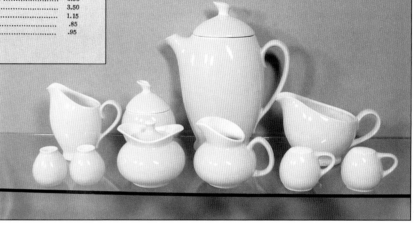

Yellow, Coupe & Stone China, MK 114, Stone China salt & pepper, $8-12 set; 5" H Coupe creamer, $8-12; 3" H Stone China sugar, $5-10; 5" H Coupe sugar, $12-18; 10" H Coupe coffeepot, $18-24; 4" H Stone China creamer, $5-10; Coupe gravy, $10-15; Coupe salt & pepper, $8-12 set.

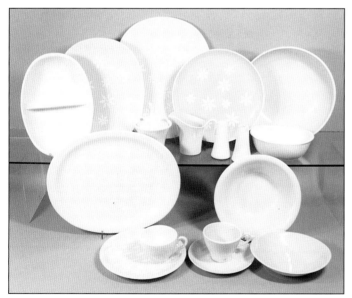

Yellow, Intaglio, Daisies & Viking Patterns, Assorted Shapes, MKs 101, 105, & 112, **Top** – Olympic Shape 10" divided bowl, $6-10; 11" Daisies platter, $4-6; 13" Daisies platter, $5-10; 6" H sugar, $3-5; 4" H creamer, $3-5; 10" Daisies plate, $5-10; salt & pepper, $4-8 set; 10" bowl, $5-10; 7" Stone China Shape oval bowl, $3-5; **Bottom** – 13" Coupe Viking platter, $6-10; 8" Coupe Cup Ring Plate & cup, $10-15; Olympic cup & saucer, $2-4; 9" Coupe bowl, $4-6; 7" Olympic oval bowl, $5-8.

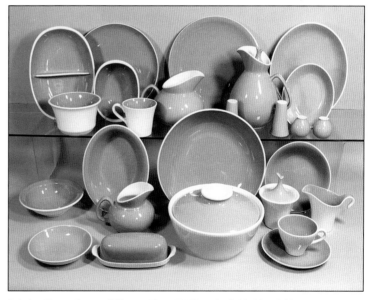

Celadon Green, Assorted Shapes, **Top** – 10" Olympic divided bowl, $8-10; 5" slope sided bowl, $5-8; 10" plate, $4-6; 7" Stone China oval bowl, $5-8; 3.5" H Olympic Shape mug, $3-5; 6" H Stone China jug, $15-20; 11" Olympic plate, $8-10; Olympic salt & pepper, $6-10 set; 9" H Olympic stopper jug, $20-30; 2" H Stone China salt & pepper, $6-10 set; 11" oval bowl, $8-12; 7" oval bowl, $8-10; **Bottom Back Row** – 6" Coupe Shape bowl, $5-8; 9" Olympic oval bowl, $8-10; 11" bowl, $8-12; 8" oval bowl, $3-5; **Bottom Front Row** – 6" Olympic bowl, $2-4; 4" H Stone China jug, $5-10; 8" Covered Butter, $8-10; 9" Olympic casserole, $20-25; 5" H sugar, $5-8; 4" H creamer, $3-5; Olympic cup & saucer, $5-8.

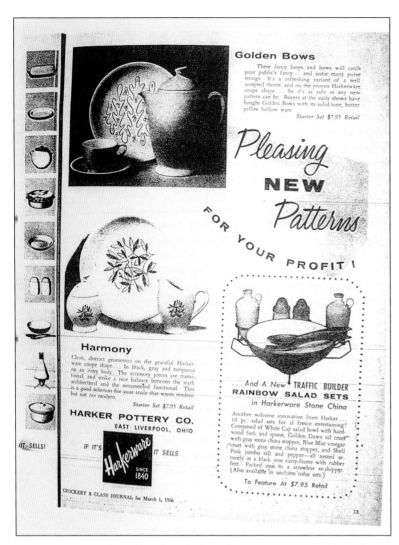

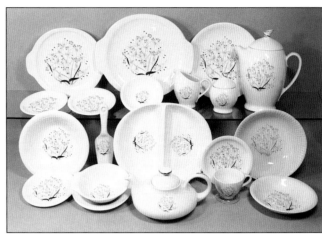

Wild Oats I (black leaves a.k.a. Donna I), Assorted Shapes, MKs 93, 98, 136, 167A, & 167B, **Top Back Row** – Aladdin, 11" platter, $12-15; 13" platter, $15-20; 10" plate, $8-12; **Top Front Row** – 6" saucer, $4-6; 6" plate, $5-10; 5" bowl, $2-4; 5" H Coupe creamer, $8-12; 5" H sugar, $8-12; 10" H Coupe coffeepot, $30-40; **Bottom Back Row** – 9" Aladdin Shape bowl, $8-12; lifter, $12-15; 12" Russel Wright divided bowl, $30-40; 9" Shellridge bowl, $8-12; **Bottom Front Row** – 6" saucer, $2-4; 6" tabbed bowl, $4-6; 7" bowl, $4-8; 9" L Aladdin teapot, $45-60; cup & saucer, $8-12; 7" bowl, $7-10.

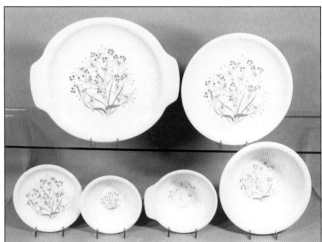

Wild Oats II (green leaves, a.k.a. Donna II) on Aladdin, MK 98, **Top** – 13" platter, $18-24; 10" plate, $5-10; **Bottom** – 6" plate, $4-8; 6" bowl, $4-8; 7" tabbed bowl, $8-10; 8" bowl, $12-18.

Sales Brochure, Golden Bows Intaglio Coupe Shape, Harmony decal, & Stone China Rainbow Salad Sets Ad, c. 1956, $5-8.

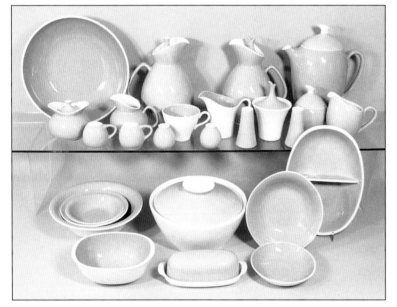

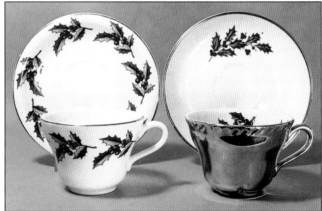

Christmas Holly decals on Aladdin & Gadroon, MK 94, Aladdin cup & saucer, $18-25; Gadroon gold glaze with Holly inside cup & 6" (non-Gadroon) saucer, $12-20.

Pink Cocoa, Assorted Shapes, MKs 101, 105, & 114, **Top Back Row** – 11" Olympic bowl, $6-10; 9" H Olympic stopper jug, $18-24; 9" H Olympic lobed stopper jug, $18-24; 10" H Coupe coffeepot, $30-40; **Top Front Row** – 4" H Stone China sugar, $4-8; Coupe salt & pepper, $10-15 set; 4" H Stone China creamer, $4-8; Olympic cup, $1-3; Stone China salt & pepper, $5-8 set; 4" H Olympic creamer, $5-8; Olympic salt & pepper, $5-10 set; 6" H Olympic sugar lobed top, $6-10; 5" H Coupe sugar, $6-10; 5" H Coupe creamer, $6-10; **Bottom Back Row** – 3 PC Coupe bowl set 5", 6", & 9", $18-25; 9" casserole, $15-20; 8" Olympic oval bowl, $3-5; 10" Olympic divided bowl, $8-12; **Bottom Front Row** – 7" Olympic oval bowl, $5-8; 7" L covered butter, $12-15; 6" Olympic bowl, $2-4.

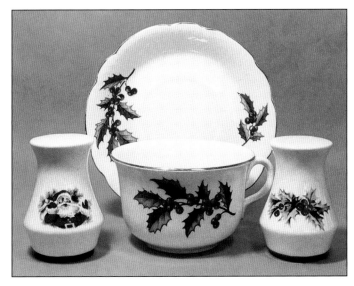

Christmas Decals, No Marks, 4" H Laurelton Santa salt, $5-8; Jumbo Holly cup & saucer, $30-50; 4" H Laurelton Holly pepper, $5-8.

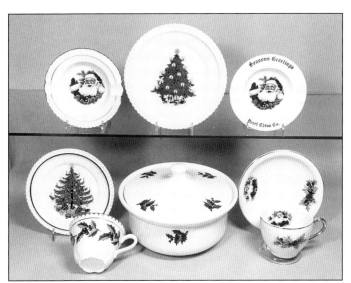

Christmas on Assorted Shapes, MKs 98, 120, 141, 145, & 172, **Top** – 5" Gadroon Santa Claus ashtray, $5-8; 7" Gadroon Christmas Tree plate, $8-10; 5" Santa Claus ashtray, $8-12; **Bottom** – 6" Gadroon Christmas Tree plate, $5-8; Gadroon Holly cup, $5-8; 8" W Holly casserole, $12-18; Santa & Holly cup & saucer, $12-18.

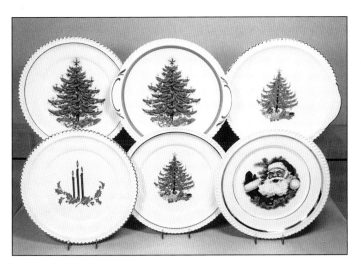

Christmas Decals on Gadroon, MK 172, **Top** – 10" Christmas Tree (red line) plate, $8-10; 11" lugged Christmas Tree green line plate, $15-18; 11" Lugged Christmas Tree plate, $12-15; **Bottom** – 10" plates, Holly & Candles, $8-12; Christmas Tree, $12-15, Santa Claus, $10-15.

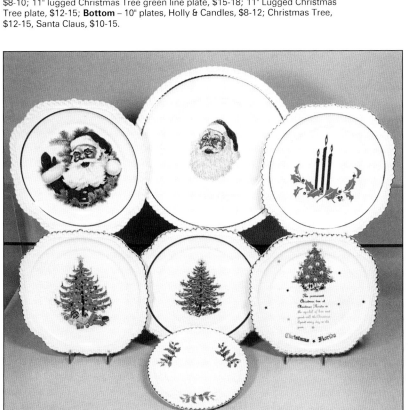

Blue Dane (a.k.a. Delft) Ad, Heritance Shape, c. 1955, *Courtesy Cynthia Boyce Sheehan.*

Christmas on Gadroon, MK 172, **Top** – square Santa Claus plate, $8-12; 10" Santa Claus plate, $5-8; square Holly & Candles plate, $12-15; **Bottom** – square Christmas Tree plate, $12-15; square (red line) Christmas Tree plate, $12-15; square "Christmas Florida" plate, $5-8; 6" round Holly plate, $3-5.

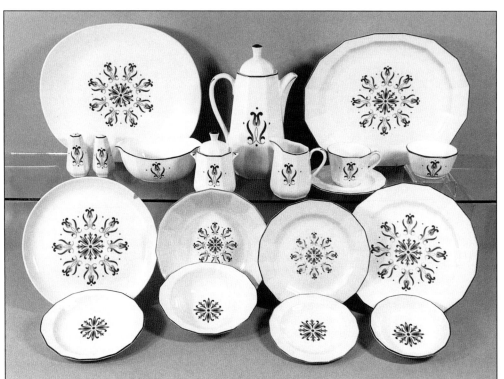

Blue Dane, Heritance & Olympic Shapes, MKs 100, 101, 126, & 126A, **Top** – 13" Olympic platter, $12-15; Heritance salt & pepper, $15-20 set; Heritance gravy, $10-15; 5" H sugar, $12-18; 10" H coffeepot, $50-65; 4" H creamer, $12-18; cup & saucer, $12-15; 14" platter, $18-24; 4" bowl, $8-12; **Bottom** – 10" Olympic plate, $8-12; rest are Heritance, 7" oval plate, $5-8; 9" bowl, $15-18; 7" oval bowl, $5-10; 8" plate, $4-8; 6" plate, $4-6; 10" plate, $6-10; 5" bowl, $5-8.

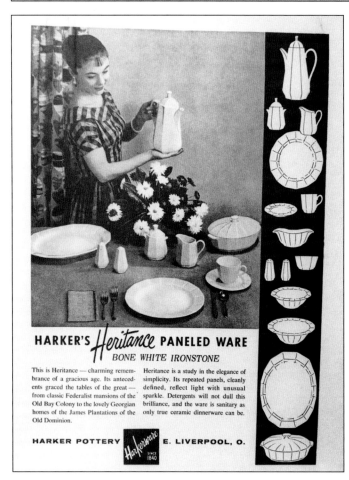

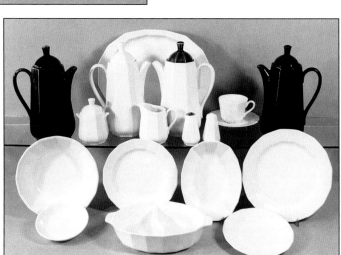

Bone White & Brown on Heritance, MK 112, 127, & 171, **Top** – 10" H brown drips glaze coffeepot, $50-65; 5" H white sugar, $8-12; white coffeepot, $30-40; 14" platter, $15-20; 4" H creamer, $8-12; white coffeepot with brown lid, $30-40; silver top salt & white pepper, $8-12 set; white cup & saucer, $8-10; brown coffeepot, $50-65; **Bottom** – white, 9" bowl, $10-15; 5" bowl, $3-5; 11" divided bowl, $18-24; 8" plate, $4-6; 8" oval bowl, $8-12; 7" plate, $4-8; 10" plate, $5-10.

Bone White Ironstone Ad, Heritance Shape, c. 1955, *Courtesy Cynthia Boyce Sheehan.*

Golden Wheat & Plain White Sales Brochures, Heritance, *Courtesy Cynthia Boyce Sheehan.*

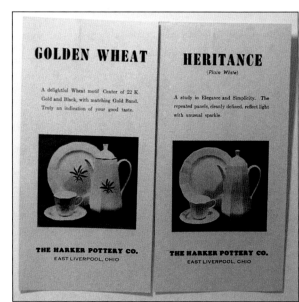

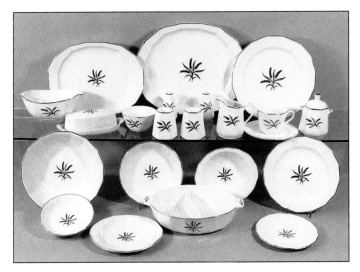

Golden Wheat on Heritance, MKs 101, 105, 126, & 126A, **Top Back Row** – 11" platter, $10-15; 14" platter, $15-20; 10" plate, $8-12; **Top Front Row** – 7" gravy, $12-15; 8" covered butter, $12-18; 4" bowl, $5-8; 3" H Candle Holders, $25-40 set; salt & pepper, $20-25 set; 4" H creamer, $12-15; cup & saucer, $12-18; 5" H sugar, $15-20; **Bottom** – 9" bowl, $10-15; 5" bowl, $3-5; 7" oval plate, $5-10; 7" bowl, $8-10; 10" divided bowl, $20-25; 7" oval bowl, $6-10; 6" plate, $3-5; 8 plate, $8-12.

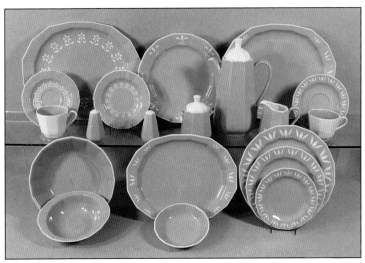

Blue, Heritance, Assorted Patterns, MKs 57, 101, **Top** – 14" Petit Fleurs platter, $15-18; cup & saucer, $8-12; 6" plate, $3-5; salt & pepper, $5-10 set; 10" Fleur-de-lis plate, $20-25; 5" H white lid sugar, $8-12; 10" H white lid coffeepot, $30-40; 4" H creamer, $8-12; 14" Lotus platter, $10-15; cup & saucer, $10-15; **Bottom** – 9" bowl, $10-15; 7" oval bowl, $7-10; 11" Lotus platter, $10-15; 5" bowl, $2-4; 3 PC Lotus plate set, 6", 8", & 10", $10-20.

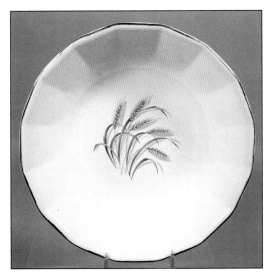

Natural Wheat on Heritance, no mark, 9" bowl, $18-24.

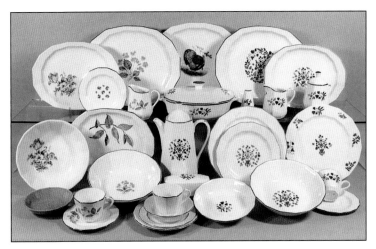

Heritance, Assorted Decals, MKs 101, 105, 112, & 126, **Top Back Row** – 11" Pink Tulip Bouquet platter, $10-15; 11" Forget-Me-Not platter, $18-24; 14" Turkey platter, $20-25; 14" Flora platter, $10-15; 11" platter, $8-12; **Top Front Row** – 6" Rose Spray plate, $3-5; 4" H Forget-Me-Not creamer, $5-10; 11" Flora covered vegetable, $15-25; salt, $5-8; 4" H creamer, $5-10; 5" H sugar, $5-10; **Bottom Back Row** – 9" Pink Tulip Bouquet bowl, $10-15; 11" Birch Leaves platter, $15-18; 10" H Flora coffeepot, $25-35; 8" & 10" plates, $5-8 each; 10" Flora Variation plate, $5-8; **Bottom Front Row** – 5" Avocado bowl, $3-5; Forget-Me-Not cup & saucer, $5-10; 9" Forget-Me-Not bowl, $5-10; Silver Line cup & saucer, $5-10; 5" Silver Line bowl, $3-5; 7" Silver Line plate, $1-3; 7" L Flora covered butter, $15-20; 7" bowl, $5-10; 9" bowl, $8-12; cup & saucer, $8-12.

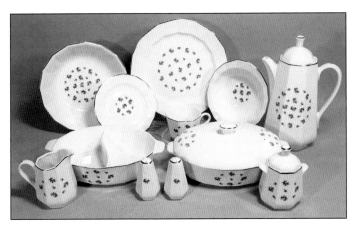

Rose Spray (Cluster) on Heritance, MKs 99 & 126, **Back** – 9" bowl, $12-18; saucer, $3-5; 10" plate, $8-12; cup, $4-6; 7" oval bowl, $8-12; 10" H coffeepot, $30-40; **Front** – 4" H creamer, $12-15; 11" divided bowl, $20-25; salt & pepper, $10-15 set; 11" covered vegetable, $25-30; 5" H sugar, $10-15.

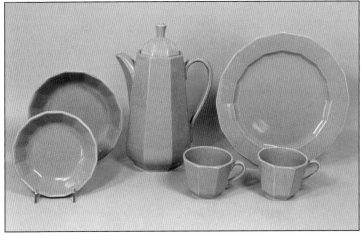

Avocado, Heritance, MK 112, 5" bowl, $3-5; 7" bowl, $8-10; 10" H coffeepot, $20-25; Two cups, $3-5 each; 10" plate, $6-8.

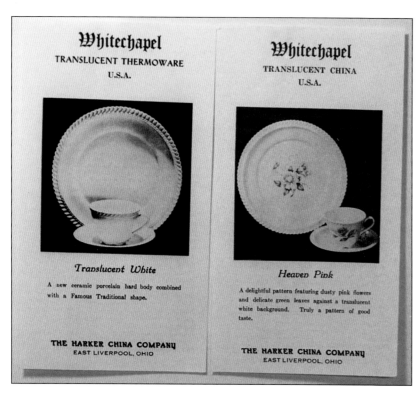

Assorted Shapes & Decals, MKs 98, 98A, 129B, 141, & 170, **Top Back Row** – 13" Whitechapel Cynthia platter, $5-10; 10" plate, $4-8; 10" Aladdin Pine Cones plate, $5-10; 11" Aladdin platter, $8-12; **Top Front Row** – Whitechapel Cynthia gravy, $5-10; 5" W Whitechapel sugar, $5-10; 5" W creamer, $5-8; 5" W Blue Pine Cones sugar (no lid), $5-10; 6" plate, $6-10; Aladdin gray cup & Pine Cones saucer, $4-8; **Bottom Back Row** – 8" Whitechapel Cynthia soup, $5-8; Whitechapel cup & saucer, $5-8; 6" lugged bowl, $3-5; Pine Cones lifter, $10-15; 6" & 8" Aladdin Pine Cones plates, $2-4 each; 9" Aladdin bowl, $8-12; **Bottom Front Row** – 6" Whitechapel Cynthia plate, $1-3; 5" Aladdin Pine Cones bowl, $2-4; 7" W plate, $2-4; 7" Shellridge Pine Cones bowl, $6-10; 6" Aladdin lugged bowl, $3-5.

Whitechapel (Translucent Thermoware) Sales Brochures, c. 1959, *Courtesy Cynthia Boyce Sheehan.*

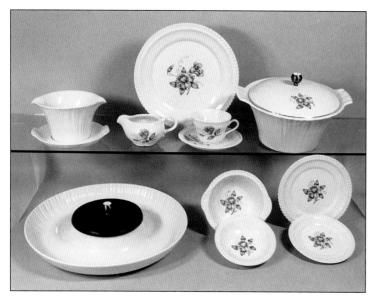

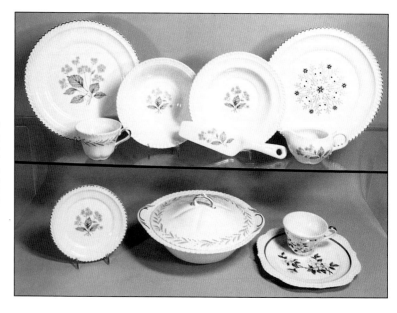

Assorted Shapes & Decals, MKs 100B & 159, **Top** – 6" Gadroon Babies Breath & Roses plate, $2-4; 10" Gadroon plate, $5-8; 7" Whitechapel lugged bowl, $4-6; 9" Gadroon plate, $5-8; 9" L Gadroon Pink Rose Buds teapot, $40-50; 12" Gadroon platter, $8-12; Gadroon cup & saucer, $5-10; 9" Gadroon bowl, $5-8; 5" W Whitechapel sugar (no lid), $5-8; 5" bowl, $2-4; 10" Gadroon plate, $5-8; 5" W Whitechapel creamer, $4-6; 6" plate, $2-4; **Bottom** – 3 PC Pink Rose Buds utensil set, 2 lifters & spoon, $40-50; 5" Gadroon Blue Leaves Bouquet bowl, $3-5; 8" Gadroon soup, $8-10; 3 tier Gadroon Pink Roses tidbit (6", 8", & 10"), $15-20; 6" Gadroon Blue Leaves Bouquet plate, $2-4; Gadroon saucer, $2-4; 10 Gadroon plate, $8-10.

White & Heaven Pink, Whitechapel & Shellridge, MKs 136, 137, & 142, **Top** – 7" W Shellridge gravy bowl & fused under plate, $12-18; 5" W Whitechapel Heaven Pink creamer, $4-6; 10" plate, $4-6; cup & saucer, $5-8; 10" Shellridge Heaven Pink covered vegetable, $20-30; **Bottom** – 14" W Shellridge Chip & Dip with 6" W walnut lid, $25-35; 6" Whitechapel Heaven Pink lugged bowl, $3-5; 5" bowl, $2-4; 7" plate, $2-4; 6" plate, $2-4.

Assorted Shapes & Decals, MKs 100 & 159, **Top** – 10" Whitechapel Forget-Me-Not plate, $8-10; Gadroon Regal cup, $4-6; 7" Gadroon Forget-Me-Not bowl, $8-10; lifter, $15-20; 8" Gadroon soup, $8-12; 6" Whitechapel creamer, $8-12; 10" Whitechapel Golden Star plate, $6-8; **Bottom** – 6" Whitechapel Forget-Me-Not plate, $2-4; 10" Gadroon lugged Regal covered vegetable, $25-35; Gadroon cup & square Dogwood Cup Ring Plate, $8-10.

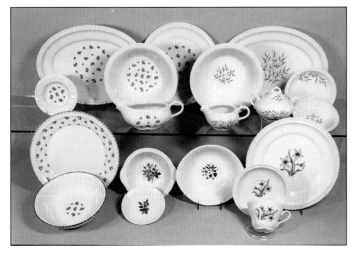

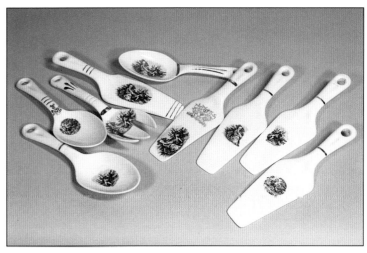

Assorted Shapes & Decals, MKs 129A, 129B, 138, 141, 142B, 143, 169, & 170, **Top Back Row** – 13" Whitechapel Rose Spray (Cluster) platter, $12-18; 8" bowl, $8-12; 10" plate, $8-12; 8" Cortland (a.k.a. St. John's Wort) bowl, $8-12; 13" platter, $12-18; saucer, $1-3; **Top Front Row** – 5" Whitechapel Rose Spray (Cluster) ashtray, $3-5; gravy, $10-15; 5" W Cortland creamer, $4-8; 5" W sugar, $6-10; 5" bowl, $2-4; **Bottom** – 10" Whitechapel Rose Spray (Wreath) plate, $8-12; 7" Shellridge Rose Spray (Cluster) bowl, $8-12; 6" Whitechapel Babies Breath & Roses lugged bowl, $3-5; 5" Shellridge plate, $3-5; 7" Flora oval bowl, $4-8; Whitechapel Trout Lily cup & saucer, $4-8; 10" plate, $4-8.

Godey, Assorted utensils, $12-15 each.

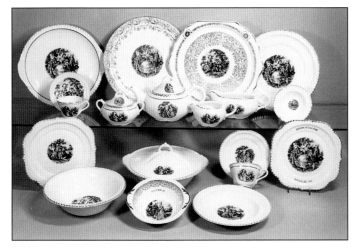

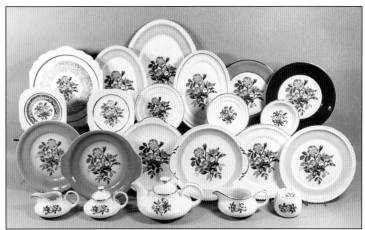

Godey, Assorted Shapes, MKs 77, 87, & 100, **Top Back Row** – 11" Gadroon lugged plate, $15-20; 11" Modern Age cake plate, $12-15; Virginia utility plate, $15-20; 10" Gadroon plate, $8-10; **Top Front Row** – Gadroon demitasse cup & saucer, $12-15; 6" W sugar, $10-15; 9" L Gadroon teapot, $35-45; 5" W creamer, $5-8; gravy, $12-15; 4" Gadroon ashtray, $6-10; **Bottom Back Row** – Gadroon square plate, $4-6; 10" W lugged covered vegetable, $18-25; 6" plate, $2-4; cup, $3-5; square plate, $5-8; **Bottom Front Row** – 9" Gadroon bowl, $12-15; 7" lugged bowl, $8-12; 8" Gadroon soup, $8-10.

Old Rose, Assorted Shapes, MKs 87 & 159, **Top** – 7" Lace edge square plate & gold filigree, $5-8; Virginia utility plate Lace edge, $25-30; 7" Lace edge square plate, $5-8; 12" Gadroon gray edge platter, $15-20; 16" platter, $25-30; 7" plate, $5-7; 12" platter, $12-18; 6" plate, $2-4; 10" Aladdin gray edge plate, $8-10; 5" Gadroon bowl, $2-4; 10" Aladdin Teal edge plate, $8-10; **Bottom Back Row** – 10" Aladdin gray plate, $8-10; 11" lugged platter, $10-15; 11" Gadroon lugged plate, $10-15; 11" gray edge lugged plate, $12-18; 10" plate, $8-10; 10" gray edge plate, $10-12; **Bottom Front Row** – 6" W Aladdin creamer, $10-12; 3" H Aladdin sugar, $10-12; 9.25" L Aladdin teapot, $35-45; Aladdin gravy, $15-20; 3" H sugar, $25-35.

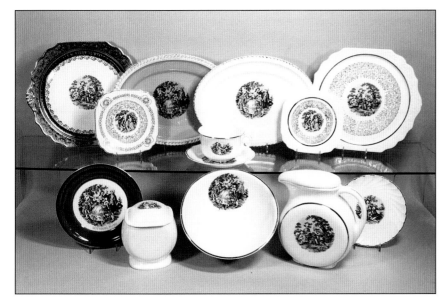

Godey, Assorted Shapes, MKs 68, 77, & 87, **Top** – Virginia utility plate gold edge, $12-15; 6" square plate, $3-5; 13" Gadroon gray platter, $15-20; Jumbo Cup & Saucer, $20-25; 14" Gadroon platter, $12-15; 7" square Lace edge plate, $5-8; Virginia utility plate Lace edge, $15-20; **Bottom** – 8" Aladdin teal edge plate, $6-8; D-Ware Drips, $8-12; 9" mixing bowl, $20-25; Round Body Jug, $40-50; 7" Shell plate, $3-5.

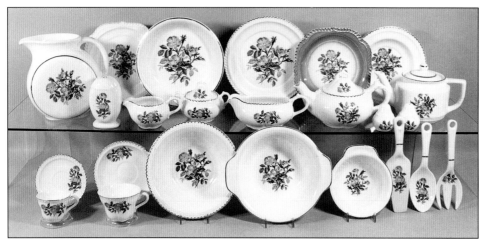

Old Rose, Assorted Shapes, MKs 87, 98, 98A, & 100B, **Top Back Row** – Round Body Jug (no lid), $25-30; Gadroon square plate, $3-5; 9" pie baker, $12-18; 9" Gadroon plate, $3-5; square purple edge plate, $8-10; 8" Gadroon soup, $8-12; **Top Front Row** – D-Ware salt, $6-10; 5" W Gadroon creamer, $5-8; 6" W sugar, $8-10; Gadroon gravy, $8-12; 9" L Gadroon teapot, $35-45; Gadroon salt & pepper, $8-12 set; 9" L teapot, $30-40; **Bottom** – Gadroon demitasse cup & saucer, $5-10; Gadroon cup & saucer, $5-10; 9" bowl, $18-24; 10" Aladdin lugged bowl, $12-18; 7" Aladdin lugged bowl, $5-8; 3 PC utensil set, $40-50.

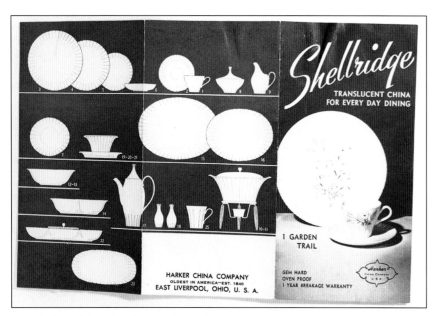

Shellridge Ad, c. 1959, *Courtesy Cynthia Boyce Sheehan.*

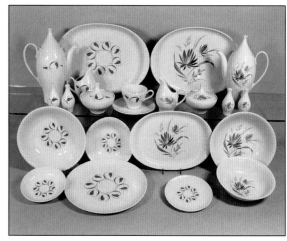

Leaf Swirl & Forest Flower on Shellridge, MKs 114, 129B, 130, & 131, **Top Back Row** – 10" H Leaf Swirl teapot, $40-50; 5" H creamer, $8-12; 14" platter, $18-24; 14" Forest Flower platter, $18-24; 10" H teapot, $40-50; **Top Front Row** – Leaf Swirl salt & pepper, $12-18 set; 4" H sugar, $10-15; cup & saucer, $5-10; 5" H Forest Flower creamer, $8-12; 4" H sugar, $10-15; salt & pepper, $12-18 set; **Bottom Back Row** – 9" Leaf Swirl bowl, $10-15; 7" oval bowl, $8-12; 11" Forest Flower platter, $15-18; 9" bowl, $10-15; **Bottom Front Row** – 5" Leaf Swirl bowl, $3-5; 10" plate, $8-12; 6" plate, $3-5; 7" Forest Flower bowl, $8-12.

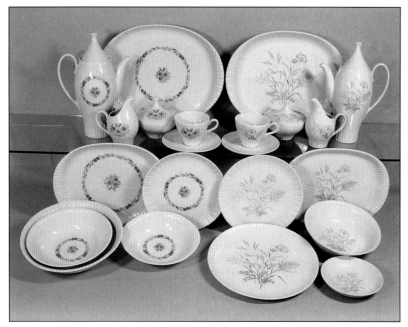

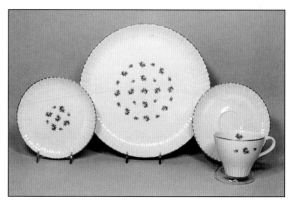

Rose Spray (Cluster) on Shellridge, MK 129B & 130, 6" plate, $4-6; 10" plate, $8-10; cup & saucer, $3-5.

Forever Yours & Garden Trail on Shellridge, MKs 114, 129B, 130, 132, & 137, **Top** – 10" H Forever Yours teapot, $40-50; 5" H creamer, $8-12; 13" platter, $20-25; 4" H sugar, $5-12; cup & saucer, $5-10; Garden Trail cup & saucer, $5-10; 13" platter, $20-25; 4" H sugar, $5-12; 5" H creamer, $8-12; 10" H teapot, $40-50; **Bottom Back Row** – 11" Forever Yours platter, $12-15; 8" plate, $4-8; 8" Garden Trail plate, $4-8; 11" platter, $12-15; **Bottom Front Row** – 7" & 9" Forever Yours bowls, $5-10 each; 7" oval bowl, $3-5; 10" Garden Trail plate, $8-12; 7" bowl, $5-10; 5" bowl, $3-5.

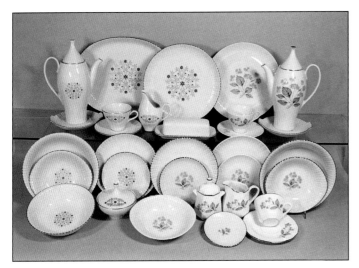

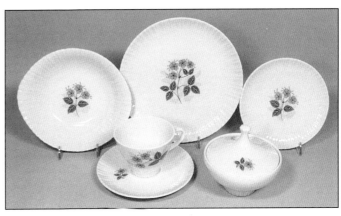

Cynthia on Shellridge, MKs 129B & 130, 7" oval bowl, $4-6; cup & saucer, $5-8; 8" plate, $4-6; 4" H sugar, $6-8; 6" plate, $2-4.

Golden Star & Forget-Me-Not, Shellridge & Heritance Shapes, MKs 126, 129B, 133, 134, & 137, **Top** – 10" H Golden Star teapot, $40-50; 7" under plate, $8-10; 14" platter, $10-15; cup & saucer, $4-9; 5" H creamer, $8-12; 8" L covered butter, $20-25; 10" plate, $5-8; 10" Forget-Me-Not plate, $5-8; cup & saucer, $4-8; 10" H teapot, $40-50; 7" under plate, $8-10; **Bottom Back Row** – 9" Golden Star bowl, $5-8; 7" oval bowl, $3-5; 6" & 8" plates gold trim, $3-5 each; 6" & 8" Forget-Me-Not plates silver trim, $3-5 each; 6" & 8" Forget-Me-Not plates, $3-5 each; 9" bowl, $8-12; 7" oval bowl, $5-8; **Bottom Front Row** – 7" Golden Star bowl, $5-8; 4" H sugar, $8-12; 7" Forget-Me-Not oval bowl, $5-8; 5" H Heritance sugar, $5-10; 4" H creamer, $5-10; 5" Shellridge plate, $3-5; Heritance cup & saucer, $4-8.

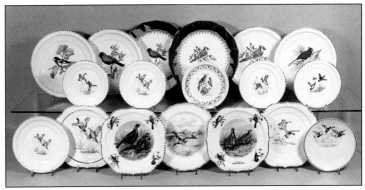

Birds, Assorted shapes, MKs 25, 31, 87, 100B, & 101, **Top** – 9" Gadroon Red-Breasted Grosbeak plate, $5-8; 6" Canada Geese, $3-5; 9" Indigo Bunting, $5-8; 6" Ring-Necked Pheasants, $3-5; 10" Heritance gold edged Indigo Bunting, $15-20; 10" Blue Jay plate, $15-20; 6" Gadroon "Arizona Cactus Wren" plate, $5-8; 9" Blue Jay, $5-8; 6" Mallards, $3-5; 9" Cardinal, $5-8; 6" Grouse, $3-5; **Bottom** – 7" Gadroon Ring-Necked Pheasants plate, $4-6; square Ring-Necked Pheasants, $5-8; square Black Grouse, $10-15; 9" Melrose Mallards plate, $12-18; square Grouse, $10-15; square Mallards Cup Ring Plate, $5-8; 7" Mallards "Changing Seasons", $8-12.

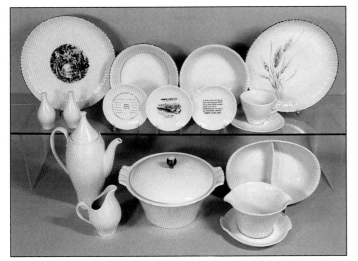

Shellridge, Assorted decals & white, MKs 97, 129A, 130, 135, 137, & 168, **Top Back Row** – 10" Godey plate, $15-18; 7" Gold Trim bowl, $8-12; 7" bowl, $6-10; 10" Bearded Wheat plate, $10-15; **Top Front Row** – white salt & pepper, $15-18 set; 5" "I.B.O.P." plate, $3-5; 5" "Harker China Co." plate, $25-30; 5" "First National Bank" plate, $3-5; cup & saucer, $8-10; **Bottom** – white 10" H teapot, $15-20; 5" H creamer, $8-12; 10" covered vegetable, $30-40; 7" gravy & fused under plate, $15-20; 10" divided bowl, $10-15.

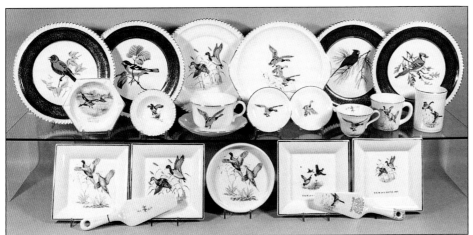

Birds, MKs 31, 69, 84A, 87, 98B, 100B, 115, & 194, **Top Back Row** – Gadroon, 10" plates, one lugged plate, $8-12 each: Royal Dresden Indigo Bunting; Red-Breasted Grosbeak; Mallards; 11" lugged Mallards plate; Royal Dresden Cardinal; Blue Jay; **Top Front Row** – 5" Hexagon Mallards Ashtray, $15-20; 4" Gadroon Mallards Ashtray, $5-8; Mallards Jumbo Cup & Saucer, $25-30; Two 4" Mallard Drake & Mallard Hen plates, $5-7 each; Gadroon Mallard Cup, $4-6; 3.25" H Mallard Mug, $8-10; 4.25" H Canada Geese Tumbler, $10-12; **Bottom** – 7" Square Ring-Necked Pheasants Ashtray, $12-15; Mallards Lifter, $10-15; 7" Square Mallards Ashtray, $12-15; 7" Round Ring-Necked Pheasants Ashtray, $10-12; 7" Square Quail Ashtray, $12-15; Canada Goose Lifter, $10-15; 7" Square Mallards Ashtray, $12-15.

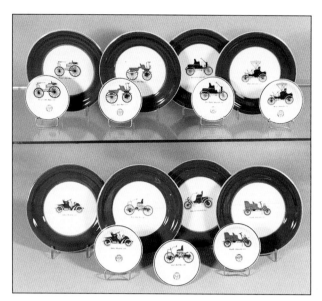

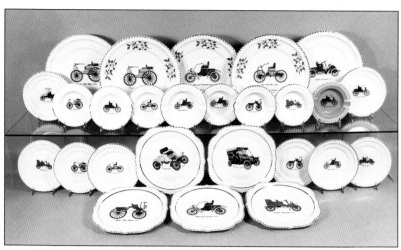

Antique Automobile Plates, MK 87, 6" Aladdin teal edged plates, $5-8 each & 3" plates, $2-4 each.

Antique Automobiles, MKs 84A, 87, 98B, & 100B, Five 10" Gadroon plates, $8-12 each; Eight 6" Gadroon plates, $3-5 each; One 5" non-Gadroon ashtray, $2-4; Seven 5" Gadroon ashtrays, $2-4 each; Five 8" Gadroon square plates, $5-10 each.

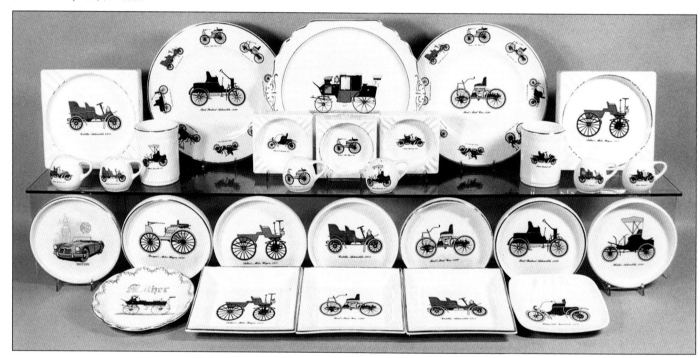

Antique Automobiles, MKs 98B, 100B, & 191, **Top Center**, Virginia utility plate, $10-15; **Top**, Two 11" plates, $8-12 each; **Top**, Two 7" square ashtrays, $10-15 each; **Top Center**, Three 4" square ashtrays, $5-8 each; **Top**, Two 4" H Tumblers, $12-18 each; **Top**, Six Coupe salt & pepper shakers, $3-5 each set; **Bottom**, Seven 7" round ashtrays, $5-10 each; Three 7" square ashtrays, $5-10 each; **Bottom Left Front**, Jumbo Mother saucer, $3-5; **Bottom Right Front**, 6" square ashtray, $5-10.

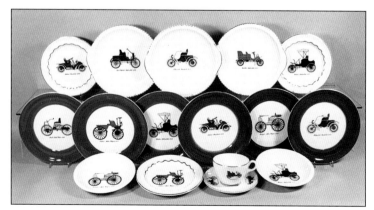

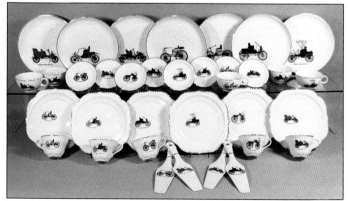

Antique Automobiles, MKs 70A, 87, & 98B, Three 8" ashtrays, $5-10 each; Three 11" Gadroon lugged plates, $8-12 each; Six 10" Aladdin Teal edged plates, $8-12 each; Two 8" bowls, $5-10 each; One Jumbo Cup & Saucer, $15-20.

Antique Automobiles, MKs 87, 100B, & 191, Seven 9" round Cup Ring Plates, $8-12 each; Five cups, $2-4 each; Eight 4" plates, $3-5 each; Six 8" Gadroon square Cup Ring Plates, $10-15 each; Five Gadroon cups, $2-4 each; Four lifters, $10-12 each.

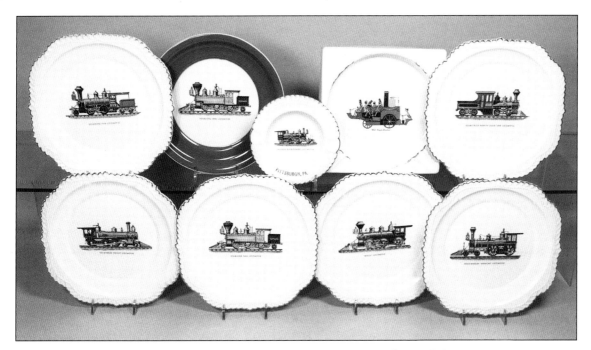

Antique Trains, Gadroon & Aladdin Shapes, MKs 84A & 98B, Six 8" square Gadroon plates, $8-12 each; 8" Aladdin teal edge plate, $10-12; 5" Gadroon ashtray, $5-8; 7" square ashtray, $12-15.

Currier & Ives, Gadroon & Aladdin Shapes, MKs 84A & 100B, Eight 10" Gadroon plates, $5-10 each; Two 10" Aladdin gray edge plates, $5-10 each; Seven lifters, $10-15 each; Two 8" Gadroon square plates, $25-35 each; **(Bottom Center),** One 6" plate, $4-6; **Bottom, standing at either end,** Four 5" Gadroon saucers, $3-5 each; **Bottom Front,** Two 5" Gadroon ashtrays, $5-10 each.

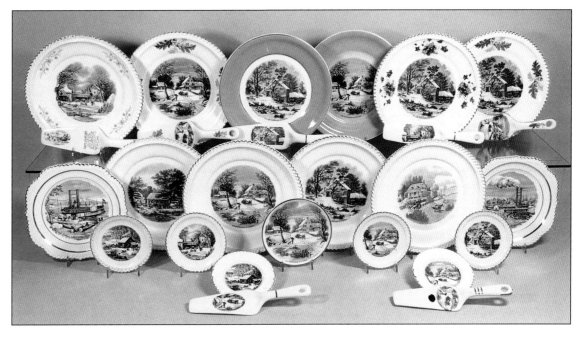

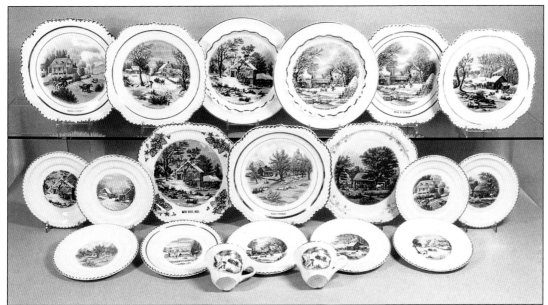

Currier & Ives, Gadroon Shape, MKs 84A, 87, & 100B, Seven 8" square plates, $5-10 each; Two 8" round ashtrays, $20-30 each; Nine 6" round plates, $3-5 each; Two demitasse cups, $3-5 each.

1960 – 1972

This last chapter of the Harker Pottery Company is sad, but not without merit. Harker utilized every creative talent they could find locally, and within the company, to stay alive. They battled not only cheap imports, but myriad new plastic, glass, and aluminum products. In 1960, Harker introduced a series of intaglio designs they called "Harker Engraved Patterns". Series I included Cock O'Morn on coral, Star-Lite on celeste blue, Coronet on celadon green, Sun-Glo on butter yellow, and Everglades (cattails) on pink cocoa. These were produced on Olympic shape. Series II, produced sometime between 1960 and 1964, included Country Cousins on coral, Petite Fleurs on celeste blue, Provincial on celadon green, White Daisy on butter yellow, and Springtime on pink cocoa, all on Olympic shape.

At this time, Harker was making the lovely Rockingham-look Quaker Maid for Pearl China Company, a firm still in business in East Liverpool, Ohio. Pearl China Company was not a china producing company, but rather a sales and outlet firm. Trinidad was introduced in 1960 on Harker stone china. In December of 1960, Harker announced they were discontinuing their Heritance, Coupe, and Whitechapel lines, with replacement pieces still available.

John Pinney was the designer of the beautiful Maple leaf Woodsong line. Woodsong was introduced in gray, green, and honey, in 1961. Woodsong in white came out just a little later, and may have been a Pearl China Company exclusive. The Polynesian-looking Tahiti was also designed in-house by Douglas Manning in 1961. Tahiti's hollowware interiors and backs bear a different slip color from their exteriors and faces. In addition, each lovely leafy design was hand applied, making this line very labor-intensive. The all green Rockingham type drip effect for Old Riverport was also designed in-house, and introduced in 1961.

In 1962, Harker Pottery employed the well-known East Liverpool artist, Hans Hacker. He designed the Pennsylvania Dutch inspired decals for the Country Style USA line on Harker stoneware. These designs won first place in a West Virginia ceramics exposition in 1962. Country Style has its own heavy, but attractively shaped teapots, creamers, and sugars, with high domed lids. One of the most interesting lines in the Country Style shape is Rawhide (NOT to be confused with Quaker Maid or Rockingham). Rawhide has a subdued drip effect on a matte finish, giving the visual and tactile effect of leather. Most Rawhide is not marked. We own one piece with a tiny USA imprinted on the bottom.

In 1963, the United States began using zip codes. We believe the Mr. Zip tumblers were placed in businesses and post offices, probably as pencil/pen holders, to remind people to use their zip codes. The intricate intaglio design, Peacock Alley, on stoneware was introduced in 1963.

In 1964, Vincent Broomhall, who designed for several Ohio and West Virginia potteries, designed an exclusive decal for Harker Pottery, called Dining Elegance (see mark # 96).

Near the end of 1964, Harker advertised their Series III "Harker Engraved Patterns". These were Dogwood on pink cocoa, Snow Leaf on celeste blue, Ivy Wreath on celadon green, Rooster on butter yellow, and Bamboo on pink cocoa. These designs and all their accessories were on Olympic shape. In December of 1964, Harker presented five new Engraved Patterns, Series IV, to celebrate their 125th Anniversary in 1965. They were Mosaic on charcoal, Rose on cameo blue, Fruit on amber, Wheat on butter yellow, and Grapes on teal. Accessories for these came not in the expected Olympic shape, but on the old Laurelton shape with no intaglio! Series V followed with Patio on amber (on charcoal, it was called Mosiac), Spring Breeze on aqua (called Springtime on pink cocoa), Orchard on yellow (called Fruit on amber), Fern on beige, and Vintage on celadon (called Grapes on teal). Series V also used the Laurelton shape for accessories. Another Engraved design, produced in 1965, was Acorns. This was made in three colors: charcoal, pink cocoa, and gray. Creamers and sugars for Acorns, Diamonds, and Trinidad were made in the Contadinesca shape. Also in this time frame, the tropical Spanish Gold was produced. It features bamboo leaves engraved on variegated butter yellow/pumpkin plates. Olympic shape accessories had butter yellow interiors with pumpkin exteriors. Engraved children's dishes, cups, and potties were also made about this time. The only colors we have seen these in are teal green, sage, and butter yellow.

Norman Clewlow spent countless hours in the basement of the East Liverpool Carnegie Library, looking at and sketching the original Harker Taylor hound handled jugs in the Harold Barth collection. He was not allowed to handle one for a closer examination. Eventually, he molded a superb copy, and Harker Reproduction Rockingham hound handled jugs went into production in 1965. They are beautifully molded, and each item's color is slightly different due to the hand applied drip glaze. That same year the line was

expanded to include hound handled mugs, some with candleholder inserts, Davy Crocket jugs, Jolly Roger jugs, Rebecca at the Well teapots, Rockingham soap dishes, Give Us This Day Our Daily Bread plates, American Eagle plates and trivets, and leaf shaped ashtrays. All of these can be found in Rockingham brown, honey, and bottle green. Rockingham American Eagles and Jolly Roger pipes were made exclusively for Boyce family members, probably as 125th Anniversary gifts. We own a Rockingham rolling pin, sold to us by Valma Baxter's family. She was a long time Harker employee in the decorating department. We have never heard of another one, and believe it may have been an experimental piece.

The mid-1960s witnessed some of Harker's most beautiful experimental efforts, even though many of these never went into retail production. One of these was the attempt to make Wedgwood-like bone china plaques. The plaques featured Grecian ladies in various poses, the head of Christ crowned with thorns, and intricate Oriental motifs. Different background colors were tried, but Wedgwood blue appears to have been the favorite. White liquid bone china was first poured into the fine recesses of a rubber mold. We have been told this was frozen, then unfrozen, and blotted with paper towels to remove excess moisture. This process was repeated until the face was stable enough to receive what would become the background color. The few pieces of this Harker "Wedgwood" that have survived are truly beautiful, even if one can occasionally see the white figure mixing with the backing color. Our friends, Charles Boyce Lang and Mary Sue Lang, worked on these pieces during the early 1960s, when they were college students. Their father, Francis Lang, was Harker's attorney at that time. Charles and Mary Sue irreverently called these works of art, "the belly dancers", and were amazed to find these Harker treasures hanging in our living room.

Perfume ewers, resembling KTK Lotus Ware perfume ewers, but somewhat larger & heavier, were tried. The only items that ever went into brief commercial production from this experimentation were bone china sake cups and saucers in antique Oriental themes. These were marketed exclusively in the art departments of Horne's Department Store in Pittsburgh, and Woodward & Lothrop in Washington, D.C. Both of these upscale department stores met their demise in the 1990s.

We believe Harker's last unique shape was Eurasia, produced in 1967. It has a matte finish, like Rawhide, and came in avocado, brown, amber, and blue. We own pieces in Orbit, Europa, and one other pattern. When marked, it bears the square Harker stoneware mark. We have never seen a teapot, creamer or sugar. Eurasia apparently was also marketed as "Colonial", as we have an advertisement, and the shapes look identical.

In David Boyce's Christmas letter to Harker employees in 1960, he tried to be optimistic while noting that there hadn't been a dividend paid to Harker stock holders in five years. Social Security and state unemployment taxes had risen. Gas, maintenance, and labor costs had increased dramatically. Many Harker employees worked hard and long to create new designs, new china formulas, new colors, and new shapes that might help keep the company in business. In the end, this family business tried to save its family, their employees.

The Harker Pottery Company was sold to Jeannette Glass in late 1969. Jeannette Glass retained most of the employees and the Harker Pottery name as they tried to make the Harker Pottery profitable once again, but without success. On March 24, 1972, Jeannette Glass closed the Harker Pottery doors forever.

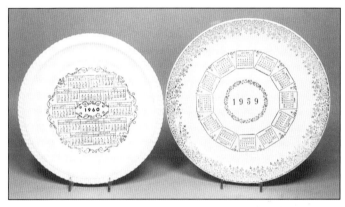

Calendar Plates, no marks, 1960 Gadroon, $5-10; 1959, $5-10.

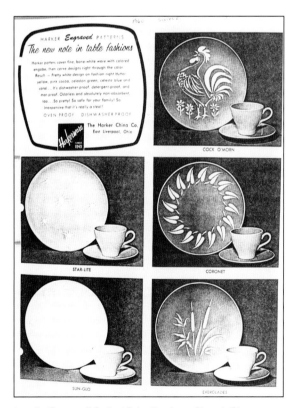

Intaglio (Engraved) Series I Sales Brochure, Olympic Shape, showing Cock O'Morn, Star-Lite, Coronet, Sun-Glo, & Everglades (photo in Chapter 7).

Postscript

Thirty years later, former employees came together again at a Harker Pottery Reunion Picnic. This event had been a dream of the authors for many years. We organized it at the urging of The East Liverpool Pottery Collectors' Convention Planning Committee in our final year of managing that event. Kent State University – East Liverpool Campus, made video and audio recordings of interviews with former Harker employees as part of their Oral History Project. A videotape was produced highlighting these interviews, 2002 Convention activities, and a brief visit to our home. The Harker Pottery Reunion Picnic was financed in large part by Rachel Boyce Lang, Charles and Mary Sue's mother. Rachel's generosity was yet another example of the warm feelings and closeness the Harker and Boyce families demonstrated to their employees during their 131-year history. We were honored to host this event and to count Rachel Lang among our friends. Rachel has since gone on to her reward, as have most of Harker's dedicated and skilled craftspeople.

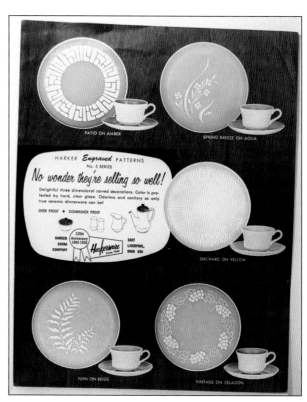

Intaglio Series V Sales Brochure, Olympic, showing Patio on Amber, Spring Breeze on Aqua, Orchard on Yellow, Fern on Beige, & Vintage on Celadon (Green). *Courtesy Cynthia Boyce Sheehan.*

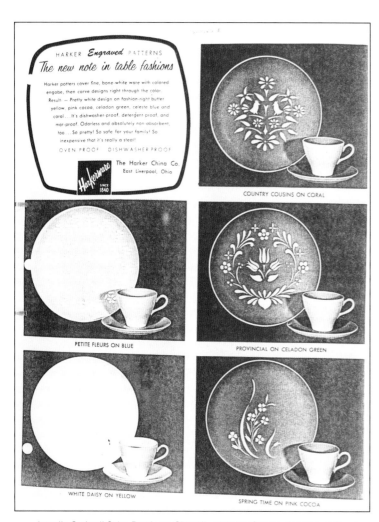

Intaglio Series II Sales Brochure, Olympic, showing Country Cousins on Coral, Petite Fleurs on Blue, Provincial on Celadon Green, White Daisy on Yellow, & Spring Time on Pink Cocoa.

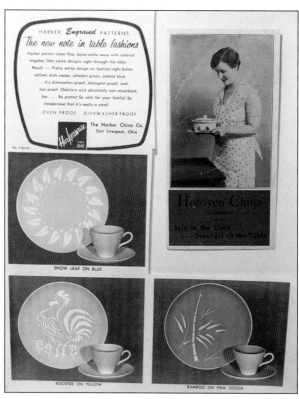

Intaglio Series III Sales Brochure, Olympic, showing Snow Leaf on Blue, Rooster on Yellow, & Bamboo on Pink Cocoa. Lady in upper right, is Mary Louise Boyce, wife of Robert E. Boyce, President of Harker Pottery. *Courtesy Cynthia Boyce Sheehan.*

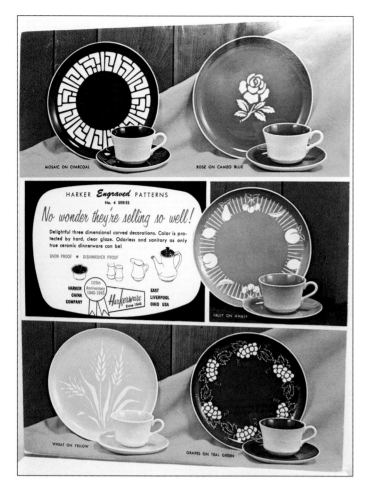

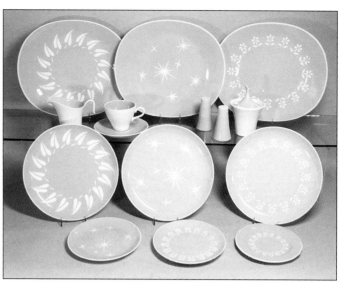

Intaglio, Blue, Snowleaf, & Star-Lite, & Petite Fleurs, Olympic (all but one), MK 101, **Top Back Row** – 13" Snowleaf platter, $12-18; 13" Star-Lite platter, $12-18; 13" Petite Fleurs platter, $12-18; **Top Front Row** – 4" H creamer, $4-6; cup & saucer, $5-8; 3.5" H salt & pepper, $5-8; **Bottom Back Row** – 10" Snowleaf plate, $5-8; 10" Star-Lite plate, $5-8; 10" Petite Fleurs plate, $5-8; **Bottom Front Row** – 7" Star-Lite plate, $3-5; 7" Petite Fleurs plate, $3-5; 6" Heritance Petite Fleurs plate, $2-4.

Intaglio Series IV Sales Brochure, Olympic (note Laurelton shape cups), showing Mosaic on Charcoal, Rose on Cameo Blue, Fruit on Amber, Wheat on Yellow, & Grapes on Teal. *Courtesy Cynthia Boyce Sheehan.*

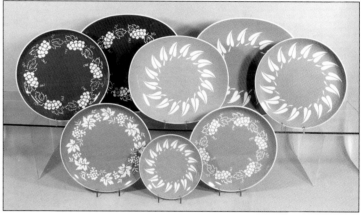

Intaglio, Coronet, Grapes, & Vintage I & Vintage II, Olympic, MK 101, **Top** – 10" Grapes on Teal plate, $5-10; 13" Grapes on Teal platter, $10-15; 11" & 13" Coronet Celadon Green platters, $8-12 & $12-18; 10" Coronet plate, $5-8; **Bottom** – Celadon Green, 10" Vintage II plate, $5-8; 7" Coronet plate, $3-5; 10" Vintage I plate, $5-8.

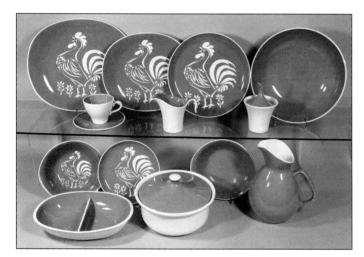

Cock O'Morn in Coral, Olympic, MKs 101, 105, & 120, **Top** – 13" platter, $18-24; cup & saucer, $4-6; 11" platter, $15-18; 4" H creamer, $6-8; 10" plate, $5-8; 6" H sugar, $6-8; 11" bowl, $10-12; **Bottom** – 10" divided bowl, $8-12; 8" oval bowl, $8-12; 7" plate, $5-8; 8" covered casserole, $12-18; 8" oval bowl, $3-5; 9" H jug (missing stopper), $15-18.

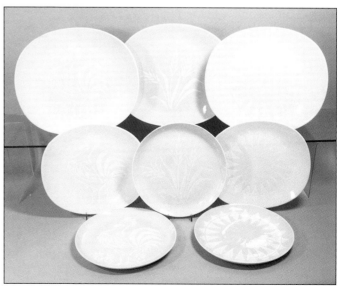

Intaglio, Butter Yellow, Rooster, Wheat, Sun Glo, Olympic, MK 101, **Top** – 13" platters, Rooster, Wheat, & Sun Glo, $10-20 each; **Bottom** – 11" Rooster platter, $6-10; 10" Rooster plate, $6-10; 10" Wheat plate, $5-10; 11" Sun Glo platter, $8-12; 10" plate, $6-10.

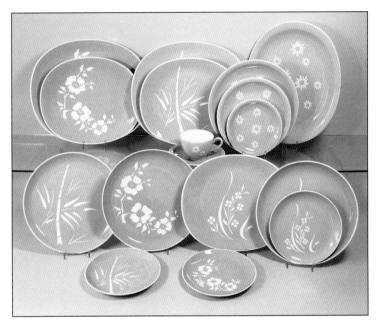

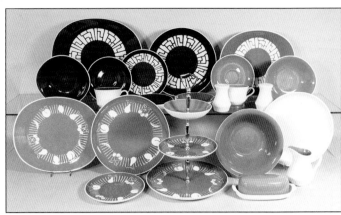

Intaglio, Mosiac, Fruit, Patio, & Orchard, Olympic Shape, MK 101, **Top** – 7" Charcoal oval bowl, $2-4; 13" Mosaic platter, $12-15; cup & saucer, $3-5; 7" Mosaic plate, $4-6; 6" bowl, $1-2; 10" Mosaic plate, $5-8; 6" Amber bowl, $1-2; Amber salt & pepper, $8-10; cup & saucer, $4-6; 11" Amber Patio platter, $15-20; 6" oval bowl, $2-4; **Bottom** – 11" Olympic Amber Fruit platter, $15-20; 7" plate, $5-8; 10" plate, $8-10; 3 tier tidbit (5", 7", & 10"), $20-25; 9" Amber bowl, $12-15; 7" L covered butter, $15-20; 5" Amber creamer, $5-8; 10" yellow Orchard plate, $8-10.

Intaglio, Pink Cocoa, Spring Time, Bamboo, Dogwood, & Summer Asters, Olympic & Coupe, MK 101, **Top** – 11" & 13" Olympic Dogwood platters, $5-8 & $8-10; 11" & 13" Bamboo platters, $8-12 & $12-15; Coupe Summer Asters cup & saucer, $6-10; 3 PC Coupe Summer Asters plates, $10-15 set; 13" Summer Asters platter, $8-12; **Bottom Back Row** – Olympic Shape, 10" Bamboo plate, $4-6; 10" Dogwood plate, $4-6; 11" Spring Time platter, $12-15; 7" & 10" plates, $2-4 & $4-6; **Bottom Front Row** – 7" plates, Bamboo, $2-4; Dogwood, $2-4.

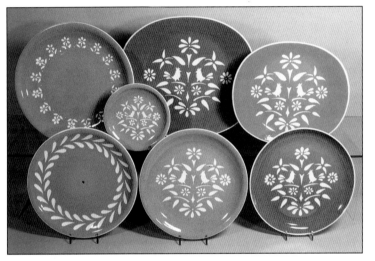

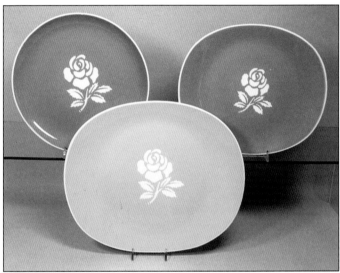

Intaglio, White Rose, Olympic Shape, MK 101, 10" White Rose on Cameo Blue plate, $5-8; 13" White Rose on Aqua platter, $15-20; 11" White Rose on Cameo Blue platter, $12-15.

Intaglio, Petite Fleurs, Country Cousins, & Wreath, Olympic & Coupe Shapes, MK 101, **Top** – 11" Coupe Deep Beige Petite Fleurs plate, $15-18; 6" Country Cousins plate, $3-5; 13" Olympic Coral Country Cousins platter, $10-15; 11" Olympic Coral Country Cousins platter, $10-12; **Bottom** – 10" plates, Coupe Deep Beige Wreath plate, $12-15; Coupe Deep Beige Country Cousins plate, $10-12; Olympic Coral Country Cousins plate, $8-10.

Intaglio, Celadon Green, Provincial, Country Cousins, & Europa, Olympic & Coupe Shapes, MKs 101 & 164, **Top Back Row** – Olympic Shape, 13" Provincial platter, $12-18; 11" Provincial platter, $10-15; 11" Europa platter, $8-12; 13" platter, $15-20; **Top Front Row** – Coupe Provincial cup & saucer, $8-10; 3" H Country Cousins sugar, $8-12; Olympic cup & saucer, $4-8; **Bottom** – 11" Coupe Provincial plate, $10-15; 7" Olympic Provincial plate, $3-5; 10" plate, $5-8; 10" Europa plate, $4-8; 7" plate, $2-4.

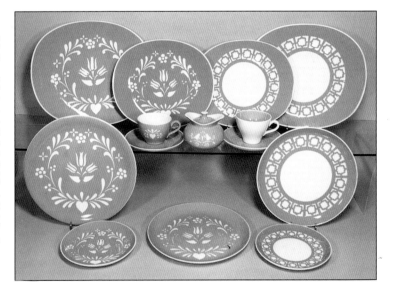

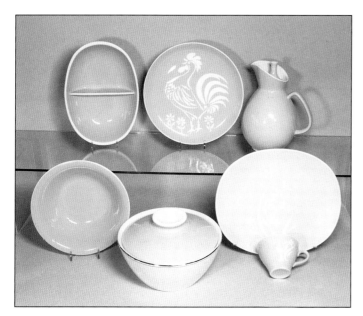

Intaglio, Aqua, Spring Breeze, & Rooster, Olympic Shape, MKs 98, 101, 105, 114, & 166, **Top** – 10" divided bowl, $8-10; 10" Rooster plate, $5-8; 9" H stopper jug, $12-15; **Bottom** – 9" bowl, $8-10; 9" W covered casserole, $12-18; 11" Spring Breeze platter, $12-15; Spring Breeze cup, $2-4.

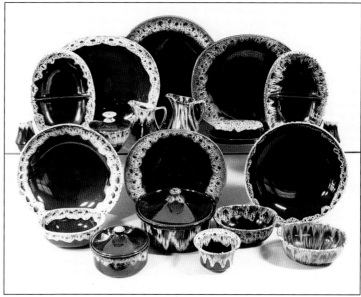

Quaker Maid, MKs 105, 114, 120, 122, & 123, **Top** – salt & pepper (either end), $12-15 set; 10" divided bowl, $8-10; 13" platter, $20-25; 4" H sugar, $8-10; 5" H creamer, $8-12; 5.25" H Creamer, $8-12; 13" round platter, $20-25; 13" platter, $20-25; 8" L covered butter, $12-18; 10" divided bowl, $8-10; **Bottom** – 11" bowl, $15-20; 7" oval bowl, $8-10; 5" W covered dish, $12-18; 11" platter, $10-15; 8" W covered casserole, $20-25; 4" W sugar (no lid), $5-8; 7" oval bowl, $8-10; 7" oval bowl, $8-10; 11" bowl, $10-15.

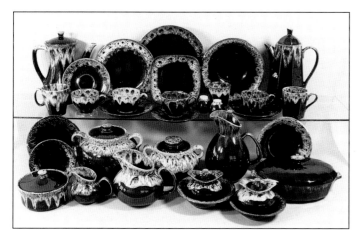

Quaker Maid, MKs 112, 114, 122, & 123, **Top Back Row** – 10" H Laurelton shape coffeepot, $35-45; 8" ashtray, $10-12; 10" plate, $5-10; 7" square ashtray, $8-10; 8" bowl, $5-8; 11" H Heritage shape coffeepot, $30-40; **Top Front Row** – mug, $4-8; cup & saucer, $6-10; cup & saucer, $8-10; cup & saucer, $8-10; salt & pepper, $10-15; 4" H tumbler, $5-8; cup & saucer, $8-10; 3" H Heritance mug, $5-8; **Bottom Back Row** – 8" oval bowl, $4-6; 5" bowl, $3-5; 7" H handled cookie jar, $25-35; 5" H handled bean pot, $20-30; 9" H stopper jug, $25-35; 7" oval bowl, $4-6; **Bottom Front Row** – 6" W covered dish, $18-24; 4" H creamer, $4-6; 6" H jug, $20-30; 7" bowl, $3-5; 4" H sugar, $6-10; 6" bowl, $3-5; 4" H sugar, $6-10; 11" L Heritance divided covered dish, $35-45.

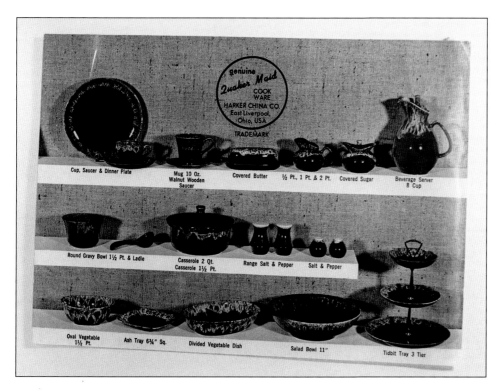

Quaker Maid Sales Brochure, showing Harker backstamp, c. 1960, *Courtesy Cynthia Boyce Sheehan.*

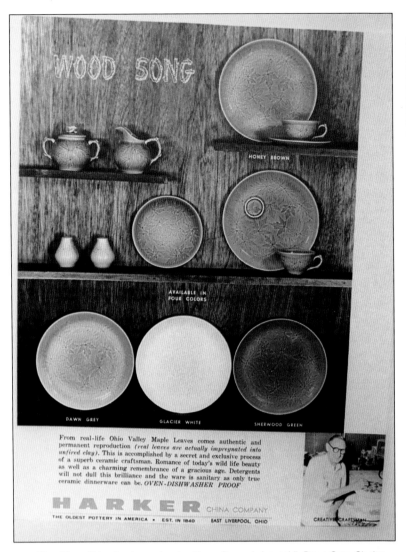

Wood Song Sales Brochure, showing Honey Brown (a.k.a. gold), Dawn Grey, Glacier White, & Sherwood Green, c. 1961, *Courtesy Cynthia Boyce Sheehan.*

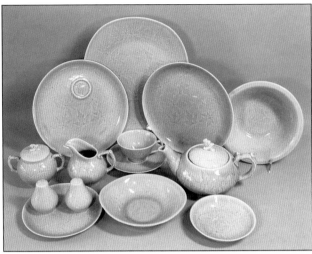

Wood Song, Dawn Grey, MKs 101 & 125, **Back** – 10" Cup Ring Plate, $8-10; 13" platter, $15-20; 10" plate, $5-8; 9" bowl, $18-24; **Center** – 4" H sugar, $15-20; 4" H creamer, $10-15; cup & saucer, $10-15; 9" L teapot, $75-90; **Front** – 7" plate, $5-8; salt & pepper, $12-20 set; 8" oval bowl, $8-10; 6" bowl, $4-6.

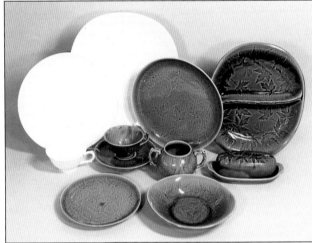

Wood Song, Glacier White & Sherwood Green, MKs 101, 114, 125, & 162, **Back** – 10" White Cup Ring Plate & cup, $12-15; 13" platter, $15-20; 10" Sherwood Green plate, $8-10; 12" divided bowl, $35-45; **Center** – cup & saucer, $10-15; 3" H sugar (no lid), $8-12; 8" L covered butter, $20-30; **Front** – 7" plate, $4-8; 8" oval bowl, $8-12.

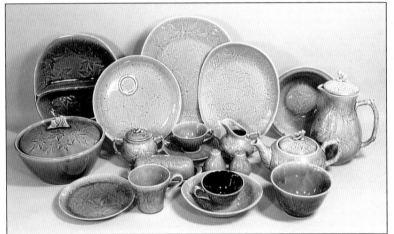

Wood Song, Honey Brown, MKs 101, 114, 125, & 162, **Back** – 12" divided bowl, $20-30; 10" Cup Ring Plate, $8-10; 13" platter, $20-25; 11" platter, $12-15; 9" bowl, $15-20; **Center** – 9" covered bowl, $20-30; 4" H sugar, $20-25; 7" L covered butter, $12-20; cup & saucer, $8-12; salt & pepper, $8-12 set; 4" H creamer, $12-18; 9" L teapot, $70-90; 10" H jug, $25-40; **Front** – 7" plate, $4-6; 3.5" H mug, $5-8; cup (dark throat), $4-6; 8" oval bowl, $8-12; 6" W bowl, $12-18.

Tahiti Sales Brochure, c. 1961, *Courtesy Cynthia Boyce Sheehan.*

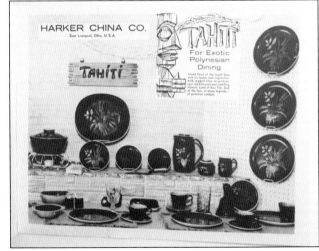

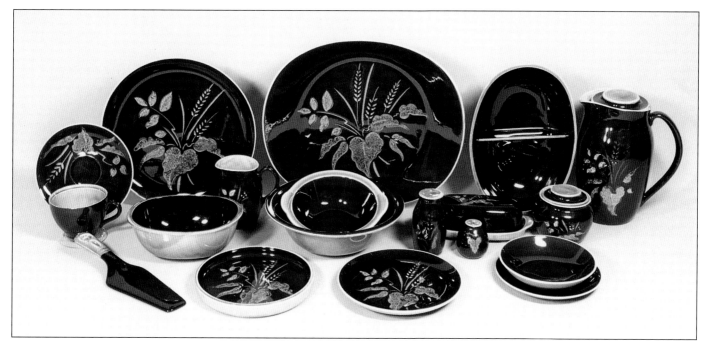

Tahiti, MKs 101, 105, 114, & 128, **Back** – cup & saucer, $8-12; 10" plate, $7-10; 13" platter, $18-24; 10" divided bowl, $18-20; 9" H jug, $30-40; **Center** – 7" oval bowl, $8-10; 4" H creamer, $10-12; 9" bowl, $8-10; 7" lugged bowl, $5-8; salt & pepper, $18-24; 8" L covered butter, $20-25; 3" H sugar, $15-20; **Front** – lifter, $25-30; 7" ashtray, $15-20; 7" plate, $8-12; 6" plate, $4-6; 6" bowl, $4-6.

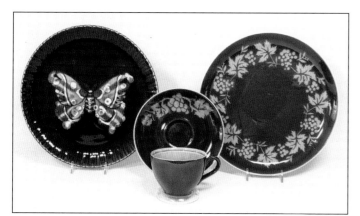

Tahitian Brown, MK 101, 10" Large Moth on Shellridge plate, $25-30; Grapes cup & saucer, $12-15; 10" Grapes plate, $10-12.

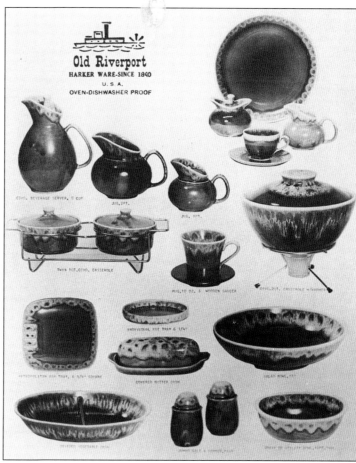

Old Riverport Sales Brochure, c. 1961, *Courtesy Cynthia Boyce Sheehan*.

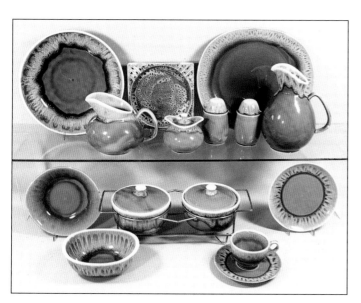

Old Riverport, MKs 114 & 124, **Top** – 11" bowl, $25-30; 6" H jug, $50-60; 7" square ashtray, $25-35; 4" H sugar, $10-15; 13" platter, $20-30; salt & pepper, $25-35; 9" H jug (no stopper), $30-40; **Bottom** – 8" oval bowl, $10-15; 7" oval bowl, $18-25; 2 PC 6" W covered dish set wire stand, $25-35; cup & saucer, $15-18; 7" plate, $8-12.

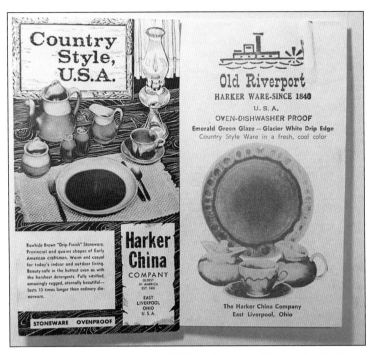

Old Riverport & Country Style c. 1962 Sales Brochures, *Courtesy Cynthia Boyce Sheehan.*

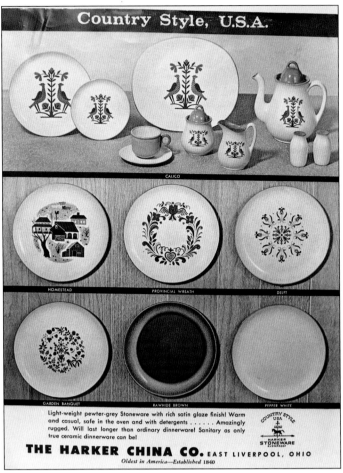

Country Style Sales Brochure, showing Calico (a.k.a. Lapwings), Homestead (a.k.a. Farm House), Provincial Wreath, Delft (a.k.a. Blue Tulip & Blue Dane), Garden Bouquet, Rawhide, & Pepper White, *Courtesy Cynthia Boyce Sheehan.*

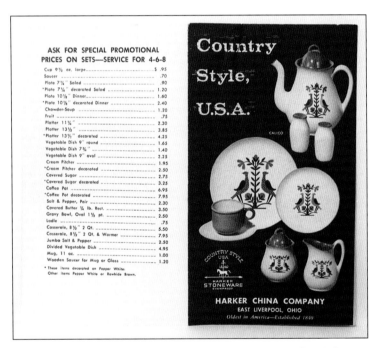

Country Style (Stoneware) Sales Brochure & price list, *Courtesy Cynthia Boyce Sheehan.*

Country Style artwork for newspaper ad, showing Early Morn, Farm House (Homestead), Leaf Dance, Blue Tulip (a.k.a. Delft & Blue Dane), & Pond Lily, *Courtesy Cynthia Boyce Sheehan.*

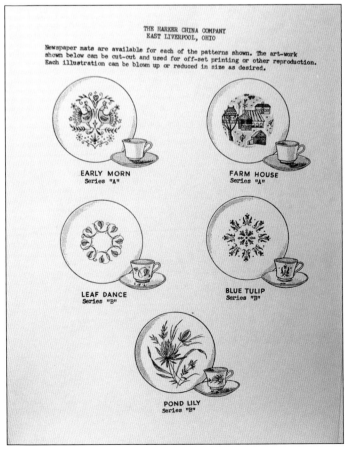

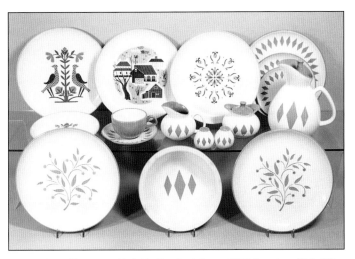

Country Style, MKs 107, 110, & 114, **Top Back Row** – 10" Calico plate, $5-8; 10" Homestead plate, $5-8; 10" Delft plate, $5-8; 3 PC Kimberly plate set 6", 7", & 10", $12-20; **Top Front Row** – 7" Calico plate, $3-5; Kimberly cup & saucer, $8-10; 3" H creamer, $10-15; salt & pepper, $8-12 set; 4" H sugar, $10-15; 8" H stopper jug, $25-35; **Bottom** – 10" Blue Forbidden Fruit plate, $12-15; 8" Kimberly bowl, $12-18; 10" Red Forbidden Fruit plate, $12-15.

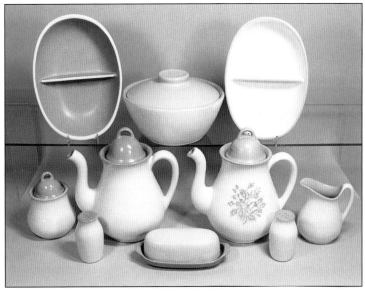

Country Style Miscellaneous, MKs 105 & 106, most not marked, **Top** – 10" Tan Matte divided bowl, $10-15; 9" covered casserole, $15-20; 10" white divided bowl, $10-15; **Bottom** – 5" H sugar, $5-8; salt & pepper, $12-15 set; 9" H coffeepot, $15-25; 8" L covered butter, $8-12; 9" H Yellow Petit Point coffeepot, $20-25; 5" H creamer, $5-10.

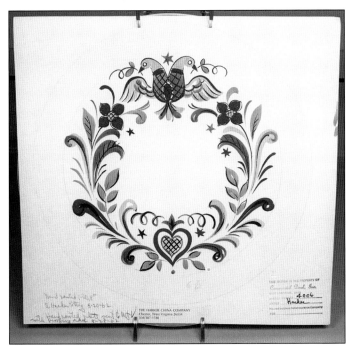

Original artwork for "Provincial Wreath" decal, 1962, signed by artist Hans Hacker, $50.

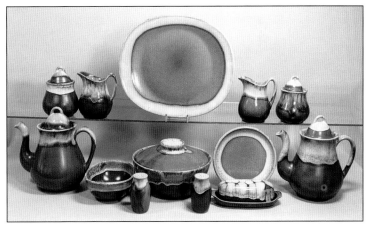

Country Style Rawhide, MK 108, most not marked, **Top** – 5" H sugar, $5-10; 5" H creamer, $5-10; 13" platter, $15-20; 5" H creamer, $5-10; 5" H sugar, $5-10; **Bottom** – 9" H coffeepot, $20-30; 7" oval bowl, $10-15; salt & pepper, $12-18 set; 9" covered casserole, $35-45; 8" L covered butter, $12-18; 7" plate, $4-6; 9" H coffeepot, $20-30.

Country Style, 5 decals, MK 110, **Top Back Row** – 13" platters, Provincial Wreath & Early Morn I, $12-18 each; **Top Front Row** – 5" H Tulip Wreath sugar, $8-12; 5" H Tulip Wreath creamer, $8-12; 5" H Early Morn I creamer (light throat), $8-12; 5" H Early Morn I creamer (dark throat), $8-12; 5" Early Morn I sugar, $8-12; **Bottom** – 10" Provincial Wreath plate, $10-15; 7" plate, $8-12; 9" Royal Wreath coffeepot, $20-30; 7" Royal Wreath plate, $8-12; Early Morn II coffeepot, $20-30; 7" Early Morn II plate, $8-12; 10" Early Morn I plate, $8-12.

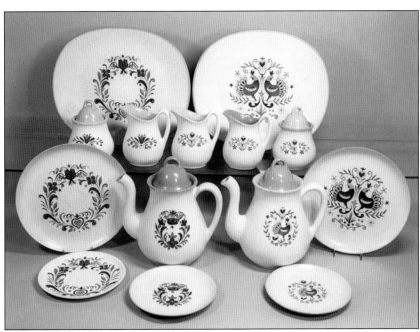

1963 Start of Zip Code use in U.S., 4.25" H Zip Code tumblers/pencil holders, MK 95, $10-25 each, one red & one platinum trim.

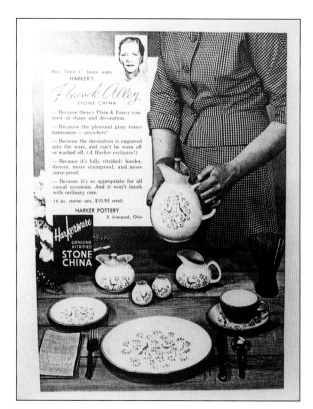

Peacock Alley Intaglio Sales Brochure, c. 1963, *Courtesy Cynthia Boyce Sheehan.*

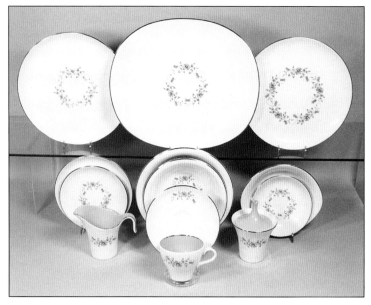

Dining Elegance by Vincent Broomhall, Olympic Shape, MK 96, **Top** – 10" (small decal) plate, $4-6; 13" platter, $10-12; 10" (large decal) plate, $4-6; **Bottom** – 6" & 7" plates, $3-5 each; 5" H creamer, $5-8; 7" & 9" bowls, $6-8 each; cup & saucer, $5-8, 6" H sugar, $7-10; 8" oval bowl, $4-6; 6" bowl, $2-4.

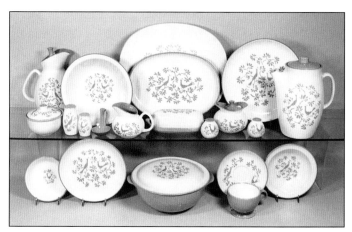

Peacock Alley, MKs 104, 105, 107, & 114, **Top** – 9" stopper lid jug, $25-35; 4" W condiment, $10-12; salt & pepper, $15-18 set; 8" bowl, $8-10; 4" L ladle, $2-4; 4" H creamer, $8-12; 11" & 13" platters, $10-12 & $15-18; 7" L covered butter, $20-25; salt & pepper, $8-12 set; 3" H sugar, $10-12; 10" plate, $10-12; 9" H coffeepot, $25-35; **Bottom** – 5" bowl, $2-4, 7" plate, $5-8; 10" W covered bowl, $35-40; cup & saucer, $4-6; 6" bowl, $3-5.

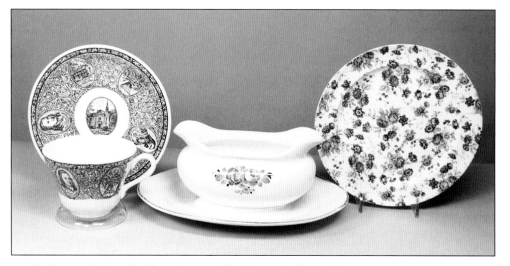

Highly unusual pieces, Aladdin cup & saucer, Lititz PA souvenir, MK 98, $50-55; 9" L gravy with fused under plate (Homer Laughlin Shape) but marked with Harker MK 84A and Homer Laughlin marks, $10-12; 7" Harker Chintz plate (decorated in 1967), MK 90, $10-12.

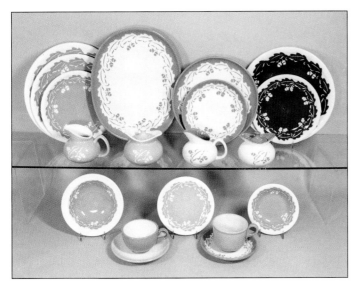

Acorns (Harmony House), Intaglio, MKs 58, 107, & 114, **Top** – 3 PC set, 8", 10", & 11" Parchment Beige plates, $15-25; 4" H creamer, $8-12; 4" H sugar, $8-12; 13" White on gray Stoneware platter, $15-20; 7" & 10" plates, $5-10 each; 4" H White creamer, $15-20; 4" H sugar, $15-20; 8" & 11" Charcoal on white plates, $5-10 & $12-18; **Bottom** – 6" Parchment Beige bowl, $4-8; Stoneware cup & saucer, $6-12; 6" Parchment Beige plate, $3-5; White on Stoneware cup & saucer, $6-12; 5" Parchment Beige bowl, $4-8: (Note cup shapes).

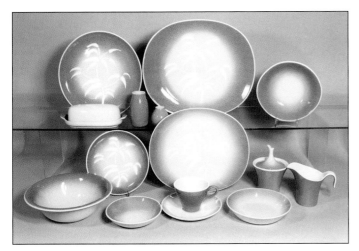

Spanish Gold, Olympic Shape, MK 101, **Top** – 8" L covered butter, $12-18; 10" plate, $10-12; salt & pepper, $15-18 set; 13" platter, $25-30; 7" oval bowl, $8-10; **Bottom** – 9" bowl, $8-12; 7" plate, $5-8; 6" bowl, $3-4; 11" platter, $12-18; cup & saucer, $8-10; 6" bowl, $6-8; 5" H sugar, $8-10; 4" H creamer, $8-10.

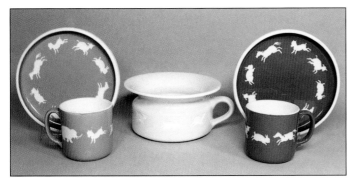

Intaglio Children's Ware, 6" Celadon Green dish, $20-30; 3" H cup, $15-20; 4" H Yellow potty, $50, *potty Courtesy Brett Hartenbach*; 3" H Teal cup, $15-20; 6" Teal dish, $20-30.

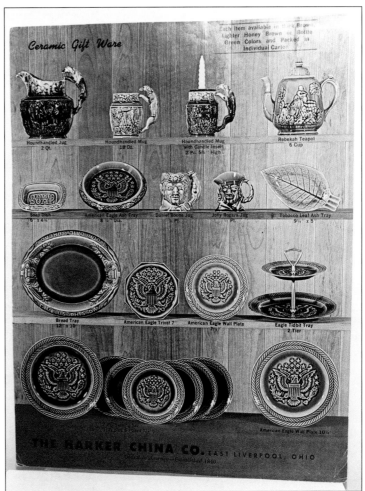

Ceramic Gift Ware Sales Brochure, (a.k.a. Reproduction Rockingham) & shown in Dark Brown (Rockingham), Honey Brown (Gold), & Bottle Green, 1965, *Courtesy Cynthia Boyce Sheehan.*

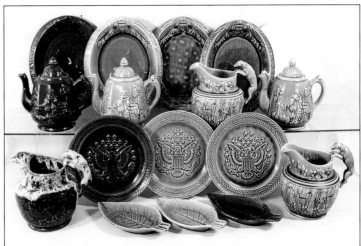

Ceramic Gift Ware (Reproduction Rockingham) 1965, MKs 101, 117, 118, 121, & 173, **Top Back Row** – 12" "Give Us This Day Our Daily Bread" plates, Dark Brown, $15-20; Honey Brown (Gold), $20-25; Bottle Green, $30-40; White, $30-40; **Top Front Row** – 8.5" H "Rebecca At The Well" teapots, Dark Brown, $40-60; Gold, $50-75; Bottle Green, $70-80; 8" H Gold Hound Handled Jug, $50-60; **Bottom Back Row** – 8" H Dark Brown Hound Handled Jug, $35-45; 10" Dark Brown American Eagle plate, $15-20; 10" Gold plate, $18-24; 10" Bottle Green plate, $20-30; 8" H Bottle Green Hound Handled Jug, $65-80; **Bottom Front Row** – 9.5" L Tobacco Leaf ashtrays, Bottle Green, $20-30; Gold, $20-30; Dark Brown, $12-18.

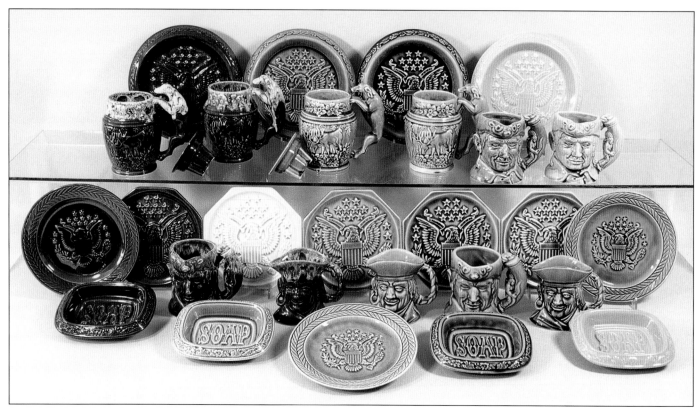

Ceramic Gift Ware (Reproduction Rockingham) 1965, MKs 116 & 118, **Top Back Row** – 8" American Eagle ashtrays, Dark Brown, $15-25; Gold, $20-30; Bottle Green, $50-60; Lime (rare), $50-60; **Top Front Row** – Two 6" H Dark Brown Hound Handled mugs, $15-20 each; 3.25" Dark Brown mug candle holder insert, $20-25; 3.25" Gold candle holder, $25-30; 6" H Gold Hound Handled mug, $20-30; 6" H Bottle Green mug, $30-40; 4.5" H Gold Daniel Boone Jug, $15-20; Creamy Gold Daniel Boone Jug, $30-40 **Bottom Back Row** – 7" Brown American Eagle plate, $5-8; American Eagle Trivets, Dark Brown, $12-18; Cream (rare), $20-30; Gold, $12-18; Bottle Green, $20-30; Light Olive Green (rare), $25-35; 7" Bottle Green American Eagle plate, $12-18; **Bottom Front Row** – 6" L Dark Brown Soap, $8-12; 4.5" H Dark Brown Daniel Boone jug, $18-24; Gold Soap, $15-20; 4.5" H Dark Brown Jolly Roger jug, $18-24; 7" Gold American Eagle plate, $18-24; Bottle Green Jolly Roger jug, $25-35; Bottle Green Soap, $20-30; Bottle Green Daniel Boone jug, $25-35; Gold Jolly Roger Jug, $20-30; Lime Soap (rare), $40-50.

Reproduction Rockingham, 6" L Dark Brown skillet spoon rest, no mark, c. 1965, $20-30, *Courtesy Cynthia Boyce Sheehan.*

Experimental, c. 1960s

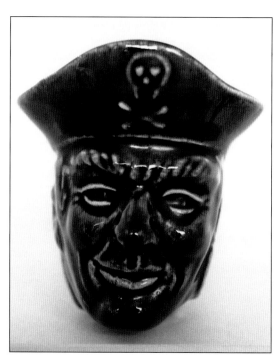

Reproduction Rockingham, Front view of Jolly Roger Ceramic Pipe, (too hot to hold when in use), extremely rare, *Courtesy Cynthia Boyce Sheehan.*

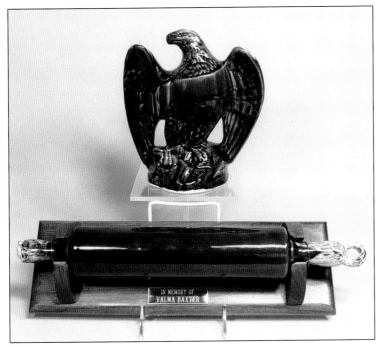

Reproduction Rockingham, 1965, 7.5" H American Eagle, $90-120; 15" Rolling Pin (very rare), purchased from Niece of Valma Baxter, long-time decorator at Harker Pottery, $300-400.

Experimental, 6" x 8" plaque, no mark, framed by Paul Pinney, $200.

Reproduction Rockingham, Side view of Jolly Roger Ceramic Pipe, (opposite page,) *Courtesy Cynthia Boyce Sheehan.*

Experimental, 4" x 8" plaque, no mark, framed by Paul Pinney, $200.

Experimental, 4.5" x 8" plaques, light olive green background, no mark, $40-60 each, *Courtesy Marsha Seeley Nurmi.*

Experimental, 4" x 9" plaque, creamy beige background (repaired), no mark, $150.

Experimental, 3" Oriental medallion, no mark, framed by Paul Pinney, $80.

Experimental, 3.25" Oriental disk, no mark, $40.

Experimental, 4" medallion, no mark, $40.

Experimental, 4" x 5" Oriental plaque, no mark, framed by Paul Pinney, $150.

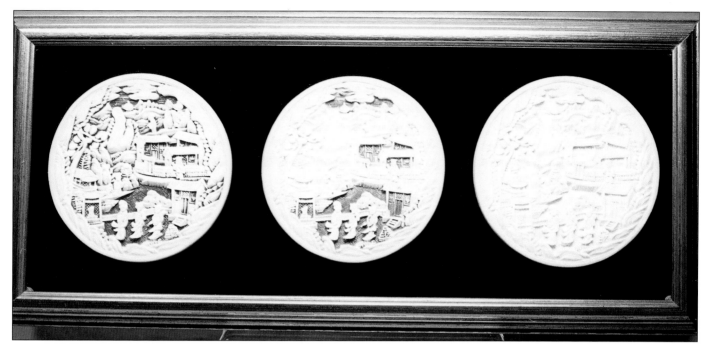

Experimental, Three 5" Oriental plaques, no mark, $150 each.

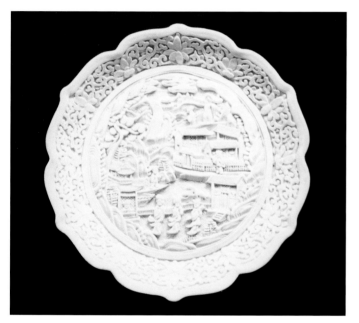

Experimental, 7" Oriental plaque, no mark, $50-75.

Experimental, 4.75" H Head of Christ plaque, no mark, $50-60.

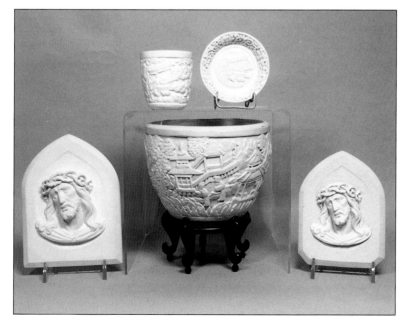

Experimental, **Top** – 2.5" H white Oriental sake cup, $25-35; 3" white Oriental saucer, $15-20; **Bottom** – 5.5" H pale green Head of Christ plaque, $35-50; 5.5" W white Oriental bowl, MK 155, $50-75; 5" H beige & white Head of Christ plaque, $35-50.

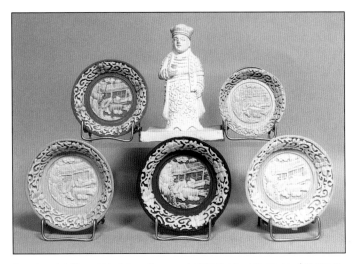

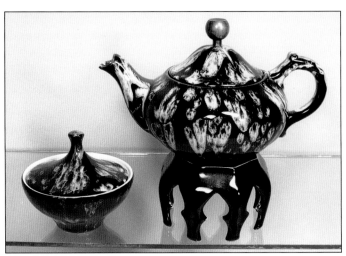

Experimental, **Top** – Oriental motif, no mark, 2.5" blue & white saucer, $10-15; 4" H white Oriental figure, $75-100; 2.25" beige saucer, $10-15; **Bottom** – 3" saucers, beige & white, $10-20; green & white, $20-25; gold & white, $15-20.

Experimental, no mark, 4" H Shellridge brown spatterware sugar, $10-12; 9" L Gadroon brown spatterware teapot with same finial as Shellridge chip & dip set, no mark, $40-50; 4" H teapot stand (cut from the bottom of a Heritance coffeepot), no mark, $5-10.

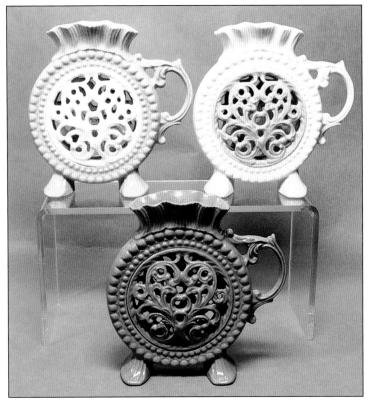

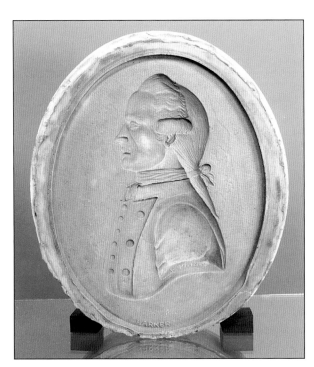

Experimental, 9" W x 10.5" L rubber mold & plaster support for William Penn plaque, sculpted by Paul Pinney. Note Harker name (reversed) at bottom of mold and artist's name (also reversed) at bottom of the sleeve, $100. 3 plaques known made from mold.

Experimental, 5" H x 4" W Perfume Ewers, no mark, $300 each, pink outer & white center, *Courtesy Marsha Seeley Nurmi*; white outer & pink center, & all gray.

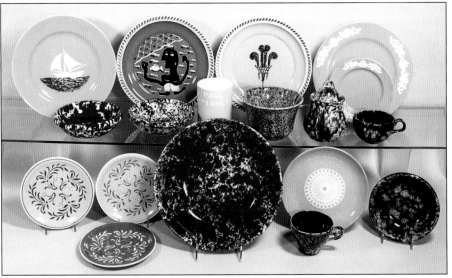

Experimental, no mark unless specified, **Top Back Row** – 9" 3 color sailboat plate by Paul Pinney, $20-30; 9" Gadroon Corinthian Picasso-like plate by Paul Pinney, MK 71, $20-30; 9" Gadroon Gray Feathered Crown plate by Paul Pinney, MK 71, $10-15; 6" & 9" Blue Cameo prototype plates, no mark, $20-25 each; **Top Front Row** – 6" cobalt spatterware bowl, no mark, $5-10; 6" blue spatterware bowl, MK 137, $5-10; 4" H light blue "Paul Pinney" tumbler, no mark, $10-15; 5" H blue spatterware bowl, no mark, $10-15; 5" H brown spatterware Country Style sugar, no mark, $20-25; brown spatterware cup, no mark, $5-8; **Bottom** – 3 different Intaglio blue Rocaille plates, no mark, $5 each; 12" cobalt spatterware bowl, MK 106, $20-30; 7" white doily plate, no mark, $20-25; brown spatterware Shellridge cup, no mark, $5-8; 6" brown spatterware bowl, MK 137, $5-10.

Experimental, 10" W x 8.5" H Oriental plaque, only known example, $1200.

Experimental, 7" W x 9" H plaster plaque of William Penn, sculpted & framed by Paul Pinney, 1 of only 3 made, $300.

Experimental, Two 6" glazed plaques, **Left** – White House, U.S. Capital, & Statue of Liberty, MK 136, signed "Norman Clewlow 11/15/62", $40-50, gift from Kathy Eberling (Boyce Family descendant); **Right** – Cherubs & Roses, MK 136, signed "Norman Clewlow 1/15/59", $40-50.

Experimental, nude with cherubs plaque, no mark, $25-30.

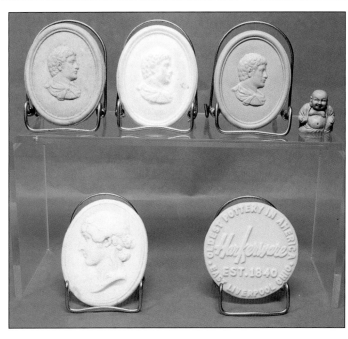

Experimental medallions, no mark, $5-10 each, **Top** – 2.25" H green Grecian man; 2.25" H white Grecian man; 2.25" H green Grecian man:, 1" H x 1" W Buddha, $50; **Bottom** – 2.5" H white Grecian lady; 2.25" raised trademark. Buddha, trademark, & medallion in top right, *Courtesy Marsha Seeley Nurmi.*

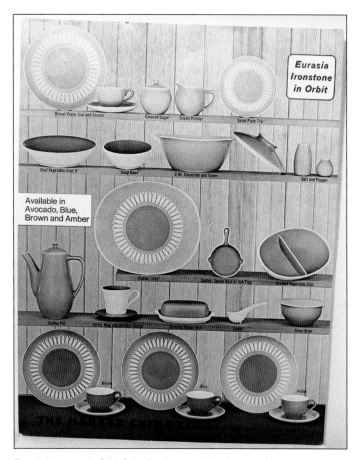

Eurasia Ironstone in Orbit Sales Brochure, c. 1967, *Courtesy Cynthia Boyce Sheehan.*

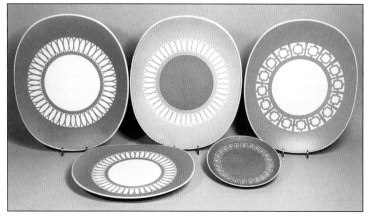

Eurasia, MK 101, **Back Row** – 13" Orbit avocado platter, $15-25; Orbit gray & avocado platter, $40-50; Europa avocado platter, $15-25; **Front Row** – 11" Orbit avocado platter, $10-15; 7.25" Broken Squares plate (likely an experimental piece), $8-10.

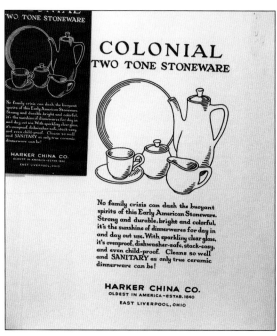

Colonial Two Tone Stoneware Sales Brochures, *Courtesy Cynthia Boyce Sheehan.*

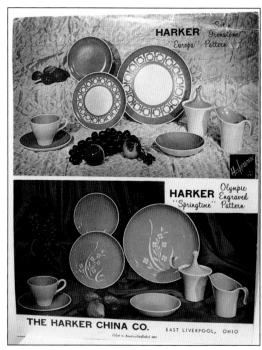

Europa & Springtime Sales Brochure, *Courtesy Cynthia Boyce Sheehan.*

Ironstone Sales Brochure, showing Quaker Maid, Citation, Blue Bell, Americana, Clover, & Dogwood patterns, *Courtesy Cynthia Boyce Sheehan.*

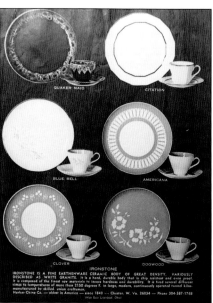

Eurasia, MKs 101, 105, & 114, 4" H creamer, $6-8; 10" divided bowl, $10-15; 8" L covered butter, $12-15; salt & pepper, $8-12; 6" bowl, $3-5; 6" H sugar, $6-8.

Calendar plates, MK 112, 10" 1970 – USA, Heritance Shape, $8-10; 10" 1971 – USA, $8-10.

Unknown Shape, MK 129B, 10.5" plate, $5-8; 6" L creamer, $5-8.

3.125" Jeanette Glass Co. paperweight & insert, listing Royal Crystal Imports, Harker, Royal China, & Brookpark, $20-30.

American Ironstone, "Square Dance" plate, MK 156, $15-20.

Chapter Nine

Backstamps and Marks
Found on Harker Pottery

Initially, we attempted to arrange backstamps in chronological order, but many marks were discovered as the photography for this book progressed. Numbers were assigned to backstamps as they were discovered on specific pieces of ware and were designated in one or more photographs of ware. This, in large part, is the reason backstamps are out of chronological order.

Marks may help determine the approximate manufacture date of a piece and possibly even the shape, glaze or applied decoration. Known decorator marks are identified with a TM (Trade Mark) and can be found on pieces of Harker sold as "blanks" or as fully or partially decorated ware. These and other likely decorator's marks are on Harker pieces in our collection. We have also included two manufacturer's marks. Our reasons for including these marks are listed below. Unless a caption indicates otherwise, the mark is a Harker mark.

We included a Wallace & Chetwynd backstamp because Jesse Chetwynd was a mold maker for George S. Harker and because we have identical pieces in our collection with Harker with Wallace & Chetwynd backstamps. When Jesse died, his brother, Joseph Chetwynd, also a mold maker, emigrated to East Liverpool and helped start Wallace & Chetwynd. Joseph either acquired or duplicated his brother's molds for Wallace & Chetwynd.

We included a Bennett backstamp because collectors sometimes confuse the Bennett Cameo Apple Blossom and Lily of the Valley patterns and Bennett's "Cameo" backstamp with Harker's Cameo Ware. Bennett's pink and blue colors were slightly more intense than Harker's. The holder of the patent for this process, George Bauer, worked with the Bennett Pottery in Baltimore prior to their closure in 1938.

George Bauer brought his patented cameo process to the Harker Pottery Co. after the Bennett Pottery closed and this process was used by Harker to produce their Cameo Ware line.

Actual sizes of the marks in this chapter are not indicated due to space limitations, so comparing size differences is not a valid indicator of mark size.

While we were able to date many marks with a high degree of certainty based on information contained in journals and advertisements, dates for many marks in this chapter can only be approximated. Unfortunately, Harker kept few records pertaining to shape names and decals, and three fires at the plant after it closed in 1972 destroyed what remained. Dates such as circa 1891-?, indicate a known or approximate start date, but no information was available to indicate when a line or backstamp was discontinued.

We photographed several pieces belonging to the East Liverpool Historical Society, some housed in the Thompson House, but most are on permanent loan to the Ohio Historical Society – Museum of Ceramics, in East Liverpool. Marks reprinted with permission from the *Journal of the Society for Historical Archaeology*, Volume 16, Nos. 1-2, 1982, are so identified.

Just prior to beginning work on this book, we thought we had identified approximately ninety Harker backstamps. When the reality began to dawn on us, we were amazed at the ever-increasing number of backstamps coming to light. We are sure there are more backstamps awaiting discovery and look forward to the prospect of making the discovery ourselves or of having encouraged another collector to make and share such a discovery with us.

MK 1, "Harker Taylor & Co., East Liverpool, Ohio", impressed, 1846-51.

MK 2, "Harker Taylor & Co., East Liverpool, Ohio", impressed, 1846-51.

MK 3, "Etruria Works, 1861, East Liverpool", Rockingham Spittoon, impressed.

MK 4, "Etruria Works, East Liverpool", impressed, 1852-79.

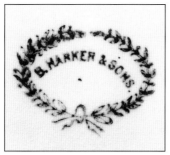

MK 9, "B. Harker & Sons", 6" ironstone plate "DR Franklin's Maxims", 1877-81.

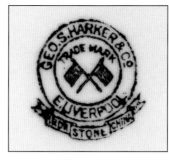

MK 13, Crossed Flags, 1879-90.

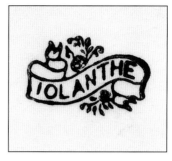

MK 18, "Iolanthe", 1883-90.

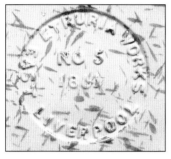

MK 5, "Etruria Works, No5, 1861, East Liverpool", Rockingham Spittoon, impressed.

MK 10, Bald Eagle, ironstone gravy tureen, 1879-90.

MK 14, Modified "British" mark, note lack of hair around lion's face, 1879-1910.

MK 19, "Mineola", blue, c. 1884-?

MK 6, "Etruria Works, G.S. Harker & Co., East Liverpool, O.", Rockingham Spittoon, impressed, *Courtesy East Liverpool Historical Society*.

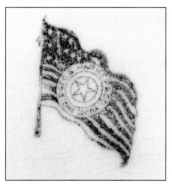

MK 11, Flag & Star, 1879-90.

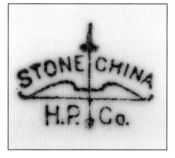

MK 15, "Stone China", 1890-1910.

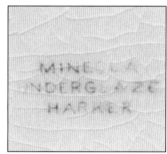

MK 20, "Mineola", brown, c. 1884-?

MK 7, "Harker Thompson & Co., E. Liverpool, Ohio", rectangular Rockingham Bowl, Impressed, 1851-54.

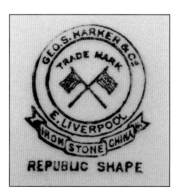

MK 12, Crossed Flags & Republic Shape", 1879-90.

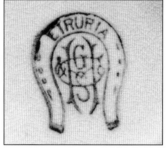

MK 16, "Etruria", black, 1880-90.

MK 21, Inverted Bow & Arrow, 1890-1910.

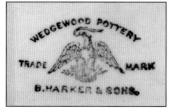

MK 8, "Wedgewood Pottery, B. Harker & Sons", ironstone bowl, 1877-81.

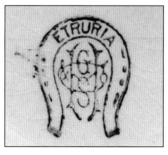

MK 17, "Etruria", brown, 1880-90.

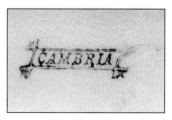

MK 22, "Cambria", brown, MK 22A Black, c. 1887-?

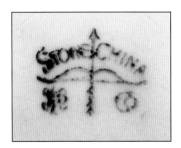

MK 23, "Stone China", 1890-1900.

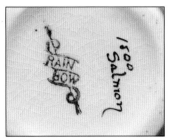

MK 28, "Rainbow", c. 1892-?

MK 33, "Sun-Glow Bakerite", multicolored, c. 1935-?

MK 38, "Bakerite", "22 K. Gold", c. 1935-?

MK 24, "Columbia", c. 1890-?

MK 29, Arrow across the "H", c. 1890-1904, *Reprinted from Historical Archaeology 16 (1&2) by permission of The Society for Historical Archaeology.*

MK 34, "Sun-Glow Bakerite", black, MK 34A gold, MK 34B silver, c. 1935-?

MK 39, "Bungalow Ware", green, c. 1931-?

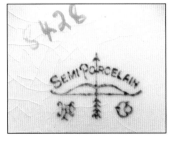

MK 25, "Semi-Porcelain", 1890-1931.

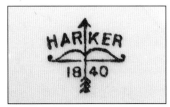

MK 30, "Harker 1840", black, 1930-45.

MK 35, "Columbia" multicolored, c. 1935-55.

MK 40, "Bungalow Ware", green & multicolored, c. 1931-?

MK 26, "Hotel", 1890-1920.

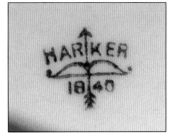

MK 31, "Harker 1840", green, MK 31A Silver, MK 31B Gold, 1930-45.

MK 36, "Columbia" green, c. 1935-55.

MK 41, "Dundee Ware", green, c. 1931-?

MK 27, "Tremont", c. 1891-?

MK 32, "Oven Ware", multicolored, 1920-30.

MK 37, "Bakerite", c. 1935-?

MK 42, Modern Inverted Bow & Arrow (decal), 1931-40.

MK 43, "Hotoven", black, MK 43A gold, 1926-50.

MK 48, "Cameo Ware, Patented", 1940-48.

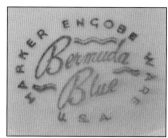

MK 53, "Harker Engobe, Bermuda Blue", c. 1944-?

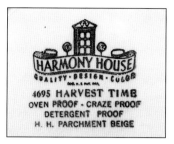

MK 58, "Harmony House, Harvest Time, Parchment Beige", 1945-55.

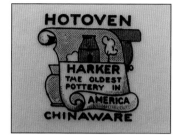

MK 44, "Hotoven", purple, red & yellow, 1926-50.

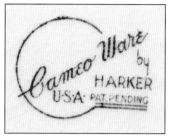

MK 49, "Cameo Ware, Pat. Pending", 1940-48.

MK 54, "Glazed Inside", impressed on hollow Baby Dishes, c. 1940-48.

MK 59, "Harmony House, Lotus, Lt. Horizon Blue", (small mark), 1945-55.

MK 45, "Hotoven", red, blue & green, 1926-50.

MK 50, "White Rose Carv-Kraft", Montgomery Ward Exclusive, c. 1950.

MK 55, "Modern Age", note arrow shafts & feathers, c. 1939-?

MK 60, "Wild Rice", c. 1950-?

MK 46, "Hotoven", red, blue & green, pale colors, 1926-50.

MK 51, "Wellesley Ware"™, 1940-50.

MK 56, "For Victory, Buy War Bonds And Stamps", 1941-46.

MK 61, "Wild Rice", c. 1950-?

MK 47, "Hotoven" & Good Housekeeping Seal", 1926-50.

MK 52, "American Engobe", 1940-55.

MK 57, "Harmony House, Lotus, Lt. Horizon Blue", 1945-55.

MK 62, "Royal Gadroon, Vintage", 1948-1963.

MK 63, "Royal Gadroon", green &
yellow, 1948-63.

MK 68, "Chesterton", (Royal Gadroon),
1946-63.

MK 73, "Dresden Duchess", 1950-60.

MK 78, "Royal Lovelace", 1940-50.

MK 64, "Royal Gadroon", burgundy,
yellow & blue, 1948-63.

MK 69, "Pate Sur Pate", (Royal
Gadroon), 1949-63.

MK 74, "Royal Dresden Maroon",
1950-60.

MK 79, "Royal Lovelace", 1940-50.

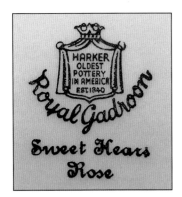

MK 65, "Royal Gadroon, Sweet Hears
(should be Heart) Rose", 1949-63.

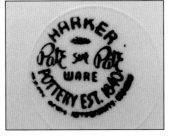

MK 70, "Pate Sur Pate", MK 70A blue,
MK 70B black, (Royal Gadroon),
1949-63.

MK 75, "Duchess", 1950-60.

MK 80, "Southern Rose", (a.k.a.
Compass Rose), 1949-63.

MK 66, "Royal Gadroon, Bouquet",
1949-63.

MK 71, "Pate Sur Pate", (Royal
Gadroon), larger than MK 70, 1949-63.

MK 76, "Royal Dresden", 1950-60.

MK 81, "Southern Rose", (a.k.a.
Compass Rose), 1949-63.

MK 67, "Corinthian", (Royal Gadroon),
1948-63.

MK 72, "Sun Valley", (Royal Gadroon),
1951-63.

MK 77, "Early American", 1930-40.

MK 82, "Laurelton", 1955-65.

MK 83, "Laurel", 1955-65, No marked pieces found to date, *Reprinted from Historical Archaeology 16 (1&2) by permission of The Society for Historical Archaeology.*

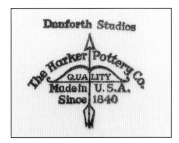

MK 88, Modern Bow & Arrow, "Danforth Studios", c. 1949-?

MK 93, "Harkerware by Russel Wright", impressed & divided, c. 1953-58.

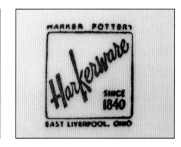

MK 98, black, MK 98A silver, MK 98B gold, 1952-60.

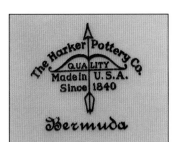

MK 84, Modern Bow & Arrow, black, MK 84A gold, MK 84B silver, c. 1950-?

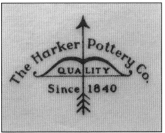

MK 89, Modern Bow & Arrow, "Primrose", c. 1949-?

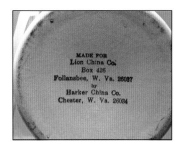

MK 94, "Norman Clewlow 11-15-62", incised, Experimental plaque.

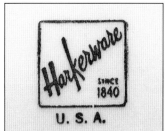

MK 99, "Blue Dane", 1958-60.

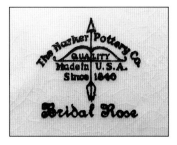

MK 85, Modern Bow & Arrow, "Bermuda", c. 1949-?

MK 90, Red, MK 90A Black, c. 1950-?

MK 95, "Lion China Co." ™, On Tumbler, c. 1950-?

MK 100, 1955-72.

MK 86, Modern Bow & Arrow, "Bridal Rose", c. 1949-?

MK 91, "Russel Wright", impressed, c. 1953-58.

MK 96, "Dining Elegance, Vincent Broomhall", 1964.

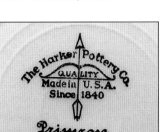

MK 101, 1955-72.

MK 87, Modern Bow & Arrow, "22 KT. Gold", c. 1950-?

MK 92, "Designed by Russel Wright", impressed, c. 1953-58.

MK 97, "International Brotherhood Operative Potters", c. 1959-?

MK 102, "Tarrytown", c. 1938-?

MK 103, "Stone China, Pat. Pend.", impressed, 1954-72.

MK 108, "Stone Ware", impressed, 1954-72.

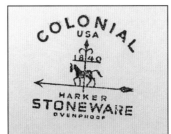

MK 113, "Colonial", c. 1962-?

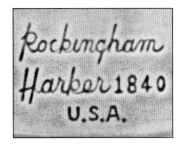

MK 118, Reproduction "Rockingham", impressed, c. 1965.

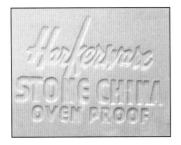

MK 104, impressed, 1954-72.

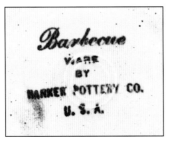

MK 109, "Barbecue Ware", c. 1951-?

MK 114, "USA", impressed, on Reproduction Rockingham, c. 1965.

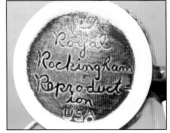

MK 119, "Royal Rockingham Reproduction", impressed, made by Royal China from Harker Reproduction Rockingham Molds, 1972-75.

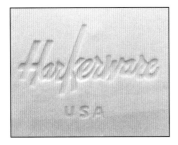

MK 105, "USA", impressed, 1954-72.

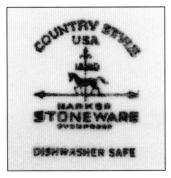

MK 110, "Country Style", c. 1962-?

MK 115, "USA", raised, c. 1960-?

MK 120, impressed, Quaker Maid casserole, 1960-1972.

MK 106, impressed, 1954-72.

MK 111, "T.W.A. Part # 44-1136", On Shallow Rectangular Plate, c. 1960-?

MK 116, Reproduction "Rockingham", c. 1965.

MK 121, impressed, on Reproduction Rockingham, c. 1965.

MK 107, "Stone China, USA", impressed, 1954-72.

MK 112, "Ironstone U.S.A.", impressed, c. 1962-?

MK 117, "Reproduction Rockingham", impressed, c. 1965.

MK 122, "Quaker Maid, Pearl China" ™, c. 1960-72.

MK 123, "Quaker Maid, Harker", c. 1960-72.

MK 128, "Tahiti", c. 1961-?

MK 133, "Enchantment", combined with MK 132 & MK 134, 1960-?

MK 138, "Spring Bouquet", 1959-?

MK 124, "Old Riverport", green glazed ware, c. 1961-?

MK 129, "Translucent China", black, MK 129A silver, MK 129B gold, c. 1959-?

MK 134, "Enchantment", 1959-?

MK 139, "Ceremony", 1959-?

MK 125, "Woodsong", c. 1961-?

MK 130, "Translucent China", green, 1959-?

MK 135, "Write Harker Promotions-Premiums", 1959-?

MK 140, "Margarat Rose" (Harker's spelling), 1959-?

MK 126, gold, MK 126A black, 1960-72.

MK 131, "Leaf Swirl", yellow & black, 1959-?

MK 136, gold, combined with MK 114 & MK 94, c. 1959.

MK 141, "Whitechapel", 1959-60.

MK 127, "Heritance", c. 1958-60.

MK 132, "Translucent China", blue & black, 1959-?

MK 137, impressed, 1959-?

MK 142, "Whitechapel", 1959-60.

MK 143, "Whitechapel", 1959-60.

MK 148, "Hotoven" plaque, note different colors on urns, 1926-1950.

MK 153, "Bennett Bakeware", often mistaken for Harker Cameoware. Bennett closed in 1936.

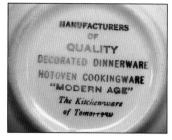

MK 158, "Modern Age", 1939-60.

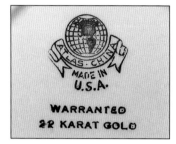

MK 144, "Atlas China" ™, c. 1959-?

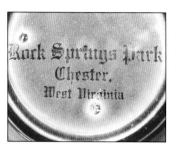

MK 149, "Rock Springs Park", c. 1965.

MK 154, Bow & Arrow, impressed on gray Ironstone cup & saucer, not certain this is a Harker mark, ware looks c. 1960-?

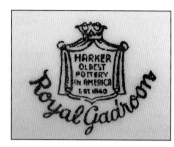

MK 159, "Royal Gadroon", 1948-63.

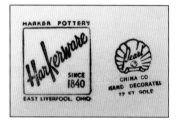

MK 145, "Pearl China" ™ & Harkerware, c. 1959-?

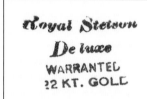

MK 150, "Royal Stetson Deluxe" ™, c. 1959-?

MK 155, "Harker Pottery, Est. 1840", on Experimental bowl, 1962-1965.

MK 146, "Pearl China" ™, c. 1959-?

MK 151, "Harker Kitchenware", raised on 4 sizes of glass lids, c. 1930-?

MK 156, "American Ironstone, Square Dance", c. 1960-?

MK 160, "Ivy", 1948-63.

MK 161, "Bridal Rose", 1948-63.

MK 147, "Harkerware", raised, in center of ashtray, c. 1959-?

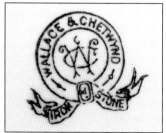

MK 152, "Wallace & Chetwynd", 1883-1900.

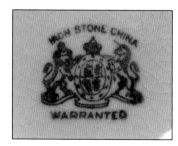

MK 157, note hair around lion's face, similar to MK 14, 1879-1900.

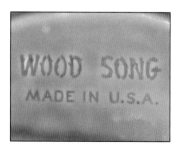

MK 162, "Wood Song", c. 1961-?

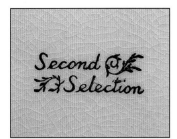

MK 163, "Second Selection" ™, c. 1950-?

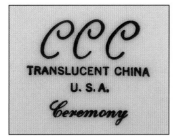

MK 168, "Ceremony", 1959-?

MK 173, "REPRODUCTION" Rockingham, c. 1965.

MK 178, "Oven Proof", c. 1959-?

MK 164, "4637 Provincial Tulip", c. 1961-?

MK 169, "Margarat Rose" (Harker's spelling), with MK 133, 1959-?

MK 174, "Celestial Blue" on Newport shape, 1938-?

MK 179, "4638 Marshland, H.H. Parchment Beige", c. 1961-?

MK 165, 22 K. Platinum, c. 1959-?

MK 170, "Translucent", black, 1959-?

MK 175, "Duchess by Franklin Kent" ™, c. 1959-?

MK 180, "Columbia Chinaware", c. 1935-55.

MK 166, "4505 Spring Breeze", c. 1961-?

MK 171, "Bone White", c. 1960-?

MK 176, "Federal China Co." ™, c. 1959-?

MK 181, "4512 Wheat, H.H. Parchment Beige", c. 1961-?

MK 167, smaller than MK 98, 1952-60.

MK 172, "22 KT. PLAT.", 1955-60.

MK 177, "DeRoy's" ™, c. 1959-?

MK 182, "Harvest Moon" ™, on Virginia utility plate, c. 1959-?

MK 183, "Southern Belle" ™, on Virginia utility plate, c. 1959-?

MK 188, "Columbia Bakerite", on Jewel Weed, c. 1935-?

MK 193, Modern Bow & Arrow, "Primrose", c. 1948-63.

MK 198, "Hotoven", 1935-60.

MK 184, "Atlas China, Southern Belle" ™, on Virginia utility plate, c. 1959-?

MK 189, Modern Bow & Arrow, "Regal", c. 1950-?

MK 194, Combination of Part of Mk 97 & MK 167, 1952-60.

MK 199, "T.W.A. Part # 44-1370", c. 1960-?

MK 185, "Atlas China" ™, on Virginia utility plate, c. 1959-?

MK 190, "Hotoven", c. 1935-50.

MK 195, "Whitechapel", probably not used on china, 1959-60.

MK 200, "Rockingham, American Eagle Trivet 7", Dark Brown", probably not used on china, c. 1965.

MK 186, "Warranted 18 Carat Gold", c. 1959-?

MK 191, "Harmony House, 23 K. Gold", c. 1959-?

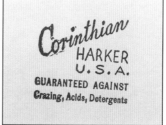

MK 196, "Corinthian", probably not used on china, 1952-60.

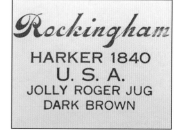

MK 201, "Rockingham, Jolly Roger Jug, Dark Brown", probably not used on china, c. 1965.

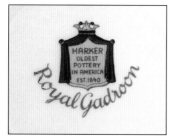

MK 187, "Royal Gadroon", 2 shades of green with brown, 1948-63.

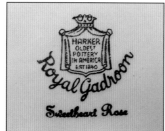

MK 192, Royal Gadroon "Sweetheart Rose", c. 1948-63.

MK 197, "Chesterton Ware", probably not used on china, 1950-60.

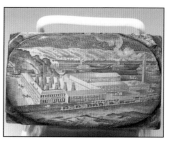

MK 202, Letterhead Printing Plate, not used on china, c. 1950-?

MK 203, c. 1960-72, *Reprinted from Historical Archaeology 16 (1 & 2) by permission of The Society for Historical Archaeology.*

MK 204, Printing plate, "Cameo ware", 1940-48, *Courtesy East Liverpool Historical Society*.

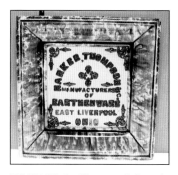

MK 205, "Harker Thompson", Ceramic Calling Card, 1851-1854, *Courtesy East Liverpool Historical Society*.

MK 206, Modern Bow & Arrow, "Dusty Pink" on Newport shape, c. 1938-?

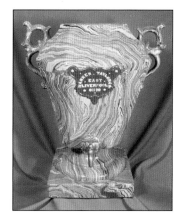

MK 207, "Harker Taylor & Co., East Liverpool, Ohio", on Rockingham Water Cooler, 1846-1850, *Courtesy East Liverpool Historical Society.*

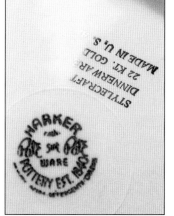

MK 208, "STYLECRAFT DINNER-WARE" ™, 1948-55.

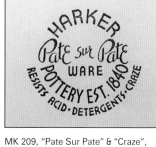

MK 209, "Pate Sur Pate" & "Craze", probably not used on china, 1948-55.

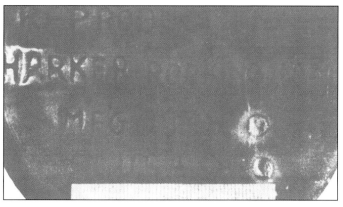

MK 210, c. 1965, "Reproduction Harker Rockingham, Mfg 1848, U.S.A.", *Reprinted from Historical Archaeology 16 (1&2) by permission of The Society for Historical Archaeology.*

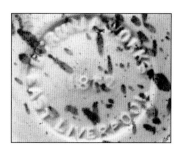

MK 211, "Etruria Works, 1862 East Liverpool", Rockingham Spittoon, *Courtesy East Liverpool Historical Society*.

MK 212, c. 1950-60, "Barbecue Outdoor-Ware", *Reprinted from Historical Archaeology 16 (1&2) by permission of The Society for Historical Archaeology.*

MK 213, "B. Harker & Sons, 1878".

MK 214, Sticker on Savoy Shape sugar with red stripe, "Harker Chinaware, The Harker Pottery Company, Established 1840, Made By The Oldest Pottery In America, Semi-Porcelain", 1890-1930.

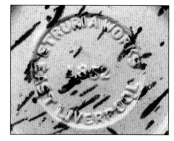

MK 215, "Etruria Works, 1852, East Liverpool" on Rockingham Spittoon.

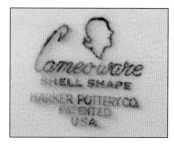

MK 216, "Cameo Ware, Shell Shape", 1948-?

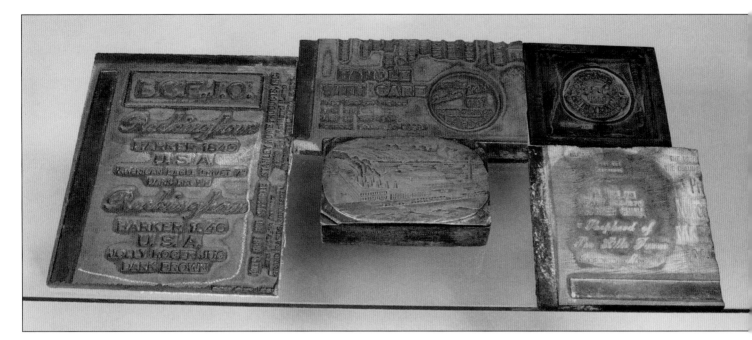

Molds from which Harker rubber backstamps were made and a printing plate.

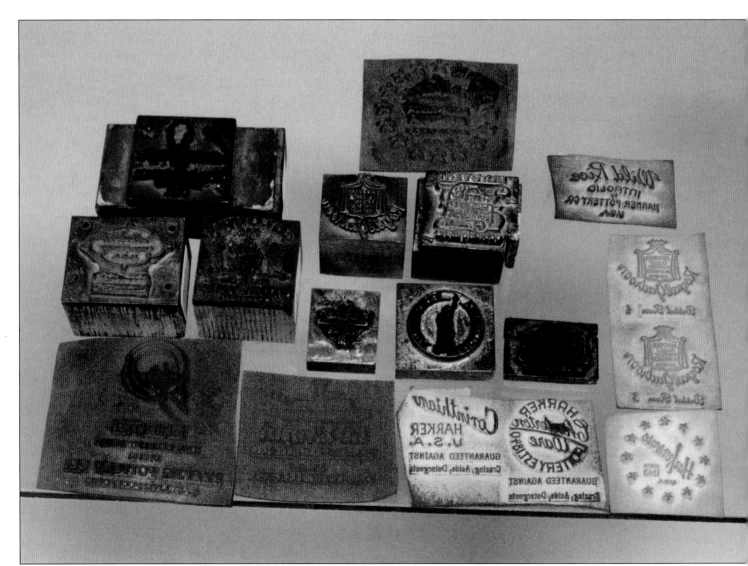

Rubber and metal Harker backstamps.

Bibliography

Books

Barth, Harold Bradshaw. *History of Columbiana County*. Topeka, Kansas and Indianapolis, Indiana: Historical Publishing Co., 1926.

Colbert, Neva. *Collector's Guide to Harker Pottery*. Paducah, Kentucky: Collector Books, 1993.

Cunningham, Jo. *Collector's Encyclopedia of American Dinnerware*. Paducah, Kentucky: Collector Books, updated 1995.

Duke, Harvey. *Official Price Guide to Pottery and Porcelain, 8th Edition*. New York, New York: House of Collectibles, 1995.

Gates, William C., Jr. and Dana E. Ormerod. *The East Liverpool Ohio Pottery District Identification of Manufacturers and Marks, USA*. The Society for Historical Archaeology, 1982.

Gates, William C., Jr. *The City of Hills & Kilns, Life and Work in East Liverpool, Ohio*. East Liverpool, Ohio: The East Liverpool Historical Society, 1984.

Keller, Joe and David Ross. *Russel Wright, Dinnerware, Pottery, and More*. Atglen, Pennsylvania: Schiffer Publishing Ltd., 2000.

Specialty Publications, Newspapers, Periodicals

Better Homes and Gardens, Des Moines, Iowa: Advertisements, Page 6, February 1942 and, Advertisement, Page 44, September 1954.

Brookes, Timothy R. *The Sunshine Soldiers: The Ohio National Guard Comes to the Rescue*. East Liverpool, Ohio: Plate Turner's Handbook, East Liverpool Pottery Festival Committee, 1989.

China, Glass, and Lamps, Pittsburgh, Pennsylvania: Advertisements, August 1936; February 1937; February 1938; December 1939, and February 1941.

China, Glass, and Tablewares, USA: Advertisement, Page 24, USA, January 1965.

Colbert, Neva. *The Harker Arrow* (Newsletter). St. Clairsville, Ohio, 1992 to present.

Cox, Lucille T. "Founder of America's Oldest Pottery Arrived in Liverpool to Buy Farm." East Liverpool, Ohio: *The Potter's Herald*, June 24, 1937.

_____. "Harker, Taylor & Co. Pottery Invaded Import Stronghold in 1850 and Captured Gold Medal." East Liverpool, Ohio: *East Liverpool Review*, October 28, 1937.

_____. "Ninety Eight Years of Progress." *The Salesman*, April 1938.

_____. "Harker, Won and Lost, On Shipment of Clay." East Liverpool, Ohio: *East Liverpool Review,* November 25, 1938

_____. "Benjamin Harker, Sr." *The Bulletin of the American Ceramic Society*, Easton, Pennsylvania & Columbus, Ohio: Volume 20, Number 1, January 1941.

Crockery and Glass Journal. New York, New York: G. Whitmore & Co., 1874-1961.

Gift and Tableware Reporter. New York, New York: Billboard Publications 1962-1971.

Gift Wares. August 1944.

Home Goods, No. 4046, Page 136. New York, New York: Butler Brothers, Midwinter 1934.

House Beautiful : Harker Advertisements, Hearst Publishing, 1960s.

Omaha Crockery Company (A Harker Distributor): Sales Brochures, Omaha, Nebraska, 1950s.

Pottery, Glass, & Brass Salesman. New York, New York: O'Gorman Publishing, 1910-1939.

Ramsay, John. "East Liverpool, Ohio, Pottery in the Museum of the East Liverpool Historical Society." *American Collector,* New York, New York: Collector's Publishing, April 1948.

The First 100 Years, East Liverpool Centennial Celebration. East Liverpool, Ohio: Sims Printing Co., October 1934.

"The Harker Pottery Company." *News and Views,* Pittsburgh, Pennsylvania: Pittsburgh Group, June 1952.

The National Glass, Pottery and Collectibles Journal, Page 234, March 1979.

Waggoner, Jason S. *Three Out of Many, Prominent Potteries of East Liverpool, Ohio 1840-1999*. Thesis for Kent State University, Kent, Ohio 1999.

Conversations and Personal Correspondence

Baxter, Valma. Harker Decorator, Extensive 1956 decal notebook. Chester, West Virginia.

Clendenning, Juanita. Harker Office Employee. East Liverpool, Ohio.

Colbert, Neva & Don. Don's father worked at Harker Pottery for many years and Neva fell in love with the lovely pottery and wrote the first book on Harker Pottery. St. Clairsville, Ohio.

Eberling, Kathy Boyce. A Boyce granddaughter and avid collector, whose inheritance included some beautiful experimental plaques and a set of black Cameoware mixing bowls. Paris, Ohio.

Holtzman, Anna Jane. Harker Ware Selector/Inspector. Bill's grandmother, who worked at Harker for 19.5 years. This book is a tribute to her and her history at Harker Pottery. Chester, West Virginia.

Horton, Charles (Chuck). Worked at Harker Pottery for over 20 years and gave us several Harker Royal Gadroon YMCA League basketball jerseys. East Liverpool, Ohio.

Lang, Charles Boyce. Worked on Harker experimental items during his college summer vacation. Chester, West Virginia.

Lang, Mary Sue. Worked on Harker experimental items during her college summer vacation. East Liverpool, Ohio.

Lang, Rachel Boyce. Mother of Charles and Mary Sue. Charles & Mary Sue worked on the experimental "Belly Dancers" and other Harker experimental plaques, medallions, and cups & saucers in bone china. Mrs. Lang shared her recollections and some of her 1960s Harker-related personal correspondence with the authors. East Liverpool, Ohio.

Pinney, Paul P. Our single most reliable and generous Harker authority. Paul's brother, John, worked his way up to become Vice President at Harker, after managing nearly every department. Paul worked at Harker for over 40 years, mostly in the "Color Shed", where colors were mixed for Cameo and many other lines. However, with his great artistic talent, Paul was frequently consulted for sales displays, as well as for color and pattern selection. Chester, West Virginia.

Scovel, Janice. Janice was raised in the old Harker homestead, behind the Harker Pottery. Her grandmother, Emmaline Golden, was a Harker liner (decorator) and Emmaline's husband looked after the Harker buildings in East Liverpool, after the company moved across the Ohio River to Chester, West Virginia. We acquired Emmaline's paint pot/palate. Janice shared stories of her life on River Road in East Liverpool and of the Harker Pottery. Thomasville, Georgia.

Shaw, Sherrill. 1) *Fire & Clay, East Liverpool, Ohio, The First 100 Years*, East Liverpool, OH, 2001. 2) *Tenth Annual East Liverpool Pottery Collectors' Convention, Collecting Harker Pottery*, 2002. Both productions were written, produced, and videographed by Sherrill Shaw, Phoneix Studios. 427 Market Street, East Liverpool, Ohio.

Sheehan, Cynthia Boyce and her brother Robert H. Boyce. Children of the last Harker President, Robert E. Boyce. Cynthia spent hours with us, reading from and recording excerpts from her father's diary from 1934-1977. This was truly an inside look at how Harker ownership and management tried in vain to keep "The Oldest Pottery in America" viable in the face of competition and rapidly rising costs of doing business. Harvey Cedars, New Jersey.

Witt, Joan. Joan is the resident East Liverpool historian and guiding light for many local success stories. When she met us and realized we wanted to learn about Harker, she promptly arranged a tour of the old Harker Pottery building on River Road. I believe we knew, when we came down from the loft with old Harker Pottery (1890-1930) ware in hand from an original ware box, that we would one day write this book. East Liverpool, Ohio.

Glossary

36 Bowl: 5" bowl, so named because 36 bowls were packed in a barrel with straw for shipment when this method of shipment was being used.

ABC Plate: 6.125" to 7.25", usually on Ironstone and most often marked with the "HOTEL" backstamp, a children's plate with nursery rhyme, animal or similar decal and alphabet letters around the perimeter.

Arches: Surface embossing on bowls and Batter Jugs in the shape of an arch.

Attached Gravy: Gravy boat with fused under plate.

Baby Dish: A thick, heavy dish, some incorporating a ceramic hot water reservoir or with an exterior metal reservoir for hot water.

Bailed Jug: A Republic Shape jug with a heavy wire handle.

Batter Jug: Heavy walled jug with a lid, used to mix and pour pancake batter.

Batter Out: Potter's tool, used to flatten a ball of clay for further shaping on a jigger or in a mold.

Bean Pot: 2.5" - 2.75" H individual container with curved neck for baking beans.

Berry Set: Large bowl for serving fruit with 6 or more matching smaller fruits or berries.

Bone China: A hard, light, and translucent body, made from a mixture of animal bone ashes & refined clays, fired at high temperatures.

Bone Dish: A crescent shaped dish for receiving fish or fowl bones.

Border Decals: Narrow strip decals placed on the edges of ware, beginning around 1910.

Bump Handle Teapot: 9" L and 9.5" L Hotoven teapots with a bump on top of the handle.

Brush Vase: Item of Toilet Set, used as toothbrush holder or small vase.

Bulbous Jug: 7.25" to 7.5" H bulb shaped jug with a lid and a vertically ribbed neck.

Butter, Covered: From the late 1800s to early 1900s, butter dishes were usually round with a round insert. Chips of ice were placed beneath the insert to keep the butter cool. From about 1940, Harker produced rectangular butters to accommodate a 1 pound block of butter and later, smaller sizes for quarter pound sticks.

Butter Pats: 3" plates, decorated to match dinnerware sets, to hold fancy pats of butter. Seldom marked.

Cake Set: Consisting of a large plate such as a Virginia utility plate, Gadroon, or Aladdin lugged plate, 6 or more smaller matching dessert plates, and lifter.

Candle Holder: Harker made candle inserts for Rockingham hound handled mugs and paneled Heritance shape candle holders.

Canister: 5" to 6" H container for flour, sugar, etc.

Casserole Dish: A round covered dish for baking/serving.

C.C. Ware: Ware made from local clays, called cream-colored or common clay.

Celery Tray: 12" rectangular dish used to serve celery or relishes.

Ceramic: Any item made from clays.

Chamber Pot: Round covered receptacle for human waste, usually about 5" high, part of a Toilet Set.

Cheese Set: Consists of a Concentric ring plate and 5" W round dish with lid.

China: Made from purer clays, fired at higher temperatures, generally more translucent, thinner, harder, finer, and impervious to water.

Chop Plate: Designed to serve lamb or pork chops and made in 2 sizes. Harker "borrowed" the shape from a French company. Most were decorated to be wall plaques, many with advertising.

Combinet: Made to accompany a Toilet Set. Older versions matched the Toilet Set shape, while later versions were more generic and were decorated to accompany a variety of Toilet Sets.

Concentric Rings Cheese/Cake Plate: 11" - 12" rings that get smaller toward the center of the plate, to accept a covered cheese dish in the smallest ring.

Compote: A tall footed flat dish to hold fruit.

Covered Vegetable: A dish with a lid used to serve vegetables.

Crazing: Tiny veins/cracks in the surface of ware caused by the difference in temperature expansion and contraction rates between the body of a piece and its glaze.

Creamer: Small hollowware piece for serving cream, in a variety of shapes.

Cream Soup: A cup-shaped soup bowl with two handles.

Crimp Top Shaker: 4.75" H shaker in 3" square and 2" x 3" rectangular shapes for salt, pepper, sugar, and flour, with a metal crimp top and punched holes.

Cup Ring Plate: A plate with a molded ring to hold a cup (Luncheon plate).

Custard: 2" - 3.75" H round cup (no handle) for baking custard, made in a variety of shapes.

Decals/Decalcomania: Multicolored designs printed on a special medium. Soaked in water, they can be lifted, placed on green (unfired) ware, and fired permanently onto the item.

Demitasse: 2" - 2.5" H cup & 5" saucer used for serving strong after dinner coffee.

Divided Vegetable: A vegetable dish with a divider down the middle.

Dresser Tray: A flat tray for a lady's dresser to hold small personal items.

Drips/Lard: Jar for bacon drippings or lard, part of a Range Set including salt & pepper.

Egg Cup: Generally, a double ended item, one end holds a boiled egg and the other end is the base.

Egg Coddler: Set of four (generally) 3" H custard cups in a wire holder with metal lids.

Elodie: See Gargoyle.

Embossed: A raised or molded surface decoration on flatware and hollowware.

Engobe: Thinned slip (liquid clay), usually colored. Green ware is dipped into the slip, resulting in a solid colored exterior.

Engraved: (See Intaglio), the opposite of Embossed.

Ewer: Jug or pitcher.

Experimental: Every new shape, pattern, color, etc., went through an experimental phase and many items never went into production. Several plaques in this book are examples of a process abandoned during the experimental phase.

Florist Vase: 6" H Melrose shape wide mouth pot. With a lid, could be used as a cookie jar.

Flow Blue: A cobalt slip decorating treatment, where thin slip was allowed to "flow" inward from the edges of flatware. Harker Flow Blue items have dark blue decals in the center and traditional Flow Blue edges.

Footed Bowls: A bowl on a raised base or foot, in 3 sizes.

Footed Sundae: Ice cream dish on a short pedestal, often with round under plate.

Flue Cover: 5.5" Fluted ceramic plaque, covered stove pipe hole on wall.

Game Set: Consists of a platter and matching plates, decaled sets for fish, fowl, & beef/venison.

Gargoyle Handle: In 1888 this shape was called Elodie. In the twentieth century, Harker reused this shape on jugs, creamers, and teapots. In the 1930s they made vases in this shape, but without the handle.

Gargoyle Teapot: 7" H Teapot with Gargoyle handle and small Gargoyles on the lid.

GC: Gem Clay, a shape with embossed vertical lines on hollowware.

Gem Cream & Sugar: 3" to 3.25" H curve handled containers, no lids.

Glaze: The last coating, most often clear and shiny, applied to ware before firing.

Greenware: Any clay item ready for its first firing in the kiln.

Hall Boy Jug: A heavy ironstone straight sided jug, made by most area potteries in the late 1800s.

Hand Colored: Black, brown, or blue transfers that were hand painted and then glazed, making the decoration more durable.

Hand Painted: Usually painted on top of the glaze, making the decoration more fragile.

Handy Style: A smaller smooth round sided bowl, made in 3 nesting sizes.

Hanging Soap Dish: Designed to be mounted on the wall with a nail. Harker produced at least 2 styles. One has a flat back with a nail hole and one has a cathedral shaped back, also with a nail hole.

Harker Jugs: 3" to 9" H fluted jugs, the largest was used in "Lemonade Sets".

Hi-Rise Jug: A GC shape 9.25" - 9.5" H square bottomed jug with a lid.

Hollow Ware: Cups, bowls, jugs, teapots, coffeepots, etc.

Hound Handled Jug: Rockingham (1850s) and Reproduction (1960s) Rockingham Jugs with stag & hounds hunting scenes embossed on the body and a hound for the handle.

Intaglio: A design that is carved or engraved through to the underlying surface.

Ironstone: A marketing term for heavy non-translucent items, implying durability.

Inverted Bow & Arrow: Harker backstamp found on late 1800s ware, often more finely formed and decorated than ware bearing other Harker marks. Also found on late 1800s Harker letterhead.

Jelly Jar: 4" paneled Melrose shape with lid, for holding a glass jar of jelly.

Jug: Hollowware receptacle for liquid, usually with spout and handle, produced in many sizes and shapes.

Jumbo Cup: 3" H cup and 7" saucer (Mom, Dad, etc.)

Kiln: Oven in which pottery is fired, pronounced "kill".

Ladle: Long handled utensil for dipping liquid or sauce from a receptacle.

Lemonade Set: Consisting of a quart size fluted Harker jug with at least 6 matching tumblers, with or without handles.

Liner: Craftsperson who applied lines (gold or other colors) or other hand decoration to ware.

Lugged: Non-pierced extensions resembling ears, on flat ware.

Match Holder/Striker: Small receptacle for holding matches, 2" H x 2.25" W, with ribbed striker on the bottom and hole for wall mounting on the back.

Matte Finish: A finish (glaze) that is not shiny or glossy.

Melrose Jug: 7.5" H jug with curved handle.

Miniature Rolling Pin: 8.5" child's rolling pin, part of Pastry Set.

Modern Age: Surface embossing resembling arrow feathers & shafts. Hollowware had lifesaver finials on lids.

Molasses Can: A small jug used for molasses or syrup, often with metal top.

Mold: A rigid shape into which clay is poured or forced to form a pottery item.

Mold Support: Often crudely formed rigid piece surrounding a rubber mold into which slip is poured and left to dry until it can be removed for firing in a kiln.

Mug: Heavy cup shaped hollowware piece, usually with a handle, for hot beverages or shaving soap.

Mustard Pot: A small pot (cup-like) with a notched lid, to contain condiments.

Nappy: A round or square open dish in a range of sizes. Harker's original nappies were square with a basket weave molded side, offered in 7 sizes.

Nesting Bowls: Bowls in 3 or more graduated sizes so they could be stored one inside another.

Notched Lid: Lids for soup or oyster tureens, casseroles, covered vegetables, mustard pots, etc., with a notch to accommodate a spoon or ladle.

Oatmeal Set: Child's breakfast set (circa 1910-1920), consisting of a 6" plate, 6-7" bowl, and 3" H creamer, usually in Dutch themes/scenes.

Ohio Jug: A round or paneled jug with a handle & lid. These were produced in five sizes from a syrup/creamer to 7" H.

Oyster Tureen: An oversized covered dish for serving oyster stew.

Paint Palette: An often hand molded piece of fired clay with a small "well". It was held in one hand by a "liner" or gold decorator, while the other hand used a fine brush to apply one or more lines of gold or other color to a piece of pottery.

Pastry Set: A pie baker and matching ice water rolling pin, full size and miniature.

Pate Sur Pate: A term originally meaning painting paste upon paste to build up a decoration. Harker used this term for Gadroon shaped items. What they actually did was spray the surface with a color and then quickly wipe the fluted edging, so only the recesses of the edges retained the color.

Perfume Ewer: A Harker experiment in the 1960s, modeled after the Knowles, Taylor & Knowles (KTK) Lotus Ware perfume ewers. These items were purely decorative, had no stoppers, and never went into production.

Pie Baker: Hotoven pie bakers (9" and 10") were immediately popular with American housewives when they debuted as the first decorated oven ware in the late 1920s.

Pin/Card Tray: A small flat dish, usually highly decorated, to hold a woman's hair pins or business cards.

Plaque: A painted, decaled or molded item designed to be hung on the wall for decoration.

Portrait Plate: Any painted or decaled picture of a person on a plate, meant for decoration.

Punch Bowl: Any large bowl on a pedestal, designed for serving beverages with a ladle.

Range Set: A 3 piece set consisting of a salt, pepper, and covered Lard/

Drips jar to save left over grease for reuse, in **D-Ware** shape with 4.75" H salt & pepper and 5.5" H Drips jar, also in **Skyscraper** shape with 4.5" H salt & pepper and 4.75" H Drips jar.

Refrigerator Jug: A covered jug, intended to go from refrigerator to table. Harker captured a sizable chunk of the market in the 1930s - 1950s with colorful decaled or intaglio offerings in round bodied, square bodied, bulbous, hi-rise, and Ohio Jug shapes.

Reproduction Rockingham (Gift Ware): 1965 ware in brown, honey, and bottle green.

Rockingham: A mottled brown or gold glaze in the 1850s-1870s and again in the 1960s. The latter were made in shades of brown, honey, and bottle green.

Rolling Pin: 15" hollow cylindrical ceramic utensil, intended to hold ice water, with a cork in one end and a loop for hanging the pin on the other end, used to flatten dough. We believe there are at least 140 different decal patterns/treatments on Harker Rolling Pins. Miniature Rolling Pins were made for children and may be found with as many as 20 different patterns/treatments.

Roll Tray: A uniquely shaped oblong dish for serving bread or rolls.

Rope Edge: Very narrow embossing along edge of cake plates and utensils.

Rose Bowl: A sphere shaped vase, usually with a ruffled neck, designed to hold a small bouquet of roses.

Round Bodied Jug: 8.5" H, viewed from the side, presented a round flat sided design, with a lid, first offered with the Cameo Ware line, later in white with decals matching various dinner and baking ware offerings.

Salad Set: Consisted of a medium size round bowl and matching ceramic fork and spoon. In Stoneware, a salad set consisted of a large bowl, salt & pepper, lidded vinegar & oil cruets, nested in a black iron frame.

Sauce Tureen: A small tureen (some examples with notched lids), made to match dish sets, 1800s to early 1900s, for serving sauces, with matching small ladle and plate.

Scoop: 6" tab handled, spoon shaped utensil, with a hole in the tab for hanging, offered with popular decaled bake ware lines.

Scrolled: Curled surface embossing on 7" and 8" H coffeepots.

Semi-Porcelain (synonymous with semi-vitreous): Simply defined as not impervious to soaking up liquids. Porcelain, on the other hand, is made of finer clays, fired at higher temperatures, and will not absorb liquids.

Sepia-tone: Brown tone transfers, most often used for advertising and store give-away items.

Shakers:
 Aladdin 3" W
 Ball 2.5" H
 Coupe 2.5" W to 3" W
 Crimp Top 4.75" H
 D-Ware 4.75"
 Flour, Crimp Top 4.75" H, Skyscraper 4.5" H
 Gadroon 2.75" H
 Heritance 3.5" to 3.75" H
 Laurelton 3.75" H
 Modern Age 3.25" to 3.75" H
 Olympic 3.75" H
 Shellridge 4" H
 Skyscraper 4.5" H
 Stoneware 3.25" H salt & 2.5" H pepper (also 4.5" H salt & pepper), 4" H salt & 2.25" H pepper, and 2.25" H salt & pepper and 5" H oval salt & pepper, 2" H salt & pepper
 Sugar, Crimp Top 4.75" H
 White Clover (Russel Wright) 4" H salt and 2.25" H pepper
 Woodsong 3" H

Shaving Mug: A heavy cup, intended to hold shaving soap and a brush, often part of a Toilet Set.

Shell Ware/Shell Shape (Shell): A swirl, seashell-like dinnerware shape, used on Cameo Ware & decaled items.

Slip: Watered down clay mixture, often colored, used for dipping or spraying, or otherwise decorating green ware before firing.

Slop Jar: Largest piece of a Toilet Set, usually with applied handles or wire bale handles, and a lid. Used for disposal of dirty water from pitcher and bowl bathing.

Soap Dish: Part of a Toilet Set, often consisted of a shallow bowl, lid, and perforated liner/strainer, to keep the soap above any water in the bottom of the dish. Earlier versions were one piece and hollow, with a hole for draining.

Soap Slab: A solid rectangular ceramic slab with slightly higher edges and raised ribs for holding a bar of lye soap.

Soup Tureen: A large covered serving dish with a notch in the lid for a ladle, sold with matching ladle and under plate.

Spittoon (Cuspidor): A utilitarian item used to dispose of used tobacco (most often by spitting it out), with a hole in the sloped top to receive the tobacco and juice, and a hole in one side to facilitate cleaning.

Spoon Holder (Spooner): Produced in two distinct shapes. The earliest was a solid molded horizontal design as a rest for a large spoon or ladle. The second was a vertical hollowware item designed to hold several teaspoons.

Square Bodied Jug: 8" H, viewed from the side, presents a square flat sided design, with a lid, first offered with the Cameo Ware line, later in white with decals matching various dinner and baking ware offerings.

Stack Dish(es) (Set): 1.5" to 2.5" H square or round dish (sometimes paneled), usually sold in sets of 2 or 3, with one lid, intended to be placed one atop the other for storing leftovers in the refrigerator.

Stone China: A marketing term for heavy non-translucent items, implying durability.

Sugar Basket: A ceramic basket, for serving sugar.

Syrup: At 3.5" H, the smallest of the Ohio Jugs, round or paneled with a lid.

Tea Leaf: A popular, simple decoration on white ironstone in the late 1800s. Each company that offered a Tea Leaf motif had its own special design. Harker's was in gold on Atlanta & Elodie shapes.

Thumbprint: Scarce shape found on bowls, plates, and platters.

Tidbit: An innovation from the 1950s, used to serve small snacks or sweets. Offered with one large plate or as a double or triple tier using graduated sized plates.

Toby Jug: A figural jug in the form of a man, Toby Fillpot, a notorious English drunkard.

Toilet Set: Consisting of a tall Ewer for hot water, a basin/bowl for bathing, shorter Ewer for cold water, brush vase for toothbrushes, covered soap with liner/strainer, shaving mug, chamber pot with a lid, and a covered slop jar or combinet.

Tom & Jerry Set: A Punch Bowl and matching small mugs (Labeled "Tom & Jerry") for serving alcoholic punch.

Transfer: An earlier method similar to decalcomania, but usually in a single color. In the late 1800s, single color transfers were often hand painted and glazed for sets of dishes & toilet sets.

Translucent China: True china made of finer clays fired at higher temperatures. It is harder, lighter, shinier, and does not absorb liquids.

Trivet: A 6.5" W octagon accessory for placement beneath hot dishes or teapots, dating from the beginning of Hotoven ware production.

Tumbler: Hollowware item in several sizes, for use with punch bowls, lemonade and water jugs, with and without handles.

Utensils: Harker made a variety of utensils, including 15" rolling pins, 8.5" miniature rolling pins, 6" scoops, ladles, 8.25" - 8.75" spoons, 8.5" - 9.5" forks, 8.75" - 9.5" lifters (some with embossed rope edge handles), Modern Age 8.5" spoons, 8.75" forks & lifters.

Vase: A hollow vessel intended to hold flowers. Harker made several sizes from the tall Native American art vases, to a shorter version with a "Four Seasons" lady, to fluted top Gibson Girl of medium height, to round rose bowls and square Cameo bud vases, all rare. Less rare are the Melrose Florist Vases and Gargoyle Vases with a variety of decals.

Vent Lid: Casserole or baking dish lids manufactured with a tiny round hole for venting steam.

Virginia Utility Plate: 11.75" - 12.75" lugged square plate.

Waffle Set: Consists of a Virginia utility plate, 5" H covered Ohio Jug and a smaller covered Ohio syrup jug.

Water Set: Harker Water Sets were made in the Empress and Paris shapes, consisting of a jug and 6 or more matching tumblers.

White Ware: Made from more refined and purified clays than the native (yellow) clay found along the Ohio River.

Wire Bale: A sturdy metal handle fashioned to go on Republic Shape jugs, slop jars, and combinets for easier handling.

Yellow Ware: Simple utilitarian ware made from local clay found along the Ohio River banks, most often covered with a clear glaze and minimal decoration.

Zephyr Lid: A fin shaped handle/finial found on lids for bowls, casseroles, cheese dishes, teapots, coffeepots, cookie jars, and Ohio jugs.

Zephyr Shape: According to some Harker ads, bowls with straight sides and a .5" collar on the outside top edge of bowls were designated as "Zephyr".

Index

Bake and Refrigerator Ware

Bean Pots, 98, 100, 114, 116, 117, 124, 126, 127, 131, 136, 143, 144,
147, 148, 151, 152
Cameo Ware, 11, 121, 147, 152-158, 202
Carv-Kraft, 147, 154, 155
Containesca, 148, 172, 173, 176, 186, 187
Custards, 95, 97-100, 105, 112, 114, 116, 117, 123-125, 127-136,
144-146, 149-154, 167
Egg Coddlers, 98, 130
Foil Covered Casseroles, 148, 172, 173
Glass Covers, 95, 96, 98, 135, 153, 173, 214 (Mark)
HotOven, 10, 95-98, 147, 148
Kelvinator, 95, 98, 118
Mixing Bowls
 Arches, 99, 102, 103, 105, 106, 124, 129, 132, 133
 GC Shape, 95, 99, 116, 123, 124, 126-128, 131, 133, 137, 144, 152
 Handy Style, 123, 124, 135
 Spout, 96, 98, 99, 105, 115-117, 124, 127, 129-136, 138, 143, 151, 152
 Zephyr, 96-98, 116, 130, 134, 135, 138, 146, 152-156, 164
Ohio Jugs, 96, 98, 99, 113, 115, 116, 125, 127-131, 133-137, 143, 146,
149, 151-156, 164
Old Riverport, 186, 193
Oven Ware, 96, 112
Pie Bakers, 97-100, 102, 105-107, 112, 115, 116, 122-124, 126-131,
133-139, 144, 145, 149, 151-154, 156, 162-164, 167, 182
Quaker Maid, 186, 191
Range Set
 Skyscraper, 97-99, 114, 116, 117, 127-131, 135, 137, 144, 151, 153-155
 D-Ware, 97, 106, 135, 150, 154, 155, 164
 Stack Dishes, 97-99, 102, 112, 113, 115, 116, 123, 124, 126, 127,
129-136, 146, 150-155

Dinnerware Shapes

Aladdin, 114, 115, 130, 148, 152, 163-167, 170, 171, 175, 176, 180-182,
184, 185, 196
Atlanta, 29-32
Bedford, 18, 25, 29
Bungalow Ware, 11, 95, 112
Cable, 9, 18, 19, 21, 22, 36, 37, 48, 89
Cameo Shellware, 147, 154, 158
Country Style, 11, 186, 194, 195
Coupe, 148, 174-176, 184, 186
Dixie, 29, 38-40, 42-44, 56-58, 63, 69, 70, 81, 83, 86-89
Dundee, 113
Embassy, 96, 115, 126, 135-137, 139, 140, 146, 150, 163, 164
Empress, 30, 91-94, 106, 123-125, 133
Eurasia (Colonial), 187, 204, 205
Fairfax, 29, 33, 34, 36, 37
Gadroon/Royal Gadroon, 61, 98, 99, 126, 135, 137, 147-149, 151, 159-167,
171, 175, 177, 180-185, 187, 202

Gargoyle/Elodie, 18, 19, 26-29, 99-107, 115, 123-125, 129, 130, 132,
133, 137, 138, 162
Heritance, 148, 177-179, 183, 186, 191, 202, 204, 205
Hostess, 96, 126, 128, 138, 139, 163
Laurelton, 148, 169, 170, 177, 186, 188, 189,
Loraine, 29, 36-38
Melrose, 10, 63, 65, 89, 95, 99-112, 115-117, 123, 127-130, 132, 133,
137, 139, 143, 149, 152, 158, 163
Modern Age, 98, 115, 116, 134-137, 143, 147-153, 155, 156, 162, 167
Newport, 96, 143-146, 149, 150, 152, 163, 166
Nouvelle, 95, 98, 107, 113-116, 127, 129-131, 136, 139, 140, 143, 144,
146, 149, 150, 152, 163, 167
Olympic, 170, 174-176, 186-191, 196, 197, 204, 205
Paris, 29, 44, 50-52, 60, 94
Republic, 9, 18-22, 25, 55
Rosemere, 96, 139, 150
Savoy, 29, 53, 54, 68
Shellridge, 149, 180, 182, 183, 202
Stoneware/Stone China, 11, 29, 121, 147, 148, 171-173, 176, 186,
194-197, 202, 204
Sun-Glow/Bakerite, 11, 95, 96, 124-128
Tahiti, 11, 186, 192, 193
Unknown Shapes I & II (1897), 33, 47, 48
Unknown Shapes III & IV (1936), 96, 114, 117, 127, 131, 138, 139
Unknown Shape V (c.1960-70), 205
Virginia, 96-99, 105, 106, 112, 114-117, 123, 125-131, 133-139, 144-146,
149-158, 161-164, 167, 181, 184
Waverly, 29, 35-37
Whitechapel Translucent China, 149, 180, 181, 186
White Clover (Russell Wright), 11, 147, 168, 169, 176
Windsor, 96, 114, 116, 128, 130, 131, 140, 143, 144, 146, 149, 152
Woodsong, 186, 192

Popular Decals or Patterns

Amy I & Amy II, 120, 136
Anemones, 124, 125
Anna, 128
Anti-Q, 119, 137, 138
Antique Automobiles, 184
Asters, 101
Autumn Ivy, 103-105
Autumn Leaf (Jewel Tea), 11, 95, 123
Bands (Silver & Gold), 121, 145, 146
Barbecue, 148, 169
Bermuda, 147, 160
Berries (red & blue), 131
Birds & Flowers, 100, 103
Blue Basket, 107
Blue Birds, 45, 79, 87, 94
Blue Rose, 120, 134
Bouquet, (Rose Bouquet), 147, 161
Bridal Rose, 118, 147, 161, 162
Calico Tulip (Gingham Tulip), 96, 98, 120, 147
Cameo Ware, 11, 121, 147, 152-158, 202
Carnivale, 118, 130

Carla, 140
Carv-Kraft, (White Rose), 147, 154, 155
Cherries, 45, 52, 55, 89, 94, 104
Chesterton, 147, 159, 160, 165, 181
Corinthian, 147, 159, 160, 165, 202
Country Garden, 112, 148
Countryside, 95, 116-118
Country Style, 11, 186, 194, 195
Crayon Apple, 120, 131
Currier & Ives, 185
Cyclamen, 119, 133, 134
Cynthia, 149, 180, 183
Daffodils, 106
Dainty Flower, 121, 147, 153-156
Deco Dahlia, 118, 130, 131
Delft
 Delft & Blue Dane (decal), 148, 177, 178, 194, 195
 Ware marked "Engobe", 147, 159
Donna (Wild Oats), 148, 176
Early American, 121, 131
Emmy, 119, 134
English Ivy, 120, 147, 149
Fire in the Fireplace, 116, 118
Forest Flower, 149, 182, (a.k.a. Pond Lily), 194
Forever Yours, 149, 182
Garden Trail, 149, 182
Godey, 119, 149, 181, 183
Golden Wheat, 179
Heaven Pink, 149, 180
Hollyhock Cottage, 106, 118
Honeymoon Cottage, 96, 118, 144
Intaglio/Engraved, 147
 Acorns, 186, 197
 Alpine, 148, 174
 Aqua Abstract, 148, 170
 Brown-eyed Susan, 148, 174
 Cock O'Morn, 186, 187, 189
 Coronet, 186, 187, 189
 Country Cousins, 186, 188, 190
 Dogwood, 186, 190
 Everglades, 174, 186, 187
 Ivy, 174
 Ivy Wreath, (a.k.a. Ivy Lace), 148, 174, 186
 Kimberly, 172, 195
 Peacock Alley, 172, 186, 196
 Petite Fleurs, 148, 179, 186, 188, 189, 190
 Provincial, 186, 188, 190
 Orange Tree (Lemon Tree), 148, 172, 173
 Rocaille, 148, 174, 202
 Seafare, 148, 172
 Spanish Gold, 186, 197
 Spring Time, 186, 188, 190 (a.k.a. Spring Breeze), 191
 Sun Glo, 186, 187, 189
 Viking, 148, 174, 175
 White Daisy, 175, 186, 188
Ivy, 118, 164, 165, 171
Ivy on Teal, 170
Japanese Lantern, 101
Jessica, 96, 125, 126
Jewelweed, 95, 96, 121, 124, 125
Leaf Swirl, 149, 182, (a.k.a. Leaf Dance), 194
Lillian, 101, 104
Lisa, 102, 103
Lovelace, 119, 151
Magnolias, 167
Mallow, 96, 119, 125, 127, 128, 147
Mary, 105
Modern Tulip, 119, 147, 149
Monterey, 120, 147, 152

Morning Glory, 133
Moss Rose, 20-26, 31, 35
Nasturtiums, 98, 99
Old Riverport, 186, 193, 194
Old Rose, (a.k.a. Wild Rose), 149, 181, 182
Orange Blossoms, 103, 106, 119
Orange Poppy, (Red Poppy), 135
Oriental Poppy, 95, 99, 100, 103, 118
Pansy, 47, 55, 119, 137
Papyrus, 107
Pastel Posey, 119, 146
Pastel Sunflower, 150
Pastel Tulip, 95, 96, 118, 126
Pear Blossoms, 102, 104
Petit Point, 118, 120, 147, 150, 151
Quaker Maid, 186, 191, 204
Rawhide, 186, 187, 194, 195
Red Apple I & Red Apple II, 95-98, 119, 147
Rose Chintz, 139, 163
Rose Spray, 166, 179, 181, 182
Royal Dresden, 120, 145, 150
Royal Rose, 165, 170
Ruffled Tulip (Shaggy Tulip), 103, 120, 128, 129
Shadow Rose, 92, 118, 138, 139, 147, 162, 163
Silhouette, 95, 114-116, 118
Slender Leaf, 171
Southern Rose, 119, 167
Strawberries, 45, 46
Taffy, 120, 137
Tahiti, 11, 186, 192, 193
Tarrytown, 96, 145
Tulip Bouquet, 118, 135, 150
Vintage, 118, 164, 165
Violets, 164
Wampum, (a.k.a. Navajo), 118, 147, 152
Whirligig, 132
Whistling Tea Kettles, 96, 143
White Clover, 11, 147, 168, 169
Wild Rice, 147, 158
Woodsong, 186, 192
Yellow Roses, 38, 49, 106, 119

Special Items

ABC Plates, 29, 70, 74-79
Advertising Items, 13, 29, 61-65, 76, 80, 82-89, 96, 109-112, 122,
141-143, 149, 159, 183, 196, 203, 205, 214
Bailed Jugs, 18, 25
Bump Handled Teapots, 95, 98, 99, 115-117, 127, 128, 131, 133-136, 143,
144, 151
Bungalow Ware, 11, 95, 112
Calendar Plates, 29, 82, 83-85, 110, 111, 141, 187, 205
Candle Holders, Heritance, 179
Rockingham Inserts, 197, 198
Celery Trays, 29, 37, 106, 127
Children's Ware, 28, 29, 66-79, 121, 122, 123, 157, 158, 186, 197
Chop Plates, 29, 36, 40, 41, 43, 56, 85
Clocks, Gadroon, 160
Russel Wright, 147, 168, 169
Compotes, 9, 18, 22, 26, 28, 30
Covered Butters, 29, 39, 50, 105, 114, 136, 137, 151, 152, 163, 169,
170, 173-176, 179, 183, 190-193, 195-197, 204, 205
Dundee Ware, 113
Embossed (Scrolled) Teapots, 95, 114, 127, 128, 131, 136
Experimental, 11, 187, 198-203
Flow Blue, 29, 42-44
Flue Covers, 29, 61-63
Footed Bowls, 22, 70, 97, 99, 102, 105, 114, 116, 124, 128-130, 136,
137, 151
Game Sets, 29, 41, 42, 44, 57-59, 87, 179
Hall Boy Jug, 18, 22, 37
Harker Jugs, 33, 36, 45, 54, 55, 66, 85, 89, 100
Hound Handled Jugs, 7, 13, 14, 186, 197
Ice Creams, 37, 54
Inkwells, 13-15, 18, 25
Juvenile Pastry Sets, 121, 122
Kiddo Sets, 157, 158
Lemonade Sets, 29, 54, 55, 66
Match Strikers, 29, 76, 82
Miniature Rolling Pins, 95, 121, 122
Molasses Cans, 18, 20, 37
Patriotic Novelties, 29, 80, 82, 83, 107-109, 143, 156, 158, 197-199,
202, 203
Portrait Plates, 29, 56, 57, 170
Punch Bowls, 29, 54
Reproduction Rockingham, 11, 186, 187, 197-199
Rockingham, 7, 9, 12-16, 187
Rolling Pins, 95, 97, 118-121, 148, 153, 187, 199
Roll Tray, 29, 37, 47
Sepia Tone Novelties, 29, 60-63, 70, 74-76, 84, 86, 88
Shakers
 Aladdin, 165, 170, 171
 Ball, 114, 136, 139, 146, 149, 150, 163
 Coupe, 173, 175, 176, 184
 Crimp Top, 100, 105, 125, 127, 128, 130, 135, 137, 143
 D-Ware, 97, 106, 130, 135, 150, 154-156, 164, 182
 Flour, 100, 105, 130, 135, 137
 Gadroon, 135, 159-161, 164, 165, 167, 182
 Heritance, 178, 179
 Laurelton, 169, 170, 177, 190, 191
 Modern Age, 98, 149, 150, 151, 153, 155, 156, 159, 162
 Olympic, 170, 175, 176, 189, 205
 Shellridge, 182, 183
 Skyscraper, 97-100, 114, 116, 117, 124-131, 133-137, 144, 146, 149, 151-155
 Stoneware, 172, 173, 175, 176, 191, 193-197, 204
 White Clover (Russel Wright), 168, 169
 Windsong, 192
Soaps
 Covered, 23, 24, 26, 30, 34-36, 48-50
 Dishes, 22, 197, 198
 Hanging, 29, 36, 47
 Hollow, 22, 36
 Slabs, 36
Souvenir Plates, 29, 60-65, 80-82, 86-89, 157, 183, 185, 198
Spittoons, 7, 12, 14-16, 29, 36, 45, 48
Sugar Baskets, 29, 36, 45
Sunbonnet Sue, 62, 69, 76, 88
Tea Leaf, 27, 29, 31
Trivets, 100, 101, 109, 111, 112, 115, 116, 129-131, 134, 141, 142, 149,
152-156
Utensils, 30, 31, 96-99, 105, 106, 112-114, 116-131, 133-137, 144, 146,
148-156, 159, 160, 162-167, 170-173, 175, 176, 180-185, 191, 193, 196,
199, 204
Vases, 29, 47, 81, 85, 103-105, 155
Water Sets, 29, 52, 94
Yellow Ware, 7, 12-15

Toilet Set Shapes

Argonaut, 18, 23
Bennett, 50
Cable, 9, 18, 19, 48
Cambria, 18, 26
Columbia, 29, 30
Combinet, 18, 29, 49
Etruria, 18, 23
Iolanthe, 9, 18, 24, 25
Manila, 29, 33, 45, 48-50
Menlo, 29, 48, 50
Miami, 29, 48, 49
Rainbow, 29, 35
Republic, 9, 18, 21, 50, 55
Tremont, 29, 34
Unknown Shapes, 22, 29, 32
Western, 29, 50